SENSATIONAL MODERNISM

SENSATIONAL MODERNISM

EXPERIMENTAL FICTION

AND PHOTOGRAPHY IN

THIRTIES AMERICA

BY JOSEPH B. ENTIN

The

University of

North Carolina

Press

Chapel Hill

© 2007
The University of North Carolina Press
All rights reserved
Set in Bodoni Book, Futura, and Mostra types
by Tseng Information Systems, Inc.
Manufactured in the United States of America

Library of Congress Cataloging-in-Publication Data

Entin, Joseph B.
Sensational modernism : experimental fiction and photography
in thirties America / by Joseph B. Entin.
 p. cm. — (Cultural studies of the United States)
Includes bibliographical references (p.) and index.
ISBN 978-0-8078-3136-6 (alk. paper)
ISBN 978-0-8078-5834-9 (pbk. : alk. paper)
1. American fiction—20th century—History and criticism.
2. Experimental fiction, American—History and criticism.
3. Art and literature—United States—History—20th century.
4. Documentary photography—United States—History—20th
century. 5. Mass media and art—United States. 6. Modernism
(Literature)—United States. 7. Visual perception in literature.
8. Social problems in literature. 9. Poverty in literature.
10. Poor in literature. I. Title.
PS374.E95E58 2007
813'.5209355—dc22 2007005601

An earlier version of chapter 3 was published as "Modernist
Documentary: Aaron Siskind's *Harlem Document*," *Yale Journal
of Criticism* 12, no. 2 (1999): 357–82; used by permission of the
Johns Hopkins University Press. Portions of chapters 4 and 5
first appeared as "Monstrous Modernism: Disfigured Bodies and
Literary Experimentation in *Yonnondio* and *Christ in Concrete*," in
*The Novel and the American Left: Critical Essays on Depression-Era
Fiction*, ed. Janet Galligani Casey (Iowa City: University of Iowa
Press, 2004), 61–80; used by permission of the publisher.

11 10 09 08 07 5 4 3 2 1

*For
my parents
and
for Sophie*

CONTENTS

ILLUSTRATIONS

ACKNOWLEDGMENTS

In the course of working on this project, I have benefited enormously from the generosity of many people, and it gives me great pleasure to express my gratitude. For a sense of what cultural studies can be and do, I am indebted to Dick Ohmann and Joel Pfister. Joel's infectious enthusiasm for critical thinking and Dick's big-hearted radicalism showed me why teaching matters and convinced me I wanted to be a teacher myself. In Yale's American Studies Program, Jean-Christophe Agnew, Laura Wexler, Matthew Jacobson, Franny Nudelman, Bryan Wolf, Alicia Schmidt Camacho, and Vicki Shepard each supported me and my work at crucial moments, and I remain exceedingly grateful to them. Alan Trachtenberg has provided a model of exceptional intelligence and rigor, and his support for this project has been essential. Michael Denning deserves special thanks; his creative thinking and dedication to activist intellectual work have long inspired me, and without his early and unwavering encouragement this project would not have been completed.

This project was shaped by the struggle for union recognition and social justice in New Haven carried out by the Graduate Employees and Students Organization and the Federation of University Employees. I am immensely grateful to the staff members and organizers of GESO, especially those in American studies, who, with great flair and conviction, showed me that labor activism, teaching, and research could be combined in remarkably synergistic and generative ways. I am particularly indebted to Rebecca Schreiber and Cynthia Young, and to Gaspar González, Scott Saul, and Brendan Walsh, whose friendship and solidarity have buoyed me for years, and whose own work, both inside and outside the academy, continues to amaze and inspire me. I also want to thank the members of the *Radical Teacher* editorial collective for their encouragement and perverse humor. Will Holshouser, Kathy Belden, and the members of Commonplace provided music, good cheer, and other forms of beautiful and necessary distraction. I have also been aided by advice and assistance from a host of kindhearted friends and colleagues, including Steve Biel, Sara Blair, Sarah Chinn, Lenny Davis, Jeanne Follansbee Quinn, Alyosha Goldstein, Larry Hanley, Bayard and Betsy Klimasmith, Paul Lauter, Bill Mullen, Kathy Newman, Lee Quinby, Robert Perkinson, Bob Rosen, Maren Stange, Pat Willard, Leonard Vogt,

Janet Zandy, Sandy Zipp, and the late Shafali Lal. In 1997, I spent an afternoon with Tillie Olsen; her commitment to social change and her extraordinary generosity of spirit stirred me immensely and helped put this project in motion.

My work on this project has been made possible by generous institutional support. In 2002–2003 I was awarded a postdoctoral fellowship at the American Academy of Arts and Sciences, and I am grateful to Leslie Berlowitz, the academy's director, and to Sandy Oleson and the academy staff. I particularly want to thank James Carroll and the other fellows, especially Andy Jewett, Ann Mikkelson, and Jay Grossman, whose friendly criticisms of portions of this manuscript were vital to my revisions. Fellowships from the PSC-CUNY Research Award Program and the Mrs. Giles Whiting Foundation provided release time that allowed me to complete the manuscript. The Aaron Siskind Foundation, Getty Images, the Mary Ryan Gallery, Jonathan Toby White, and the Avery Architectural and Fine Arts Library at Columbia University kindly granted permission to reprint visual images.

Working with the University of North Carolina Press has been a pleasure; I am particularly indebted to Sian Hunter, who gracefully guided this manuscript though the review process and into production, and to Paul Betz, for his very thoughtful editorial work. I also want to thank the two readers for the Press, Michael Thurston and Miles Orvell, whose insightful feedback helped make this project better.

Brooklyn College has been a vibrant and friendly professional home, and for that I am grateful to my colleagues in English and American studies, especially Julie Agoos, Ray Allen, Lou Asekoff, Elaine Brooks, Rachel Brownstein, Ken Bruffee, George Cunningham, Geri Deluca, Marty Elsky, Wendy Fairey, Len Fox, Julia Hirsch, Brooke Jewett-Nadell, Nicola Masciandaro, Paul Moses, and Bob Viscusi. I feel exceedingly fortunate to be under Ellen Tremper's capacious wing; her sage counsel, keen wit, and unflagging support have saved me time and again. Likewise, I thank Roni Natov for her radiant warmth and generosity. My fellow Americanists, James Davis, Geoffrey Minter, and Martha Nadell, have, quite simply, proved to be the most sympathetic, engaging, and committed colleagues I could ever have hoped for.

Along with close friends, my family has provided the most sustaining forms of support. The seeds of this project were planted in conversations with the late Michael Davitt Bell, the executor of the first and only Marian Whieldon and Davitt Stranahan Bell Research Fellowship, which afforded me time to begin thinking about this project in the summer of 1996. I

sorely wish Michael had lived to see this book come to fruition. Cathleen Bell and Rick Kahn, and along with them, Sam Ouk, and Claudia and Walter Gwardyak, have steadfastly nurtured, encouraged, and humored me; their support means the world to me. Mabel Entin and Dorothy Riehm have offered calm, steady encouragement, and their confidence in me has been a source of great reassurance. My sister, Lena Entin-O'Neill, and her husband, Steve O'Neill, give me reason to believe a better world is possible, and their love and sense of fun enrich my life immeasurably. My parents, Audrey Entin and David Entin, have supported me and my work through ups and downs, without hesitation or reservation. Their faith in me has never wavered, and I am forever grateful to them. My work as a teacher and writer pales in comparison to my life as a parent, and for that I thank Miriam and Rachel Entin-Bell, who infuse my world with untold joy and wonder. Finally, and most significantly, I thank Sophie Bell, companion, colleague, and co-conspirator, the light of my life, whose love and support made this book—and so much more—possible.

SENSATIONAL MODERNISM

INTRODUCTION

In 1939, the Italian American writer Pietro di Donato denounced what the narrator of his novel *Christ in Concrete* calls the "transparent distant eye like policemen" with which the socially powerful survey the poor.[1] When the impoverished immigrant protagonists of di Donato's novel visit the State Workmen's Compensation Bureau, seeking redress for the death of a family member who was killed while working construction, the condescending way they are treated by bureau officials makes "them feel they had undressed in front of these gentlemen and revealed dirty underwear."[2] Two years later, in 1941, in the first section of the written portion of *Let Us Now Praise Famous Men*, James Agee's documentary collaboration with Walker Evans, Agee caustically mocked the attitudes he feared his well-to-do liberal readers might bring to his portrait of "an undefended and appallingly damaged group" of southern tenant farmers.[3] "This is a book about sharecroppers," Agee stated sardonically, "and is written for all those who have a soft place in their hearts for the laughter and tears inherent in poverty viewed at a distance."[4] Taken together, di Donato's reproach of a policing eye and Agee's sarcastic disparagement of middle-class pity critique the impulses animating two of the most prevalent modes of portraying impoverished and disenfranchised persons in early twentieth-century American narrative and visual arts: naturalism, which scrutinized the dispossessed in a way that echoed the regulatory gaze of the police, and sentimentalism, which enacted a gesture of charity that paradoxically reaffirmed the social "distance" of the sympathizers from the poor.

Di Donato's and Agee's criticisms anticipate recent claims made by cultural critics concerning a range of aesthetic forms—including realism, documentary photography, and high modernism—that U.S. artists used to depict the nation's underprivileged populations in the first half of the twentieth century. Critics have argued persuasively that these forms typically cast the disenfranchised as abject figures of middle-class pity, disdain, or supervision. For instance, several commentators have contended that realism's effort to expose the lives of modern America's "other half" constituted a disciplinary gesture that extended the social privilege and power of an emerging professional managerial class.[5] Similarly, numerous scholars have advanced the idea that documentary photography's depictions of the

poor reinforce the moral and political prerogatives of its intended audience, "reassuring a liberal middle class that social oversight was both its duty and its right," in the words of Maren Stange.[6] Likewise, several critics have argued that high modernism supports forms of condescension and social detachment founded on a punitive attitude toward socially marginalized figures. Peter Nicholls asserts that the brand of high modernism that has achieved literary and critical preeminence is marked by "an aggressive objectification of the other."[7] The high modernist literary subject, Nicholls and other critics contend, maintains a defensive attitude toward the social world, preserving the autonomy of the self by disdaining and debasing—if also at times paradoxically fetishizing—racially, ethnically, and economically subordinate persons and populations.[8]

Sensational Modernism examines a countertradition of left-leaning, Depression-era modernist writers and photographers whose work challenges the tendency of established representational and aesthetic modes— including sentimentalism, realism, naturalism, documentary photography, and high modernism—to cast the poor as romanticized versions of the middle-class self or as passive objects of a disciplinary or denigrating gaze. Confronting the widespread unemployment, labor unrest, and privation brought about by the Great Depression, these artists—William Carlos Williams, Tillie Olsen, Weegee, Richard Wright, Pietro di Donato, Aaron Siskind, Nathanael West, Meridel Le Sueur, and others—aspired to arouse in their audiences a new, more urgent understanding of poverty, industrial violence, and racial injustice. To do so, sensational modernists used striking images of pain, prejudice, crime, and violence to create avant-garde aesthetics of astonishment. These explosive motifs were designed not only to startle audiences into a new awareness of destitution, discrimination, and conflict, but also to spark a meditation on the ways in which aesthetic forms support—and perhaps might help to undermine—hegemonic structures of power. Sensational modernists drew their tactics of aesthetic astonishment from a most unlikely source, popular culture, in particular from a wide range of arts, entertainments, and institutions (including cinema, pulp magazines, freak shows, and tabloid newspapers) that collectively constituted an emerging culture of spectacle. Blending tropes from popular culture, avant-garde techniques of shock and estrangement, and a realist focus on the social fringes, sensational modernists fashioned willfully unorthodox forms of experimental expression to depict the shock of class, racial, and ethnic difference.

Sensationalism is a somatic discourse, rooted in the body and the senses,

which emerged in the eighteenth and nineteenth centuries to describe the philosophic theory that all knowledge stems from the immediacies of physical experience. Over the latter half of the nineteenth century, the sensational came to denote, in popular parlance, an exciting experience or a violent emotional response by an audience, reader, or spectator prompted by scenes or images of extreme contrast, disaster, or lurid behavior.[9] In contrast, modernism is conventionally considered to be a highly cerebral mode that employs forms of aesthetic experimentation to render the intricacies of modern consciousness. As an aesthetic mode, sensational modernism blends a sensational focus on the body, shock, and social extremes with a modernist emphasis on formal innovation and aesthetic self-consciousness. More specifically, the sensational aspects of these texts include a focus on "low," "exotic," and "alien" figures (immigrants and slum dwellers, criminals and cabaret dancers) and the use of tropes of bodily harm and disfigurement to express both social crisis and cultural critique. The modernist elements include canonical modernist devices (such as stream of consciousness, narrative fracture and fragmentation, and surreal sequences) as well as various kinds of generic experimentation, including the fusion of naturalist, realist, documentary, and proletarian modes to create composite forms of expression.[10] Combining a sensational focus on visceral impact and social contrast with a modernist emphasis on aesthetic experimentation and cognitive disorientation, sensational modernists deploy arresting images of disfigured bodies to depict the poor and dispossessed in ways that challenge the sense of moral authority and cultural control that sentimentalism, naturalism, documentary photography, and high modernism typically grant the middle and upper classes.

As an analytic category, sensational modernism expands our sense of modernism's scope and cultural power, and argues for considering a new group of artists as modernists. Traditionally, critics defined modernism as a collection of dense and difficult texts whose authors sought to transcend the sordid realities of modern, industrial-commercial society—what T. S. Eliot famously referred to as "the immense panorama of futility and anarchy which is contemporary history"—by creating an autonomous realm of aesthetic complexity, purity, and abstraction.[11] In recent years, however, scholars have definitively cracked open the narrow, formalist conception of modernism established by the New Critics. Indeed, we can now see modernism as a diverse field of intersecting movements and subtraditions, made up of artists who used experimental rhetorical and representational techniques for a wide variety of social and political projects: ethnic modernism, New

Deal modernism, pulp modernism, crossroads modernism, to name just a few.[12] Building on this scholarship, *Sensational Modernism* examines the ways in which a group of dissident modernists adopted what I call America's sensational imagination to address the social distress and cultural conflict of the Great Depression, a period in which dominant ideologies of American progress and prosperity fell into crisis and flux. *Sensational Modernism* contends that, for many artists, modernism was a mode of social engagement rather than evasion, an aesthetic form in which socially committed writers and photographers registered the violence of class distinctions, racial discrimination, and industrial injury. Indeed, it is typically by undertaking a "realist" enterprise—the effort to transmit the most visceral, compelling, gritty sense of poverty, prejudice, and harm—that these artists develop their experimental styles, as the attempt to fashion an aesthetic of social extremity pushes them beyond the bounds of conventional narrative and visual modes and registers. Moreover, this study suggests that modernism's experimental energies and techniques appear in texts and cultural locations that critics have tended to overlook: in the work of tabloid and documentary photographers such as Weegee and Siskind and in the work of proletarian and ethnic writers such as Olsen and di Donato. As an interpretive frame, sensational modernism allows us to see a previously neglected line of modern artists whose work integrates innovative techniques usually associated with high modernism, as well as tropes and formal tendencies emanating from an expanding culture of mass sensationalism, in an effort to confront and convey the sharpening social inequality brought about by the Great Depression.[13]

When I set out to write this study, I began to examine a line of texts that ran from the 1890s up through the middle years of the twentieth century, all of which shared certain aesthetic and ideological features. In particular, I became interested in a set of novels and works of photography that took as their drama the crossing of boundaries marked primarily by social class. These texts aimed to bring news and views of the "other half" to middle-class readers. Some were produced by middle-class artists who ventured "down" the social ladder to bring back images and stories of the dispossessed. Others were created by artists "from below" who aspired to challenge the assumptions held by the well-to-do about the disenfranchised. Formally, these texts deviated from conventional aesthetic expectations by blending tendencies and techniques from modes traditionally thought to be at odds with one another, such as modernism and documentary, naturalism and pulp fiction. Ideologically, the texts sought to challenge normative as-

sumptions about the innate inferiority, passivity, or degradation of the disenfranchised. Tropologically, the works shared a fascination with physical disfigurement, using images of distorted or misshapen bodies to signify the harm of industrial injury or social prejudice. As my collection of texts began to grow, I noticed that the works of fiction and photography that interested me the most—largely because they seemed to be the most aesthetically daring and the most politically engaged—were almost all from the 1930s.[14] What was it about the decade's expressive culture that had facilitated the production of these unusual texts, which seemed to be strange composites of realism and modernism, tinged with the sensational energies of mass culture? Why did this cultural form flourish during the 1930s? The answer, I think, is evident. The central features of sensational modernism—a concern for the poor and a preoccupation with social boundaries, aesthetic experimentation and a blurring of "high" and "low" culture, the trope of the disfigured body, and a commitment to documentary exposé—all acquired particular saliency in Depression-era culture.

Depression Modernity and Sensational Modernism

The Great Depression represented what Antonio Gramsci called a crisis of hegemony, a moment when established relations of social force, cultural power, and political representation are disrupted, and prevailing notions of "common sense" are called into question.[15] In the wake of such turmoil, Gramsci contended, blocs of power are reconfigured and a new hegemonic formation, with newly secured patterns of ideological consent, is constituted. The Great Depression was such a period of crisis and transition, when the material, ideological, and representational field was subject to immense fluctuation and uncertainty. Eventually, through the coalition of governmental, popular, and corporate forces brought together in the New Deal and galvanized by World War II, a new hegemonic alliance was established. In recent years, cultural historians of the Depression era have underscored the force of continuity over flux and downplayed the extent and significance of the period's political instability and radicalism. Alan Brinkley, Terry Cooney, and Lawrence Levine have followed Warren Susman in arguing for the relatively conservative tenor of the period's expressive, popular, and intellectual cultures, which in the end tended to promote an ideology of collective national purpose and acquisitive individualism. Susman famously maintains that in the 1930s the modern, anthropological notion of culture as a comprehensive and inclusive "way of life" emerged in the United States, as writers, photographers, and social scientists launched a massive effort to

identify and record what was most distinctive about the nation's "character" and values. Susman contends that this search led to a celebration of an idea of the "people" that "could and did have results far more conservative than radical."[16] Similarly, Alan Brinkley argues that writers and artists who early in the decade had promoted revolutionary solutions turned in the latter years of the period to "a new kind of radicalism—folksy, unthreatening, American."[17] Brinkley's paradoxical notion of an "unthreatening" "radical-ism" echoes Terry Cooney's claim that American culture and thought dur-ing the decade were characterized by a series of "balancing acts," in which central tensions—between persistence and change, caution and confidence, heterogeneity and cohesion—were managed and contained.[18] Traditional values and beliefs were challenged and altered, but ultimately reaffirmed, Cooney asserts. Overall, although these historians acknowledge much that was unprecedented and unsettling in the Depression decade, they empha-size political and ideological continuity, finding in the decade's culture a reassertion of national pride and unity, a renewal of capitalist individualism, and a reestablishment of institutional and social stability.

In highlighting the conservative implications of the search for commit-ment and community, however, these studies tend to displace the primary economic, social, and cultural dynamics that animated and shaped the crisis of the 1930s in the first place: class conflict and labor strife.[19] It is to these dynamics, as well as to the politics and patterns of racial exclusion and seg-regation, that sensational modernists direct attention. As a group, sensa-tional modernists constitute a countertradition of Depression-era cultural expression that for the most part contradicted the forces of cultural cohe-sion, continuity, and equilibrium that seemed to prevail during the middle and later years of the decade. Indeed, if the dominant culture of the thirties, especially the late thirties, was defined, as Cooney suggests, by its "balancing acts," then sensational modernists produced what might be called arts of *im*balance—forms of fiction and photography that push audiences off kilter in an effort to create forms of knowledge about the nation's poor that could disrupt the period's more conservative frameworks of visual and narrative understanding. As such, sensational modernism takes its place alongside a range of artistic movements that responded to the trauma of the crash with an outpouring of unconventional art in which social conflict, philosophic absurdism, and aesthetic distortion take center stage.

The crash that opened the Depression caught millions of American citi-zens by surprise, throwing their economic security and sense of well-being into chaos, and generating feelings of fear, dread, and confusion. In a 1931

article in *Contemporary Review*, a commentator named S. K. Ratcliffe stated that "the shock of the depression has been terrific, overwhelming, and there does not exist in any country so widespread a spirit of perplexity, concern, and self-criticism."[20] Ratcliffe's assertion reminds us that the crisis of the Depression was not only economic, but social and cultural as well. The crash represented not only a dive in the stock market and the employment rate, but also a collapse in cultural optimism, an acute blow to the idea that America was the most technologically advanced and culturally sophisticated nation of the twentieth-century world. For many, the crash represented what Alfred Kazin called "an education by shock" that challenged the belief in ever-expanding technological progress and material prosperity that had been vital to the country's sense of itself as "modern" during the opening decades of the twentieth century.[21] As the historian Robert McElvaine explains, "Perhaps the chief impact of the Great Depression was that it . . . took away, at least temporarily, the easy assumptions of expansion and mobility that had decisively influenced so much of past American thinking."[22]

The sense of uncertainty caused by the crash had several cultural consequences that help explain sensational modernism. Perhaps most significant, the collapse of the nation's industrial and economic machinery inaugurated a heightened consciousness about poverty, class distinctions, and the politics of cultural and social exclusion. The decade witnessed an outpouring of socially concerned art, as a wave of writers and cultural explorers set out, often on the road or the rails, to expose the harshness of depression existence by focusing on the life of the nation's outsiders and outcasts: hoboes, migrants, prostitutes, criminals—figures Edward Dahlberg famously called "bottom dogs."[23] As Morris Dickstein puts it, the 1930s was a period when cultural workers "keenly pursued an interest in the backwaters of American life: the travail of the immigrant, the slum, the ghetto, the failures of the American dream, and above all the persistence of poverty and inequality amid plenty."[24] In the midst of extensive social flux, writing became, for many authors, an experiment in social boundary crossing.[25] For middle-class writers, this meant an exercise in downward mobility—writing as a form of ethnographic or imaginative slumming. For an emerging generation of working-class, ethnic, and immigrant writers who were entering into the world of American print for the first time in substantial numbers, the crossing was in the other direction—up and out to a marketplace of predominately middle-class readers.[26]

The sharpened sensitivity to class difference and conflict was in large

part a byproduct of the militancy of the unemployed and workers, who agitated and organized in unprecedented numbers during the thirties. In 1932, for instance, almost 20,000 impoverished veterans of World War I marched on Washington to protest the lack of government aid, camping across the Potomac River from the Capitol in lean-tos, cardboard shacks, and tents, until they were evicted and dispersed by federal cavalry and six tanks, led by General Douglas MacArthur. Across the country people organized Unemployed Councils to stop evictions and to call for assistance to the millions without work. On March 6, 1930, thousands of people in major urban centers, including 35,000 in New York City, marched to protest widespread unemployment. Many of the demonstrators clashed violently with police.[27] Workers, too, took radical collective action to protest economic hardship and unfair treatment. Nineteen thirty-four in particular was a banner year for American labor unrest. In San Francisco, longshoremen led a general strike (discussed in chapter 4) of 130,000 people that immobilized the city. A similar municipal strike took place in Minneapolis the same year, and in the South 325,000 textile workers struck, to be joined later by thousands of laborers in Lowell, Massachusetts, and Woonsocket, Rhode Island. Overall, 1.8 million workers across the country participated in roughly 1,800 job actions that year.[28] Dissatisfied with the conservative stance of the American Federation of Labor (AFL), many workers and organizers, led by mine union leader John Lewis, founded the Congress of Industrial Organizations (CIO), which promised to organize the female, immigrant, and unskilled workers that the AFL had largely ignored. But even labor leaders could not contain workers' militancy, as nearly 500,000 laborers participated in sit-down strikes in 1936–37, actions that ultimately led to union recognition at two of the country's most anti-union corporations, U.S. Steel and General Motors. The rise in class consciousness evident in this wave of organizing — especially among immigrant, women, and African American workers who had historically been excluded from the labor movement — translated into the political realm. As Eric Foner observes, "In the mid-1930s, with urban working-class voters providing massive majorities for the Democratic Party and business large and small bitterly estranged from the New Deal, politics reflected class division more completely than at any time in American history."[29]

In addition to an upsurge in class-based activism, the 1930s witnessed a growing militancy — often in the face of significant, and at times quite violent, white resistance — among African Americans, on whom the Depression had a disproportionately disastrous impact. As whites began to suffer

layoffs, their resentment of black workers increased. Whites began not only to take many of the menial jobs that had traditionally been reserved for African Americans, but also to declare publicly that blacks should not be hired if capable whites were out of work. A group in Atlanta adopted the slogan, "No Jobs for Niggers until Every White Man Has a Job," and in 1932, black unemployment hit 50 percent nationwide, roughly twice the rate for whites. As economic opportunities diminished, racial tensions escalated. The number of lynchings in the United States rose from eight in 1932 to twenty-eight, fifteen, and twenty in the following three years.[30] Many African Americans responded to the hardship and heightened racial violence of the Depression by organizing, setting off a wave of militancy that would crest during the civil rights movement after World War II. A. Philip Randolph founded the Brotherhood of Sleeping Car Porters, which won union recognition—and greatly needed economic benefits—for black railroad workers during the mid-1930s. In both rural and urban areas, many African Americans joined Communist Party–led initiatives to fight evictions, unemployment, and discrimination, and to defend the Scottsboro Boys, nine youths who had been unjustly accused of raping two white women in Alabama. Black politicians led an interracial alliance to call for national antilynching legislation. In several cities, coalitions of black individuals and organizations joined together in "Don't Buy Where You Can't Work" boycotts. In 1935 in Harlem, African American resentment exploded when rumors that a young black shoplifter had been killed by police sparked a riot and looting. In 1940, Randolph led the planning for a massive march on Washington, D.C., to protest racist hiring practices in wartime industries. The threat of the march prompted President Roosevelt to pass Executive Order 8802 forbidding racial discrimination by defense contractors, and the march was called off as a result of the political victory.[31] The planning of such public actions, as well as the strategy of calling on the federal government to rectify discriminatory practices, prefigured the forms of activism that would characterize the civil rights movement of the succeeding decades.[32]

While dominant social and political agents and agencies bent their resources toward unifying the country under the New Deal in an effort to turn the potential for radical changes into support for institutional reform, many artists, including sensational modernists, remained focused on the profound social and cognitive dissonance generated by the crisis. In particular, sensational modernists shared a preoccupation with class conflict and the boundaries of class as well as racial distinction. The short fiction of William Carlos Williams, who had witnessed the dramatic textile strikes in Paterson

and Passaic, New Jersey, in 1913 and 1926, displays an acute awareness not only of the dire poverty in which immigrant mill workers were living at the time, but also of the ways class and ethnic differences condition the edgy encounters he describes between a native-born white doctor and foreign-born, ethnic workers. Similarly, Aaron Siskind's photography takes white, middle-class slumming in Harlem—the crossing of both racial and class boundaries—as a reference point for his documentary project. Both Pietro di Donato, in *Christ in Concrete*, and Tillie Olsen, in *Yonnondio*, posit class boundaries as obstacles to cultural understanding and place corporate violence against working people (and in di Donato's case, against immigrants) at the center of their stories. Richard Wright's early works, including *Lawd Today!*, *Native Son*, and *12 Million Black Voices*, provide penetrating portrayals of the ways in which class and race collide to produce material and ideological forms of discrimination. For all of these artists, the economic and ideological instability caused by the crash, combined with widespread social unrest and political protest, sparked sharpened political consciousness and resonant skepticism about the politics of national unity.

The upheavals of the 1930s prompted many artists to move to the Left, and to put the formal tactics of modernist innovation to expressly political, often radical, ends. As Michael Denning, Walter Kalaidjian, Laura Browder, Paul Lauter, Cary Nelson, Anthony Dawahare, and others have demonstrated, many Depression-era writers and visual artists used the verbal and graphic experiments pioneered during the previous decades to produce forms of "social modernism."[33] While some of these artists positioned their work in opposition to the expanding culture of mass entertainment and consumerism, others borrowed, consciously or unwittingly, the language, motifs, and techniques developed by the culture industry's advertisers, filmmakers, radio producers, photographers, and cartoonists. Rita Barnard has argued that the decade was notable for the "blurring between 'high' art and 'mass culture,'" a blurring that she suggests foreshadows the work of postmodern artists.[34] Similarly, as Günter Lenz has suggested, many writers, artists, and social scientists who set out to record and examine U.S. culture during the 1930s invented "new experimental, often 'interdisciplinary' or strikingly 'unpure' modes of writing and criticism,"[35] such as the phototext, a blend of layout techniques drawn from advertising, documentary photography, and poetic or social scientific writing; the living newspapers, which adopted techniques from cinema, journalism, and theater to create an unprecedented form of popular infotainment; and the fiction of John Dos Passos, which combines realism, references to historical events and fig-

ures, direct transcriptions of newspaper headlines, and a form of stream-of-consciousness writing—the Camera Eye—inspired by film and photography.[36] Sensational modernism is one of these experimental forms, in which artists blend the energies and impulses of mass culture, the aesthetic techniques of high modernism, and a commitment to contesting hegemonic assumptions about the poor.

Although the 1930s have traditionally been considered an age that saw a renewed dedication to realism after the experimental exploits of the twenties, for many artists—including sensational modernists—realism, and the impetus to capture the unvarnished, straight "truth" of the economic and social chaos, frequently turned surreal.[37] Faced with a culture that seemed violently out of balance, many artists who aspired to offer a "realist" accounting of the contemporary scene found themselves using exaggeration and hyperbole, the bizarre and the uncanny, to convey feelings of despair, disorientation, and dislocation engendered by the crash and, more generally, by life in an increasingly mechanized, mass produced society. Indeed, the 1930s was a golden age of distortion in the arts, an era when the fantastic and the monstrous were pervasive. American painting during this period was rife with disfiguration, as a number of socially committed artists, including Harry Gottlieb, Harry Sternberg, Philip Evergood, and Louis Guglielmi, adopted the techniques of European expressionism, such as "distortions of form, or the seemingly grotesque accentuations of physical attributes," to depict the plight of the dispossessed and to present an image of American society that sharply contradicted the folksy, nativist version found in the works of celebrated regionalist painters such as John Steuart Curry and Thomas Hart Benton.[38] It was also in the 1930s that American surrealism achieved its first substantial measure of public exposure, through the 1931 exhibition titled "Newer Super-Realism" at the Wadsworth Athenaeum in Hartford, the first museum display of surrealism in the United States, and at the subsequent show called "Fantastic Art, Dada, Surrealism," which Alfred Barr organized at the Museum of Modern Art in 1936.[39]

Writing in the middle of the decade, the critic Kenneth Burke proposed the grotesque as a heuristic for making sense of contemporary culture. Describing the grotesque as "planned incongruity," the combination of unexpected and unlikely elements that threatens old orders of classification and proposes new ones, Burke argued that it is a potentially "revolutionary" form that flourishes in moments of social instability like the Depression, when established values are under duress and open to change.[40] Several critics have picked up Burke's emphasis, contending that thirties art was per-

meated by grotesque images and impulses. Timothy Libretti and Michael Denning argue for the presence (and subversive power) of the "proletarian grotesque," evident in radical novels such as *Jews without Money* and *Call It Sleep*, as well as bizarre and disturbing paintings by Evergood and Peter Bloom.[41] The theater historian Mark Fearnow has suggested that the grotesque was "the hallmark of depression America," the form most suitable for addressing the decade's tensions between despair and boosterism, fear and confidence, technological progress and economic collapse.[42] In addition to its prevalence in the literary, visual, and dramatic arts, the grotesque also pervaded thirties popular culture, especially films made before the institution of the 1934 Hays Code. *Frankenstein, Dracula, The Mummy, King Kong*, and Tod Browning's notorious 1932 *Freaks* all featured monstrous deviations from the physical norm.

While the texts examined in this project, due to their unusual aesthetic mixtures, bear some resemblance to the grotesque, I use the term "sensational" to describe the form of modernism under examination here because of its etymological links to the body and its associations with powerful feelings. Sensationalism's philosophical roots extend back to the pre-Socratic Greeks, but it was developed most decisively from the latter half of the seventeenth century onward, when empiricist thinkers such as John Locke, David Hartley, and James Mill used the term to refer to the notion that all knowledge is ultimately derived from bodily sensations.[43] Its dominant colloquial meaning shifted in the mid-nineteenth century, when it was adopted to describe works of art, especially "sensational fiction," that provoked strong emotions. Today, it is used primarily as a term of opprobrium to disparage the seemingly endless menu of violence and sex delivered by the mass media. This study extends the late nineteenth-century meaning of "the sensational" to denote dynamics of fear and fascination sparked by looking and moving across boundaries of social division. To understand the forms of sensation deployed by sensational modernists, it is necessary to look briefly at the popular culture of modern mass sensations that it echoes.

The Modern Culture of Sensations

Sensational modernists' emphasis on shock, disparity, and disaster echoes the mass culture of sensationalism that emerged in the early twentieth century and flourished during the 1920s and 1930s. This sensational culture was embodied in an array of popular arts, institutions, and attractions designed to titillate, amuse, frighten, and thrill: amusement parks, freak shows, tabloid newspapers, pulp magazines, and dime museums.[44]

Some sensational modernists adopt mass cultural forms in a direct and self-conscious manner, while others do so in more indirect, even inadvertent, ways. *Sensational Modernism*'s argument is not predicated on drawing direct, material connections between modernist texts and mass culture, although in some instances those connections do exist. Rather, I contend that these modernist texts manifest a modern sensational imagination that was also visible in quite different form in the tabloids, spectacular entertainments, and pulp narratives that were so popular during the first half of the twentieth century.

Turn-of-the-century sensationalism in the press and popular culture reflected a sense that modernity represented a newly unpredictable, turbulent, and potentially dangerous world in which the texture of sensory experience had been radically remade. Modern individuals, especially in cities, were subjected to a new intensity of shocks, jolts, and impressions that echoed the pace of the assembly line, the speed of rapid transportation, the frenzy of the crowd.[45] A discourse of sensationalism emerged to express anxiety about the potential for accidents, injuries, and iniquities in this new metropolitan setting. Images and stories in the popular press recounted pedestrians being run over by trolley cars and automobiles or being trampled by crowds, workers being mangled in factory machinery or falling from scaffolds (figure I.1). In addition, new forms of sensational amusement that emphasized speed and spectacle—including roller coasters, vaudeville slapstick, and automobile stunt shows—ushered in what one historian has called a "commerce in sensory shocks."[46]

The modern culture of sensationalism offered a hyperbolic vision of modern existence and a spectacular view of the human body. John Kasson has argued that these novel forms of commercial leisure constituted a "new society of spectacle" in which "men's and women's bodies were displayed and dramatized as never before in popular theater, sports, photography, fiction, film, and advertisements."[47] One of the most dynamic and ubiquitous manifestations of sensational culture's volatile aesthetics of excitement and danger could be found in the tabloid newspaper. Named after small chemical tablets because of their reduced size, tabloid newspapers were first issued in London in the late nineteenth century and then in New York beginning in 1919 with the *Daily News*, founded by James Patterson, scion of the family that published the *Chicago Tribune*. Patterson, who had served on the executive board of the Socialist Party in the early years of the century, envisioned the tabloid as a populist source of news and entertainment for the urban working classes.[48] Incorporating copious photographs, comics, a stridently

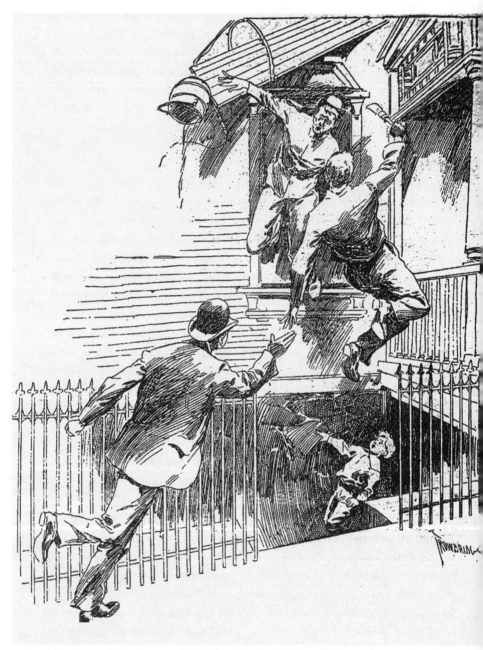

Figure I.1. "A Falling Man Kills a Boy," *New York World*, May 9, 1896.

patriotic and pro-labor editorial policy, and extensive coverage of crime, sex, and sports, the *Daily News* rapidly became the best-selling paper in New York.[49] The phenomenal success of Patterson's paper prompted a host of followers, including William Randolph Hearst's *Daily Mirror* and Bernarr Macfadden's *Evening Graphic*, which imitated and extended the *Daily News* formula.

In format and style, the tabloids were characterized by the abbreviation of information, a terse and colorful tone, and the extensive use of visual images. Daniel Czitrom, one of the few historians to study America's tabloid tradition, notes that, "in formal terms, the tabloid stands for the relentless compression and condensation of urban experience into compact and convenient units of cultural expression that are commercially valuable."[50] Combining photographs, oversized headlines, and brief stories written in vivid, forceful prose, the tabloids provided a graphic, virtually theatrical, view of urban society designed to cater to a mass audience with limited time or tolerance for the more subdued, conservative style of traditional daily papers. Macfadden's *Daily Graphic* was aptly named — the paper, like other tabloids, attracted readers through lurid and dramatic depictions of social conflict and transgressive behavior.

The tabloids' groundbreaking graphic appeal can be traced back to the innovative visuals and layout techniques pioneered by the yellow press of the 1890s and early 1900s, most notably Joseph Pulitzer's *New York World* and Hearst's *New York Journal*, which took advantage of new reproductive technologies and consciously sensationalized everyday urban life.[51] Hearst's *Journal* used bold, slashing headlines and line drawings to distinguish itself from its predecessors and contemporary competitors, creating "new full-page landscapes" that "seized the eye and quickened the imagination," according to the historian David Nasaw.[52] It is these sensationalistic dynamics of exaggeration and compaction that we find in sensational modernism's representations of social duress. As the sensational press sought to produce forms of scandal and drama that would overrun conservative journalistic protocols, sensational modernists aimed to generate a startling aesthetic of danger, harm, and social contrast that could exceed and disrupt prevailing conventions of photographic and literary representation.

Concerns about the accelerating speed and rhythm of life that had sparked early twentieth-century sensationalism surged again in the early years of the Depression.[53] In 1931, as the economic crisis approached its nadir, the historian James Truslow Adams published *The Tempo of Modern Life*, in which he contended that the contemporary moment was witnessing

an "immense speeding up in the process of living"[54] and that Americans, especially residents of major cities like New York, are "getting more sensations and of a more varied sort" than individuals from previous generations. According to Adams, this situation had potentially debilitating consequences: "As the number and variety of sensations increase, the time which we have for reacting to and digesting them becomes less," which leaves the distinct possibility that individuals may not be able to "adjust" properly to the "hailstorm of sensations" that assail them.[55] A similar concern about the elaborateness and perplexity of everyday life was expressed by Robert and Helen Lynd in their sociological study of Muncie, Indiana, *Middletown in Transition* (1937), the sequel to their celebrated book *Middletown* (1925). The Lynds contended that while the Depression did not in fact substantially transform the small city's economic structure, the crisis did inject a "new sense of the inescapable complexity of this assumedly simple world."[56] "For the first time in their lives," the Lynds observed, "many Middletown people have awakened, in the depression, from a sense of being at home in a familiar world to the shock of living as an atom in a universe dangerously too big and blindly out of hand."[57]

Tabloids from the 1930s reflected the rapid tempo and sense of disorientation that Adams and the Lynds describe. Highlighting visual display and stories about crime, catastrophe, and celebrity intrigue, tabloids such as the *Daily Mirror* and the *Daily News* constituted "an arresting departure" from conventional newspapers, according to the historian Mary Ann Weston, a "striking new package" of graphic presentation.[58] A sampling of headlines from the *Daily Mirror* in May and June 1935 provides a feel for the tabloids' cacophonous and spectacle-prone rendering of daily events: "Boy Confesses He Set 25 Fires. He Dies Tonight!" (May 5); "Father Held in 5 Poison Deaths" (May 11), "4-Alarm Fire Takes $75,000 Toll in Queens" (May 20), "$200,000 Kidnap of Richest Boy" (May 26), "1500 Killed! Nazi War Plant Blown Up" (June 14); "Blackmail Note Traps 2 Killers" (June 16), "Convicts in Mine Riot Seize Guards" (June 17), "Wife Killer Tries Suicide in Court" (June 22). Using hyperbole and focusing on instances of disaster, suspense, and scandal, the tabloids condensed and dramatized the most spectacular and extreme elements of Depression-era social life.

In so doing, the tabloids extended nineteenth-century strains of sensational fiction and journalism—dime novels, "sunshine and shadow" literature, and the penny press—that explored the perils and vices of the expanding city.[59] Following in this tradition, the tabloids offered a melodramatic view of the city, and of society more generally, that traced the fault lines

of social demarcation and distinction.[60] As Czitrom observes, "The tabloid revolves around exploiting the visible, often shocking, contrasts between wealth and poverty, lifestyles of the rich and famous and those of the poor and miserable. At the same time, in its intensive coverage of murder and divorce . . . vice and crime, the tabloid insists on exploring and exposing the deeper connections that exist between the underworld and the respectable realms of politics and society."[61] Highlighting cultural extremes, the tabloids crafted a highly visual and voyeuristic aesthetic of contrast and titillation. In addition, the tabloids cultivated an aesthetic of vulgarity and shock, qualities condemned by highbrow commentators who persistently identified the lurid quality of tabloid stories and the exceedingly graphic nature of display as the papers' most objectionable features. Writing in the *Independent*, Samuel Taylor Morse contended that the New York tabloids were a "quagmire of journalistic muck and filth."[62] The sensationalistic picture papers, he complained, emphasize only the most "indecent and unsavory happenings of the day," "the salacious, intimate details of human nature at its lowest."[63] In addition to decrying the tabloids' stress on the sordid elements of urban life, Morse also condemned the papers' penchant for overstatement. "Distortion, exaggeration, and undisciplined imagination are the trinity substituted" for established protocols of journalistic accuracy, Morse insisted. As examples of such excess, Morse pointed to the tabloids' habit of privileging front-page depictions of catastrophe and corpses. A "much prized expression of tabloid art," he remarked, "lies in pictures of dead bodies on the street awaiting removal, or of bandage-swathed victims of accident or attack propped up on their couches of pain."[64] The tabloids' portrayal of the urban world as a realm of danger and violence—a portrayal frequently delivered in the form of graphically mutilated bodies—violated bourgeois codes of civic propriety and public decency. It was the tabloids' focus on cultural extremes as well as their nascent capacity to generate outrage and subvert normative aesthetic standards through images of corporeal damage and disfiguration that sensational modernists adopted, echoed, and extended, crafting unconventional modes of literary and photographic art that put popular motifs to the service of avant-garde estrangement.

Aesthetic Astonishment and Bodily Disfigurement

Drawing on tropes and techniques found in America's burgeoning culture of popular sensations, sensational modernists forged what I call aesthetics of astonishment—forms of dissonance and disruption designed to destabilize established narrative and photographic codes and expectations.

These forms of astonishment can be illuminated by, even as they depart from, the theory of estrangement developed during the 1930s by the German critic Walter Benjamin in his analysis of Bertolt Brecht's drama. Benjamin argued that Brecht's epic style prevents the audience's deep affective identification with a play's characters.[65] "Brecht's drama," Benjamin asserts, "eliminates the Aristotelian catharsis, the purging of the emotions through empathy with the stirring fate of the hero."[66] By foreclosing conventional forms of emotional and psychological connection with their central characters, Brecht's plays challenge spectators to grasp the historical and political conditions of those characters' lives as well as the aesthetic conventions through which dramatic action is traditionally conveyed. "The art of epic theater," Benjamin stated, "consists in producing astonishment rather than empathy. To put it succinctly: instead of identifying with the characters, the audience should be educated to be astonished at the circumstances under which they function."[67] Astonishment is thus part of a potentially pedagogical project that suggests the historical and cultural contingency of images and figures that we have come to see as natural and eternal.[68]

But astonishment does not necessarily lead to political insight. For Benjamin, astonishment is an aesthetic manifestation of the shocks that he saw as a defining feature of urban modernity, shocks that possess a deeply ambivalent charge. As Miriam Hansen has argued, Benjamin saw shock both as "the stigma of modern life, synonymous with the defensive shield it provokes and thus with the impoverishment of experience," *and* as a moment that "may assume a strategic significance — as an artificial means of propelling the human body into moments of recognition."[69] Astonishment, then, reflects the frenzy and disintegration of modern experience, potentially prompting a defensive form of distance or distraction, but also, in certain contexts, catalyzing new modes of awareness and identification, opening the door to potentially progressive modes of cultural comprehension and connection. Sensational modernists sought to employ shock's "cognitive explosiveness" not only to burst the complacency, condescension, and desire for control that dominated middle-class modes of seeing the poor, but also to forge unorthodox perspectives for viewing the nation's cultural fringes.[70] In their depictions of life on the margins, sensational modernists aimed to generate astonishment *and* empathy, estrangement *and* recognition. On the one hand, readers and viewers are positioned to be shocked by the conditions that govern the lives of the characters depicted, the persons documented; on the other hand, we are encouraged to identify with these characters, to see

them not merely as abject figures subject to "circumstances," but as persons who merit our understanding and empathy.

My contention that popular sensationalism's confrontational aesthetics provided sensational modernists with incipient tactics for unsettling established formal codes also resonates with the film historian Tom Gunning's claims that many avant-garde artists based their tactics of formal disruption on the popular culture of "attractions," a range of nonnarrative spectacles that were designed to exert an uncanny and agitating power on audiences by delivering a series of visual and sensory shocks. In particular, Gunning argues that spectacles of catastrophe in early films—such as the beheading of a corpse, the crash of two trains, or the electrocution of an elephant— blended pleasure and anxiety, pushing excitement to the point of fear. Through tactics of titillation and confrontation, in which "the viewer's curiosity is aroused and fulfilled through a marked encounter, direct stimulus or a succession of shocks," these spectacles countered traditional ideals of detached contemplation and spectatorial absorption, a feature that appealed to experimental artists seeking to challenge the passive reception of art.[71] Like the avant-garde, which, in the words of the critic Richard Murphy, forged "a new aesthetics (or 'anti-aesthetics') of the ugly, the fragmentary and the chaotic in order to subvert . . . [the] illusory sense of mastery, artificial closure, and aesthetic control which clings to the traditional, organic notion of form," sensational modernists use the popular aesthetics of spectacle, excess, and exaggeration to disturb normative expectations of formal unity and coherence.[72] Sensational modernists aspire to produce what the surrealist André Breton calls "an attack of conscience," an epistemological crisis that puts in question hegemonic values and viewpoints, fracturing what Kenneth Burke terms "frames of acceptance."[73]

Despite their aesthetic similarities to the avant-garde, however, sensational modernists constitute a much more loosely formed tradition of artistic practice. Rather than a self-consciously oppositional movement like the more established avant-gardes, sensational modernism constitutes, to use Raymond Williams's expression, an emergent cultural form. Emergent forms express marginalized modes of social being and consciousness grounded in "alternative perceptions of others" and "new perceptions and practices of the material world."[74] Understanding emergent culture, Williams insists, "depends crucially on finding new forms or adaptations of form. Again and again, what we have to observe is in effect a *pre-emergence*, active and pressing but not fully articulated, rather than the evident emer-

gence that could be more confidently named."[75] Like the emergent culture Williams describes, sensational modernism constitutes a discontinuous, sporadic tradition of artistic practice, "active and pressing, but not fully articulated," visible only from the vantage point of historical perspective.

An expressive form through which social and epistemological violence is made legible, sensational modernism's privileged trope is the mangled or distorted working-class body. Echoing tabloids, freak shows, and pulp fiction, which frequently focused their graphic appeal on contortions, deformations, and excesses of the human body, sensational modernists used often spectacular images of physical harm and disfigurement to register the susceptibility and resistance of laboring and lower-class persons to emerging structures of social discipline and discrimination. Such images, I argue, serve as convulsive emblems of political protest, epistemological rupture, and formal innovation. These disfigured bodies—graphically exposed immigrant women in Williams's short fiction, brutally injured workers in novels by Olsen and di Donato, exaggerated racial stereotypes in Wright's fiction and Aaron Siskind's documentary photography—condense economic and social violence, giving shocking shape to the forces of harm, hunger, and prejudice that sensational modernists sought to expose. This emphasis on disparity and harm responds to the material and cognitive turmoil of the Great Depression, an era in which the celebration of technological progress and industrial power that had been so prevalent in American culture in the 1920s was called sharply into question. Sensational modernists deploy techniques of spectacle and exaggeration, as well as motifs of bodily distortion and damage, to highlight the degradations and discrepancies of modernization that acquired unprecedented visibility during the Depression: hunger, homelessness, the violence of industrial labor, and the constrictions of slum living. These artists sought to pierce the liberal faith in expert, institutional reform that dominated New Deal civic discourse about social problems. Indeed, sensational modernism's shock represents moments when liberal sympathy and concern collapse or burst into more volatile, direct expressions of social energy—violence, voyeurism, defiance, desire. Modernist sensation constitutes moments (as the chapters of this book suggest) when medical objectivity explodes into sexual desire or ethnic prejudice; when the act of photographing others produces a palpable record of documentary's invasiveness; when the process of romanticizing the poor and abstracting the pain of the working class as "eternal" sorrow is exposed as a form of political domination; when stereotypes employed to maintain emotional distance from figures of racial alterity are exposed as specious tropes.

In its tropological focus on disfigured bodies, sensational modernism echoes a broader fascination with bodily form that characterizes 1930s art. Bodies have long served as metaphors for society, the human body standing for the body politic, and during the Depression, when the material and even emotional impress of the economic downturn was often legible on human faces and bodies, corporeal images were used to signify both crisis and recovery. In documentary culture, the body, especially the body in pain—the haggard faces, stooped backs, and gaunt frames that pervade the Farm Security Administration (FSA) photographic file—came to signify pure, visceral "truth," the degree-zero "evidence" of social conditions. In contrast to the needy, if dignified, bodies that generally populate the FSA archive, muscular male bodies were used by many cultural producers to signify a longed-for social resilience and potency.[76] In several paintings from the decade, for instance, John Steuart Curry used images of brawny, virile men to express his faith in the native, American (and implicitly Anglo-Saxon) spirit.[77] On the opposite end of the political spectrum, the radical lithographer Hugo Gellert employed iconic images of massive male laborers, bulging with muscles, to express his commitment to working-class power (see figure I.2). In the case of both Curry and Gellert, "full" male bodies countered the images of emaciated, hollow male bodies on breadlines that became signature icons of the period. In a survey of paintings about labor completed during the decade, Erika Doss concludes: "When the male worker was imaged in the 1930s, he was made into a physical icon of national recovery: the body of the worker as an emblem of the well-bodied American economy."[78] Yet, as Walter Kalaidjian has noted, this insistence on the phallic prowess of white masculine physicality serves not only as an assertion of male power, but also as an anxious admission of the loss of authority in the face of massive social change.[79]

For other artists, images of bodily injury, decay, and distress expressed the acute anxiety that many Americans felt during the decade. Particularly in Depression-era painting, images of distended and distorted bodies proliferated. In *East Tenth Street Jungle* (1934), for instance, Reginald Marsh's depiction of homeless men in New York, the jumbled arrangement of the human figures and the rough, loosely drawn style convey a harrowing sense of psychic angst as well as physical pain. In literature, too, images of physical distortion abounded. William Solomon has argued that in the thirties several radical writers used images of "mutilated, diseased or oddly shaped bodies" to construct trenchant, albeit often ambiguous, critiques of modern, industrialized America, in which the human form was increasingly

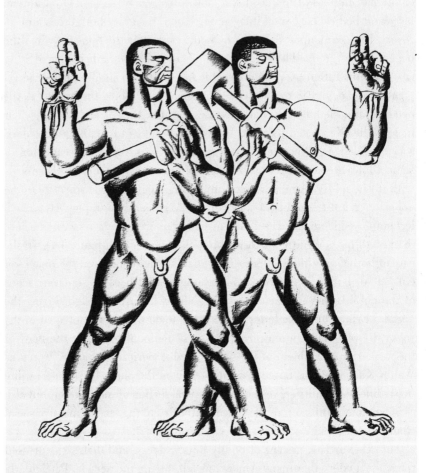

Figure I.2. Hugo Gellert, "Primary Accumulation." From *Karl Marx' "Capital" in Lithographs* (1934). Courtesy of the Mary Ryan Gallery, New York.

shaped, molded, and conditioned by machines, especially new technologies of mass amusement.[80] Solomon takes a more psychosexual approach to the rhetoric of corporeal distintegration than this study does, but his insistence that disfigured bodies served as a central trope through which Depression-era artists expressed social anxieties and political opposition strikes a parallel with my own findings.

It is essential to note that sensational modernists' stress on motifs of corporeal distortion and harm has deeply ambivalent political implications. At one level, these graphic, often excessive, representations can galvanize social and cultural critique. Susan Sontag has argued that while images of persons in pain typically obfuscate relations of power, lending viewers a sense of both innocence and impotence, it is also possible to combat such forms of displacement. Such practices, she suggests, would entail "a reflection on how our privileges are located on the same map as their suffering, and—in ways we might prefer not to imagine—be linked to their suffering."[81] Sensational modernism's astonishing images of bodily distortion and pain gesture toward the forms of political "mapping" to which Sontag alludes. By disrupting contemplative reading or viewing, and by implicitly or explicitly exposing connections between traditional modes of aesthetic pleasure and established patterns of dominance, sensational modernists encourage audiences to interrogate the forms and frames through which social, economic, and racial difference are customarily produced.

Yet while the depiction of sensational bodies frequently disrupts or disables the inverse affirmation that looking at the poor often affords the privileged—what Richard Wright calls the "consolation of tears"—these images can also reproduce the dynamics of marginality, abjection, and stereotyping that sensational modernists aspire to overturn. Consider, for example, *You Have Seen Their Faces* (1937), a documentary book about sharecroppers written by Erskine Caldwell, with photographs taken by Margaret Bourke-White on a trip through the South the two artists took together in 1936, the same year Walker Evans and James Agee were in Alabama working on the article for *Fortune* that would eventually become *Let Us Now Praise Famous Men* (discussed in chapter 4). Written at the height of national attention to the plight of tenant farmers, *You Have Seen Their Faces* was the decade's first and most popular photo-textual book, and reviewers were nearly unanimous in their enthusiasm, especially for the photographs. Yet at the time of the book's publication, very little documentary photography was visible for comparison and when viewed alongside work by most FSA photographers and members of the Photo League (discussed in chapter 3), the occasion-

ally demeaning, even exploitative, character of Bourke-White's images, and of Caldwell's prose, become evident.[82] Caldwell, who was himself a southerner, aspired to demonstrate the ways the sharecropping system had damaged the lives, as well as the personalities and the very bodies, of tenant farmers. But in so doing, he and Bourke-White frequently reinforced prevailing images of poor southerners as degenerate, dirty, and shiftless. While some of the book's photographs, such as a sober close-up of a black woman behind prison bars and a head shot of a black man from Porter, Arkansas, who looks resolutely into the camera, lend their subjects dignity and power, other images capture individuals at their most pathetic: disheveled or in moments of weakness, looking dazed and helpless (see figure I.3). As William Stott observes, "These people are bare, defenseless before the camera and its stunning flash."[83] Bourke-White described her approach in a way that emphasizes the carefully calculated, almost punitive, nature of her camera work: "It might be an hour before their faces or gestures gave us what we were trying to express," she stated in her notes about photography at the end of the book, "but the instant it occurred the scene was imprisoned on a sheet of film before they knew what had happened."[84] Caldwell, best known for his shockingly lurid fiction about poor white farmers, insisted in the written portion of the text that the agricultural system, rather than innate depravity, was to blame for the present state of the farmers pictured. Yet the book nonetheless confirms stereotypical images of southern farmers as, in Caldwell's words, "perverted," "wasteful and careless," even "bestial."[85] The photographic captions—fictional quotations written as if they had been spoken by the persons depicted—fortify the sense that tenants are simple-minded, wretched people. An image of an African American woman sitting on a porch with two children, for instance, is accompanied by the statement: "I got more children now than I know what to do with, but they keep coming along like watermelons in the summertime."[86] The book's final photograph, of an exhausted looking white man in tattered overalls, is underwritten by the caption: "It ain't hardly worth the trouble to go on living."[87] *You Have Seen Their Faces* asks middle-class readers to feel outrage at the economic conditions that have left these poor people so destitute, but it does so at times by stripping the people themselves of agency and resilience, casting them as passive and pathetic objects of grotesque fascination and sentimental pity. In underscoring the destructive impact of poverty, sensational images like Caldwell and Bourke-White's can produce a sense of the dispossessed as inherently or irreparably harmed, as figures with whom it is virtually impossible to empathize and futile to assist. Making sense of

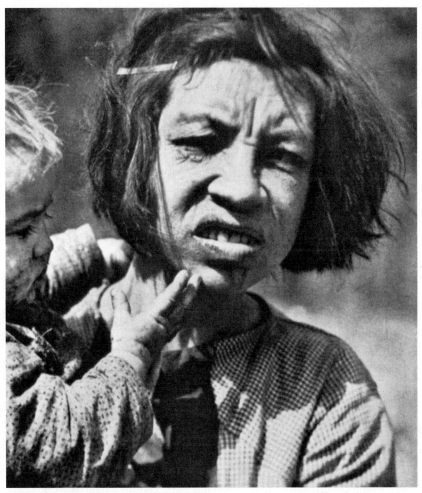

Figure I.3. Margaret Bourke-White, "McDaniel, Georgia. 'Snuff is an almighty help when your teeth ache.'" From *You Have Seen Their Faces* (1937). Courtesy of Jonathan Toby White.

sensational modernism's cultural politics requires a careful assessment of its multiple, and even competing, impulses and implications.

Literature and Photography: Documentary Modernism

Sensational Modernism focuses on fiction and photography for several reasons. In the first instance, this emphasis is largely historical: these are the two modes of expression in which American sensationalism took root most firmly in the late nineteenth and early twentieth centuries. As noted earlier, modern American sensationalism emerged in antebellum novels of urban vice and transgression and in journalism that took the mysteries and miseries of the city as its central theme. Photography, with its capacity to bring "foreign" and "strange" sights to distant viewers, was rapidly assimilated into this tradition. Beginning in the final years of the nineteenth century, with the invention of dry plate and flexible films, bromide paper, hand-held cameras, and half-tone reproduction, and continuing into the mid-twentieth century, photography became, along with fiction and prose journalism, a primary medium through which Americans made sense of new and alien spaces and places. Photography achieved especially significant cultural status during the Depression, when a widespread desire to grasp the full extent of the crisis, in combination with the increasing availability of inexpensive hand-held cameras, produced an explosion in printed visual images in such magazines as *Fortune*, founded in 1929; *Life*, founded in 1936, the success of which was linked to its pioneering use of the picture essay; and *Look*, *Life*'s primary competitor in the burgeoning field of large-format photo magazines, which was founded in 1937 and by 1938 had a circulation, as did *Life*, of over 2 million. During the 1930s, photography became, in the words of Terry Smith, "the dominant visual medi[um] in the United States."[88]

Sensational Modernism focuses primarily on documentary, rather than "art," photography because the ethnographic nature of the documentary endeavor, in which views of the "other half" are brought home for (voyeuristic) inspection, is deeply, if at times subtly, sensationalistic. Even while documentary domesticates the strange, it provokes a frisson of excitement, fear, or amazement at the display of dramatic difference. Indeed, documentary's appeal derives from its capacity to deliver the shock of social difference, which is at the heart of the sensational as I define it. Documentary crosses into "alien" territory to uncover "hidden"—and often, by implication, strange or unsettling—"truths," and to render them in a striking, graphic manner. Recently, Paula Rabinowitz has argued that thirties documentary was in fact "encrusted" with the voyeuristic impulses of pulp fiction, just

as the pulpy noir films and fictions that emerged as the decade was ending borrowed heavily from the stock images and the visual cues established by documentary photographers.[89] In a compelling case for what might be considered the inherent "impropriety" of documentary art, she states: "Documentaries are always a bit unseemly. They come about because someone has crossed a line of decorum—snapping pictures of the worst moments, cruelest situations, most extreme events—snatching a bit of another's miserable life and parading it for all to see. It is this perversity that is so fascinating and so disturbing, and that evokes from even the most nostalgic documentary project a pulp modernist effect."[90]

Rabinowitz's comments also give us a renewed sense that documentary, which has so long been conceived of as a fundamentally realist endeavor, is a deeply modernist idea, one that resembles the ethic of "vital contact" so crucial to American modernists such as William Carlos Williams.[91] The documentary desire to capture the world "as it is," to strip away the artifice and conventions that might cloud our vision, echoes the modernist ideal of "terrible honesty," the brutal directness that Ann Douglas has contended is at the heart of early twentieth-century American experimental culture.[92] Sensational modernism, both fictional and photographic, is driven by the documentary impulse to carry information across cultural boundaries and to *expose* what has been overlooked or hidden. It is, in a sense, a form of documentary modernism. Where sensational modernism departs from conventional social documentary is in its effort to avoid creating what Wendy Kozol calls "spectacles of need" that reaffirm middle-class prestige and power.[93] "Social documentary," William Stott observes, "is instrumental, and its people tend, like the innocent victims in most propaganda, to be simplified and ennobled—sentimentalized, in a word."[94] Documentary can be, as Stott claims, "a radically democratic genre" that "dignifies the usual and levels the extraordinary," but it can also be an exercise of power, in which the capturing of images coincides with a larger project of social regulation.[95] To avoid or subvert the possibility of sentimentalizing and simplifying the socially inferior figures they depict, sensational modernists push the boundaries of moral propriety and the conventions of realism to extremes in an attempt to short-circuit links between documentary transparency and assumptions of social power, in which seeing serves as an act of surveillance and control.

The relationship between language (and, more specifically, literature) and photography, the manner in which they are or are not similar forms of expression, is a notoriously thorny issue. Roland Barthes suggests that

photography's relation to language is fundamentally paradoxical. On the one hand, a photograph is "a message without a code," in Barthes's words, a purely denotative rendering of the real that exceeds, indeed denies, language. On the other hand, language inevitably intervenes when we consider what Barthes calls photography's connotative code—the meanings we give to a photograph, meanings that are always already embedded in language.[96] Extending the tenor of these suggestions, W. J. T. Mitchell contends enigmatically: "Photography is and is not a language; language also is and is not a 'photography.'"[97] Mitchell reminds us that there is no definitive, axiomatic dividing line between photography and literature, the visual and the verbal, and insists that "all arts are 'composite' arts (both text and image); all media are mixed media."[98] In reading literature through photography and photography through literature, I have tried to attend both to the different manner in which (and the distinct technologies with which) writers and photographers approach the world and to the ways in which those differences might bring certain elements of each individual art form into relief. Literature, for instance, can give us a heightened sense of photography's narrative and textual elements. I say "heightened" because I do not mean to imply that this type of reading entails importing foreign elements—"narrative" or "text"—into photography, but rather to say that experience with literary texts can make us more cognizant of a particular aspect of photography that is always already there. Coming to photography from literature has made me attentive to the "story" behind a particular photograph as well as the "stories" embedded within it. Thus I am interested in narratives of photographic production (What interaction or events led to the taking of this photograph? How did this photographer come to be in this particular spot at this particular time?) as well as in a kind of textual reading that seeks to uncover the multiple, often competing narratives within a particular photographic frame (What stories does this photograph tell? How do these stories intersect, clash, and/or contradict one another?).

Photography in turn gives us a heightened sense of literature as frame. As a "process of rendering observation self-conscious," in John Berger's words, photography draws attention to its own frame—both to the arbitrariness of what it includes and what it excludes and to the lines of inclusion and exclusion it draws.[99] Coming to literature from photography reminds us that literature, too, is a process of framing. Both photography and literature offer not only a picture, but also a perspective; not only a story, but also a point of view. And it is through point of view that ideologies are established and maintained. Indeed, ideology *is* a point of view, a framework or grid

through which events are perceived and interpreted. It is here, in an analysis of visual and narrative framing, that *Sensational Modernism* brings literature and photography together most deliberately and explicitly.[100] While I trust that my readings are adequately attuned to the particularities of each medium's manner of representing the world, I also hope that my analyses suggest that point of view can serve as an analytic device for examining these two art forms in conversation: both frame the material they present in ways that ultimately fortify and/or denaturalize established social hierarchies and regimes of power.

The focus on framing in the analyses that follow is concomitant with a focus on the crises and limitations of framing, the prevalence of which is, finally, what unites the texts this book examines. Critics of photography have insisted not only on the ways in which the medium's presumed capacity to transparently index the "real" has served to perpetuate hegemonic power arrangements, but also on the camera's uncanny powers to disturb, to produce effects that exceed the force of captions and institutional frameworks to determine definitively or unequivocally an image's full meaning. The capacity of the photographic image to "prick," to "wound" (and to do so in a way that cannot be fully organized or controlled), is what Roland Barthes refers to in his notion of the "punctum," an inadvertent detail that disrupts the coherence of a photographic shot; or what Walter Benjamin refers to as the "tiny spark of accident" that can rupture imagistic unity.[101] Photography's capacity, even its penchant, to destabilize its own claims to epistemological certainty has led me to focus on literary texts that likewise suffer crises of formal and perspectival coherence. Indeed, what sensational modernist texts do is foreground their own formal and epistemological limitations (their inability to fully or definitively "capture" or convey the lives of poor and outcast figures) and highlight the volatile, contradictory impulses and effects (titillation, shock, voyeurism, empathy, horror) that animate or stem from the various boundary-crossing ventures that these texts represent. My argument about the startling motifs used by sensational modernists is that they disrupt and destabilize—always only partially and incompletely—social perspectives and frames of seeing that reinforce prevailing cultural inequalities.

A Tradition of Discontinuity

Sensational Modernism contains six chapters. Chapter 1, "Scrutiny, Sentiment, Sensation: American Modernism and the Bodies of the Dispossessed," sets out the conceptual tensions that structure the chapters that

follow. The chapter opens with analyses of *The Great Gatsby* and *The Grapes of Wrath*, as well as photographs by Dorothea Lange and Walker Evans, arguing that representations of socially marginalized figures in the first half of the twentieth century were dominated by discourses of scrutiny and sympathy that, respectively, objectified and sentimentalized the poor. To greater or lesser degrees, however, these texts are also laced with sensationalism, a lurid fascination with the dispossessed and debased working-class figures they depict. Sensationalism is the hidden aesthetic in these boundary-crossing texts, which peer into the worlds of the poor and do so not only with sympathy or sociological interest, but also with a voyeuristic impulse that disrupts the narrators' and photographers' manifest claims to professional detachment or sentimental compassion. The chapter then examines four Depression-era texts—Weegee's collection of photographs *Naked City* (published in 1945, but containing images taken predominately in the 1930s), Nathanael West's novel *Miss Lonelyhearts* (1933), Meridel Le Sueur's short story "I Was Marching" (1934), and Dalton Trumbo's novel *Johnny Got His Gun* (1939)—all of which use arresting images of working-class injury and deformation to contest the cultural condescension and aesthetic closure that mark scrutiny and sympathy. Although Weegee's photographs at times sentimentalize and at other moments belittle the urban outcasts he takes as subjects, he forcefully employs the tabloid stylistics of speed, shock, and exposé to disrupt both photography's putative "objectivity" and the tendency of liberal documentary to cast the poor as submissive objects of pity. Similarly, West's novella, Le Sueur's short story, and Trumbo's novel deploy startling images of bodily harm and deformation to fashion avant-garde critiques of social injustice that assertively challenge readers' anticipated indifference to working-class pain. Throughout these readings, I maintain that sentiment, scrutiny, and sensation are deeply intertwined, related forms of social perception and representation. Sensational modernists use sensational imagery to counter scrutiny and sentiment, but they invariably reproduce aspects of those discourses as well.

Chapter 2, "Sensational Contact: William Carlos Williams's Short Fiction and the Bodies of New Immigrants," examines Williams's short fiction, most of which was written during the 1930s. The chapter argues that Williams's lurid stories about New Jersey immigrants—in particular, Williams's doctor tales, which consistently fixate on the ill and exposed bodies of ethnic women—are animated by an uneasy blend of clinical detachment and sexual desire. By underscoring his patients' resistance to his frequently prejudicial assertions of authority, the narrator ironically invites readers to

criticize, even as they identify with, his volatile ambivalence toward the immigrant poor. Williams's mixed feelings are best captured in his philosophy of "contact," outlined in his book *In the American Grain* (1925). Contact, for Williams, embodies his desire for a paradoxical mode of cross-cultural engagement that could combine a sensuous, sexualized touch with dispassionate, abstract accuracy.

Chapter 3, "Modernist Documentary: Aaron Siskind's *Harlem Document*," examines photographs Siskind took in the late 1930s while leading one of the documentary working groups sponsored by the leftist New York Photo League. The chapter argues that Siskind's Harlem photographs, poised delicately between a documentary imperative to expose and a modernist self-consciousness about photographic point of view, resonate with social and aesthetic tension. Departing from traditional documentary photography, which typically strives for an illusion of visual transparency, several elements of Siskind's work—including its unconventional framing and the strained poses and contentious glances of his African American subjects—draw attention to the technical, formal, and racial conventions that his images both invoke and disrupt. Although the work of a committed modernist, Siskind's photographs incorporate aspects of sensational culture—celebrity pin-ups, a cabaret striptease, and racial stereotypes—as a way of destabilizing traditional documentary aesthetics and underscoring his own discomfort with cross-cultural looking.

Chapter 4, "A Piece of the Body Torn Out by the Roots: Tillie Olsen, James Agee, William Faulkner, and the Contingencies of Working-Class Representation," opens with a brief analysis of the textual portion of James Agee and Walker Evans's *Let Us Now Praise Famous Men*, in which Agee asserts that a "piece of the body torn out by the roots" would convey the lives of his subjects, three families of Alabama tenant farmers, more accurately and fully than any combination of written words he might place on the page. Agee's evocation of this sensational image of a torn body serves as a springboard for a discussion of Tillie Olsen's mid-1930s reportage and fiction, which also use images of disfigured bodies to startle readers. Olsen's writing is framed by her critique of "classical" aesthetics, modes of representation that extract the struggles of the poor from historical and social context in order to lend them an eternal, timeless, and stubbornly nonpolitical, appeal. In contrast to classicism's emphasis on aesthetic order and historical transcendence, Olsen crafts a composite, contingent form of avant-garde expression, employing high modernism's techniques of fragmentation and stream of consciousness to narrate the material contradictions of class con-

flict that high modernism typically seeks to transcend. Olsen employs sensational images to capture her readers' attention, but her writing resolutely de-sensationalizes the bodies of the poor, lending them political rather than voyeuristic significance. The chapter concludes by comparing *Yonnondio* to William Faulkner's *As I Lay Dying*, which, like Olsen's novel, uses experimental narrative techniques to engage and then upset derogatory typologies of poor whites.

Chapter 5, "Monstrous Modernism: Laboring Bodies, Wounded Workers, and Narrative Heterogeneity in Pietro di Donato's *Christ in Concrete*," opens by comparing di Donato's 1939 novel about a family of Italian American construction workers to Henry Roth's *Call It Sleep* (1934), a Joycean narrative about a Jewish family's immigration to New York told from the point of view of a young boy. A work of ethnic proletarian modernism like Roth's masterpiece, *Christ in Concrete* blends a realist emphasis on working-class pain with an avant-garde dedication to linguistic and perspectival experimentation. This explosive fusion is designed to convey the fundamentally distorted quality of the social world seen from the perspective of the text's central characters—the sense that "this land has become a soil that has contradicted itself," as one character asserts. Lacking traditional forms of political or social agency, the laborers are literally crushed beneath the weight of industrial capitalism, twisted and deformed into monstrously inhuman figures that become, through an imaginative twist, incarnated in the notion of Christ in concrete, figures of potential redemption. My analysis of the text focuses on the scenes of worker death, brutal scenarios that both engage and contest the overly embodied status of workers in modern American culture, invoking and refuting the transparent eyes of scrutiny that confirm proletarian abjection. The formal heterogeneity of di Donato's novel—which combines allegorical, high modernist, naturalist, and proletarian modes—represents both an explicit challenge to the invasive, disciplinary gaze of the powerful and an expression of experimental creativity that implicitly refutes the debilitating force of social oppression.

Chapter 6, "No Man's Land: Richard Wright, Stereotype, and the Racial Politics of Sensational Modernism," focuses on Wright's sensational best seller of 1940, *Native Son*. The chapter places the book in the context of the two texts that Wright authored before and after his most famous novel: *Lawd Today!*, a novel about a Chicago postal worker that Wright penned in the mid-1930s, and *12 Million Black Voices*, a photo-textual history of African Americans published in 1941. *Lawd Today!* focuses on the life of Jake Jackson, a figure who blatantly embodies many of the most incendiary

stereotypes about African American men, setting the stage for Wright's portrait of Bigger Thomas. Blending naturalism's emphasis on the gritty brutality of modern lowlife with modernist techniques of estrangement drawn from Joyce and Stein, *Lawd Today!* simultaneously invokes and destabilizes racist clichés. *12 Million Black Voices* likewise engages white images of and assumptions about African American life, offering a rich meditation on the ontology of racial identity and the cultural politics of cross-racial looking. Taking up *Lawd Today!*'s focus on stereotype and foreshadowing *12 Million Black Voices*'s interrogation of racial imagery, *Native Son* mobilizes sensationalistic images of racial crime to critique the racist imaginary from within. Combining naturalism, modernism, and a pulp plot, Wright fashions an indeterminate narrative voice that places the reader in what the author refers to as "No Man's Land," a literary and epistemological space in which the ontological certainties seemingly provided by stereotypes are unsettled.

As a collection of texts, sensational modernism represents what Susan Buck-Morss, paraphrasing Walter Benjamin, calls "a tradition of *disconti-nuity*."[102] Benjamin's paradoxical notion of a "discontinuous" tradition applies to the texts I have grouped together in several senses. First, these texts narrate encounters with persons generally omitted from, or marginalized within, the hegemonic continuities of conventional history and patterns of cultural representation. Second, this tradition cuts an unorthodox and jagged path, shuttling among writers and photographers rarely placed in conversation with one another (William Carlos Williams and Pietro di Donato; Aaron Siskind and Richard Wright; James Agee and Tillie Olsen; Weegee and Dalton Trumbo). Third, these texts represent singular events in the careers of their authors, examples of aesthetic forms that were discontinued (Tillie Olsen, Pietro di Donato, Henry Roth never wrote books comparable to their early efforts, each lapsing into years of literary "silence," as Olsen would describe it) or experiments that constituted "minor" episodes in "major" careers (the short fiction of William Carlos Williams, the documentary photography of Aaron Siskind, and the audacious experimentalism of Wright's *Lawd Today!*). Finally, these texts constitute what Benjamin calls a tradition of discontinuity because they do not ultimately resolve the thorny problems of engagement and representation that they raise. They remain examples of forms that their authors subsequently abandoned, no doubt in part because they are immensely fragile, tentative political and aesthetic settlements of the dilemmas they confront. These texts are "failures," in Rita Barnard's sense of the word, unable to imagine fully formed solutions to the problems

that they present in such dramatic fashion.[103] Tillie Olsen, for instance, is unable to envision a viable revolutionary ending for her novel that can overcome the violence and oppression she depicts; Richard Wright cannot find a single, coherent literary form adequate for situating Bigger Thomas and his struggle; Aaron Siskind's Harlem photography wavers between abstract modernism and social documentary, caught in aesthetic tension; Pietro di Donato's novel ends on a note of epistemological instability, blending hope and despair, simultaneously evoking and denouncing Catholicism's central symbolic legacies; Williams Carlos Williams's short stories continually reproduce paradoxes of prejudice and sympathy, uneasy mixtures of cruelty and compassion toward the immigrant figures his narrator confronts.

At the last, *Sensational Modernism* suggests that these texts are significant, in part, precisely *because* of their very lack of aesthetic and political "success." Culminating in epistemological confusion and compromise, these texts frequently leave readers in that terrain of aesthetic, political, and emotional uncertainty Wright calls "No Man's Land." The *lack* of resolution and formal integrity makes for texts in which the compromises, tensions, gaps, and hesitations that invariably inform all literary and photographic expression are woven into their very organizing structures, manifested in their most fundamental shapes and textures. These texts "fail," finally, because of the immensely complex and ambitious tasks they set for themselves: to engage and counter hegemonic conventions of modern representation and seeing and to chart the alternate paths taken by the disenfranchised through the landscapes of modernity and modernism, pathways that provide a vision not only of an overlooked cultural past but of alternative futures as well.

1

SCRUTINY, SENTIMENT, SENSATION
AMERICAN MODERNISM AND THE BODIES OF THE DISPOSSESSED

This chapter traces three distinct, yet interrelated representational modes—scrutiny, sentiment, and sensation—that shaped early twentieth-century depictions of socially marginalized figures in U.S. fiction and photography. What I call the discourse of scrutiny describes a form of realist representation that emerged in the United States in the latter half of the nineteenth century and endeavored to make the lives, thoughts, and bodies of various socially subordinate populations—especially workers, tramps, and immigrants—legible to middle-class audiences. Echoing the analytic and regulatory aspirations of the emergent social sciences, in which the production of knowledge and social control were frequently two sides of the same coin, scrutiny insisted that the personal and cultural identities of the poor and disempowered were imprinted on their bodies, which were exposed to the reader's or viewer's eye for close, unobstructed inspection. The discourse of sentiment, which came to prominence during the middle of the nineteenth century, likewise aimed to make the experiences of the disempowered, especially slaves and the poor, accessible to socially and economically privileged audiences, and also identified the body as a source of truth about interior states of mind and being. Sentiment sought to construct pathways of cultural connection through depictions of bodily suffering or sacrifice, in which the vulnerability of the less fortunate sparked feelings of pity and empathy in middle-class readers, whose moral virtue was reinforced by the extension of feelings across the chasms of class and race difference. Both sen-

timent and scrutiny thus extended the literary and visual field to previously overlooked or excluded populations, but did so in ways that typically served to render these populations familiar and nonthreatening to their social superiors, casting subaltern figures either as abject specimens available for critical examination (in the case of scrutiny) or as needy persons whose vulnerability paradoxically confirmed the ethical prerogatives of the well-to-do (in the case of sentiment). Yet both scrutiny and sentiment are frequently contaminated by a third aesthetic strand, the sensational, which registers the more unseemly forms of social feeling that often underwrite hegemonic attitudes toward the poor and disenfranchised, such as disgust, dread, and desire. In most texts dominated by scrutiny or sentiment, the sensational is a residual element, visible in brief moments of rhetorical excess, contradiction, or slippage. Sensational modernists, however, seize on what is usually submerged, using arresting and frequently disorienting images of bodily harm, sexual aggression, or racial prejudice to make palpable the unacknowledged forms of discrimination that give shape to conventional modes of seeing and representing the dispossessed.

To explain the dynamics and dimensions of these three representational strategies, and to set the stage for an analysis of experimental fiction and photography from the 1930s, I want to begin by examining a canonical modernist text from the previous decade in which corporeal motifs figure prominently: F. Scott Fitzgerald's *The Great Gatsby* (1925). Like many novels written during the 1920s and preoccupied with questions of cultural difference and distinction, *Gatsby* suggests that its characters' bodies manifest their inner personalities.[1] Tom Buchanan's hubris and sadism, for instance, are legible in his severe physical features, which are punctuated by "two shining, arrogant eyes [that] had established dominance over his face and gave him the appearance of always leaning aggressively forward. Not even the effeminate swank of his riding clothes could hide the enormous power of that body — he seemed to fill those glistening boots until he strained the top lacing and you could see a great pack of muscle shifting when his shoulder moved his coat. It was a body capable of enormous leverage — a cruel body."[2] Tom's heft, exaggerated musculature, and piercing eyes clearly embody his overbearing, brutal nature. Likewise, the bodies of other characters seem to express their inner identities. Gatsby's restlessness, his industrious yearning, is reflected in his "resourcefulness of movement" (68), the fact that his body "is never quite still; there was always a tapping foot somewhere or the impatient opening and closing of a hand" (68). Similarly, Jordan Baker's haughty indifference and sexual ambiguity are rendered material in her

stiff, androgynous figure: "She was a slender, small-breasted girl with an erect carriage which she accentuated by throwing her body backward at the shoulders like a young cadet" (15).

The figure whose body receives the most rhetorical attention in *Gatsby* is Myrtle Wilson, Tom Buchanan's working-class mistress. In sharp contrast to the slim Jordan Baker, and to the ethereal Daisy, who first appears "buoyed up as though upon an anchored balloon" (12), Myrtle is characterized by an excessive fleshiness. Struck initially by her "thickish figure," Nick states that Myrtle "was in her middle thirties, and fairly stout, but she carried her surplus flesh sensuously, as some women can. Her face, above a spotted dress of dark crepe-de-chine, contained no facet or gleam of beauty but there was an immediately perceptible vitality about her as if the nerves of her body were continually smoldering. She smiled slowly and walking through her husband as if he were a ghost shook hands with Tom, looking him flush in the eye" (29–30). Nick finds Myrtle's body, and the personality it appears to reflect, unsettling, yet also perversely appealing. On the one hand, she constitutes a disruptive presence whose lack of physical refinement signifies her lack of grace and her affront to social propriety. Her crudely assertive sexuality, for instance, which has beguiled the aristocratic Tom, threatens established class divisions and domestic relations. Similarly, her bulky figure subverts conventional gender expectations: she not only lacks any trace of feminine beauty, she is in fact more masculine than her husband, whom she disregards throughout the novel as if he were a submissive housewife. On the other hand, Myrtle is oddly enticing: Nick's description of her "smoldering" energy and "sensuous" manner suggests that he finds her alluring, even sexy, in spite of himself. Moreover, Myrtle's "vitality" links her to Gatsby, who is likewise distinguished by a certain vigor of spirit and body—an exuberant "restlessness" (68) and a "romantic readiness" (6). However, if Gatsby's "heightened sensitivity to the promises of life" (6) culminates in what Nick describes as a "gorgeous" "series of successful gestures" (6), Myrtle's tactics of self-fashioning, our narrator ultimately implies, are decidedly more contrived and crude. Indeed, as she begins to perform her fantasies of style and glamour in chapter 2, changing into a more elaborate dress and playing host to an afternoon party that turns increasingly vulgar, Nick states that "the intense vitality that had been so remarkable at the garage . . . became more violently affected moment by moment" (35).

The novel links Myrtle's vulgarity and artificiality—the tendency for her "vitality" to become "violently affected"—to her appetite for mass

culture, especially for celebrity gossip papers and tabloids such as "'The Town Tattle,'" the "moving picture magazine[s]" (31), and "the small scandal magazines of Broadway" (33) that litter the apartment Tom has rented for her. More than mere entertainment, these pulpy periodicals provide the building blocks of Myrtle's sense of self. Unlike Gatsby, whose aspirations are driven by desires seemingly untainted by historic specificity, Myrtle's ambition to become Mrs. Tom Buchanan—to play the working girl who marries into high culture—echoes the most trite, commonplace scripts of Jazz Age mass culture fantasy. Indeed, the novel suggests that her fascination with fashion, scandal, and celebrity reflects the inherently imitative, synthetic nature of her identity. Myrtle thus represents not only (along with her husband George) the novel's image of the working-class, but also the figure of the popular, pulp reader and of sensational culture more generally, which the text appears to hold out for immense disdain. Myrtle's excessive sensuality, cheap taste, and seemingly innate lack of elegance mark her as the symbolic counterpoint both to Gatsby's idealism and to what Nick describes as the "fundamental decencies" (6) represented by his nostalgic vision of the Middle West before World War I. Myrtle's status as a symbolic repudiation of the novel's primary values is underscored in the description of her dead body, which collapses in the street after being run over by Daisy, driving Gatsby's car:[3]

> . . . Myrtle Wilson, her life violently extinguished, knelt in the road and mingled her thick, dark blood with the dust.
> . . . When [the two men who witnessed the accident] had torn open her shirtwaist still damp with perspiration they saw that her left breast was swinging loose like a flap and there was no need to listen for the heart beneath. The mouth was wide open and ripped at the corners as though she had choked a little in giving up the tremendous vitality she had stored so long. (144–45)

While readers might expect the novel to display some sympathy here for Myrtle, the exceedingly graphic nature of this scene and the cold indifference of Fitzgerald's prose echo, indeed rhetorically redouble, the violence done to her body by the car. Like Daisy's maliciously determined driving, the text is unflinching, even sadistic, in its delineation of Myrtle's mutilated form. There is no romance, no pathos to her death. She is not only dead, but also debased—the severity of the terms "loose," "wide open," "ripped" insist that she has not only been killed, but disfigured, vitiated. The brutal directness of the prose emphasizes the lack of beauty that her body has in

death as it had in life. Although already extinguished, she appears actively to mingle her blood with the dirt in the road, as if herself insisting on her own degradation, reinforcing her own abjection. Moreover, in her dirty death, as in her cheap and sordid existence, Myrtle subverts the novel's most compelling romantic motifs. For instance, the dust in which she expires strikes a noted contrast to the snow that blankets Nick's "Middle West," a symbol of the region's peace and purity. In a similar fashion, Myrtle's torn breast prefigures, by way of negative contrast, the "fresh, green breast of the new world" (189) that Nick evokes to symbolize the sense of "wonder" (189) that Dutch explorers first felt on their arrival in the New World. In the end, the rhetoric in which her eviscerated body is rendered—and the shape of that body itself—legitimates her death, naturalizing her demise even as the text portrays her murder as an act of cold-blooded cruelty. In fact, the passage goes so far as to imply that her death, or at least the disfigurement of her mouth, may have been caused by gagging on her own vitality, as if her own energy was a danger to her body, as if the victim herself is to blame.

The clinical detachment and callousness with which Fitzgerald describes Myrtle's body at its moment of mutilation represents an example of what I call the discourse of scrutiny, a mode of literary and photographic seeing that echoes larger cultural and political techniques of social discipline. The harsh, almost punitive quality of Fitzgerald's prose can be traced to the emergence in the late nineteenth century of a brand of literary realism that employed the terms and ideological strategies of an ascending culture of scientific rationalism and professional expertise, a form of realism that aspired to what Mark Seltzer identifies as a "fantasy of surveillance," an impulse to inspect, classify, and ultimately regulate the quotidian objects and ordinary, often lower-class, persons that realists conventionally take as their subjects.[4] Seltzer contends that the efforts of many realists to bring "the every day ordinariness of every body" into literature echoes the efforts of late nineteenth- and early twentieth-century reformers, journalists, and documentary photographers to bring society's "other half" under the regulatory gaze of newly formed social sciences. "The realist desire to see," Seltzer states, "is also necessarily a desire to make visible, to embody, physically or materially, characters, persons, and inner states and, collaterally, to 'open' these states to what [Stephen] Crane calls the 'machines of perception' and what the turn-of-the-century reformer, police reporter, and photographer Jacob Riis called the social technologies of 'eternal vigilance.'"[5] According to Seltzer, realism and naturalism are animated by an impulse to dissect previously obscured portions of the social world, an "imperative

of making everything, including interior states, visible, legible and govern-able."[6] Similarly, June Howard argues that naturalist writing dovetails with turn-of-the-century modes of cultural supervision and control. Howard con-tends that naturalism reinforces Progressive-era structures of social domi-nance in which the poor become objects of professional-managerial class scrutiny. For Howard, naturalism is defined not, as critics have traditionally argued, by a particular philosophy, but rather by a central dichotomy be-tween a privileged, autonomous narrator, with whom the reader is ideologi-cally aligned, and a "brute," a degraded inhabitant of a deterministic world. Instead of being an autonomous subject, the "brute" is the central figure in a spectacle of determinism that confirms the power of the narrator's gaze and the moral authority and freedom of the readers. Although the specta-tors describe and explain the brute, they retain their autonomy from the deterministic environment the brute inhabits; while "we explore determin-ism, we are never submerged in it and ourselves become the brute."[7] Ulti-mately, Howard argues, the narrator/brute split anticipates the Progressive movement, which placed reform in the hands of a small cadre of ostensibly enlightened, nonpartisan experts. "It is a very short step from naturalism's gesture of control to progressivism's," Howard contends, "from the sym-pathy and good intentions of the naturalist spectator to the altruistic and ultimately authoritarian benevolence of the progressive reformer."[8]

Although it emerged as a component of realism, the discursive drive for "scientific" legibility, for an exacting, almost violent, precision—what I'm calling the discourse of scrutiny—extends through a variety of modernist texts, as several critics have suggested and my reading of *The Great Gatsby* implies. Peter Nicholls, for example, argues that the stylistic protocols of high modernism "tended to encode a violence or aggressivity" toward both things and persons.[9] Along similar lines, Ann Douglas has recently described modernism's driving impulse as "terrible honesty," an aggressive ideology of precision and accuracy that sought to overcome the emotional excesses and artificialities of the genteel past.[10] Other scholars have noted the resonance of modernist ideologies of style and subjectivity with Tay-lorist and Fordist techniques of social control.[11] Modernism's desire to cut to the core of a thing, to probe the deep essence of a phenomenon, extends the links between writing and disciplinary violence integral to many forms of nineteenth-century realism and naturalism. In addition, as the emphasis on stylistic brutality in these descriptions suggests, the literary transparency and narrative detachment to which these strains of realism, naturalism, and modernism aspire are underwritten by a distinctly antifeminine gender poli-

tics. Michael Davitt Bell has observed that "a prominent function of claiming to be a realist or a naturalist . . . was to provide assurance to one's society and oneself that one was a 'real' man rather than an 'effeminate' artist."[12] Similarly, Nicholls argues that high modernism's stylistics of mastery are inextricably bound up with a virulent misogyny.[13] Likewise, Douglas asserts that modernism is animated in large part by an ambivalent but persistent matricidal impulse, a desire to destroy the influence of the Victorian mother who presided over the feminization of American culture and whom so many male modernists found stifling. But rather than slaying the genteel matriarch, Fitzgerald's 1925 novel dismembers her working-class sister instead.

However, as my analysis of Nick's description of Myrtle suggested, the rhetorical violence that the novel directs toward Myrtle is paradoxically animated by—and perhaps a response to—Nick's fascination with her. Nick's disgust is laced with sexual desire, a desire that represents scrutiny's sensational undercurrent, the erotic flow that is the flip side of the novel's cruelty toward this proletarian moll. My emphasis on the text's presiding ambivalence toward Myrtle recalls Peter Stallybrass and Allon White's argument that discursive forms and formations are typically forged through a complex process of rejection and longing, in which the dominant element "continually define[s] and re-define[s] itself through the exclusion of what it mark[s] out as 'low'—as dirty, repulsive, noisy, contaminating."[14] "But disgust," they contend, "always bears the imprint of desire. These low domains, apparently expelled as 'Other,' return as the object of nostalgia, longing, and fascination."[15] Myrtle possesses a similar status in Fitzgerald's novel: she stands for what the text marks out as "dirty" and "contaminating," but, by virtue of these associations, she emerges as "an object of . . . fascination," a figure who becomes, in Stallybrass and White's words, "instrumentally constitutive" of the text's primary imaginary operations.[16] Thus, while the text clearly disparages Myrtle's investment in pulp formulas, the novel's own story structure mimics those very mass-produced narratives. Indeed, even as the text condescends to Myrtle's tawdry and formulaic ambitions, her affair with Tom and its violent denouement recall one of the most notorious tabloid stories from the early twenties, the unsolved Hall-Mills murder case (to which Fitzgerald alluded in a 1922 newspaper interview) in which an affluent minister and his poor mistress, a member of the church choir, were brutally shot.[17] Moreover, the novel's central plot—Gatsby's daring, but shadowy rise to fame through a past of dark secrets and illicit activities that culminates in his cold-blooded murder by a vengeful man who in turn kills himself—itself echoes the very pulp narratives for which Myrtle

and her working-class peers are the ideal audience. The perverse dynamics of disavowal and desire with which Fitzgerald's novel regards Myrtle, and by extension the working-class, popular culture that she personifies, underscores the fact that the discourse of scrutiny, however powerful, is never seamless or complete. While the text treats Myrtle as a debased, inferior figure against whom it can define the purity of Gatsby's ambitions and Nick's vision of middle-class, midwestern morality, the text simultaneously grants her an erotic charge that threatens to undermine the disdain with which it regards her. As we'll see, this is one thing that sensational modernism, as a cultural phenomenon, exposes: the capacity of subordinate figures to disturb the very structures of rhetorical power that are put in place to enforce and legitimate their subjection.

Modernist Sentiment

Despite the desire of many realists and modernists to eradicate excessive narrative feeling in favor of scientific clarity, sentiment—like romance—by no means disappeared from the modern literary landscape.[18] On the contrary, sentiment persisted, both as a negative example—invoked by authors as a mode against which they defined their own style—and as a powerful discourse in its own right, especially in texts that depict the dispossessed.[19] In particular, just as it served as a primary genre through which writers addressed the crisis and conflict of the Civil War, so it emerged as an important mode for making sense of, and ideologically managing, the crisis of the Great Depression. In the nineteenth century, sympathy emerged as a preeminent mode of literary address and persuasion—especially in works about "less fortunate" persons ("life among the lowly," as Harriet Beecher Stowe subtitled *Uncle Tom's Cabin*). In sympathetic discourse, sentiment acted as a form of social and emotional glue that could bind both the nation and individual persons together across significant divisions. As the editor of an influential collection on sentimental culture, Shirley Samuels, has argued, "Sentimentality in nineteenth-century America . . . appears not so much a genre as an operation or set of actions within discursive models of affect and identification that effect connections across gender, race, and class boundaries."[20] In establishing such connections, sympathy performed important political and social work,[21] work that several critics have argued was animated by a democratic impulse to grant cultural legitimacy to marginalized or persecuted persons. As Philip Fisher states, "The political content of sentimentality is democratic in that it experiments with the extension of full and complete humanity to classes of figures from whom it has been

socially withheld."[22] Sympathy functions by establishing clear, virtually seamless lines of identification in which we understand other persons insofar as they represent what is most familiar and essential in ourselves. Fisher explains: "The sentimental novel creates the extension of feeling on which the restitution of humanity is based by means of equations between the deep common feelings of the reader and the exotic but analogous situations of the characters."[23]

However, it is precisely this assumption of "common feelings" that many critics have questioned, arguing that sympathy's tendency to affirm the "humanity" of strangers only to the extent that they are like "us" is a presumptive gesture of cultural appropriation. Elizabeth Barnes, for instance, contends that "sentimental literature teaches a particular way of reading both texts and people that relies on likeness and thereby reinforces homogeneity."[24] In early American novels, she notes, sentimentality "reinforce[s] a familial mode of politics that subordinates difference to sameness and that teaches readers to care for others as if they were reflections of themselves."[25] Similarly, Laura Wexler argues that historically sentimentalism has been intimately intertwined with imperialist strategies of social domination: "The energies [sentimentalism] developed were intended as a tool for the control of others, not merely as an aid in the conquest of the self"; sentiment, Wexler maintains, provided both the essential "stuff" of bourgeois selfhood and a remarkably subtle tool of social governance aimed "at the subjection of different classes and even races."[26]

The persistence of the sentimental—and its complex legacies of democratic feeling and social control—in thirties literature is demonstrated quite vividly by John Steinbeck's *The Grapes of Wrath* (1939), a text that might be described as a work of sentimental modernism. In the novel's final scene, Rose of Sharon, who has just lost her baby in child birth, offers her breast to feed a starving stranger, an exercise of sentimental sacrifice that the novel imagines as a model form of private charity through which a renewed national public community could be forged:

She hoisted her tired body up and drew the comfort about her. She moved slowly to the corner and stood looking down at the wasted face, into the wide, frightened eyes. Then slowly she lay down beside him. He shook his head slowly from side to side. Rose of Sharon loosened one side of the blanket and bared her breast. "You got to," she said. She squirmed closer and pulled his head close. "There!" she said. "There." Her hand moved behind his head and supported it. Her fingers moved gently in his

hair. She looked up and across the barn, and her lips came together and smiled mysteriously.[27]

This scene rewrites Myrtle Wilson's death, transforming the torn breast into a full, redemptive breast, recasting the wounded and corrupted working-class woman's body as a wholesome, healing body. In Fitzgerald's version of the scene, Myrtle's death literalizes the callousness of the wealthy, who are responsible (in the person of Daisy) for her doom; in Steinbeck's rendition, death (of Rose of Sharon's baby) facilitates life—the poor woman's body represents idealized abundance rather than repulsive degradation. But Steinbeck's reversal of the terms of Myrtle's death requires an unreflexive romanticization of the body of the working-class woman, endowing it with an essentially nurturing, maternal, self-sacrificing identity—qualities first hinted at in the novel's initial description of Rose of Sharon's pregnant body:

> Her hair, braided and wrapped around her head, made an ash-blond crown. Her soft round face, which had been voluptuous and inviting a few months ago, had already put on the barrier of pregnancy, the self-sufficient smile, the knowing perfection-look; and her plump body—full soft breasts and stomach, hard hips and buttocks that had swung so freely and provocatively as to invite slapping and stroking—her whole body had become demure and serious. . . . And the world was pregnant to her; she thought only in terms of reproduction and of motherhood. (123)

The physiological changes wrought by pregnancy have the effect of disciplining Rose of Sharon, taming her potentially seductive side and highlighting her apparently innate maternal instincts. Pregnancy isolates and confines Rose of Sharon, placing a "barrier" between her and the world, locking her in a castle of sentimental superiority, complete with a "crown" and a "knowing perfection-look." Perhaps to forestall the impression that Rose of Sharon may end up like Myrtle Wilson (we should note that Rose of Sharon's "voluptuousness" echoes Myrtle's notable "vitality"), the text seems to employ her pregnancy as a mode of regulating her behavior and altering her identity. Sentimentalism sanitizes Rose of Sharon, reducing her to a body that has been pacified, desexed, made "serious and demure." Domesticity occupies the full scope of her energies, engulfing her personality so that "she thought only in terms of reproduction and of motherhood." That the domestic has a punitive effect in Steinbeck's novel should perhaps come as no surprise—such a regulatory impulse is implied in the novel's political

agenda, which promotes what Michael Szalay calls a "national welfarism" built on the rigorous extension of the most personal forms of private sentiment into an anonymous public sphere under the aegis of the federal government.[28] In this passage, the centralized state control of resources that the novel encourages is expressed as the literary domestication and control of Rose of Sharon's body. Yet it is important to note that Steinbeck's sentimental rendering of Rose of Sharon is laced with qualities that subtly disturb the totalizing—and regulatory—rhetoric of his prose. The text's insistence on her "demure" behavior follows a deeply erotic description of her body that suggests its sexual appeal and autonomy. This reminds us that the attempt to "contain" Rose of Sharon's body entails invoking the very thing (i.e., her powerful allure) that needs to be controlled. Thus, just as the discourse of scrutiny is inflected with a more sensational discourse of desire, so Steinbeck's rhetoric of sentiment is here contaminated by a similar language of erotic fascination.

Steinbeck's depiction of Rose of Sharon and Fitzgerald's portrayal of Myrtle Wilson designate opposite ends of the representational spectrum within which canonical works of literature from the first half of the twentieth century typically portray working-class characters, especially women. While both novels imply that working-class women possess a potentially disruptive sensuality, a sexual vitality that threatens established social boundaries and expectations, the two texts deploy divergent strategies to control these women and their anxiety-producing appeal. *The Great Gatsby* tames Myrtle's sensuality by demeaning her—both by suggesting that her sexual allure and "surplus flesh" signify a more general tendency to transgress and corrupt hegemonic gender and class boundaries and by describing her in severe, objectifying prose that magnifies, in the guise of merely describing, her debased status, enforcing the narrator's (and reader's) sense of superiority over her. In contrast, *The Grapes of Wrath* tames Rose of Sharon's plump and tantalizing body by domesticating her, painting her with the brush of sentimental maternalism that casts her as a static and transcendent image of sexless self-sacrifice.[29]

In both of these cases, poor women are represented by—and reduced to—their bodies, which are subjected to various forms of narrative discipline. In these examples, the identities of the poor are inscribed on their bodies, made accessible and legible to narrators and readers, who are thereby placed in a position of power.[30] As a strategy of control, reducing the presence and identity of the poor to their bodies is a well-established technique, central to the apparatus of modern power, as Robyn Wiegman has convinc-

ingly argued. In *American Anatomies: Theorizing Race and Gender*, Wiegman contends that modern regimes of power are underwritten by economies of visibility that create a disembodied norm against which definitive bodies of difference can be located and subjected to a "discipline of the particular."[31] Modern citizenship, Wiegman explains, "functions as a disproportionate system in which the universalism ascribed to certain bodies (white, male, propertied) is protected and subtended by the infinite particularity assigned to others (black, female, unpropertied)."[32] This system, Wiegman continues, "is itself contingent on certain visual relations, where only those particularities associated with the Other are, quite literally, seen."[33] The dynamics Wiegman describes are clearly at work in Fitzgerald's and Steinbeck's novels. In *Gatsby*, the ethereal purity of Nick's idealized Middle West acquires meaning through contrast with the degraded "particularities" of Myrtle's debauched body; in *Grapes*, the model for a nationalizing, public sentiment is presented as a process through which Rose of Sharon's bodily "particularities"—her "hard hips and buttocks that had swung so freely and provocatively"—are confined in a form of domestic discipline, transforming her into the agent of a kind of social sacrifice that Steinbeck imagines can heal and unify the nation.

Scrutiny, Sentiment, and Documentary Photography

As in literature, the representation of working-class bodies in documentary photography from the first half of the twentieth century, in particular images taken under the auspices of the Farm Security Administration (FSA), also tended to skate between the poles of scrutiny and sentiment, enclosing the nation's displaced and destitute populations in reductive frames of recognition. Recently, the historian Cara Finnegan has argued that although "there was indeed no monolithic, overarching visual rhetoric of poverty during the Depression," the manner in which FSA images were used tended to de-particularize the poor, extracting them from the precise political, social, and individual situations they faced.[34] Rather than presenting their subjects as figures who make specific political demands on viewers, FSA images tended to cast the poor either as a homogenous, abstract mass or as "a spectacle of the downtrodden other," "something to LOOK at, but not to engage as a social or political reality."[35] Other critics have argued that the FSA archive tends to be characterized either by images of what Terry Smith calls "docile desperation," in which the poor are frozen in postures of fear, fatigue or resignation, or by images underscoring the noble innocence of the "worthy" poor, grounded in a consensual, sentimental view of common

"humanity."[36] More broadly, Smith argues, the FSA's focus on rural settings functioned as a form of ideological displacement and substitution, steering viewers away from concerns about urban, industrial problems. Smith contends: "the task of this body of images was to concentrate attention on the rural victims of modernity (desperate but recoverable) and the basic values of the small town, diverting focus from the modernizing forces at work in the countryside (mechanization and monopoly) as well as from the industrial victims of modernity (desperate and angry) and the uncontrollable complexities of the city."[37] As Smith and others argue, the dominant channels of photographic imagery in the 1930s, from the FSA to *Life*, functioned in large part to diminish and deflect—and to frame in a way that would ideologically and iconographically *contain*—potent anxieties about the unrest, resentment, and activism of the nation's disenfranchised and minority populations, especially ethnic, immigrant, and African-American workers who had been hardest hit by the Depression and had begun to organize in substantial numbers. Franklin Roosevelt implied as much, suggesting that the possibility of working-class revolt was reason to support state-sponsored reform. "The millions who are in want," he proclaimed in a 1932 campaign speech, "will not stand silently by forever while the things that satisfy their needs are within easy reach."[38]

The photographic conventions of sentiment and scrutiny can be seen in two well-known pictures of poor people taken by FSA photographers in 1936: Dorothea Lange's image of a mother and children known as "Migrant Mother" (figure 1.1), and Walker Evans's image of sharecropper Bud Fields and his family (figure 1.2), published in 1941 in *Let Us Now Praise Famous Men*. In his monumental study of Depression-era documentary expression, William Stott contends that the power of documentary derives from "its special emotional value."[39] "The practitioners of the documentary genre in the thirties realized," Stott asserts, that "emotion counted more than fact."[40] It was documentary photography's ability to induce tears from New Jersey housewives over the struggles of Oklahoma farmers, or to tug the heartstrings of Boston businessmen over the plight of southern sharecroppers, that gave the genre its power. One of the most widely circulated images from the FSA file, Lange's "Migrant Mother" offers an example of the ways in which pictures were often carefully calculated to maximize their sentimental appeal. As James Curtis has demonstrated, the famous Lange photograph was the last one in a series of six she had taken of the mother and her four children during a ten-minute stop at a pea pickers' camp. Each of the six shots moved progressively closer to the mother's face, eliminating

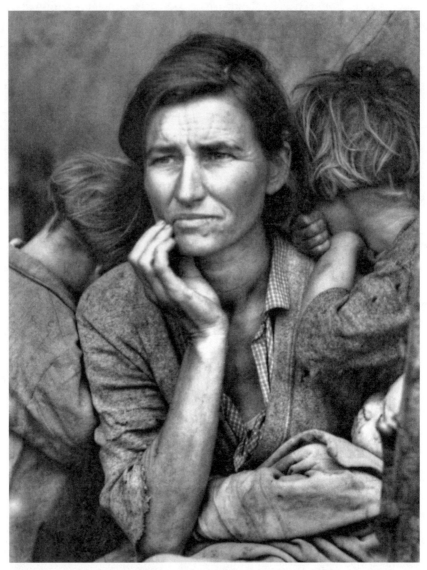

Figure 1.1. Dorothea Lange, "Destitute peapickers in California. Mother of seven children. Age thirty-two. Nipomo, California," 1936. [The photograph is commonly referred to as "Migrant Mother."] FSA-OWI Collection, Prints and Photographs Division, Library of Congress.

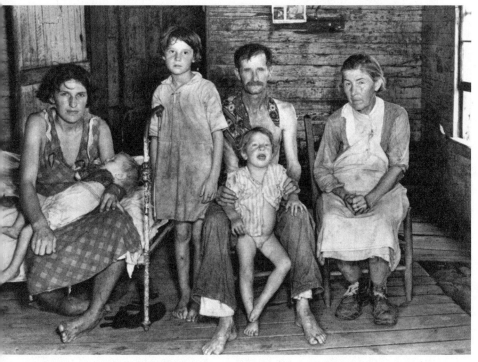

Figure 1.2. Walker Evans, "Sharecropper Bud Fields and his family at home. Hale County, Alabama," ca. 1935–36. FSA-OWI Collection, Prints and Photographs Division, Library of Congress.

elements that provided a sense of the material conditions of her existence, but could potentially distract from the focus on her visage or, in the case of dirt and disorder, interfere with the sympathy viewers might have for the mother. The first image in the series was taken from a position several yards away from the family and includes their tent, the camp in the background, the family's belongings, and a fourth child—an adolescent girl—who is not in the frame of the final three shots. With each ensuing shot, Lange moved closer to the mother, carefully posing her and her children to heighten the emotional intensity of the image. For the final shot, Lange captured the children as they face away from the lens, preventing the possibility of intersecting glances or competing countenances. Lange also requested that the mother raise her hand to her mouth in a gesture that heightens the photo's poignancy. In short, through a sequence of shots, Lange honed and narrowed her image of the mother and children, obscuring the immediate social context and intensifying the emotional power of the final image.[41] In this way, "Migrant Mother" is typical of FSA portraits of women, which, as Wendy Kozol argues, tend to rely on and reproduce traditional iconographies of motherhood—in Lange's case the trope of Madonna and Child—in an effort to endow the images with universal import. Such photographs, Kozol observes, "tend to move away from the historically specific context of poverty to the more idealized iconography of maternity."[42] Lange uses the body's gestures and textures—its expressive capacity—in a way that lifts these figures out of their particular surroundings and into a realm of abstract, sentimental meaning (much as the manner in which Steinbeck's romanticized portrait of Rose of Sharon's pregnant body lends her an ostensibly timeless, transcendent significance).[43]

Evans's image of the sharecropping family possesses a remarkably different tone, more akin to the scrutiny that marks Fitzgerald's description of Myrtle's disfigured body than to the sentimental tenor of Steinbeck's depiction of Rose of Sharon or Lange's image of the migrant mother and her children. In contrast to most of the images Evans included in *Let Us Now Praise Famous Men*—pictures that grant their destitute subjects remarkable autonomy, dignity, and subjective power—this image has a harsh, graphic quality to it. The frontal poses and straight, lateral arrangement of the family members position them for unobstructed inspection by the viewer. They sit squarely, but passively before the lens, like specimens; their nakedness underscores their vulnerability before the viewer.[44] As critic John Pultz suggests, "They control nothing of their own representation. Their home, their flesh, even the son's genitalia, are laid bare to the camera's piercing

eye."[45] The direct lighting exposes the details of their physical wounds and defects, the dirt and scabs that mark them as malnourished and overworked. Surveying the family with a flat, emotionally detached eye, Evans's gaze, marked by its dispassionate rigor, strikes a notable contrast to the emotionally expressive quality of Lange's style.

My readings of these various scenes and images suggest that depictions of the bodies of poor persons in U.S. fiction and photography in the first half of the twentieth century, and in the 1930s in particular, vacillated between an aesthetic of sentiment and an aesthetic of scrutiny. Both sentiment and scrutiny represent strategies of social control through embodiment. In both, the poor are reduced to their bodies, which become material manifestations of their subjectivities, which are in turn made transparently legible to narrator, reader, and viewer. In this sense, both sympathy and scrutiny are modes of ideological management, ways of rhetorically containing potentially strange or threatening figures. As Elisabeth Barnes argues, sympathy converts heterogeneity to homogeneity; as June Howard suggests, narrative scrutiny functions as a mode of social exposure that echoes and reinforces modern policies of social reform and regulation.

The group of artists I call sensational modernists intervene in the field of verbal and visual representation I have been mapping, attempting to recast the conventions in which socially marginalized figures—workers, immigrants, African Americans—are depicted. Sensational modernist texts evoke images of bodies, but rather than suggesting the transparency of those bodies to an invasive eye, these texts more typically suggest the irreducibility of persons to their bodies and the incapacity of pen and camera to fully capture bodily experience. Sensationalism is a rhetoric of excess and exaggeration that, in the hands of the artists whose work is explored below, generally—but not always—complicates the modern triumph of "rationality," exposes the horrors inherent in "progress," suggests the violence and ultimate impossibility of total social "control." Whereas modern U.S. industrial society, driven by Fordist modes of production and Taylorist techniques of efficiency, represented a culture of integration—an effort to integrate all the components of the productive system, including and especially the bodies of workers, into a single, ceaseless, self-reproducing process—these texts depict figures of *dis*integration: images of bodies distorted, harmed, wounded, fractured. It was precisely the ideology of productive integration that the Depression called into question, and sensational modernists, seeking to make this material and ideological crisis palpable, used motifs of mangled, disfigured bodies to do so. To provide a sense of the range and significance of

sensational modernist bodies, and to furnish a framework for the chapters that follow, I want to offer now brief analyses of four texts from the Depression decade: Weegee's *Naked City* (published in 1945, although comprised of photographs taken largely in the mid- to late 1930s), Nathanael West's *Miss Lonelyhearts* (1933), Meridel Le Sueur's "I Was Marching" (1934), and Dalton Trumbo's *Johnny Got His Gun* (1939).

Weegee's Tabloid Documentary

In 1945, Weegee, a freelance photojournalist who made his living selling pictures of urban catastrophes such as murders, fires, and automobile accidents to tabloid newspapers, published *Naked City*, a collection of photographs dedicated exuberantly "TO YOU THE PEOPLE OF NEW YORK."[46] Weegee's New York is a decidedly plebeian metropolis. The "people" to whom he flamboyantly devoted *Naked City* and who comprise the book's central cast of characters include tenement dwellers fleeing blazing buildings or gawking at murder victims lying in the street; working-class patrons of Bowery bars, dance halls, and Coney Island beaches; homeless men sleeping on sidewalks. *Naked City* depicts a city of desperation and destitution (of criminal suspects being cuffed by police, bloody corpses lying in the street, lonely men and women wandering dark sidewalks), cut through with scenes of joy and humor (a young girl swooning at a Frank Sinatra concert, couples kissing in the backs of movie theaters, tenement children splashing in the spray of an open fire hydrant).

A volatile blend of varied stylistic strains, *Naked City* simultaneously employs and dismantles many of the central protocols of canonical documentary and journalistic photography, gesturing toward unprecedented modes of representing the poor. Through a unique hybrid aesthetic that blends documentary and tabloid conventions—a style that might best be termed tabloid documentary—Weegee simultaneously records the urban scene and exposes the privileges and pretensions prevalent in traditional documentary practice. In particular, *Naked City*'s sensationalism—its presentation of the city as an endlessly fascinating spectacle that invites a prying eye—disrupts documentary's pretensions to objectivity, exposing the voyeurism that drives cross-cultural looking.

In recent years, critics Maren Stange, John Tagg, and Martha Rosler, among others, have contended that documentary's emphasis on visual clarity and presumption of ideological "objectivity" served to bolster the moral legitimacy and social prestige of its intended well-to-do audience. The depiction of poverty reinforced by contrast the privilege and authority of

documentary photography's largely middle-class viewers—"their" poverty underscores "our" well-being; "their" lack of agency highlights "our" social power. Critics have often placed Weegee within the documentary canon, and his photographs do contain certain elemental features of conventional documentary practice. For instance, Weegee's late-night flash and infrared photographs of people sleeping on park benches and fire escapes recall the work of Jacob Riis, the turn-of-the-century reformer, often considered the inventor of modern documentary, who routinely burst uninvited into crowded tenements in the middle of the night with a police escort to snap photographs of startled, sleepy-eyed immigrants. Like Riis, Weegee often captures his subjects unawares, exposing their private, intimate acts for public scrutiny. Furthermore, his images of suspected criminals exiting the "pie wagon" or entering the police station double as mug shots, participating in the creation of what Allan Sekula calls a "shadow archive" of deviant "types," a process that recalls the use of documentary photography by late nineteenth-century sociologists and criminologists.[47]

In addition to echoing the logic of turn-of-the-century reformist photography, *Naked City* also draws on the visual rhetoric of 1930s FSA documentary, which invoked photography's "truth effect" to induce a liberal, sentimental response from middle-class audiences to pictures of privation and resilience. Weegee himself stressed the emotive nature of his approach, both in his well-known image of a mother and daughter crying as they watch a burning building, which he captioned "I cried when I took this picture," and in his advice to novice photographers in the last section of *Naked City*: "When you find yourself beginning to feel a bond with the people you photograph, when you laugh and cry with their laughter and tears, you will know you are on the right track."[48] Weegee's affinity with the New Deal documentary tradition is further evident in his work for the liberal tabloid *PM*, the editor of which, William McCleery, wrote the foreword to *Naked City*, underscoring Weegee's "love for the city and her children—especially the troubled and unfortunate ones."[49]

However, even as Weegee's photography invokes the protocols of established documentary practice, his work also suggests the inadequacy of documentary realism as a mode of rendering the urban "real." In particular, the tabloid dynamics of Weegee's enterprise—his emphasis on photographic spontaneity, the aggressive nature of his gaze, and his focus on catastrophe—disturb both liberal documentary's sentimental humanism and the conventions of realist clarity and legibility that traditionally give documentary realism its authority. For instance, Weegee's disaster photos, shot in the

frenzied aftermath of gruesome accidents or crimes, are often off-kilter and compositionally confusing. Many of his images, such as "Their First Murder" (figure 1.3), which depicts a group of children and two women reacting to the sight of a murder victim lying on the street, capture congeries of shocked or agonized witnesses to frightful events whose diverse, even bizarre response to both the scene and the photographer endow these images with a chaotic, frenetic feel. Here, the awkward gestures and wildly contrasting expressions create a scene that disorients as it documents. The jostling crowd, pouring out past the edges of the frame, disrupts compositional order and clarity, undermining conventional documentary notions of compositional balance and pictorial intelligibility.

Engineered for the tabloid reader's impatient eye, Weegee's photography makes a spectacle of urban culture, sensationalizing it by underscoring its crime and its comedy, its theatrical glamour as well as its grotesque vulgarity. The intrusive, even predatory, quality of his work, which often captures his subjects in moments of acute agony or pain, is remarkably hard-boiled, seemingly devoid of affect or compassion. And, unlike FSA photography, his images of urban destitution, despair, and disaster generally do not make demands for active intervention or involvement. Rather than a view of the city that calls for middle-class reform, Weegee's Gotham is a frenzy of fascinating sights, a spectacle that exposes—and advances—the voyeurism at the heart of the documentary impulse to "expose" "foreign" territory. However, the frequently invasive, seemingly indifferent quality of Weegee's eye is itself complicated by his persistent populism, his presentation of a city stratified by class difference and his unabashed identification with the plebeian populace. Rather than exoticizing the urban scene from a distance, Weegee identifies with the very people he objectifies, his own art mirroring their fascination with looking at the bizarre and unseemly. Relative to the metropolitan people he photographs, Weegee is both outsider and insider, both a privileged onlooker and a member of the crowd. As Miles Orvell has suggested, Weegee's photography represents both the very entertainment that the crowd, as the audience of mass culture, craves and a record of the crowd's pleasures in having its desires fulfilled.[50] Thus, unlike conventional documentary, which brings images of the underprivileged back to the privileged, Weegee's images position the urban proletariat as both subject and imagined audience.

Weegee's identification with his photographic subjects was quite likely a function of his own existence on New York's social fringes. Born in Austria, Weegee (né Arthur Fellig) immigrated to the United States at the age of

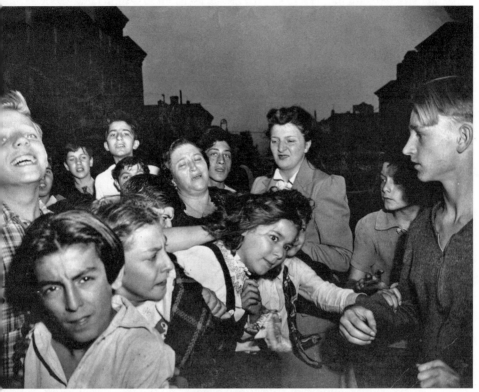

Figure 1.3. Weegee, "Their First Murder," 1941. Courtesy of Getty Images.

eleven, left his parents at the age of fifteen, and spent most of the next ten years sleeping in New York flophouses, earning a meager living as an itinerant street photographer and as a darkroom assistant at several news services. Even after becoming a successful freelancer, Weegee often slept in his car (the first civilian automobile to be equipped with a radio that received police and fire department transmissions) or in a news service "shack" behind a police station, awaiting news of urban emergencies he could photograph.[51] As one who spent most of his waking and working hours prowling New York's late-night streets looking for disaster and conflict, Weegee was, in many ways, one of the nocturnal loners he spent his professional life photographing.

In addition to adopting the sensationalistic quality of the tabloids, Weegee's photographs echo the eerie darkness of European expressionism. His use of a blinding flash to eliminate grays and middle distances endows his images with hard shadows and an excess of black, empty space, mimicking film noir and further compromising documentary transparency. The swaths of impenetrable darkness in many of his images raise the possibility that photography obscures or buries as much as it illuminates. In addition, his style of framing tends to foreground the difficulties of achieving clarity. Frequently, the subject of an image is isolated within an oversized field of black, socially decontextualized, or, in contrast, tangential elements flood the edges of a shot, distracting from the central focus of a photograph, suggesting the hopelessly overdetermined quality of a scene, the inability of a single photographic shot to capture adequately the immensely complex narratives of urban existence.

The uncanny formal dynamics of his images lend much of his work an incipient avant-garde quality. Reproducing what critic J. Hoberman calls the tabloid's "aesthetic of shock, raw sensation [and] . . . blunt, 'vulgar' stylization," many of Weegee's pictures, filled with "the jarring perspectives, arbitrary framing, and bizarrely frozen gestures that his successors have turned into formal tropes," possess what André Breton called a "convulsive beauty," an unsettling, even agonizing, appeal that refutes quiet contemplation.[52] Yet if Weegee's work might be said to contain proto-surrealist or Dada-esque elements, his is an inadvertent, vernacular modernism, an unorthodox aesthetic of commercial urgency, the formal innovations and violations of which derived from the deadline-driven circumstances of tabloid labor.

An unstable amalgam of multiple impulses and styles, Weegee's photography is at once regulatory and irreverent, sensational and sentimental,

cruel and compassionate. We can see the convergence of these conflicting elements in one of his most celebrated images, "Heat Spell, May 23, 1941," a photograph that depicts eight children sleeping on a tenement fire escape (figure 1.4). "Heat Spell" contains the traces of at least three representational modes. First, by surreptitiously documenting the habits of the poor, recording their activities without their knowledge, the photograph enacts a Jacob Riis–like gesture of surveillance. Like Riis, Weegee seems to have "stolen" this image without the consent, or even knowledge, of his subjects, offering viewers a glimpse of lower-class life in which they do not have to confront the gazes of the persons being photographed. The potentially regulatory aspect of this image, however, is crosscut by a sentimental strain that encourages us to feel tenderly toward the young children, underscoring their innocence and vulnerability. As they so often appear in the discourse of liberal reform, children are offered as a synecdoche for the poor, representing the helplessness and dependency of an entire class. Yet this sentimental dimension is in turn complicated by the sensational presentation of the oldest girl's naked breast, an element of the image that encourages a sexual glance, inviting us to look — and perhaps be titillated — without the threat of having our glance returned. In sum, this image contains deeply conflicting impulses, aesthetic threads that both confirm and contradict documentary's twin tendencies toward sentiment and scrutiny.

For Weegee, the body was a primary mode of urban expression. His images focus on the agonies, distortions, and pleasures of bodies in urban settings: the twisted bodies of accident victims and blood-splashed corpses of murder victims, the grotesque performers at Sammy's Follies, the intertwined forms of lovers on beaches in the dark. As one critic notes, "Weegee's New York was purely a corporeal city."[53] But the bodies in Weegee's images constantly suggest the fundamental incapacity of the camera to capture the fullness of their existence. Frequently, these bodies are captured mid-gesture, partially obscured from view, or frozen in the midst of an awkward moment. His images emphasize the vulnerability of bodies, but also their plastic and pliable qualities. The complexity of his attitude toward the human form is indicated by his photograph of beach-goers at Coney Island (figure 1.5). On the one hand, the beach shot captures the bathing bodies in a highly exposed state, with very little clothing, which establishes a voyeuristic aspect to the image. On the other hand, however, bathers welcome the camera, waving and gesturing to the photographer. They participate in the shot, enhancing their immense physical (if not racial) diversity with a variety of hand movements and postures. Although they form an unoffi-

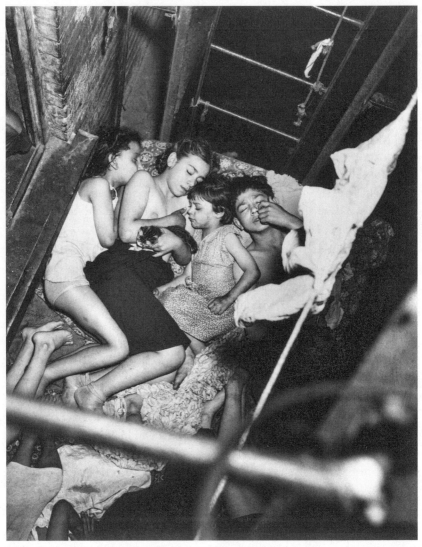

Figure 1.4. Weegee, "Heat Spell," 1941. Courtesy of Getty Images.

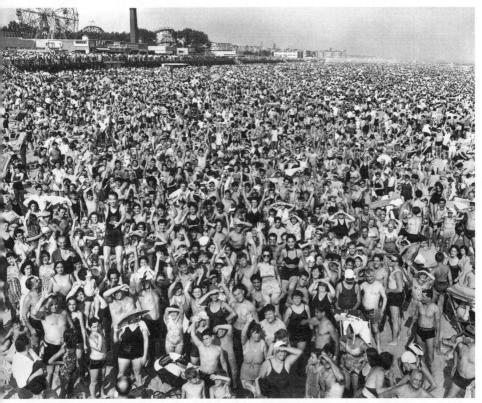

Figure 1.5. Weegee, "Crowd at Coney Island," 1940. Courtesy of Getty Images.

cial collective that seems to imply the potential for mass conformity, they also suggest the irreducible range of human difference and individuality, the impossibility of fully capturing that diversity on film or of marshaling those bodies in a single direction. Like the other proletarian bodies in Weegee's oeuvre, the beachgoers suggest the stubborn densities of human particularity that defy easy or complete categorization and control. Similarly, although many of Weegee's subjects are poor, they do not appear trapped by their poverty. They seem to handle the difficulties and even catastrophes of their lives with humor and intrepidity. They may be victims of fire and violence, but their reactions to catastrophe are unpredictable and widely varied. By and large, they are defined not by their status as sufferers, but by the nature of their diverse, and frequently creative, responses.

Weegee's hard-boiled, deadpan aesthetic vacillates between overblown emotional excess and stark emotional indifference. Although echoing some signature elements of established documentary practice and aesthetics, his approach refuses the careful "neutrality" that "impartial" photojournalists exuded or the "concerned objectivity" claimed by documentary reformers. Weegee thus works within and against dominant liberal modes of rendering the poor, challenging, even as he invokes, documentary's desire for legibility. The intense emotions that his subjects display—whether anger, pain, or love—suggest an excess and intensity that is deferred, never completely captured by the camera. Even as he earned his living recording the antics and agonies of the urban underworld, Weegee's images suggest the failure of definitively "documenting" the city's poor and outcast populations—they surpass and overrun his frames, crowding and spilling beyond the edges of his images, exhibiting an ultimately uncontainable subjectivity.

Broken Hands and Torn Mouths: Physical Damage, Class, and West's *Miss Lonelyhearts*

If Weegee's sensibility has a literary equivalent, it might be found in the work of Nathanael West. Like Weegee, West's style is marked by an uneasy blend of dark satire and sentiment, of savage humor and sincere empathy.[54] Also like Weegee, West was fascinated by outcasts and outsiders and drew inspiration for his art from mass culture, although, contrary to the photographer, West derided the culture industry as an engine of mystification even as he borrowed its motifs and styles. Unlike many radical writers of the 1930s, West was interested less in the problems of working-class labor than in mass consumer culture, which he called "the business of dreams."[55] His fiction blends biting irony, absurdist humor, and graphic depictions of

suffering in a unique brand of American surrealism that conveys both sympathy for the socially despised and a precocious critique of the culture industry's capacity to mold and commodify human desires.

West has been the subject of a great deal of critical attention in recent years, primarily due to his self-conscious adoption of mass media forms, which has prompted some scholars to identify him as a precocious anomaly among thirties writers, a figure who anticipates the sophisticated concerns and styles of a later era. Rita Barnard, for instance, identifies West and the poet Kenneth Fearing as incipient postmodernists, while Jonathan Veitch, in a rich examination of West's surrealism, likewise treats West as a nascent poststructuralist. West was "almost alone among his contemporaries," Veitch claims, in taking "representation as his subject."[56] While Barnard and Veitch isolate West, Michael Denning, in his expansive history of the Popular Front linking artists from a wide range of social locations, only gives West a passing glance, despite West's active involvement in 1930s progressive literary circles. In the work of all three of these critics, West is thus detached from his peers, treated as a special case whose strange and unique aesthetic seems incongruent with the work of his contemporaries.

While it is true that West's intricate, sophisticated experimentalism is unique, his work was not as anomalous as critics have made it appear. In fact, West's work shares many qualities with the other artists in this study: he draws extensively from the vocabularies and forms of mass culture to construct an innovative aesthetics of disorientation and shock, his novels are obsessed with physical irregularity and damage, and he is fascinated by persons inhabiting the social fringes. These elements coalesce in West's 1933 novel *Miss Lonelyhearts*, which chronicles the professional and personal crisis of a male newspaper advice columnist writing under a female pseudonym. Inspired by actual letters to the "Susan Chester" column of the *Brooklyn Eagle* that West had seen in 1929, the novel was drafted while West was working as the night manager at a New York hotel that catered to drifters and loners. As West biographer Jay Martin explains, during the early 1930s, West "concentrated his vision on the vagrant lives of the inarticulate and attempted to originate an art form whereby to express a new state of mass consciousness."[57] As West saw it, this new state of mass consciousness was characterized by loneliness and anomie, brought about by a consumer culture and an economy that promised but failed to deliver satisfaction and opportunities for self-advancement.

Faced with a world of pervasive suffering, Miss Lonelyhearts finds conventional forms of solace—religion, art, family—unsatisfactory. "If he

could only believe in Christ," he tells himself, "then everything would be simple."[58] But he does not. The world around him is saturated with forms of violence brought on as a defense against (or a reaction to) the misery and apparent emptiness of life. "In America," West wrote in the magazine *Contact*, which he edited in the early 1930s with William Carlos Williams (discussed in chapter 2), "violence is idiomatic."[59] *Miss Lonelyhearts* reflects this assessment. The novel is replete with images of injury and cruelty: one letter-writer describes being hit by a car and beaten by her husband, Miss Lonelyhearts and a friend abuse an elderly homeless man, and most of the acts of sexual contact are described in sadomasochistic terms. Shrike, Miss Lonelyhearts's editor, deflects the pain of such violence by maintaining a posture of unmitigated cynicism—"the dead-pan" (6)—and his moral indifference is appealing to the weary advice columnist. Yet Miss Lonelyhearts remains moved by the anguish he sees in the letters written to him. Although he initially takes his job as a joke, "after several months at it, the joke begins to escape him. He sees that the majority of letters are profoundly humble pleas for moral and spiritual advice, that they are inarticulate expressions of genuine suffering" (32). Here, as elsewhere, the novel displays compassion for the letter-writers even as it portrays them as pitiful and abject. Miss Lonelyhearts is horrified and repulsed by the people who write to him, yet also deeply stirred by them and their troubles, aware that their bad habits and pathetic conditions bespeak profound human torment. West's attitude is clearly indebted to Dada's dark irony, yet also informed by a developed sense of political justice and social compassion.

As several critics have argued, West's novel offers an incisive critique of the culture industry's role in the perpetuation of mass suffering. The novel describes consumer goods as "the paraphernalia of suffering" (30) and provides a searing depiction of mass culture's empty promises: "He saw a man who appeared to be on the verge of death stagger into a movie theater that was showing a picture called *Blonde Beauty*. He saw a ragged woman with an enormous goiter pick a love story magazine out of a garbage can and seem very excited by her find" (39). "Men have always fought misery with dreams," West writes on the same page. "Although dreams were once powerful, they have been made puerile by the movies, radio and newspapers. Among many betrayals, this one is the worst" (39). Yet even as West disparages the culture industry, he adopts mass cultural forms for his own artistic enterprise. The novel's plot, for instance, which centers on an extramarital sexual affair and a subsequent revenge murder, could have been lifted straight from pulp fiction. West himself famously referred to

Miss Lonelyhearts as "a novel in the form of a comic strip,"[60] and the novel seems to reject the notion that a solution to the social problems it portrays can be found *outside* the structures and languages of the commercialized, industrialized capitalist economy that is the root source of those problems in the first place.[61] Indeed, West's novel does not posit a "solution" to the situation it depicts; it merely offers a portrait of what has gone wrong.

While West's interrogation of the apparatus of mass consumption has been analyzed extensively, his deployment of motifs of physical damage to articulate a class-based critique of U.S. society has been overlooked. In the world West depicts in *Miss Lonelyhearts* emotional suffering almost always takes physical form. The problems plaguing poor and working-class people are inscribed on their bodies, which are hurt, deformed, or ill-shaped. The letter-writers, for instance, include a woman who has given birth to seven children in twelve years and is in "such pain I don't know what to do some-times" (2); a sixteen-year-old girl who "was born without a nose" and has "a big hole in the middle of my face that scares people even myself" (2); and Fay Doyle, who seduces Miss Lonelyhearts after writing him a letter and is described as a "big woman" with "legs like Indian clubs, breasts like balloons and a brow like a pigeon" (27). (It is worth noting that Fay repre-sents a version of Myrtle Wilson, the working-class woman whom the pro-fessional man finds both repulsive and alluring.) Fay's husband, Peter, who also writes a missive to Miss Lonelyhearts and who shoots him in the book's final, pulpy scene, is a "cripple" who "drag[s] one of his feet behind him in a box-shaped shoe with a four-inch sole" (44). Hobbling along, he looks like a "partially destroyed insect" (44).

The delineation of these physical ailments and abnormalities is designed to underscore the depth of the cultural and social problems the poor con-front in mass-mediated, Depression-era America, and reflects West's po-litical concern for the less fortunate. West hailed from a well-to-do family and was something of a dandy as a young man, but turned to the Left in the 1930s. He became friends with several progressive writers, includ-ing Edmund Wilson, Josephine Herbst, Mike Gold, William Carlos Wil-liams, John Dos Passos, and Dashiel Hammett, and signed the anticapital-ist American Writers' Congress statement, sponsored by the Communist Party, in 1935. Although he never joined the party, he was active in various affiliated organizations and initiatives. After moving to Hollywood to work as a screenwriter in 1935, for instance, he participated in the Screenwriters' Guild's drive for union recognition and joined the Communist-led Holly-wood Anti-Nazi League.

Although critics have noted West's political activities, they have tended to downplay both his commitment to progressive ideals and the class-based character of his politics. Jonathan Veitch, echoing Jay Martin, insists, "West was less interested in the masses than in the phenomenon of 'mass man.'"[62] On the whole, this may be true, yet in *Miss Lonelyhearts* these two categories—the (working-class) masses and mass man—converge: the text's critique of mass culture runs hand-in-glove with its subtle, yet persistent exposure of the economic basis of mass suffering. While the novel does not trace disfiguration directly to the demands and dangers of labor, as does Pietro di Donato's *Christ in Concrete*, for instance (see chapter 5), it does link physical injury and abnormality to poverty, suggesting that the pressures and circumstances of deprivation are figuratively and physically debilitating, even disabling. This connection is underscored in the letter to Miss Lonelyhearts written by the "cripple" Peter Doyle, who works for a gas company. Doyle frames his despair in explicitly class-coded terms, contrasting his own physical impairment to the material luxuries available to his corporate superiors: *"What I want to no [sic] is why I go around pulling my leg up and down stairs reading meters for the gas company for a stinking $22.50 per while the bosses ride around in swell cars living off the fat of the land"* (46, italics in original). Fay's marriage to Peter was itself driven by economic hardship: as a young, working-class woman, she turned to him after getting pregnant by another man, who left her when she was unable to afford an abortion. Elsewhere, the novel links sensational images of violence and distortion not only to the deceptions of mass culture, but also to urban poverty. Driving through the "Bronx slums" (38) on his way back from rural Connecticut with his (soon to be ex-) fiancée, Miss Lonelyhearts sees "crowds of people mov[ing] through the street with a dream-like violence. As he look[s] at their broken hands and torn mouths he [is] overwhelmed by his desire to help them" (38–39). Here, as elsewhere, social inequality and psychic pain are given physical form, as the degraded conditions of slum living are embodied by the Bronx residents' "broken hands and torn mouths."

Yet despite its interest in the dispossessed and their afflictions, *Miss Lonelyhearts* is by no means a proletarian novel. The protagonist is, after all, a professional middle-class figure, and, despite the book's emphasis on class divisions, it does not hold out any hope for working-class unity or organization (in a letter to Edmund Wilson, West stated, "There is nothing to root for in my books, and what is even worse, no rooters").[63] Rather, like other examples of sensational modernism, the novel addresses a key documentary concern of the 1930s: how can people in positions of relative power

and privilege learn about, understand, and relate to the growing number of Americans who have been left out and left behind? This documentary impulse—alive in Miss Lonelyhearts's ethnographic (and sexual) encounter with the Doyles—is, I have suggested, central to sensational modernism. Much like William Carlos Williams (chapter 2) and James Agee (chapter 4), who considered themselves intrusive voyeurs in the lives of the poor people about whom they write, West referred to himself as a "lonely spy."[64] (And like Agee's documentary and Williams's doctor stories, West's novel allegorizes the crisis of detachment suffered by many professional documenters and chroniclers who set out to investigate the lives of the Depression-era destitute.) Jay Martin argues that West held himself at a remove from the people and world around him, feeling himself to be "above emotional displays, 'outside' social life."[65] Yet this sense of distance was countered by a genuine empathy for the isolation or despair of others, "an extraordinary capacity for emotional involvement."[66] This balance between estrangement and empathy, shock and solidarity, lies at the heart of sensational modernism, as artists similar to West in social position and political temperament invented experimental forms of representation to offer unconventional, often unsettling, depictions of the poor that challenged early twentieth-century tendencies to romanticize, demean, or disregard them.

Labor, Violence, and Disorientation: Meridel Le Sueur's "I Was Marching"

Sensational modernists frequently use images of maimed bodies and torn limbs in an attempt to evoke the pain, hunger, and violence of industrial existence from the point of view of socially oppressed and marginalized persons. Many of the texts in this project agree, explicitly or implicitly, with James Agee's assertion that a hunk of human flesh is more appropriate for conveying pain and exploitation than a volume of writing. "If I could do it, I'd do no writing here at all," Agee asserts early in *Let Us Now Praise Famous Men*. "A piece of the body torn out by the roots might be more to the point."[67] Agee's comment is provocative not only because it expresses a desire to move beyond writing, to surpass or exceed textuality, but also because it suggests that to render the body would be to tear it. Agee implies that to offer the body up as the sign itself would require an act of violence and would also inevitably be a partial gesture—only a "piece" could be "torn out." Like Agee, sensational modernists not only invoke images of disfigured proletarian bodies, but also link the depictions of such bodies to problems and possibilities in linguistic and visual expression. Indeed, these

texts are united by images of bodies employed as emblems of aesthetic crisis and formal experimentation, a pattern whereby the wounding of bodies signals the rupture and deformation of expressive conventions and the deformation of established rhetorical patterns and protocols.

This link between formal disruption and injured or incapacitated bodies is made powerfully in a short story by the radical writer and activist Meridel Le Sueur, "I Was Marching," which recounts the tale of a well-to-do woman who joins a local strike. The narrator opens the story by arguing that for socially privileged persons, language obscures rather than clarifies the material events of daily life. "If you come from the middle class," she insists, "words are likely to mean more than an event. You are likely to think about a thing, and the happening will be the size of a pin point and the words around the happening very large, distorting it queerly."[68] The narrator argues that middle-class persons tend to aestheticize experience, treating events as substance for abstract, linguistic reflection rather than phenomena in and of themselves, out of which meaning arises during the course of action. "When you are in the event," she explains, "you are likely to have a distinctly individualistic attitude, to be only partly there, and to care more for the happening afterwards than when it is happening" (158). As the story proceeds, however, the narrator's escalating engagement with the strike, ignited by unsettling confrontations with injured strikers, challenges her capacity to extract herself and her understanding of events from their immediate, material context.

Initially, the narrator is hesitant to enter the strike headquarters for fear of "losing herself, of being unknown and lost" (159). "After all," as someone not directly engaged in the strike, "I could remain a spectator" (159). But as she watches, and witnesses the wounding of several strikers, the narrator undergoes a transformation that alters the way she inhabits her own body as well as the manner in which she perceives what occurs both to her and around her. Observing the strike, the narrator sees "muffled violence" splash "into the open": "whole men suddenly spouting blood and running like living sieves, another holding a dangling arm shot squarely off, a tall youngster, running, tripping over his intestines, and one block away, in the burning sun, gay women shopping and a window dresser trying to decide whether to put green or red voile on a manikin" (159). What is noteworthy here is not only the eruption of violence, which disrupts the narrator's passive and detached spectatorship, but also the way in which violence foregrounds cultural contradictions: the spouting blood adjacent to the oblivious shoppers exposes the way in which proletarian pain is obscured by, but

also linked to, consumer culture, which obfuscates the connections between labor and commodities. For the narrator, the explosion of conflict and bodily harm—in particular, the sight of the "dangling arm"—forces her to recognize her own complicity in the events. "In these terrible happenings," she states, "you cannot be neutral now" (159). The next day, "with sweat breaking out on my body" (159), she enters the strike support center.

The narrator's induction into the union headquarters, where she works pouring coffee and tending to injured picketers, is described as a version of what Fredric Jameson calls dereification, a process of cognitive unlearning and readjustment in which the analytic fragmentation that dominates modern experience is interrupted as new ways of seeing arise.[69] The initial sight of the strikers' collectivity—which the narrator characterizes as their "close and glowing cohesion like a powerful conflagration" (159)—unsettles her, engendering a sense of deep disorientation: "I knew my feelings to be those belonging to disruption, chaos, and disintegration" (159). Then, for a second time in the story, the sight of an injury sparks a crisis, compounding her feelings of cognitive confusion: "Something broke all my surfaces in something that was beyond horror and I was dabbing alcohol on the gaping wounds that buckshot makes, hanging open like crying mouths" (162). The notion of "surfaces breaking" suggests a cubistlike explosion of traditional vision, a new conception of reality emerging in the midst of social crisis and collective action. The sight and feel of the agony and conflict that surround her constitute a painful challenge to her established manner of perceiving the world. "My eyes burn," she states. "I can hardly see" (163). Indeed, she appears unable to assimilate the frenzied swirl of activity that engulfs her: "No matter how many times I looked at what was happening I hardly knew what I saw" (163). The new sense of reality that emerges as her earlier spectatorial attitude dissolves—a shift prompted by the sight of the "dangling arm" and extended by the confrontation with the "gaping wounds"—is itself experienced as a physical sensation, a corporeal orientation (the immediacy of which is underscored by a brief shift to the present tense): "I have the brightest, most physical feeling with every sense sharpened peculiarly. The movements, the masses that I see and feel I have never known before. I only know part of what I am seeing, feeling, but I feel it is the real body and gesture of a future vitality" (163). "If you are to understand it," she insists, "you must understand it in the muscular event" (162). As the story concludes, the strikers take to the street in a massive demonstration. Although she initially hesitates to join the crowd, "not knowing if I could march" (164), she is soon swept into the mass as her body bends

to a collective rhythm: "I was marching with a million hands, movements, faces, and my own movement was repeating again and again, making a new movement from these many gestures, the walking, falling back, the open mouth crying, the nostrils stretched apart, the raised hand, the blow falling, and the outstretched hand drawing me in. . . . I was marching" (165). For Le Sueur's narrator, joining the collective requires new ways of thinking and seeing ("surfaces breaking") as well as "new movement[s]," new motions, an orientation experienced "in the muscular event."

The narrative stages that Le Sueur's short story maps—the sensational shock of the torn limb, the cognitive dissonance and disorientation stemming from that shock (what the narrator describes as "disruption, chaos, and disintegration") which overturns spectatorial distance, and the emergence of solidarity between the narrator and collective—constitute some of the central narrative and ideological movements and moments that the texts in *Sensational Modernism* chart. In Le Sueur's story, modernism's explosion of perspective and rhetorical experimentation stem not from a retreat from the social world into the depths of interior consciousness, but from an agonized engagement with the social world and its most pitched conflicts. The avant-garde shattering of the narrator's point of view is a product of being drawn violently—and physically—into the frenzy of political action, an induction that calls into question the stance of detachment and indifference toward social strife that her privilege had previously afforded her. For Le Sueur, as for other sensational modernists, the sensational represents a discourse of shock and contrast through which the cultural and class contradictions of the material world can be expressed in experimental discursive forms.

Figuring the Stump of a Man:
Dalton Trumbo's *Johnny Got His Gun*

As Weegee's photography, West's novel, and Le Sueur's story indicate, violence suffuses sensational modernism. Perhaps the most acute depiction of bodily violence in the countertradition examined in this study appears in Dalton Trumbo's 1939 pacifist novel, *Johnny Got His Gun*.[70] A ferociously chilling narrative of physical harm, Trumbo's novel recounts the story of Joe Bonham, a World War I soldier who awakens in a hospital to discover that a bomb has destroyed his nose, eyes, ears, arms, and legs. He is alive, but his corporeal integrity has been obliterated: "He was nothing but a piece of meat like the chunks of cartilage old Prof Vogel used to have in [high school] biology" (63), nothing but "raw material" (82), "a side of beef" (109), a

"stump of a man" (162), "something you can't plow under . . . something that will never grow and flower . . . something less than manure because it won't die and decay and nourish even a weed" (226–27). He is a figure of pure abjection, a coagulation of raw tissue, shredded muscle, and shattered bone. His identity as a recognizable human being has been radically compromised. He occupies a liminal no-man's-land between the world of the living and the dead: "He was the nearest thing to a dead man on earth" (117). "I am," he explains, "the dead-man-who-is-alive. I am the live-man-who-is-dead" (226). In such a condition, the possibility of "oblivion" (100) provides an ironic sense of relief: "Maybe nothing was real not even himself oh god wouldn't that be wonderful" (100).

The novel's relentless focus on Joe's shattered flesh is highlighted through intermittent flashbacks depicting the seminal experiences of Joe's formerly healthy body, such as sex with the woman he loved, fishing with his father, working in the heat, and bringing hamburgers home on Saturday night to share with his parents: "The hamburger man would put the sandwiches in a bag and he would put the bag inside his shirt next to his body. Then he would run all the way home . . . through the sharp autumn nights feeling the heat of the hamburgers next to his stomach" (17). The images of physical unity and pleasure, available only through the fragments of fleeting memories, accentuate by contrast the inescapable horror of Joe's present deformation.

Trumbo's evocation of the wounded body forms part of a sustained attack on the power of abstract words: "I'm not a fool," Joe insists, "and when I swap my life for liberty I've got to know in advance what liberty is and whose idea of liberty we're talking about and just how much of that liberty we're going to have" (111). Describing the war as an effort to "make the world safe for words without meaning" (116), the novel rails against the emptiness of the grand terms that form the nation's ideological lexicon — "democracy," "liberty," "freedom," "decency." "You take the words," Joe says at the height of his diatribe against war. "Give me back my life" (118).

The novel itself follows the trajectory of Joe's effort to find a language for communicating with the world, no easy task given his lack of mouth and arms. Eventually, he learns to tap Morse code with his head, a signal initially interpreted by doctors as spasms (for which he is drugged), but which is eventually recognized by a nurse, raising Joe's hope that he can convey to others his unique perspective as one inhabiting the interstices of life and death. "He would tell them everything," he thinks to himself. "He would speak from the dead. He would speak for the dead. He would tell all

the secrets of the dead" (216). But the hospital staff is not interested in Joe's ethical message, and dopes him again rather than "listen" to his frantic tapping. Unable to communicate his thoughts—or unable at least to find an audience willing to listen—Joe imagines himself at the novel's end traveling the countryside in a glass case as a spectacular, public testimony to the terrors of war. He envisions circling the United States like a horrifyingly serious circus act, "to show it to people so they could see the difference between a war that's in newspaper headlines and liberty loan drives and a war that is fought out lonesomely in the mud somewhere a war between man and a high explosive shell" (224). He "would concentrate the whole war into such a small piece of meat and bone and hair that they would never forget it as long as they lived" (225). Joe's imagined exhibit—like the novel as a whole—is an attempt to shatter our "frame of reference," to pierce complacency and indifference and explode hegemonic narratives that would marginalize and dematerialize Joe's experience by transforming his harrowing pain into abstract statistics, empty rituals, or hollow phrases.[71] The novel's attempt to rupture the conventional frames in which war is conceived and justified—as, for example, a gallant contest to protect abstract notions of democracy and decency—is mirrored by Joe's ruptured body. Ideological rupture parallels corporeal fracture: the figure of Joe's body, so damaged that it complicates the boundaries of life and death (the distinction between being "human" and being a mere amalgamation of tissue) is a material figure for the novel's disruption of patriotic discourse and military abstraction.

If Trumbo's novel is an explicit attack on prevailing ideologies of military logic, it is also an implicit assault on the aesthetic modernism of artists such as Ernest Hemingway, who compares his own prose to the highly aestheticized violence of such "manly" sports as bullfighting, hunting, and fishing.[72] What marks the excellence of Hemingway's prose, as his writing itself implies, is its ability to order and contain the violence it depicts. In *The Sun Also Rises* (1926), the figure for such mastery is Romero, whose smooth, youthful body faces danger with poise and elegance: "Romero's bull-fighting gave real emotion, because he kept the absolute purity of line in his movements and always calmly let the horns pass him close each time. He did not have to emphasize their closeness. . . . Romero had the old thing, the holding the purity of line through the maximum of exposure, while he dominated the bull by making him realize he was unattainable, while he prepared him for the killing."[73] A model for Hemingway's writing, Romero's style dominates death and violence through aesthetic "purity," recontaining the threat of bodily injury through flawlessly executed technique. In con-

trast, Trumbo's writing exposes precisely what Hemingway's sublimates — the terror and destructiveness of violence, the impossibility of truly assimilating pain and harm. Unlike Hemingway's clipped, terse writing, Trumbo's prose is a frantic rush, "almost without pause or punctuation," as a reviewer for the *New York Times* noted. The fury that underwrites Trumbo's novel bursts through the narrative in flights of caustic sarcasm, vicious outbursts, and nightmarish dream sequences, puncturing any potential pretensions to grace or economy. *Johnny Got His Gun* refuses, in fact repudiates, the logic of masculine, aesthetic heroism to which Hemingway's writing aspires — the organic grace of the bullfighter, the quiet skill of the master fly-fisher, the deadly precision of the big-game hunter. In contrast, Trumbo renders Joe's predicament in a rhetoric of debilitating abjection:

> I can't. I can't stand it. Scream. Move. Shake something. Make a noise any noise. I can't stand it. Oh no no no no.
>
>
>
> I can't breathe but I'm breathing. I'm so scared I can't think but I'm thinking. Oh please please no. No no. It isn't me. Help me. It can't be me. Not me. No no no. (64)

A form of writing akin to what Shoshana Felman calls testimony, Trumbo's breakage of conventional syntax echoes the breakage of Joe's body and Joe's consciousness, which has lost its sensory moorings. Felman contends that testimony — the recounting of traumatic events — is an inevitably fractured form of discourse that defies traditional understanding. "As a relation to events," Felman writes, "testimony seems to be composed of bits and pieces of a memory that has been overwhelmed by occurrences that have not settled into understanding or remembrance, acts that cannot be constructed as knowledge or assimilated into full cognition, events in excess of our frames of reference."[74] Trumbo's prose in the passage above is no more than "bits and pieces." Its fragmentary form and short, breathless particles of speech convey desperation, a lack of control, and the inability to make cognitive and aesthetic "sense" of pain and injury. This cognitive disorder echoes the larger political disorder that Joe's presence represents to the ideology of warfare and national unity. Similar to the manner in which other disabled bodies disturb the assumptions of personal and political autonomy on which liberal capitalist democracy depends, Joe's deformed body — a body entirely at the mercy of external forces, unable to express or represent its own will or desires, without any functional autonomy or integrity — mocks the compliant, standardized, efficient body of the modern soldier and offers an implicit

rebuke to the discourses of individual liberty, democratic choice, and self-determination in the name of which American war is waged.[75]

The Aesthetics of Disfigurement

Each of the texts discussed above presents central aspects of the aesthetic project this book explores: Weegee's *Naked City* deploys a deadpan eye to survey social contrast and disaster; West's novel stages the convergence of physical disfiguration, class division, and social violence; Le Sueur's "I Was Marching" illustrates the trajectory of shock and disorientation that sensational modernists suggest is engendered by middle-class engagement with the poor; Trumbo's *Johnny Got His Gun* highlights the insurgent modernist poetics and focus on bodily harm. Despite their substantial differences, all four texts foreground damaged or distorted bodies. By way of concluding this chapter, and laying the ground for the chapters that follow, I want to address the political and cultural significance of the disfigured bodies around which sensational modernist texts characteristically revolve.

"In the modern period," the cultural historian Tim Armstrong states, "the body is re-energized, re-formed, subject to new modes of production, representation, and commodification."[76] In both the realm of consumption and the realm of production, modern corporations aspired to produce what Armstrong calls "capitalism's fantasy of the perfect body."[77] Through commodity culture, modern capitalism offered consumers a body enhanced to perfection through cosmetics, fashion, cosmetic surgery, and exercise. In the sphere of material production, capitalist culture sought to engineer what Michel Foucault calls "docile-productive" bodies, perfectly proletarianized bodies that functioned, under subtle and pervasive regimes of observation and control, as efficient machines.[78] In the novels, stories, and photographs that this book examines, the sensational trope of the disfigured body not only disrupts both sympathy and scrutiny but also upsets capitalist ideologies of bodily perfection and bodily docility, illustrating the violence inherent in forms of corporeal discipline as well as the often subtle forms of resistance subjugated bodies offer to regimes of control and power, the refusal of bodies to function as stable objects of inspection, to adequately or fully "represent" the persons to whom they belong. If sympathy and scrutiny insist and depend on the representational "fullness" of the body, the bodies in sensational modernism suggest the irreducibility of the human form to complete representation.

Traditionally, the body has symbolized the unity of the social world, the wholeness of the individual body serving as a figure for social and politi-

cal totality. In contrast, the images of deformed and wounded bodies in this project, which I contended in the introduction can be found throughout 1930s culture, suggest the constitutionally ruptured quality of the social world, the impossibility of social "unity," given the uneven patterns of dominance and submission that structure the modern political landscape, as well as the specific forms of cultural confusion, crisis, and conflict brought on by the Great Depression. The disfigured bodies in this project—bodies distorted by racial stereotypes, misshapen by disease, injured by industrial accidents—represent what Paul Gilroy calls "willfully damaged signs" that call into question established modes of representation, that challenge (often unsuccessfully or incompletely) the hegemonic narratives through which the lives of modernity's dispossessed and working populations are conventionally rendered, revealing "the hidden internal fissures in the concept of modernity" and drawing our attention to the pain, subjugation, and violence through which "progress" is achieved.[79] As is illustrated by Weegee's unflinching photographs of bloodied bodies, West's story of wounded and "crippled" advice-seekers, Le Sueur's evocation of gaping wounds, and Trumbo's horrifying depiction of a human "stump," the texts this project analyzes are preoccupied with pain and injury. Modernity appears in these texts as a "state of emergency," in Walter Benjamin's words, an extended compilation of "wreckage upon wreckage" in which the advance of civilization is achieved through human destruction.[80] Figures of hunger, harm, and hyperbolic racial stereotype, these sensational bodies challenge the pleasure or inverse affirmation that looking at the poor often affords the privileged—what James Agee refers to as "the laughter and tears inherent in poverty viewed at a distance."[81]

The disfigurements of the bodies represented in these texts echo the various forms of rhetorical experimentation that mark these sensational texts as modernist. The range of bodies—from William Carlos Williams's ill and naked ethnic workers to Tillie Olsen's scalded factory workers to Richard Wright's overblown stereotypes of African Americans—mirrors the range of formal innovation—from Williams's cognitive and rhetorical reversals to Olsen's anticapitalist surrealism to Wright's existential, pulp-inflected naturalism. These species of semantic experimentation borrow but also differ from canonical high modernism, which has conventionally been defined by its distance from and hostility to the social world. Several critics have contended that elite modernists "dislocated the primary site of subjectivity from the realms of politics and everyday life to that of highly stylized literary works," "bracketing off the real social world" and imaginatively iso-

lating themselves in an "impermeable space" of psychological depth and interiority.[82] However, such conservative forms of aesthetic modernism represent only one manifestation of the diverse range of modernist art. As Sara Blair has recently argued, a wide variety of artists adopted canonical modernist devices for an array of aesthetic and political purposes: the "vaunted energy, formal experimentation, and psychic shock of modernist texts . . . were hardly the sole property of culturally conservative writers, nor were their effects limited to the familiar circles associated with those figures."[83] Writers inhabiting a multiplicity of positions and contexts, Blair asserts, adopted modernism's signature techniques "for the expression of varied responses to modernity, and various political and social claims on its realities."[84] If high modernism is typically dominated by an ironic distance from the social world at large and other persons in particular, the various modernisms in this project endeavor—with varying degrees of success—to bridge such distance, to employ broken syntax and narrative fragmentation to convey social as well as individual pain, and to challenge high modernism's aesthetics of disembodiment, its aspiration to achieve what critic Quentin Anderson calls "secular transcendence."[85] For the artists in this study, the modernist sensibility stems not from the cultivation of social distance but from various forms of social engagement. For middle-class professional artists like William Carlos Williams and Aaron Siskind, modernism's shock comes from unsettling encounters with impoverished immigrants and ghetto residents whose destitution, racial difference, and/ or resistance to the inquiring eye spark not only hesitation and confusion but also new and emerging forms of self-awareness. For working-class and ethnically or racially marked artists like Tillie Olsen, Pietro di Donato, and Richard Wright, modernism constitutes an effort to register not the shock of the strange but the traumas of everyday existence, not the return of the repressed but daily struggles against poverty and prejudice.

In closing, let me note that despite my emphasis on the ways in which the sensational bodies in these modernist texts frequently destabilize rhetorical forms of surveillance and control, it is important to insist that sensational modernism is by no means a solely or even predominately "subversive" aesthetic force. Although the representation of disfigured bodies generates forms of cognitive dissonance and disorientation, typically disturbing what James Baldwin calls "the eye of persecution," these works at times also reformulate the very aesthetics of objectification they at first overturn. William Carlos Williams's short fiction deploys an objectifying medical gaze even as his tales question its validity; Aaron Siskind's images skirt a fine

line between undermining and reinforcing racial stereotypes; the narrator of Tillie Olsen's *Yonnondio* longs for the very aesthetic transcendence that she condemns; Richard Wright's depiction of Bigger evokes the brutalizing language of scientific naturalism even as he searches for a nonobjectifying discourse with which to render his protagonist. As a cultural formation, sensational modernism is neither inherently subversive nor hegemonic, neither oppositional nor dominant; rather, it is an emergent form of experimental aesthetics in which a range of dissident or "minor" modernists explore the vicissitudes of modern embodiment, vision, and rhetorical power.[86]

2

SENSATIONAL CONTACT
WILLIAM CARLOS WILLIAMS'S SHORT FICTION AND THE BODIES OF NEW IMMIGRANTS

In an interview, William Carlos Williams once remarked that the distinctly "American" language that forms the basis of his particular brand of indigenous modernism springs, paradoxically, "from the mouths of Polish mothers."[1] Williams's remark highlights the importance of ethnic and other socially marginalized figures to his writing, underscoring the fact that immigrants, African Americans, the poor, and the diseased not only pervade his oeuvre but also serve as crucial metaphors though which Williams imagined his own artistic identity and practice.[2] The ambiguous place that subaltern subjects occupy in Williams's work is captured vividly in his well-known poem "To Elsie."[3] Originally written as a segment of *Spring and All* (1923), "To Elsie" articulates many of canonical modernism's central social and ideological concerns. The poem describes the modern world as a waste land, a domain of fragmented social relations in which the proverbial center cannot hold. The scene the poet describes is undoubtedly a familiar one to readers of modernist literature. Organic, firmly rooted customs and communities ("peasant traditions" and "old names") have given way to promiscuity and aimlessness. All that is stable, authentic, and essential seems to have been superseded by rootlessness, fleeting and demeaning social encounters, and a tumultuous ocean of tacky consumer goods. Domesticity has been replaced by "lust for adventure," sexual restraint and intimacy by "numbed terror / under some hedge of choke-cherry." Moral and physical integrity have given

way to "filth," "excrement," and easy sex. In short, what was "pure" has gone "crazy."

However, the poem is not simply a lament for an earlier era, a simpler and more wholesome time. The poet recognizes the impossibility of rolling back history, of returning to a premodern world. Furthermore, the poem offers no substantial signs of regeneration or optimism for the renewal of what has been outstripped and left behind. "To Elsie" does offers signs of hope—deer gliding "by fields of goldenrod," "isolate flecks"—but these are merely glimpses, fleeting and opaque, which do not pose fully fledged alternatives to the comprehensive and seemingly inevitable social collapse the poem describes. The world that the poet depicts offers little resistance to the ills that he sees sweeping the landscape.

Elsie, the foster child turned doctor's maid, personifies the poet's ambivalence toward the modern world. On the one hand, she literally and figuratively embodies his anxieties. Her bloated body—"ungainly hips and flopping breasts"—gives physical form to the social and psychological decay the poet decries. A racial "half-breed" ("with a dash of Indian blood") raised in a state home, Elsie incarnates the lack of social authority and interpersonal connection that characterize the modern world as a whole. In addition, although Elsie is the central, indeed the only, individual in the poem, she does not speak; the poet speaks for her, summing her up in a brief, presumptive gesture. She is brushed past, generalized ("some Elsie"), described as a case who exemplifies a trend, rather than a complex individual or a fully fledged subject in her own right. The poet limits the ease with which we might identify with her; she is decidedly Other, alien, someone to be viewed. The poet's gaze is cold, cutting, cruel—he strips her naked before our eyes, exposing her breasts and hips, as if under a harsh, direct light. She is a symbolic specimen, an object of contemplation, and his objectification of her body suggests that he views her with at least as much disdain as empathy.

However, the derision and scorn that the poet directs toward Elsie is complicated by his identification and fascination with her. For instance, even as the poet treats Elsie so severely, he claims that she expresses "the truth about us." Although she repulses the narrator, he writes the poem "to," not merely "about," her—she is not only the object of his gaze but also his interlocutor. The poet holds her at a distance and examines her with a callous look, but she shares his home and, he implies, his fate as well. As the representative figure of modernity's ills, Elsie also represents the hope for modernity's future. Furthermore, the poet's gaze suggests not only anxiety

and hostility, but also desire. His figurative stripping of Elsie expresses not just violence but also attraction and lust—she may be "broken," but she is also somehow, like Myrtle Wilson, "voluptuous." The poet seems to find her presence enervating—to the point of sexual excitement.

I have focused close attention on Williams's depiction of Elsie, and the gaze with which he examines her, because the poem crystallizes several vital elements of Williams's complicated and contradictory attitude toward the "new immigrants" who inhabited the urban neighborhoods of northern New Jersey where the Rutherford bard worked as a physician. In this chapter, I examine one of the understudied segments of Williams's work, his short stories, most of which were written and published during the 1930s, a decade when his poetic output declined significantly. I argue that these stories display both a pervasive anxiety about immigrant figures and a sense that, like Elsie, they may represent a "truth" that extends far beyond the bounds of class, ethnicity, and gender that separate Williams—and many of his likely readers—from the impoverished people about whom he writes.[4] To begin to understand the volatile dynamics of angst and identification, prejudice and compassion, disgust and desire that animate Williams's short fiction, it is worth briefly examining one of his paradigmatic tales, "The Use of Force," which appeared in his 1938 collection *Life along the Passaic River*.

Throat Culture

Like many of Williams's doctor stories, "The Use of Force" recounts a house visit to an immigrant, working-class family, in this case the Olsons. The parents ask the narrator to examine their daughter who is ill with what the doctor surmises is diphtheria. When the doctor first arrives, the parents appear apprehensive, "very nervous, eyeing me up and down distrustfully."[5] The daughter, however, is inscrutable: "She did not move and seemed, inwardly, quiet; an unusually attractive little thing, and as strong as a heifer in appearance" (131). The story's drama stems from the fact that the young girl refuses to allow the narrator to open her mouth and examine her throat. The doctor dismisses her resistance with claims of social necessity and proceeds to force open her jaw. "I had to do it," he states, "I had to have the throat culture for her own protection" (133). The narrator has the parents hold the girl down, while in a strong-willed "assault I overpowered the child's neck and jaw," uncovering her "secret," a membrane on her tonsils (135).

This brief, disturbing story foregrounds several dynamics that are at the heart of Williams's other tales. I want specifically to underscore two

of those elements. First, the young girl's resistance to the doctor turns the examination—in which the patient is expected to submit passively to the professional's probing—into a contest. The doctor-patient hierarchy is momentarily suspended as the two engage in a bitter struggle. The young girl's tenacity is remarkable—although the parents are nervous in the doctor's presence, she "was fairly eating me up with her cold, steady eyes" (131). As the narrator struggles to pry her mouth open, she offers spirited resistance. "Both her hands clawed instinctively for my eyes" (132). "In the ensuing struggle," the narrator notes, the parents "grew more abject, crushed, exhausted while she surely rose to magnificent heights of insane fury of effort" (132). The girl's resistance produces a complex reaction in the narrator: in addition to frustrating and angering him, the girl's "insane fury" also ignites the doctor's desire. Indeed, as the "battle" progresses he admits that he has "fallen in love with the savage brat" (133), a strange turn that recurs throughout Williams's fiction. Consistently, Williams's narrators find ethnic culture—typically embodied by female figures such as the Olson girl—profoundly enigmatic: fascinating, even arousing, yet opaque and resistant to his medical (and sexual) probing.

Second, the fervor with which the narrator pursues the throat culture encourages readers to question his approach. The narrator admits that visceral excitement—in this case both violent and lustful—clouds his professional judgment: "The worst of it was that I too had got beyond reason. I could have torn the child apart in my own fury and enjoyed it. It was a pleasure to attack her. My face was burning with it" (134). Although he justifies his assault with claims of "social necessity" (134), the narrator confesses that a baser motive, "a blind fury . . . a longing for muscular release" (135), impels him forward despite the girl's protests. In "The Use of Force," the exercise of medical expertise requires such an unsettling level of physical and emotional coercion that it encourages readers to question the validity of the narrator's medical strategy, which involves an aggressive, sexualized assault on the young girl's jaw (the throat culture, in short, is analogous to a rape). As a result, the legitimacy of the narrator's expertise is called into question and opened to criticism. The story thus exposes not only the patient—her illness, her fears, her stubbornness—but the doctor as well—*his* stubbornness, ferocity, and lechery.

In this chapter I argue that in his Depression-era short stories Williams employs, but also modifies, the logic of a modern medical gaze to imagine fictional forms of cross-cultural "contact" in which impoverished ethnically marked figures like Elsie and the Olsons might be depicted without being

subsumed or assimilated into self-confirming frames of reference. Williams's form of experimental realism constitutes an effort to write beyond the paradigms of scrutiny and sentiment, to imagine a new mode of portraying poor immigrants that traditionally stand as objects of pity, condescension, or derision in the eyes of culturally privileged authors and readers. Throughout, bodies, in particular the bodies of ill women, serve as metaphors for ethnic culture at large—that which resists clarification and representation, but is the point of "entry" for Williams's engagement with the immigrants.

Recent criticism of Williams's short fiction about ethnic figures has tended to follow one of two lines. One strain of commentary contends that the stories constitute an ideal "act of empathy," a democratic and pragmatic balance of Self and Other. Such criticism contends that Williams's tales of trans-ethnic and cross-class encounter model genuinely egalitarian forms of intersubjective understanding.[6] In contrast, the other critical tendency finds a debilitating, reductive primitivism in the stories' approach to ethnic culture, asserting that Williams's fiction presents the poor and oppressed as the passive objects of his voyeuristic and essentializing gaze.[7] In what follows, I contend that Williams's stories embody neither a fully reciprocal "empathy" nor a ruthless essentialism. Rather, I suggest that his fictions about the immigrant inhabitants of northern New Jersey are sensational, often lurid and violent, depictions of both compassion and prejudice, desire and disdain, complex and deeply compromised records of the difficulties, as well as the promises, that mark the narrator's encounters with the ethnic poor.

As "The Use of Force" suggests, the efforts of Williams's narrator to touch, probe, and heal the poor are consistently rebuffed; immigrants offer multiple forms of resistance to his frequently invasive medical and sexual approach. Instead of merely accepting his aid, they both demand and contest it. As a result, the narrator's efforts to assist or understand his ethnic neighbors and patients often fail, and his texts burst into (sometimes extreme) violence or prejudice. In Williams's short fiction, then, the moment of "contact" is repeatedly represented as a sensational instance of medical-sexual exposure in which an ethnic (and predictably female) body is literally or figuratively laid bare for inspection. What makes these fictional encounters "sensational" is not only the depiction of the immigrants—disfigured by disease or privation, or sexually exposed by the narrator's predatory gaze—but also the narrator's attitude, the startling and unstable blend of compassion, prejudice, and arousal that characterizes his approach to the poor. However, rather than cover his tracks, erasing or disguising the violent

underside—especially the potent misogyny—of his ambivalence toward subaltern figures, the doctor-narrator exposes his biases for the reader to examine, assess, and criticize.

By problematizing the narrator's authority even as they reinforce it, the stories open space for reading "against the grain" in a fashion that complicates or contradicts the stories' guiding perspectives, exposing the highly contingent character of social interaction and making visible the terms on which the narrator's engagement with the immigrants occur. A form of self-reflexive writing, Williams's stories expose the constitutively ambivalent process of cross-cultural identification, the ways in which such identification is formed through both exclusion and assimilation, prejudice and recognition. The narrator's identification with the Passaic River immigrants proves to be highly unstable, insecure, and incomplete. His efforts to comprehend them are daring, volatile, and deeply ambiguous exercises in alignment and affiliation.[8] To unravel these complicated dynamics, this chapter is structured in two segments. The first segment outlines the primary cultural and social elements that converge in Williams's fictions of ethnic encounter: his complex political philosophy and the impact of the Depression on his outlook; the history of the northern New Jersey immigrant communities that serve as the settings for most of his stories; the influence of modern medical techniques on his social and literary attitude; and his philosophy of "contact," a utopian theory of cross-cultural identification that his stories attempt to put into practice. The second segment of the chapter offers a reading of *Life along the Passaic River* in light of the preceding discussion.

Williams, Cultural Politics, and the 1930s

Williams, whose two closest friends, Ezra Pound and Kenneth Burke, occupied opposite ends of the political spectrum, adhered to an idiosyncratic brand of poetic radicalism. As Williams himself explained, rather cryptically, "I felt as if I were a radical without being a radical."[9] Williams was a well-known figure on the literary Left: his stories and poems appeared in a vast range of small radical journals during the 1930s, he served on the editorial board of the proletarian short-story magazine *Blast*, and he signed the call for the 1939 American Writers' Congress. Although he denounced Marxism in 1936 as a "static philosophy," he supported Gorham Munson's Social Credit movement, which advocated equal distribution of wealth, and he insisted that modern poetry critically address social injustices. "I cannot swallow the half-alive poetry which knows nothing of totality," he maintained. "It is one of the reasons to welcome communism. Never, may it be

said, has there ever been great poetry that was not born of out of a communist intelligence."[10] Although opposed to what he perceived as literature driven explicitly by political campaigns or promoting ideological slogans, Williams steadfastly claimed that literature should confront the most pressing social issues of the day.[11] In explaining his motivation for writing *The Knife of the Times*, a collection of short stories, several of which are about impoverished New Jersey immigrants, Williams stated that he "felt [the plight of the poor] very vividly" and "felt furious at the country for its lack of progressive ideas."[12] Poetry, he said, "lives where life is hardest, hottest, most subject to jailing, infringements and whatever it may be that groups of citizens oppose to danger."[13]

Most of the stories in *Life along the Passaic River* were written during the early to mid-1930s, a period that Williams and his friends, like so many Americans, registered as a time of profound cultural and ideological crisis. Kenneth Burke described the "early days of the Great Depression" as "a time when there was a general feeling that our traditional ways were headed for a tremendous change, maybe even permanent collapse."[14] Williams, too, felt the social, economic, and political dislocations of the period quite deeply. His medical practice suffered, as most of his patients were unable to pay his fees, which he refused to raise as most of his colleagues did. Politically, the decade strengthened his left-leaning tendencies, and he contributed actively to several small radical magazines. Artistically, the decade's convulsions simultaneously disoriented and focused Williams. On the one hand, his poetic production dropped off as the political urgency and instability of the period forced him to reevaluate his artistic project; on the other hand, those same circumstances confirmed his incipient sense of America's cultural absurdity and violence, and rejuvenated his interest in the problematics of social difference, disparity, and injustice.[15] In particular, Williams's writing from the 1930s, especially his fiction, focuses on things and persons that he considered low, marginal, and repressed, including detritus and debris, as well as immigrants, proletarian women, African Americans, and criminals. As the historian Bob Johnson has argued, the period's heightened political atmosphere prompted Williams "to reckon more fully with the divisiveness and multiplicity of life in the United States."[16] During the Depression, Williams's writing increasingly emphasized the shocking, unreal, and disturbing aspects of the American scene, as he tried to represent what he called the "jumbled wreckage, human and material," that seemed to be piling up around him.[17]

The Local Scene: Paterson, Passaic, and Immigrant Labor

As one would expect in the case of a writer so famously dedicated to the local scene, Williams's stories are deeply place-specific. Although Williams lived in suburban Rutherford, he spent most of his time working in the nearby municipalities of Paterson and Passaic, both of which were industrial, immigrant cities known, respectively, for their silk and woolen mills. By the early twentieth century, Paterson had become the largest site of silk production in the United States. The city's industry was powered by the massive falls that cascaded through it, falls that Williams took as the starting point for his long poem *Paterson*. The textile mills in Paterson and Passaic were worked largely by immigrants, who had come to the area in large numbers as part of the massive influx of Europeans into the United States at the turn of the century. Both cities were, in fact and in perception, immigrant identified. Indeed, according to the 1910 census, Passaic had a higher percentage of foreign-born residents than any other city in the United States.

The arrival of the "new immigrants," which began in the 1880s and continued into the 1920s, caused great consternation among conservative, Anglo-American commentators, and led to a sharp rise in nativist sentiments. Nativists felt that the arrival of large numbers of southern and eastern Europeans, Asians, Catholics and Jews, whom they perceived as especially "alien" and uncivilized, threatened to undermine America's racial and national integrity.[18] Fearing what Lothrop Stoddard notoriously called a "rising tide of color," nativists invoked various eugenic, social Darwinist, and pseudo-scientific racial theories to condemn the presence of immigrants and spread fear about alleged threats to the purity and sustainability of white dominance. One of the most outspoken critics of immigration, Madison Grant, a eugenicist and an officer at the American Museum of Natural History, warned that the infusion of inferior blood types into America would subvert the nation's capacity for self-government. As late as 1933, Grant, author of *The Passing of the Great Race* (1916), contended that, "with its two million Jews, its million and a half Italians . . . and its three-quarters of a million each of Poles and Irish, . . . the Empire State is scarcely able to meet the requirements of the Founders of the Republic, who, like Thomas Jefferson, feared above everything else the formation of an alien, urban proletariat as creating a condition under which a democratic form of government could not function successfully."[19]

Although Williams's writing at times adopts a rhetoric of purity and contamination that echoes the discourse of racial fear that spread throughout

many sectors of the Anglo-American community in the first decades of the twentieth century, Williams expressly opposed the politics of nativism.[20] He saw his fiction, in particular, as an exercise in interethnic and cross-class understanding and identification that would challenge prevailing racial and ethnic misconceptions. As he explained in an essay on short story writing, "I know [the working-class, immigrant inhabitants of northern New Jersey]. I saw them and the essential qualities (not stereotype), the courage, the humor, the deformity, the basic tragedy of their lives—and the importance of it. I saw how they were maligned by their institutions of church and state—and 'betters.' . . . I saw how stereotype falsified them."[21] Although Williams's comments are tinged with condescension (the claim that the immigrants' lives are essentially "tragic"), he clearly saw himself as writing in opposition to the voices and persons who aimed to marginalize, ghettoize, even expel these recently arrived residents. Moreover, Williams himself sprang from ethnically mixed stock (including English, Jewish, French Catholic, Puerto Rican, and Spanish lines of descent) and was perceived by many of his friends and fellow artists as something of a cultural hybrid. Painter Marsden Hartley, for instance, described Williams as "a small town of serious citizens in himself. . . . That's because he's latin and anglo-saxon in several divisions and being an artist has to give them all a chance."[22]

Despite the spread of anti-immigrant sentiment and the lack of adequate legal protections, the ethnic workers of Paterson and Passaic mobilized forcefully in two massive and widely publicized mill strikes in 1913 and 1926. The 1913 strike, which included the active participation of IWW organizers who were coming off the spectacular victory of the 1912 "Bread and Roses" strike in Lawrence, Massachusetts, began in February when 6,000 workers walked off the job and continued for five months, involving, at its peak, more than 25,000 workers. In addition, the strike attracted the participation of nationally known labor leaders such as Bill Haywood and Elizabeth Gurley Flynn as well as Greenwich Village bohemians such as John Reed and Mabel Dodge and progressive writers such as Upton Sinclair. The labor-cultural-literary alliance culminated in the 1913 Paterson Strike Pageant at Madison Square Garden, in which hundreds of strikers acted out events from the conflict as scripted by Reed. The pageant, designed as a fund-raiser, lost money, and the strikers, despite their pitched and protracted struggle, won minimal gains.[23]

In 1926, textile workers staged another huge strike, this time in Passaic, led largely by women. In January, 6,000 workers struck the Botany Textile Mills to protest wage cuts and to demand union recognition. By March,

the strike had spread to adjacent mills and surrounding towns as 15,000 workers joined the work stoppage. The strike, which ended when the mills agreed to recognize the union and to submit to arbitration, continued for almost a year and attracted support from a range of well-known radicals including Gurley Flynn and the Socialist Party presidential candidate, Norman Thomas, who was arrested trying to make a speech.[24] Commentators underscored the strikers' ethnic diversity and the central role played by women. Writing in the *New Masses*, radical journalist Mary Heaton Vorse, who compiled her reportage into a 1927 book on the work stoppage, described a massive march in May 1926 led by women: "At their head there was a baby carriage. It was Barbara Miscolocsy who headed the victorious procession and her aunt, Elizabeth Kovacs, who pushed it."[25] The June 1926 issue of the *New Masses* contained journalistic "cameos" of several strikers, which again emphasized the multiethnic, mixed-gender composition of the protesters. The magazine included brief sketches of "a young Negro picket captain," a "Polish widow wearing a gay old-country kerchief," a "lanky German Hungarian father," a "Polish peasant mother," and an "Old Italian mother."[26]

Williams was clearly well aware of these strikes. His 1917 poem, "The Wanderer," in which the speaker asks, "how shall I be a mirror to this modernity," contains a section titled "The Strike," which describes the 1913 conflict as an "electric" event. In 1926, Williams published a short story, "The Five Dollar Guy" in the same issue of the *New Masses* that contained Vorse's coverage of the Passaic strike. Like many of his stories, Williams's "Five Dollar Guy" (clearly a play on Henry Ford's vaunted "five dollar day") is more a slice of life than a fully formed narrative. It records a doctor's essentially uneventful visit to a young, working-class woman, but takes the mundane incident as an occasion for a reflection on the creative process in which Williams, as if underscoring the importance of the history and activities of working (and other overlooked and despised) peoples to modern American literature, asserts his allegiance to plain, direct writing about lowly subjects. He states his ambition to "to put down some small, primary thing, to begin low down so that all the color and the smell should be in it—plainly seen and sensed,—solidly stated—with this we should begin to have a literature; but we must begin low."[27] The environs of Passaic and Paterson, especially the run-down alleyways and cramped houses of the two cities' impoverished ethnic neighborhoods, as well as the working people who lived there, may have qualified as "low" in Williams's eyes, but they were by no means abject, as the two dramatic strikes suggest.

The labor militancy of these immigrant communities—their active resistance to prevailing structures of social, economic, and political power—forms an important, and overlooked, context for Williams's stories. For although Williams's doctor narrators typically position immigrant figures as passive objects of medical knowledge, the immigrants often respond with bold assertions of defiance or wily tactics of evasion. The 1913 and 1926 strikes gave public evidence of what Williams's stories often suggest in much more intimate settings: that despite their poverty and their marginalized social status, the new immigrants of Paterson and Passaic were not content to let figures of authority, whether textile executives or local doctors, assert their power and expertise uncontested.

The Clinical Gaze and the Vicissitudes of Medical Intimacy

Williams received his training as a doctor at the turn of the century when medical science and the social status of the medical profession were being significantly transformed. During the first three-quarters of the nineteenth century, the social standing of most physicians was relatively low and unstable. The profession had no fixed pattern of education and certification, and the field was marked by sectarianism among divergent theories of medical practice and treatment.[28] Between the 1870s and 1906, however, when Williams graduated from the University of Pennsylvania Medical School, the medical profession centralized and fortified itself, attaining a new level of legitimacy and prestige. During this period, which also marked the consolidation of many other professions, the social distance between patients and doctors increased as the distance among colleagues diminished, establishing a stronger uniformity and cohesion to the profession: physicians achieved strong consensus over medical theory, reconstituted the American Medical Association as a potent organization with the power to regulate entrance into and practice within the field, and instituted a relatively uniform and rigorous process of education and certification. The process of consolidation can be seen in the dramatic growth of the AMA, the membership of which increased from 8,000 in 1900 to 70,000 by 1910. According to the historian Paul Starr, "From this period dates the power of what came to be called 'organized medicine.'"[29] As with other professions, medicine's cultural authority derived from the profession's ability to cultivate a field of privileged and specialized knowledge to which access was limited and admittance regulated.

The second half of the nineteenth century also saw the invention and

rapid dissemination of new technologies of diagnosis that changed the medical establishment's attitude toward the body and the doctor-patient relationship. Beginning with the development of the stethoscope in the 1820s and 1830s, medical experts introduced a series of devices that helped to inaugurate "a new medical era" in which the body, its organs, and processes were increasingly isolated and objectified.[30] This new array of medical instruments—including the ophthalmoscope, laryngoscope, X-ray machine, and microscope—facilitated the growing interest of physicians and scientists in "the anatomical localization of pathology," a mode of analysis in which the body was symbolically dissected, divided for examination and study into discrete organs and systems.[31] In this new scheme, the key factors in diagnosis shifted from the patient's testimony and external bodily signs to the examination of internal phenomena that the patient could not see or hear.[32] As the medical historian Stanley Joel Reiser explains, these new devices "helped to create the objective physician, who could move away from involvement with the patient's experiences and sensations, to a more detached relation, less with the patient but more with the sounds [and sights] within the body."[33] Together, the increased professionalism of medical practitioners and the new methods of scientific examination inaugurated what Michael Foucault calls the clinical regime, a structure of medical practice that dramatically transformed relations between doctors and patients.[34] According to Foucault, the new methods of examination constituted the medical patient as "a describable, analyzable object . . . under the gaze of a permanent corpus of knowledge": "the individual as he may be described, judged, measured, compared with others . . . [and] also the individual who has to be trained or corrected, classified, normalized, excluded, etc."[35]

Although Williams was well versed in these new modes of analysis, the clinical approach, in which the individual is abstracted and scientifically measured, conflicted with the social patterns of Williams's neighborhood, house-call practice, in which visits frequently had a highly personalized, informal feel. In his autobiography, he contended that both medicine and writing are exercises in intimacy—the "coming to grips with the intimate conditions of [other people's] lives."[36] Both entail the process of exploring and exposing the hidden root of a phenomenon, be it an illness (the doctor's object of interest) or a way of living (the artist's object of interest). To Williams, medical practice represented the attempt to achieve a veritable communion with his patients in search of what he describes as his patients' underlying "perfection" (288)—"the hunted news" (360), the "rare element" (360), the "underground stream" (359), the "stuff" out of which

art is made. Although invasive, the act of searching for the essences of his patients' selves is also highly personal, and potentially reciprocal: "The pursuit of a rare element which may appear at any time, at any place, at a glance . . . can be most embarrassing. Mutual recognition can flare up at a moment's notice" (360).

Williams's brand of medical inquiry entails sympathy, ethnography, documentary, and performance all at once. The doctor-writer is simultaneously hunter, "spy" (359), reporter, interloper. As he explained, medical authority allowed him to probe his patients' inner lives:

> My "medicine" was the thing which gained me entrance to the secret gardens of the self. It lay there, another world, in the self. I was permitted by my medical badge to follow the poor, defeated body into those gulfs and grottoes. And the astonishing thing is that at such times and in such places—foul as they may be with the stinking ischio-rectal abscesses of our comings and goings—just there, the thing, in all its greatest beauty, may for a moment be freed to fly for a moment guiltily about the room. (288–89)

This passage, from his autobiography, captures the central ambiguities of Williams's medical ethic as it is manifested in his fiction. Williams imagines medicine as an artistic endeavor, a practice that allows access to the deepest recesses of personal knowledge, the "gulfs and grottoes" of a buried personality. However, such access is purchased at a price. For one thing, it requires a "badge," a source of authority, the implied threat of institutional force or law. In addition, releasing the "thing" produces a feeling of "guilt." Clinical medicine offers Williams the writer both authority and precision—the ability to probe hidden recesses and to see with an objective clarity. But the clinical eye also requires an exercise of power, a power with which Williams is not at all entirely comfortable, and with which, we will see, he makes us as readers more than equally uneasy.

Contact

Like many other modernists, Williams aimed to refresh and revitalize readers' perception by creating a new language through which to see the world. For Williams, this new language would emerge from direct, unmediated engagement with the writer's immediate surroundings, from an originary experience that captured the uninflected "truth" of local conditions and everyday objects. The term he invoked to capture this approach was

"contact," a multivalent concept that condensed several aspects of his literary and cultural attitude. The word was initially proposed in 1920 as the title for a "little" magazine by Williams's friend Bob McAlmon, who had heard pilots use the term to describe an airplane's touchdown after flight. A term of technological jargon with a precisionist ring to it, it captured the writers' desires to create an aesthetic that would be distinctly modern and "American," without regard for European traditions or foreign influences. For Williams, contact embodied his famous dictum "no ideas but in things." It became the codeword for his desire to record, without embellishment, the artist's "immediate contacts" with his "locality," to strip away inessentials to get at the "thing itself" — "the inexplicable, exquisite, vulgar thing."[37]

Although contact's immediate roots lie in the realm of mechanical technology, the term also contained a Whitmanesque resonance with significant social implications. To understand this aspect of contact, we need to turn to Williams's most extensive literary treatment of the topic, *In the American Grain* (1925), an idiosyncratic, boldly experimental cultural historical study of the colonial encounter between the Old (European) World and the New (American) World. *In the American Grain* explores the history of America's founding acts of "contact" and finds, in large part, a history of material and epistemological violence—a failure by Europeans to understand the New World's unfamiliar people and places, and the physical and psychic damage that ensues. However, woven within this narrative of prejudice and destruction are examples of what Williams calls the "animate touch," forms of contact that balance assertion and reception, exploration and respect, self-confidence and self-doubt.[38]

In the American Grain criticizes the Puritans for their narrow-mindedness, their "hard and little" spirit, "their tight-locked hearts," their unwillingness to conceive the New World on any terms other than those they imported.[39] Although the Puritans "came resting on no authority" and established "the first American democracy," they paradoxically possessed extremely limited tolerance for the unfamiliar. They feared the world they encountered and recast it within a rigid, allegorical framework, incorporating the new within prepared and inflexible doctrine: "The emptiness about them was sufficient terror for them not to look further. The jargon of God, which they used, was their dialect by which they kept themselves surrounded as with a palisade" (63–64). The Puritan mind sought to remake "everything like [itself]," "to reproduce its own likeness, and no more" (63, 68). *In the American Grain* argues that the Puritans' myopia lent them a certain "PURITY" and "cour-

age" (111), but severely limited their appreciation for the New World and its inhabitants: "The Puritan . . . was precluded from SEEING the Indian. They never realized the Indian in the least save as an unformed PURITAN" (113).

As a counterpoint to Puritan intolerance, *In the American Grain* offers the example of Père Sebastian Rasles, a French Jesuit who lived for thirty-four years with the Abnaki Indians in Maine. Williams argues that Rasles embodied "a new spirit in the New World," a spirit that differed fundamentally from the frigidity, fear, and inflexibility that characterized Puritan ideology. Rasles possessed a nature that was "rich, blossoming, generous, able to give and to receive, full of taste, a nose, a tongue, enduring, self-forgetful in beneficence" (120). The metaphors employed here speak volumes. To Williams, the Puritans' preformed expectations and reductive interpretive paradigms stifle creativity and spontaneity—much as the weight of literary conventions and established forms inhibits many contemporary writers from engaging directly with what Williams calls the "imperfect actuality" of modern life.[40] Although the Puritans "were seed[s] of Tudor England's lusty blossoming," the bloom withered within them, becoming "hard and little" (63). Whereas the Puritans recoil, shrinking from contact with the New World, Rasles extends and embraces the strange continent and its peoples. He is identified with "tongue," "nose," "taste"—those organs and senses that reach out and encounter, probe and ingest the tangible world: "For everything his fine sense, blossoming, thriving, opening, reviving—not shutting out—was tuned" (121). Williams associates Rasles with the sensual, the organic, and the feminine—that which blooms, flows, and expands. The Puritans represent an absence of feeling, desire, and sexuality; in contrast, Rasles symbolizes a proto-Whitmanesque form of democratic sexuality characterized by mutuality and sensuality.

Unlike the Puritans, then, Rasles is able to see the New World through a fundamentally open, flexible set of parameters. The Puritans, Williams insists, "damned us with their removal from the world, their abstinence, their denial" (128), while Rasles engages and embraces the world; he is "able to give and to receive" (120). He does not greet the Indians merely as uninitiated Christians, but as individuals to be acknowledged on indigenous rather than imported terms: "In Rasles one feels THE INDIAN emerging from within the pod of his isolation from eastern understanding, he is released AN INDIAN. He exists, he is—it is an AFFIRMATION" (121). Rasles is able to understand the Indians in terms other than his own. To him, they are not merely potential Europeans, but autonomous subjects.

Rasles's philosophy of contact is distinguished by his willingness to

touch. As characterized in *In the American Grain*, "touch" represents a mode of contact that is reciprocal and respectful, that refuses fear and refutes prejudice. "Rasles lived thirty-four years . . . with his beloved savages . . . TOUCHING them every day" (120). For Williams, touching is a profoundly courageous and moral act; it requires leaving a personal comfort zone and meeting another individual on neutral ground: "It is *this* to be *moral*: to be *positive*, to be peculiar, to be sure, generous, brave—to MARRY, to *touch*" (121). The result is "to create, to hybridize, to cross pollenize,—not to sterilize, to draw back, to fear, to dry up, to rot" (121).[41] Touching is thus a generative and mutual form of engagement, a mode of intersubjective connection that blends and merges aspects of both parties involved.

In the American Grain asserts that the reluctance to touch debilitates not only colonial American culture but modern American culture as well. "The characteristic of American life," Williams insists, "is that it holds off from embraces" (175): "men are trained never to possess fully but just to SEE. This makes scientists and it makes the masochist. Keep it cold and small and under the cold lens" (175). Here, Williams suggests that the clinical way of seeing in which he himself was trained promotes a dangerous form of social detachment. "Our life," he writes, "drives us apart and forces us upon science and invention—away from touch" (179). Williams caustically parodies what he describes as the modern American aversion to touch, a cultural fear of social engagement bred by a fascination with technology: "Do not serve another for you might have to TOUCH him and he might be a JEW or a NIGGER" (177); "Machines were not so much to save time as to save dignity that fears the animate touch" (177). The refusal to touch, Williams argues, has prevented America from knowing itself: "Americans," he asserts, "have never recognized themselves" (226), have never fully grasped their own diversity. Reading *In The American Grain*, we realize that what begins as a historical analysis of Puritanical prejudice in turn becomes an ambitious critique of modern ideologies of self-confirmation, of the narrow grids through which Americans filter the world, blocking out the unexpected and unfamiliar.

The question of what it means to "recognize" the New World, to "contact" its "savages," is central to Williams's modernism. However, as Williams's short stories consistently demonstrate, the ideal form of contact—a cross-pollinating, hybridizing "touch"—is virtually impossible to achieve. In the attempt to realize it, ideology and power invariably intervene. Williams desires unmediated contact, the affirming touch he contends that Rasles achieved, but his attempts to articulate such a touch inadvertently

invoke forces he seeks to avoid—violence, prejudice, fear.[42] Yet, rather than effacing, obfuscating, or ignoring the problems of contact, Williams's short fiction, as we will see, foregrounds the difficulties of the cross-cultural touch—the coercion, misunderstanding, lust, and discrimination frequently involved in such complicated encounters.

Although Williams's emphasis on direct contact with concrete particulars might at first seem to endorse a naive belief in empiricism, his comments suggest that contact in fact contained an avant-garde quality of estrangement. In "The Five Dollar Guy," Williams states that although his aim is "to get down upon the object" and to express it "in some plain phrase," he then asserts: "But I did not then know how strange the common object seems when it is stripped naked before eyes freed from that artifice of seeing which concern for a clever literature enforces."[43] Here, Williams acknowledges that his tactics of contact are not, as they first might seem, reductive but expansive. Rather than a gesture of simplification, the turn to the "local," the "actual," and the "object" rendered in "some plain phrase," opens up unanticipated sights and angles of vision. For Williams, the refreshing of perception, the artistic realization of the new through "contact" with the "actuality" of "local" experience, is a disorienting experience, an exercise designed to defamiliarize the world as we habitually see it and to force the reader, as Williams wrote in a laudatory essay on the surrealist poet Charles Henri Ford, to "re-see, re-hear, re-taste, re-smell and revalue all that it was believed had been seen, heard, smelled, and generally valued."[44]

Williams contended that the short story was conducive to such necessary tactics of estrangement. Like his poetry, Williams's tales are episodic. They are structured as brief glimpses, scenes, and sketches of working-class life. He turned to short stories more readily than the novel because, he said, of "the briefness of their chronicles, [their] brokenness and heterogeneity."[45] What he felt to be the innately fractured quality of short stories (which he described as "flashes" and "sparks") made them fertile ground for experimentation and for generating the astonishment that was central to his own form of avant-garde cultural production.[46] A short story writer, Williams asserted, "must get the punch in, the shocking punch."[47] "The shock," he insisted, "is necessary."[48] Williams's stories are exercises in incongruity, cross-cultural encounters marked not (or not only) by reconciliation but rather by the persistence of strangeness, by volatile eruptions of prejudice and lust as well as empathy and identification. In Williams's fiction, difference is approached and touched, but not assimilated; social and cultural differences are brought within the narrator's grasp, but never controlled

or comprehensively understood. Indeed, Williams's persistent emphasis on the violence of cross-cultural encounters, on the struggles of authority and the difficulties of translation, highlights the intractability of social boundaries. Although like Elsie, immigrant, ethnic, and working-class figures—especially women—are routinely subjected to harsh scrutiny, they often resist, subvert, or confuse the narrator's invasive gaze.

Williams thus exposes to us as readers the problems of his own approach, laying bare the violence, lust, and pain that his encounters with difference produce. He does not bring difference home, does not make it accessible or comfortable or familiar. Rather, in his attempt to bring it closer, he acknowledges that such a project is deeply troubled. Williams's immigrant-doctor stories suggest that difference and unity can coexist, but that such coexistence, however much a source of creativity for Williams, is also often painful, imbued with uneven power dynamics, riddled with bias, prone to misunderstanding and conflict. Fictions of complex encounter, Williams's stories represent what the poet elsewhere calls "agonized approaches to the moment."[49] The "agony" of "approach" that dominates Williams's short stories is felt nowhere more acutely than in his 1938 collection *Life along the Passaic River*.

Life along the Passaic River

In a hardboiled prose that echoes Williams's own fiction-writing style, contemporary reviewers suggested that *Life along the Passaic River* had a documentary feel, a gritty realism that captures the daily lives of down-and-out urban people. Fred Miller, editor of *Blast* and longtime friend of Williams, described the people who inhabit Williams's fictional world as "mongrel isolated Americans": "the plain (if sometimes violent) people that Williams, as a medico, meets day after day—Polacks whom transplantation has stunned, an Italian peasant woman . . . ; a Negro woman . . . ; Jews; Russians; . . . an old man, penniless."[50] Another reviewer, the New York University professor Eda Lou Walton, identified them as "the diseased, the poor, the ignorant, the immoral."[51] Williams's primary setting, Walton notes, is "the Passaic River town, its tenements, its dirty streets, and its hospital clinic where the dramatic fight for the preservation of seemingly worthless lives takes place."[52] In addition to underscoring the text's seedy setting and socially disenfranchised characters, critics also highlighted the unpretentious, unpolished formal quality of Williams's stories. One reviewer suggested that *Life along the Passaic River* is not a collection of fully developed stories at all, but rather a hodgepodge of "plotless slices . . . and hunks

of life."[53] Walton concurs, labeling the book's segments, "many of which cannot be called short stories," "sketches."[54] Likewise, Irving Howe asserts that the stories "are loosely constructed," and that "when there is a plot, it is ramshackle."[55]

These "plotless slices," contemporary reviewers recognized, represented a departure from modernism as usual. Walton, who was responsible for smuggling the copy of Joyce's *Ulysses* back from Paris that introduced Henry Roth (whose 1934 novel *Call It Sleep* is discussed in chapter 5) to European modernism, argues that Williams fashions an eccentric brand of experimental realism—"realism . . . vitalized by an imaginative way of viewing life."[56] He is "political," she argues, but "never a propagandist"; an "artist," but not a "sentimentalist, or a romanticist."[57] N. L. Rothman, writing in the *Saturday Review*, likewise implies that *Life along the Passaic River* contains seemingly contradictory artistic impulses. Williams's sketches, Rothman asserts, aim to capture the essence of "basic experiences, unadorned and unstylized."[58] At the same time, however, these flashes of quotidian life are captured through "literary powers" "exercised in experimental fashion."[59]

One of the "experimental" aspects of Williams's fiction is the fact that many of the stories in *Life along the Passaic River* lack clear beginnings or endings. Several of the tales commence and finish in the middle of a conversation, the participants of which are, at a story's start, not identified, described, or even delineated. The elements that typically provide the building blocks of narrative—character, setting, plot—are accessible only through insinuation and implication, if at all. The stories are streams of spoken speech with a minimum of narrative or descriptive detail. Moreover, the absence of quotation marks makes it difficult to distinguish one speaker from another, or speakers from the narrator. The lack of explanatory or introductory information amplifies the sense of disorientation that many of the stories take as their central theme. Just as the narrator is frequently faced with an unfamiliar scenario—a foreign part of town, a stranger's house, an unknown disease—so the reader, too, is given noticeably few clues and markers. We are thrust into strange surroundings, but stripped of the narratological road signs we expect to help us find our way. In these stories, narrative guidance is virtually nonexistent—we are on our own, traveling in alien territory without a map or compass.

As a whole, *Life along the Passaic River* reads as a response to the opening, and eponymous, tale. Rather than a cohesive story, with developed characters and a coherent plot, "Life along the Passaic River" is a voyeuristic visual survey of the working-class immigrants and African Americans who

inhabit the banks of the Passaic River in and around Paterson. The piece opens in a cinematic fashion by zooming in on a boy in a canoe drifting in the river: "About noon of a muggy July day, a spot of a canoe filled by a small boy who no doubt made it, lies west of the new 3rd St. Bridge between Passaic and Wallington, midstream opposite the Manhattan Rubber Co.'s red brick and concrete power plant" (109). The story positions readers as detached observers, empowered to scrutinize the bodies and habits of the local poor from a distance. Like a disembodied eye, we glide through the city, observing the poor and homeless, as a movie camera might pan through town, setting the scene for a film's action: "All the streets of the Dundee section of Passaic have men idling in them this summer. Polacks mostly. . . . You see a few niggers, but they're smiling. Jews, of course, trying to undersell somebody else or each other and so out of the picture" (111). The narrator's eye is remarkably unself-conscious, unaffected and unmoved by the persons being surveyed. He lumps the figures he sees into facile (if incendiary) stereotypical rubrics—grinning blacks, money-grubbing Jews. "Here they are," he insists coldly, "on the steps of the Y.M., about a hundred of them from black Wops right on through to white-haired Polacks, a regular zoo" (110). Aggressively discriminatory, blatantly racist, the narrator speaks with an aura of aloofness and icy disdain.

In addition, the narrator's voice is informal and colloquial; it assumes a kind of familiarity with readers and doesn't justify the assumptions and generalizations it makes. The story encourages us to look, to judge, to assume—in a manner that is anything but sympathetic. The narrator's gaze is cold, harsh, presumptuous; he assures us that he knows what is best for the poverty-stricken young people we see. Paddling and swimming in the river, the narrator asserts, is "what they need. You can see it by the looks on their faces. They've needed it a long time. You can see that too on their faces" (111). The narrator encourages us to "take a look at him" (112), to "take the girls for instance, take a good look," insisting that their degenerated state is "written all over them" (113), that the moral worth of these young people is inscribed on their faces, accessible at a brief glance from a superior observer. This kind of looking, which assumes that the quality of personality can be deduced from a quick visual assessment, constitutes what I have called the discourse of scrutiny—a form of seeing that makes vision an extension of social power. Scrutiny claims the transparency of socially subordinate persons, whose bodies can be "read" like alphabetic texts; it insists that to see is to know and to know is to have the capacity, the right, and even the duty, to pass judgment.

At its most inflammatory, the narrator's attitude acquires a eugenic resonance, suggesting that the immigrant poor he sees are only a rung up the evolutionary ladder from the apes: "Just a lot of gorillas, a lot of mugs. . . . And if that's all the kids is gonna learn, phooie for them" (114). Throughout, the narrator is dismissive, callous: "What are you going to do with a guy like that. Or why would you want to do anything with him" (112). The narrator's brutally dispassionate, objectifying gaze reflects his ability to treat the individuals he surveys as pure bodies, as hunks of flesh, as if they were, in effect, dead. This tendency is confirmed when the narrator escorts us into the morgue to survey the body of a deceased young woman. The "dead-pan" tone with which the narrator describes her is identical to the harsh tone he uses to delineate the living: "Look at this one lying on the autopsy slab at the hospital; you can see the whole thing. Twins. About five months on the way. Just a kid she was . . . Good legs. A fine pair of breasts. Well-shaped arms. She's dead all right and if you get what I mean, that's not such a bad thing either" (113). Here, the narrator pushes his hard-boiled, clinical attitude to an extreme, assertively displaying his cruel indifference for the reader's assessment. And here, too, as in "The Use of Force," the erotic and medical mingle, as the narrator's professional remarks take on a sexualized edge.

Several reviewers have acknowledged the surgical character of the stories' narrative gaze. Walton, for instance, states that Williams's style cuts to the core, as a surgeon slicing through flesh: "The impact of these tales is due to the fact that everything expressed in them is pared down to the bone, to the essential structure. The shock of each story is the shock of observing bone suddenly and cleanly unfleshed."[60] Walton asserts that Williams uses "realism with the precision of a surgeon exposing the vital organs," that Williams's "art is realism intensified with a skill as of X-Ray in penetration and analysis."[61] More recent reviews have also compared Williams's style to medical practice. In the introduction to the 1996 edition of Williams's collected stories, Sherwin Nuland asserts that Williams "lays bare the bone and marrow of his men and women."[62] However, these reviewers seem either unaware or indifferent to the imperial, invasive nature of Williams's surgical glance. Indeed, rather than questioning the violence implicit in the metaphors of cutting, de-fleshing, and paring, they normalize and reinforce it. The stories themselves, however, are in fact quite ambivalent about the aggressive, clinical quality of the narrator's gaze. If the opening story provides a highly prejudiced survey of the figures who will inhabit the book as a whole—"niggers," "wops," "Jews," "Polacks"—the tales that follow call

into question the presumptive, cutting gaze that readers are granted in the initial piece. Indeed, the stories are remarkable for the extent to which they divulge the biases embedded in the narrator's viewpoint. Williams's medical fictions are in fact tales of double-exposure in which the narrator reveals not only his patients but also his own prejudices and idiosyncrasies. We see through the narrator's eyes, but we are able to evaluate his point of view as well. He consistently proves himself highly unreliable—in turns intolerant, pedantic, iconoclastic—and readers are allowed, indeed encouraged, to question and contest his volatile attitude.

"A Face of Stone" provides a good example of the narrative reversals that characterize the collection as a whole. The story opens with the narrator's blatantly condescending assessment of a man who enters the narrator's office with his wife seeking care for the couple's infant boy. The story begins: "He was one of these fresh Jewish types you want to kill at sight, the presuming poor whose looks change the minute cash is mentioned. But they're insistent . . . taking advantage of good nature at first crack. . . . He got me into a bad mood before he opened his mouth just by the half smiling, half insolent look in his eyes, a small, stoutish individual in a greasy black suit, a man in his middle twenties I should imagine" (167). The narrator's malicious evaluation of the young man, based admittedly on a brief glance, is unabashedly severe, a reiteration of the crudest and most inflammatory stereotypes.

Like the young girl in "The Use of Force," the wife initially appears inscrutable to the doctor: "She stood behind her smiling husband and looked at me with no expression at all on her pointed face, unless no expression is an expression. A face of stone" (167). The woman's opaque visage signifies a refusal to be "read" by the narrator, to fulfill his stereotypical expectations. She defies an easy label, refuses to be easily classified and catalogued. But the narrator glosses over the resistant posture of the woman's demeanor and her enigmatic expression quickly takes on familiar, and decidedly "typical," contours: he states that she has "a goaty slant to her eye, a face often seen among Italian immigrants," and insists that she "looked dirty. . . . Her hands were definitely grimy, with black nails. And she smelled, that usual smell of sweat and dirt you find among any people who habitually do not wash or bathe" (167). He sums up his first impression of the couple bluntly: "People like that belong in clinics, I thought to myself. . . . Just dumb oxen. Why the hell do they let them into the country. Half idiots at best. Look at them" (167).

After arraying the narrator's crudest clichés about this immigrant family,

the story proceeds slowly but steadily to confound and ultimately undermine the doctor's presumptions. The tale's drama derives not so much from medical suspense, as we might expect from this "doctor story," but rather from the critical complication of the narrator's feelings toward the couple. The husband and wife themselves are largely responsible for the narrator's change of opinion. Although the narrator is initially hesitant to grant them an appointment ("To hell with you, I thought to myself. . . . I got to go home to lunch" [168]), they disregard his callousness and demand his attention. At the same time, however, they refuse to make the doctor's job easy. The wife in particular displays a persistent distrust of his motives and methods. She initially refuses to submit her infant for examination, and when she finally relents, she scrutinizes the doctor's handling of the child, "looking furtively at me with distrustful glances" (168) and "interfering from behind at every move" (169). In short, they insist on having their medical cake and eating it too — an appointment that imposes on the doctor's schedule and the right to inspect his examination methods as well.

Although the doctor denies them a house call requested during the following winter, their refusal to be cowed by his arrogance and indifference continues when they arrive at his office in the spring. They disregard his brusqueness ("Make it snappy because I've got to get out" [170]) and urge that the child be given a full examination despite the narrator's assertion that he appears perfectly healthy. "The blood went to my face in anger but [the woman] paid no attention to me" (172), he notes. And despite the couple's demands, the doctor learns that the family has disobeyed the central directive he issued during their first meeting — to wean the infant. During this second appointment, the family's story grows increasingly complex, and the doctor's initial assumptions about them are called into question. When the immigrants enter his office, the doctor notices "a cluster of red pimples in the region of the man's right eyebrow," most likely "bed-bug bites I thought to myself" (171). Although not compassionate by any means, the narrator's response to the pimples suggests a measure of concern. We are reminded that perhaps the couple's "dirtiness," which the doctor takes as a sign of their degeneracy, stems not from a genetic or cultural deficiency but from material privation. The narrator's first display of genuine warmth for the family comes as he examines the infant: "The child grinned and sagged back unresisting in my grasp. I looked at it more carefully then, a smart looking little thing and a perfectly happy, fresh mug on him that amused me in spite of myself" (172).

The turning point of the narrative occurs when, after assuring the couple

of the child's good health, the doctor examines the mother who, her husband states, "gets pains in her legs, especially at night. And she's got a spot near her knee . . . a big blue looking sort of spot" (173). Although infuriated that he is asked to perform an additional service, the narrator consents to examine her and does so with a mix of cold detachment and blunt sexual fascination that we might now find familiar: "What a creature. What a face. And what a body. I looked her coldly up and down from head to toe" (173). "Her lower legs were particularly bowed," he observes, "really like Turkish scimitars, flattened and somewhat rotated on themselves. . . . The whole leg while not exactly weak was as ugly and misshapen as a useful leg well could be in so young a woman" (174).

The more the doctor learns about the woman, the more his shallow and biased impression of her is exposed as insufficient. The narrator asks where she is from and her husband responds that she is a Jew from Poland, a fact that exposes as unfounded prejudice the narrator's initial comments about her being a "goaty" Italian type. More significant, however, knowledge of her history provides a traumatic explanation for the debilitated condition of the woman's legs—and perhaps her stony expression as well. She is a war refugee. "That's the probable explanation for her legs, I told the husband. She must have been a little girl during the war over there" (175). He asks the woman if that's correct, but her stolid visage doesn't flinch: "She didn't answer me, just looked back into my eyes with that inane look" (175). But the narrator persists, and finally the husband explains the extent of the atrocities the young woman has suffered:

> Did she lose any of her people, I asked him.
> Any of them? She lost everybody, he said quietly. (175)

The woman whom the narrator is examining has survived a massive trauma. She is a political refugee whose body bears testimony to the privations and violence of war. Her deformities are not genetic, as the narrator had implied on first seeing the couple; they are social. "A Face of Stone" never shifts focus to the woman's story of terror and survival. The husband offers no additional information or details, and the woman herself remains silent about her past. But the narrator's awareness of the outlines of her past allows him to see the couple for the first time as complex individuals. The hint of the woman's story "breaks the frame"[63] of the narrator's interpretive paradigm, undermining his attempts to dismiss the family as familiar "types," as degraded, pesky "aliens."

As the story concludes, the narrator offers the couple a prescription for

the woman's precocious rheumatism. When the doctor asks if the woman can swallow the rather large pill, the husband responds: "She swallows an Aspirin pill when I give it to her sometimes . . . but she usually puts it in a spoonful of water first to dissolve it. His face reddened again and suddenly I understood his half shameful love for the woman and at the same time the extent of her reliance on him" (176). The narrator responds simply, in a comment that is assigned the authority of a paragraph: "I was touched" (176).

But the story does not end with a tidy transformation of the narrator's attitudes; the narrator's poignant statement of empathy is not elaborated or explained. Likewise, if or how his feelings for the couple have changed is not addressed; he might be "touched" by them, but does that fundamentally alter his immense disdain? We receive no answer; instead, the story ends abruptly, with the woman getting the final word. Asked if she can swallow the large pills the narrator offers, the woman grins and responds cryptically. "For the first time since I had known her a broad smile spread all over her face. Yeah, she said, I swallow him" (176). The ambiguity of the ending ("him" potentially has multiple referents—the pill, the husband, the narrator) suggests the encounter we have witnessed might be interpreted in various ways. Perhaps her statement is a sign of acceptance and appreciation, suggesting that the doctor has finally broken through her "face of stone" and reached a genuinely reciprocal understanding with her. But if we take the "him" to refer in some sense to the narrator, perhaps the woman's grin is an expression of triumph, a realization that she has received what she needs from the transaction with the doctor without offering true knowledge of herself and her situation in return. She, not the narrator, has the last word—and perhaps the upper hand.

The story's lack of "answers," the absence of a climatic resolution in which, for example, the woman divulges her past and the narrator explains how the experience alters his viewpoint, underscores the generally uneasy position in which readers are placed in "A Face of Stone." The narrator is not unilaterally "unreliable" (his medical opinion seems accurate and he examines the family despite his impatience with them), but our potential identification with him is disrupted from the very beginning of the story. His attitude is unjustifiably prejudiced, and his refusal to perform a house visit calls into question his professionalism. However, while our alliance with the narrator is shaky, our identification with the immigrants is by no means stable: they seem unable to tell when or if their child is ill and they apply the doctor's instructions discriminately. In short, we do not exactly trust

the doctor or his patients. We sit in limbo, our allegiances and sympathies unattached, fluctuating. The readers' precarious position underscores the fact that "A Face of Stone" is a tale about the vicissitudes of recognition—an encounter with strangers, who are at first condescendingly placed in a readily available and reassuring framework, which is eventually undercut. It is a story of epistemological complication, in which the central drama is the assertion and eventual collapse of a way of seeing.

Like "A Face of Stone," several of the most provocative stories in *Life along the Passaic River* describe encounters with women and girls whom the narrator finds enigmatic, inscrutable, and also strangely desirable. As Marjorie Perloff observes, critics have tended to either rationalize or romanticize Williams's highly sexualized gaze as an innocent manifestation of his desire for wholesome connection with his patients, his ability to capture their "true humanity," to cut to the "core" of their existence. In contrast to these tendencies, Perloff argues that it is the fundamentally unresolved nature of the doctor's sexual gaze that makes the stories crackle. "Indeed," she writes, "it is the poet's oscillation between 'normalcy' (another routine house call with its trivial incident and predictable dialogue) and the pressure of desire, a desire neither acted upon nor fully understood, that gives the short stories of the thirties their particular poignancy."[64] Although I agree with Perloff's claim that the doctor's desire is not completely comprehended or enacted, her sense that this state of affairs imbues the stories with a "particular poignancy" ironically sentimentalizes them. To the contrary, I find that the element of desire lends the tales a decidedly unsettling feel. And it is precisely this uneasiness that gives the stories their power to destabilize commonplace assumptions, to challenge facile or axiomatic affiliations and attachments, to expose the drama of cultural identification—of "contact"—as inherently incomplete, precarious, and volatile.

Moreover, what makes the stories noteworthy is not only the element of desire, but also the fact that desire intermingles so freely with disgust, anxiety, prejudice, and compassion to create remarkably precarious narratives. The intersection of such contradictory dynamics leaves the narrator—our guide to the working-class homes of Passaic and Paterson—nowhere to hide. We see him as an incredibly fallible, inconsistent person—angry one moment, repentant the next; lustful at one instance, repulsed at another. Over and over, the narrator, as if committing an act of penitence, lays bare his biases, exposes his own faults and foibles, confesses his own political sins. However, although the narrator is self-revealing, the stories are not confessional. The narrative self-reflection is always cut short—there is no

deep brooding, no remorse, no cultivation of psychological interiority. The doctor stories ask readers to read between the lines, to interject our own subjectivities into the text, to assert our own opinions in the face of conflicting, opaque, or missing information. We are put in a position where our allegiances and identifications are in limbo—in the "No Man's Land" that Richard Wright invokes (to be discussed in chapter 6). These are dialogic texts that encourage, even demand, our input, even as such input cuts against the grain of the narrator's attitude.

Like "A Face of Stone," "The Girl with a Pimply Face" commences by establishing the doctor's prejudice and resentment toward immigrant patients. A druggist phones to ask Williams to visit a family with an ill baby. "I was just sitting down to lunch. Can't they wait till after office hours?," the narrator complains. "Oh I guess so," the druggist replies. "But they're foreigners and you know how they are" (117). The narrator doesn't respond to the druggist's condescending assertion about the patients; as readers we're left without cues for evaluating such a statement. However, the doctor's initial indifference toward the immigrant family is challenged by the figure who greets him as he enters the apartment: "I opened the door and saw a lank haired girl of about fifteen standing chewing gum and eyeing me curiously from beside the kitchen table. The hair was coal black and one of her eyelids drooped a little as she spoke. Well, what do you want? she said. Boy, she was tough and no kidding but I fell for her immediately. There was that hard, straight thing about her that in itself gives an impression of excellence" (117). By now, this girl is a familiar figure to us. Stolid and sphinxlike, her curious eye and blunt address recall the young girl in "The Use of Force" who "was fairly eating me out with her cold, steady eyes, and no expression to her face whatsoever" and the mother's unbending gaze in "A Face of Stone." The narrator perceives these women as challenges, as ontological mysteries to be cracked by his masterful medical—and sexual—expertise. They are intriguing, even seductive, in large part because they offer some form of resistance to his authority—in the case of "The Girl with a Pimply Face" a complete lack of deference. As Williams examines the ill baby (who is not "much larger than a good sized loaf of rye bread" [118]), the young woman watches him with an air of cocky self-assurance. She "looked back at me, chewing her gum vigorously, standing with her feet well apart. She cocked her head to one side and gave it to me straight in the eye, as much as to say, Well?" (118). The girl, the narrator insists, is "straight"—direct, intense, willful, a combination of traits that the narrator interprets as both a

challenge and an invitation, a sign of defiance to his masculine authority as well as a solicitation of his attentions.

Although the narrator proceeds with his care of the infant, who, we eventually learn, "had a severe congenital heart defect . . . that meant, to put it crudely, that she was no good, never would be" (124), his primary focus remains the girl, "my informant" (118). Evidently, she turns him on: "This young kid in charge of the house did something to me that I liked. She was just a child but nobody was putting anything over on her if she knew it, yet the real thing about her was the complete lack of the rotten smell of a liar" (119). What he finds attractive is her vigorousness, her hardiness, her apparent straight-forwardness — and the fact that those qualities seem to give her the strength to withstand the doctor's authority and challenge him with her steely gaze. The narrator counters her defiant nonchalance with his objectifying look, reasserting his male, professional prerogative through an aggressive fantasy of control in which he imaginatively strips her naked and assesses her body: "She had breasts you knew would be like small stones to the hand, good muscular arms and fine hard legs" (119). Stripping her bare allows him to typecast her; she is, he assures us, "just one of the kids you'll find loafing around the pools they have outside towns and cities everywhere these days. Just a tough little nut finding her own way in the world" (119). He knows her type, he tells himself, assured that she fits neatly within a familiar paradigm.

The coolness of the young girl's demeanor is juxtaposed to the frenzied quality of the mother, who pleads frantically with the narrator to cure the baby. (The narrator remarks, "Boy! what a woman. I couldn't wait to get away" [125].) Yet despite his disdain for the mother, he prescribes formula for the baby, who is malnourished in addition to having an irregular heartbeat, and calms the mother down. He writes the young girl a script for acne medicine, telling her not to pay more than fifty cents for it, and departs without receiving his fee, which the mother assures him she can provide at a later visit ("Must pay rent, must pay coal. And got no money. Too much work" [125]). As he leaves, however, he obtains the "compensation" that he actually desires: admiration from the young girl. "Say, you're all right, she looked at me approvingly" (126). When he returns three days later, he finds the condition of the infant improved, but discovers that the mother has been drinking. Again, he leaves without receiving payment.

The narrator's feelings for the family are put to the test the following morning, when he is warned about the mother and the girl by a colleague

who had visited the family a week before the narrator did. The colleague asserts that the mother lied about the father's income, claiming he earned half what he does, in order not to pay the family's medical bill; that she's an alcoholic who neglects her children; and that the young girl, whom the narrator mildly characterizes as a "pretty straight kid" (130), is a "pimply faced little bitch" who has "a dozen guys on her trail every night of the week" (130). "Boy," the colleague observes, "they sure took you in" (130). The colleague's story calls into question the narrator's claim, made early in the story, to have unearthed "that hard, straight thing about her." The narrator's assertion that the girl is "just straight," transparent to his wise and well-trained eye, has been exposed as naive. In an intriguing narrative twist, it is the narrator who appears transparent. His "sympathy" for the family — strong enough that he lies to defend the family to his fellow physicians (he claims he didn't notice whether the mother was drinking) — is neither sentimental nor pathetic nor pitiful. It is borne of sexual desire, founded on lust; he protects the family from the colleague's accusations because the girl "did something to me that I liked." Significantly, the story makes this quite clear. We may be appalled by the narrator's bluntly erotic feelings for this young woman, but the narrator does not hide them from us.

The last story in *Life along the Passaic River*, "World's End," is composed of several vignettes and anecdotes describing notable personalities that the narrator meets on his rounds as a pediatrician and gynecologist. One of the episodes recounts the doctor's taming of a shrew — a fiery young orphaned girl who represents a version of the strong-willed woman who haunts the narrator throughout the text.

> Everyone was afraid of the little bitch. She couldn't have been more than six, a solidly built little female, who screamed, bit, fought and ran for the exits as soon as the agent deposited her on the main floor corridor. The whole staff was instantly disorganized. They couldn't get rid of her — we had to keep her by law. And we couldn't take her into the ward until she had been quieted. . . . When I arrived the special policeman had her in his lap with both arms around her while she was trying to twist herself around to get her teeth into his face. (238)

The narrator volunteers to try to calm her; he has her carried into his office and locks himself in with her. At first, she offers violent resistance to his efforts, biting him in the thigh, kicking him in the shins, scratching at his eyes, shrieking. Her insistent hell-raising initially infuriates the narrator ("I wanted to annihilate her for an instant"), then alarms him ("I became a

little frightened"), and finally dispirits him ("I thought I was licked sure" [239]). As a last resort, he offers the girl one of the crackers he has stored in his desk: "I gave her a cracker which she ate. Then she stood and looked at me. I reached over and lifted her unresistingly into my lap. After eating two more crackers she cuddled down there and in two minutes was asleep" (239). When she wakes he takes her onto the ward. However, she lets no one except the doctor touch her: "She clung to me, perfectly *docile*. To the rest she was the same hell cat as before. But when I spoke severely to her in the end she went with one of the nurses *as I commanded*" (240, my emphasis). This short episode rewrites "The Use of Force," except in this instance the "patient" submits to the doctor's authority. The "hell cat" is rendered "docile." Here, the narrator enforces power through "disciplinary intimacy," a uniquely sentimental technique of control in which authority is imposed, in Richard Broadhead's formulation, through "tenderness not rigor; . . . 'by methods that are silent and imperceptible,' not visible and tangible; . . . through intersubjectivity, not the stark polarization of authority and its subject; [through] inward colonization, not outward coercion."[65] In this scene, the narrator employs a gesture of generosity to subdue the child and render her amenable to his commands. Kindness becomes a mechanism of control. However, Williams does not simply import the techniques of disciplinary intimacy; he recasts them, replacing the traditional agent of sentimental authority—the sexless mother who manages the cult of domesticity—with a sexually potent and socially commanding father figure. In Williams's world, the sentimental paradigm of the nuclear, mother-centered, moral family no longer obtains. He disciplines the child not in the maternal fashion of holding her to his breast, but by sexually taming her—placing her on his lap, where she "cuddled." Once she has accustomed herself to the doctor's charms, he is able to speak "severely" to her and "command" her.

Williams's doctor stories are fantasies of control, but control acquired through complicated transactions. Although some of the tales appear to have tidy endings, they typically leave loose ends, residues of resistance, subtle or buried signs that the narrator's mastery—medical, sexual, emotional—is not as complete or comprehensive as he initially leads us to believe. Robert Coles has argued that Williams's tales about the working poor are stories of rapprochement: "It can be said that fiction was for this particular writer a means of reconciliation. . . . Lives healed could become lives presented to others—and always, with Williams, made an occasion for moral instruction or ethical inquiry."[66] However, if the doctor stories suggest the possibility of reconciliation, they also underscore the pitfalls of cross-cultural connection,

the irreducible ambiguities of "contact." In contrast to Coles's contention, I argue that Williams's short fiction offers no easy "moral" or "ethical" lessons. On the contrary, these stories offer scenes of moral complication and compromise, of ethical disorientation and difficulty.

In Williams's short fiction, the bodies of ethnic women serve simultaneously as objects of fascination, critical examination, desire, and, frequently, frustration. To the narrator, the often disfigured or diseased bodies of these women represent complicated totems. They bear the traces of damage inflicted by modernity—bowed legs and hearts weakened by malnutrition, diphtheria aggravated by slum living conditions, frailty caused by neglect and abandonment. They represent both the "straight hard thing" and the inscrutability of "alien" cultures. His attempts to communicate with or heal them are often met with a resistance or dissimulation that confounds him. These women are more than just their bodies, but Williams's narrator rarely achieves access to much more than the physical sides of their identities. These women's bodies offer the possibility of social reconciliation, which the narrator imagines as a complex combination of sexual and medical "contact," yet the narrator's efforts to probe and diagnose are often rebuffed, leading to his own aggravation, anger, and violence. In a manner that echoes James Agee's deeply self-reflexive, self-critical writing about Alabama sharecroppers (discussed in chapter 4), Williams's stories suggest that to write from a position of professional authority about the oppressed requires acts of rhetorical (and at times, physical) violence. Obtaining a "throat culture" necessitates, as the title of Williams's story suggests, "The Use of Force," an act of sensational contact that Williams's narrator himself recognizes as coercive—and engages in nonetheless. Williams's short fiction moves beyond sympathy, but not to solidarity; his narrator can swab the tonsils of the poor, but the speech that emanates from the "mouths of Polish mothers" remains largely misunderstood.

3

MODERNIST DOCUMENTARY
AARON SISKIND'S HARLEM DOCUMENT

In the last chapter, I argued that William Carlos Williams's fictional depictions of the immigrant poor are charged with deeply conflicting impulses: desire and disgust, longing and frustration, compassion and prejudice. Combining modernist and realist tendencies, Williams's stories avoid the romantic representation of the poor that characterizes sentimental literature while at the same time chafing against, if also indulging, the tendency of naturalist fiction to cast the poor as objects of a superior gaze, as figures unworthy of compassion and subject to forms of disciplinary scrutiny. In this chapter, I contend that Aaron Siskind's photographs from the late 1930s counteract the tendency of conventional documentary images to eliminate or repress the traces of their own making. Rather than obfuscating the residual presence of the often tense social interactions between documentarian and subject that precipitate the taking of a photograph, Siskind's images underscore that very uneasiness in the awkward poses and uncomfortable, at times even confrontational, glances of the Harlem residents he photographs. By doing so, Siskind's photographs discomfit viewers, prompting us to examine the conventions of representation and form on which documentary practice is founded.

The sensational occupies an ambivalent and highly charged place in Siskind's documentary work. On the one hand, his images reproduce certain scenarios—most notably his four-photograph sequence of a cabaret striptease—that reinforce prevailing tropes of black bodies as sensational spectacles of white entertainment and desire. On the other hand, by encouraging

forms of self-consciousness in viewers, several of Siskind's images can be said both to underscore the artificiality of the very sensational tropes that his works invoke and to acknowledge the forms of interracial eroticism that drive his own cross-cultural enterprise. Siskind's images walk an acutely fine line between reproducing and subtly destabilizing the sensationalization of black bodies that has long been a central dynamic of American visual culture.

The Politics of Documentary Photography

In his essay "The Author as Producer," originally given as an address in 1934 at the Institute for the Study of Fascism in Paris, Walter Benjamin warns of the capacity of the dominant regime of cultural production to incorporate and depoliticize potentially radical materials and impulses. "The bourgeois apparatus of production," Benjamin argues, "can assimilate astonishing quantities of revolutionary themes, indeed, can propagate them without calling its own existence, and the existence of the class that owns it, into question." As an example of the power of the hegemonic regime to subsume and transfigure potentially subversive materials into a confirmation of the dominant order, Benjamin cites trends in contemporary photography, which he argues have aestheticized images of dire poverty, turning representations of social inequality and oppression into artifacts of artistic appreciation and contemplative pleasure. The school of "New Objectivity" photography, Benjamin asserts, has become "ever more *nuancé*, ever more modern, and the result is that it can no longer depict a tenement block or a refuse heap without transfiguring it." This highly refined mode of photography "has succeeded in transforming even abject poverty, by recording it in a fashionably perfected manner, into an object of enjoyment."[1]

Echoing the thrust of Benjamin's critique of German photography, recent criticism of 1930s American documentary photography, particularly the images compiled under the auspices of the federal government's Farm Security Administration (FSA), has argued that such photography "effaced its politics," eschewing or mystifying the complicated political processes and material relations that underpin the production of documentary images and diluting the power of these images to provide meaningful social criticism.[2] Describing Russell Lee's celebrated photograph depicting the gnarled hands of an elderly farm woman, Maren Stange asserts that FSA photography abstracted its subjects from their social and political contexts, playing to popular preconceptions about the poor: it "is exactly the absence of complex social reference—combined with telling graphic appeal—that makes

the image[s] attractive and meaningful to a wide audience and that ensures [their] success as a popular symbol of humanitarian sentiment."[3] According to Stange, these images narrow the interpretive possibilities, "encouraging categorical, rather than particularizing, interpretations."[4] Along similar lines, Paula Rabinowitz asserts that documentary photography confirms the authority of the bourgeois gaze and middle-class privilege. In her analysis of *Let Us Now Praise Famous Men*, Rabinowitz argues that "no matter what its political intentions, the documentary narrative invariably returns to the middle class, enlisting the reader in a process of self-recognition."[5] Maurice Berger contends that images in the FSA files tend to downplay or diminish the trauma of Depression-era suffering, to confirm rather than contest dominant social relations. "On the whole," Berger argues, "the picture that emerges from the Historical Section is that of America's perseverance and its triumphs over poverty."[6]

This chapter examines *Harlem Document*, a compilation of fifty-two photographs of Harlem and its residents taken in the 1930s by Aaron Siskind, a white photographer working at the time with the New York Photo League, a left-leaning documentary photographic collective. Although several of Siskind's Photo League images were published in periodicals and displayed in exhibitions during the late 1930s and early 1940s, none of his league work was published in book form until the release of *Harlem Document* in 1981. Siskind's images are accompanied in the book by interviews, stories, and rhymes about life in 1930s Harlem collected independently of Siskind's project by four members of the Federal Writers' Project. *Harlem Document* is divided loosely into five sections, on Harlem's businesses, children, religious and social organizations, entertainment culture, and domestic life. As a whole, the images create a narrative that moves from exterior scenes on the street to interior, domestic settings, bringing us progressively farther "inside" the Harlem community. The tone of the photographs is generally dark, with rich shadows and sharp contrasts; compositionally, the images are relatively formal, still, and stiff rather than candid.

Siskind's *Harlem Document* falls within the bounds of what is conventionally considered "documentary" discourse. However, rather than being composed for easy consumption by white, middle-class viewers, as Berger suggests of FSA photographs, Siskind's images resonate with tension. Rather than obscuring "any reference to the circumstances of its making, to the human interaction that occurred" between photographer and subject, as Stange argues with regard to Lee's photograph, Siskind's images subtly, but provocatively, call attention to the uneasiness of cross-class and interracial

looking that his photographs of Harlem entail.[7] Siskind's images generally resist sensationalizing and sentimentalizing the poor; rather than uplifting images depicting the good work of government programs and the poignant resilience of the poor in hard times—elements that critics have argued tend to naturalize rather than challenge hegemonic social arrangements—Siskind's Harlem photographs are noteworthy for the heaviness of their tone, the awkward poses and strained expressions of their human subjects, and the contentious glances offered by several individuals he captures on film— elements that make the experience of viewing his images frequently uncomfortable.

In this chapter, I argue that the tensions encoded in the *Harlem Document* images derive from two aspects of Siskind's photographic practice: first, his syncretic aesthetic, an unusual blend of social realism and a particular strain of American modernism; and, second, the tradition of racial representation into which Siskind's images enter. *Harlem Document* represents, I contend, a modernist documentary, an unstable blend of documentary's desire for transparent social referentiality (what Siskind describes as "the essentially illustrative nature of documentary photography")[8] and modernism's tendency to treat photography as a mode of symbolic and abstract expression. The political-aesthetic tension that the images embody is heightened by the tensions of race—in Siskind's case the tensions invoked by a white photographer's efforts to portray the African American community of Harlem.

An Altogether New Object: Siskind on Modernism and Documentary

Rather than as a documentarian, Siskind is perhaps best known as one of America's premier postwar, high-modernist abstract photographers. As he explains in a 1945 article, however, his modernism "was an outgrowth of my documentary style," a style that Siskind considered "very quiet and very formal," in contrast to the more spontaneous mode for which documentary photography of the thirties is famous.[9] In his "Credo" (1956), Siskind describes his postdocumentary, abstract work in terms that emphasize the self-referentiality and social autonomy of his pictures. "When I make a photograph," he stated, "I want it to be an altogether new object, complete and self-contained, whose basic condition is order—(unlike the world of events and actions whose permanent condition is disorder and change)."[10] Siskind's photographs incorporate everyday objects only to strip them of their social meaning and endow them with purely abstract, formal significance. Siskind states that in the still lifes he was beginning to shoot as he was

completing his documentary work "the objects themselves no longer functioned as objects; instead of a piece of wood I felt the wood as a shape"; "the meaning of these objects exists only in their relation with other objects, or in their isolation."[11] The "subject matter" of his photographs is the images themselves, what Siskind calls in another essay the "drama of objects," the aesthetic play of shapes, forms, and tones on the picture plane that have no direct social references: "I accept the flat plane of the picture surface as the primary frame of reference of the picture."[12]

Siskind admits that his turn from documentary to abstract photography was predicated on a need for greater control, for an artistic process in which personal vision and "order" were the defining characteristics—in contrast to images that refer to the social world, "whose permanent condition is disorder and change." In his postdocumentary style, "the object serves only a personal need and the requirements of the picture."[13] Siskind's concern with—and rejection of—a photography of social reference—the shift in his work from a social materialism to an aesthetic materialism—represented a response to documentary work, in which photography is so often facilitated by interpersonal interaction and exchange. Documentary photography is an inherently social process, in which the meanings of objects and scenes as well as the actions of human subjects cannot be completely controlled by the photographer. As Siskind describes it, modernism thrives on the very control that documentary makes impossible. The archetypal modernist work, in Siskind's words, is "altogether new," "complete and self-contained," a self-referential object governed by formal rather than social criteria. In contrast, documentary requires a social uncertainty; it is a process that is never entirely completed or entirely free from possible interference, a process that can be assessed—even contested—from within and in the midst of the act of creation by the persons who serve as the documentary's subjects.

Harlem Document's documentary style—its social referentiality—is complicated and crosscut by Siskind's emerging modernism—the mute formalism of the images, many of which seem to be carefully composed, valued for their symbolic qualities as much as for their representational ones. At the same time, the images' modernism is disrupted by documentary's social aspects; throughout *Harlem Document*, photographs bear visible traces of the subjects' resistance to, and contestation of, Siskind's presence. Ironically, however, it is the material conditions of Siskind's photographic modernism—the extended exposure, the large format camera with a tripod, the aestheticizing "distance" of his perspective—that limits Siskind's control of the setting and his subjects, that affords the people photographed in *Harlem*

Document the opportunity to question and even challenge the camera's gaze in a way they might not be able to if his images were taken quickly or candidly with a hand-held camera. In *Harlem Document*, modernism and documentary interact dialectically, each mode producing the conditions for the other's interruption.

The tensions encoded in the *Harlem Document* images make room for critical viewing, inviting us to consider the ways in which Siskind's position—and our own position vis-à-vis his images—challenge and/or reinforce racialized and sexualized conventions of seeing. Several aspects of the images—the frequently awkward framing and composition, the reaction of his subjects to being photographed, the invocation of stereotypical scenarios or figures—open a space for the viewer to achieve a slight distance from Siskind's camera and perspective, to question Siskind's relationship to Harlem as well as the political intentions driving his project, to inquire into the social and political motives and arrangements that made his photography possible. However, if the distance that several of Siskind's images establish between viewers and Siskind's perspective creates the grounds for critical spectatorship, that distance also risks a different liability—the "Othering" of his subjects through the creation of an unbridgeable gap between the audience and the people portrayed. Politically and formally, Siskind's images walk a very fine line—on the one hand creating a measure of emotional and aesthetic separation between viewers and subjects that undercuts the potential for a facile sentimental humanism (that would pretend to erase class and racial differences in a universalizing sense of sameness), and yet on the other hand trying to avoid the objectification of the people he depicts.

Siskind, the Photo League, and *Harlem Document*

Like Tillie Olsen, whom I discuss in chapter 4, Siskind was the child of Jewish immigrants. Siskind grew up in Manhattan, first on the Lower East Side, and then in other neighborhoods as his family moved about the island. As a teenager, he was an active socialist who became head of New York's Junior Young People's Socialist League, and who showed a flair for street corner speaking. After being pressured by his high school principal to denounce his political views in order to receive his diploma, Siskind turned to culture as an outlet for his energies while an undergraduate at City College in the early to mid-1920s, immersing himself in medieval and modern literature. Siskind was given a camera as a gift in 1930, and many of his early documentary images, of homeless men and of the 1932 New York May Day

Parade, reflect his long-standing interest in poverty and politics, which had been reignited by the Depression.[14]

Similar to Jackson Pollock, the avatar of abstract expressionism who began his painting career as an apprentice to politically progressive Mexican muralists during the 1930s, Siskind developed his art in a political context. Many of his most important early images, including the photographs compiled in *Harlem Document*, were taken during his work with the New York Photo League, a left-wing photographic collective that trained over 1,500 photographers from 1936 to 1947, when it was suppressed as a "subversive organization" by the U.S. attorney general's office.[15] Although affiliated with the Communist Party, the league accommodated photographers with a wide variety of left-leaning political perspectives. Not as explicitly radical as the workers' film league with which it was associated from its inception in 1930 until 1936, the Photo League committed itself to a style of documentary photography modeled after the visual work of the FSA, "an application of photography direct and realistic, dedicated to the profound and realistic chronicling of the real world," according to Elizabeth McCausland, an art critic who supported the Photo League's work.[16] In a memoir of the Photo League, Louis Stettner, a league member, asserted that in the collective's approach to its art, "the photographer was not a law unto himself, but rather, a responsible social being, with obligations not only to subject matter, but to the people engaged in the mass struggles of our time."[17] Stettner describes the league's aesthetic as "humanist realism."[18] The Photo League was thus ensconced in the burgeoning social documentary culture of the period, a loosely formed network of artistic and political organizations ranging from federally funded and directed research agencies to radical culture associations that were invested in bringing the plight of the country's down-and-outs to public attention—often in support of New Deal agencies and programs, but also occasionally in support of independent struggles for social transformation. Documentary work produced by these numerous and varied organizations circulated in a wide array of publications, from *Life*, *Look*, and *Fortune* to the *Daily Worker* and *New Masses*. In addition to training scores of amateur artists, the Photo League sponsored lectures and exhibitions by some of the most celebrated photographers of the day (including Berenice Abbott, Ansel Adams, Dorothea Lange, and Paul Strand) and received praise from Roy Stryker, the director of the FSA's photographic division, and Beaumont Newhall, the prominent art historian.[19] At the league, Siskind founded and directed the "Feature Group," which set out to create collective photo essays documenting the disenfranchised in New York. The

titles of the Feature Group's projects—*Park Avenue North and South* (1938), *Harlem Document* (1937–40), *Portrait of a Tenement* (1936), *Dead End: The Bowery* (1937)—highlight the photographers' commitment to exposing deprivation and the stark contrasts between rich and poor.[20]

The league's aesthetic and political affiliations with FSA photography were matched by its links to an artistic ideology that Alan Trachtenberg has termed "romantic modernism"—an ethic of formal experimentation based on subjective experience and perception represented, in various forms, by photographers such as Alfred Stieglitz, Edward Weston, and Paul Strand, all of whom are cited as seminal influences in the mission statement printed in *Photo Notes*, the league's house organ.[21] Many members of the league pursued aesthetic strategies that sought to introduce not only new subjects to photography but new modes of vision and cognition as well. For these modernists, the landscape around them became a scene of formal exploration and personal inquiry, in which material reality was reworked to fit artistic temperament. Siskind and other league-affiliated photographers such as Strand understood their images not simply as "documents" of a new, modern American landscape but as profoundly personal experiments in sensibility and seeing. As Louis Stettner notes, although the league was committed to using photography to document social problems, the influence of Strand in particular provided access to a tradition in which "the final picture is essentially a subjective interpretation of reality. The photograph tells us as much about the photographer as the subject matter."[22]

According to Siskind, his documentary photographs bear the aesthetic seeds that blossomed into the highly abstract style he developed in the mid-1940s and beyond, a style that expresses what Siskind considers an "essential ambiguity." "In [all of my photographs] you have the object, but you have in the object—or superimposed on it—what I call the image, which contains my idea. These two things are present at one and the same time. There is therefore, a conflict, a tension. The meaning is partly the object's meaning, but mostly my own."[23] In Siskind's view, his images encode a struggle between personal vision and material reality. Siskind's photographs aim for compositional and emotional order, but never completely resolve the "sometimes fierce, sometimes gentle, but always conflicting forces" of which they are comprised. It is to these "conflicting forces," this "tension," that I want to pay particular attention.[24]

Siskind's comments suggest that *Harlem Document* represents a hybrid form—which we might call a "modernist documentary"—that melds social realism's focus on political problems with a modernist emphasis on the

subjectivity of the photographic act and the symbolic potential of everyday objects, scenes, and figures. Siskind's documentary work was dedicated to prompting political change through the depiction of the harsh conditions in which society's marginalized and oppressed populations lived. The images' emphasis on the gritty details of poverty and their dark, almost foreboding, tone indicate the influence of American naturalism; Siskind's collaboration with the sociologist Michael Carter, discussed below, was designed to spark social reform. However, the photographs in *Harlem Document* also exhibit elements of a modernist formalism. Although the images in the project never stray from the recognizable, Siskind treats the photographic plane as a highly aesthetic, potentially symbolic space; his images, as Siskind himself states, represent the play of "objects" and "ideas" at least as much as the depiction of social forces. As the critic Carl Chiarenza has argued, Siskind's images of Harlem cut against the grain of contemporary documentary forms and created a more formalized style that frequently distanced Siskind from his subjects: "His approach was in direct opposition to the one gaining popularity at the time: the unobtrusive, candid photography, made possible by new, miniature cameras. Siskind used his view-type camera and tripod in Harlem: a white man, operating cumbersome equipment, stood opposite each situation presented in these photographs."[25] As a result, "there is a kind of distance, a vague space between photographer and subject, which strains the mood in most of his Harlem pictures. . . . The distance conveyed conforms to Siskind's insistence that the photographer concentrate on making the picture rather than engaging his subjects in a symbiotic exchange."[26] As I argue below, although this "vague space" frequently creates, as Chiarenza notes, a feeling of "distance," it also occasionally allows Siskind's subjects a certain room to maneuver, to actively participate—in what at times appear to be unexpected or disruptive ways—in the making of the images.

Harlem Document, the Representation of Harlem, and the Great Depression

The photographs in *Harlem Document* were culled from two projects on which Siskind worked in the 1930s with the Photo League: the neighborhood studies conducted by the league's "Feature Group" and the league's "Most Crowded Block" project. The initial concept for the Harlem study was conceived in the 1930s by Michael Carter, an African American sociologist, in collaboration with the league's Feature Group. Carter had planned to provide the text to accompany the group's photos, but the project as it

was initially conceived was never published and Carter's writings for the proposed book have disappeared.

Before being compiled in Siskind's collection, images from the league's "Harlem Document" project were published in issues of *Fortune* (1939) and *Look* (1940). In both instances, text by Carter accompanied photographs taken by the Feature Group. *Fortune* devoted its July 1939 issue to a celebration of New York's World's Fair. The issue is presented as a descriptive guide to the city, complete with a foldout map and sections on New York's "people" ("The Melting pot," "The Metropolitanites," "Upper Fifth Avenue," etc.); government ("La Guardia's New York," "Health and Hospitals," "Nineteen Thousand Cops"); business culture (real estate, showgirls, fashion, taxi driving, but no mention of industrial or other forms of manual labor); and a final section on the "enigma of New York." Harlem is represented quite differently in *Fortune* than it is in *Harlem Document*, primarily on account of Carter's text, which accompanies, and in fact takes precedence over, the photographs. Carter's text is pointed in its presentation of Harlem's poverty and the discrimination and economic inequities that perpetuate it. Summing up his description of the physical and geographical nature of the neighborhood, Carter concludes bluntly, "There they live in poverty, squalor, and doubt. Nearly half of them are on relief."[27] Carter is equally direct about the factors underpinning the community's economic hardships: "More than 90 per cent of Harlem buildings, shops, and businesses are owned and run by whites today. Nor do the whites employ the blacks. Eighty-five times in a hundred, when a Harlem cash register rings, the finger on the key is white."[28] Carter continues in a journalistic register, outlining the overinflated rental prices, the population density, the conditions of the work force, as well as providing a quick overview of "Harlem's intricate social life," from "Café Society" to rent parties. Written in a pithy style, the piece was clearly devised to serve as a schematic introduction for whites to the community—the essential Harlem in three pages. In this context, the photographs (three by Siskind, five by other league members) bear a heavy burden of representation, each photo standing in for an aspect of Harlem life that is described by an accompanying explanatory snippet. Because the photographs serve as secondary evidence, reinforcing the arguments of Carter's text, the formal and compositional dynamics of the pictures are de-emphasized in favor of the "indexical" qualities of the images—their ability to provide a factual "truth" that illustrates the quantitative, statistical documentation provided in the commentary. As we shall see, the photographs included in *Harlem Document*, without captions or

Carter's narrative—codes that overdetermine the meaning of the images in *Fortune*—function differently.

In *Harlem Document*, the "strained mood" that Chiarenza argues characterizes Siskind's photographs takes on an expanded charge and a pressing currency because of the field of racial representation in which the images intervene. *Harlem Document* takes its place in a crowded and contested history of cultural representations of the African American community in Harlem. Siskind's images were produced in the late 1930s, on the heels of the Harlem Renaissance, an artistic and social movement that promoted Harlem as a cultural mecca—a sophisticated center of African American art, writing, and philosophy—in the hopes that demonstration of the black community's cultural achievements could improve race relations. Although the Renaissance by and large excluded popular art forms such as the blues and neglected to address the political and economic disenfranchisement suffered by the vast majority of African Americans, the movement produced a powerful array of stories, novels, essays, and visual art that lent new visibility to black culture in the white community and, announcing the arrival of the "New Negro," assertively challenged many long-standing derogatory myths held by whites about blacks.[29] Despite the Renaissance, however, white attitudes toward African American culture, often embodied in white minds by Harlem, were frequently dominated by ignorance, prejudice, and/or primitivism. For many whites, African Americans served as exotic symbols of innocence and regeneration, inherently more "natural" than the increasingly commercialized, mechanized, and industrialized quality of modern American culture. Siskind's images, I will argue, at times play upon and reinforce these stereotypes and at other times appear to challenge them.

If Harlem served as a literal and symbolic site of pride and accomplishment for blacks during the Renaissance, it was nonetheless a largely poor, segregated neighborhood. Harlem residents were especially hard hit by the Depression, as were African Americans across the United States, because they were positioned near the bottom of the nation's economic system. In the early years of the crisis, unemployment in Harlem rose to 40 percent, roughly double the rate for white New Yorkers. Median black income fell 44 percent between 1929 and 1933; in the latter year, 40 percent of black families were on relief, as many economic sectors—from construction work to white collar to retail—remained largely closed to African Americans. The vast majority of stores in Harlem were white owned and, despite their black customer base, most refused to hire African Americans as clerks. Even in their treatment by municipal authorities, Harlem and its residents were sub-

ject to discrimination. Of the 255 parks built by Robert Moses during his massive public works program during the 1930s, only one was located in Harlem.[30]

Tensions around race and economics flared in 1935, shortly before Siskind and the Feature Group began their work in Harlem. On March 19, a black youth was caught shoplifting at E. H. Kress and Company, a department store. When the police arrived, the store manager decided not to press charges, but rumors began circulating that the boy had been beaten and killed. Protesters gathered and when police tried to disperse them, members of the crowd began smashing store windows and looting. A commission charged by Mayor La Guardia to investigate the root causes of the uprising concluded that economic hardship, including poor housing, health, and public facilities, set the stage for unrest: "The explosion on March 19 would never have been set off by the trifling incident described above had not existing economic and social forces created a state of emotional tension which sought release upon the slightest provocation. As long as the economic and social forces which were responsible for that condition to operate [continue], a state of tension will exist in Harlem and recurrent outbursts may occur."[31] It was into this "state of tension"—caused by a convergence of economic suffering, discrimination, and a long history of racial misunderstanding—that Aaron Siskind ventured as he, along with other progressive photographers in the Photo League's Feature Group, set out to document Harlem.

The Photographs

The critic Paula Rabinowitz has argued that "looking at photographs is both a transgressive and comfortable act—difference is domesticated, brought home for inspection, open to critique, but the everyday is glaringly made strange, remarking on one's own position even as another's life is revealed."[32] The interplay of strangeness and familiarity that Rabinowitz describes is especially potent in Siskind's Harlem photographs, images of African Americans taken by a white documentarian for a predominantly white audience. In particular, several of *Harlem Document*'s domestic photographs—in both form and content—make "visible," as it were, the dynamic Rabinowitz observes. One of the most provocative of Siskind's interior photographs portrays a man lying on a bed, apparently sleeping (figure 3.1). Behind him, a dresser stands against the wall, on which an array of posters of white celebrities is plastered. On the one hand, this image "domesticates" the strange. We see this man in his home environment; his pose—relaxed,

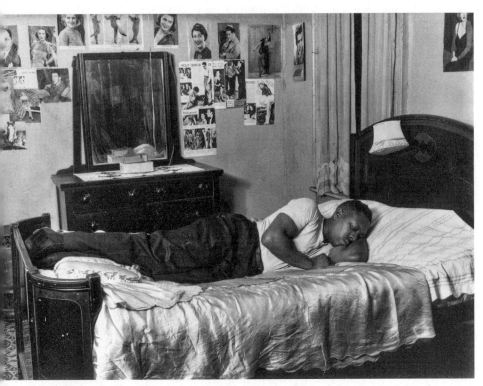

Figure 3.1. Aaron Siskind, Untitled, ca. 1932–40.
Courtesy of the Aaron Siskind Foundation and the George Eastman House.

fully extended—makes him "open for inspection," in Rabinowitz's terms. However, on the other hand, two aspects of the image also lend a quality of "strangeness" to Siskind's position as photographer and our position as viewers, "remarking on [our own] position even as another's life is revealed." First, the fact that the man is sleeping while we regard him raises questions about how this photo was made. How did Siskind come to stand in this man's bedroom? Did the man know he was being photographed? What authority did Siskind have to take this photograph—did he ask permission? How is the viewer's gaze complicit in this seeming violation of privacy?

The second element of the image that generates a self-reflexiveness about the viewer's position is the series of images on the far wall surrounding the dresser. These images are mass-produced shots of white celebrities—movie stars, dancers, performers, predominantly women, but some men as well. Their stiff poses and broad, direct smiles strike a contrast with the dormant figure of the sleeping man, stretched on the bed with his eyes closed. The pinups complicate the image in several different, but intersecting ways. First, they introduce an element of racial difference into the picture (the fact that all the celebrities are white is particularly remarkable because the man in the room is black), reminding us of the racial difference between photographer and subject. The stark contrast between the dormant black man and the sparkling white faces plastered on the wall above him evokes the racial divide separating Siskind (and most likely the viewer) from the figure on the bed. Second, the pinups also indicate the fantasy-producing power of photographic images, asking us to imagine the head shots of white celebrities as the content of the sleeping man's dreams, sugar plums dancing in his head.[33]

If this photograph implies that the images of smiling white faces serve as the focus of this black man's desire, we might also ask in what way this black man's body is positioned as the object of Siskind's (and the anticipated white viewer's) desire? Tellingly, the man is cast in a traditionally "feminized" position, displayed like Titian's *Venus* to the viewer's gaze. The sleeping man is exposed for an unobstructed view, but unable to question our right to that view. Posed in this passive position, he figures as an object of desire, fully accessible to Siskind's gaze. This desire for the black body represents the flip side of the distance and silence that so many of Siskind's photographs inject between photographer and subject, the other half of the dialectic of ambivalence on which so many of Siskind's pictures turn, the fantasy that serves as a counterweight to the anxiety about the representation of black figures that permeates Siskind's photography. The intrusiveness of Siskind's presence

suggests another perspective from which to view the celebrity shots on the wall, one that invokes the more insidious side of the circuits of desire that pervade this image. The pinups can be viewed as images not necessarily of the sleeping man's fantasies but of his nightmares; figures not only of desire but also of surveillance, representing white culture's impossible standards of polished perfection that perhaps haunt, more than fascinate, the man's dreams.

As a whole, the composition of the image—the sleeping man, the empty mirror, the pinups—suggests Siskind's awareness of the symbolic potential of photography. The combination of elements lends the image a metaphorical quality, suggesting that viewers regard the scene not only as a "document" but also as a consciously provocative artistic statement. The image of the sleeping man not only "captures the real," bringing the "interior" life of Harlem to white viewers; it also prompts one to think of photography as a mode of personal expression, in which the arrangement of objects gestures toward a thematic statement about the very act of photography itself—in this case about the relationship of photography and dreams or the unconscious. This symbolic self-consciousness represents a central aspect of the modernist component of Siskind's hybrid documentary. This image, like many of Siskind's other images, is not only about the thing represented but also about the act of representation itself. I take this high degree of artistic self-consciousness to be a mark of Siskind's modernism, his tendency to conceive of an image not just as a record of "reality" but as an entity unto itself, "an altogether new object, complete and self-contained," in his words. Siskind's image of the sleeping man thus suggests two ways in which it can be understood—both as a document embedded within a larger narrative of Harlem life and as an autonomous product of personal aesthetic vision.

Harlem Document and
"The Threatened Return of the Look"

The image of the sleeping man points to Siskind's uneasy relationship with his photographic subjects. This uneasiness pervades the pictures; very few of the persons who appear in *Harlem Document* address the camera directly (nine individuals out of the forty-eight images containing human subjects), and when they do, they frequently express surprise, or even suspicion, at the camera's presence. Two photographs, for instance, capture women striding toward Siskind in the street as he snaps their pictures. One woman returns the camera's gaze with a look of distaste, the other with a look of muted defiance. In figure 3.2, Siskind frames a group of four men

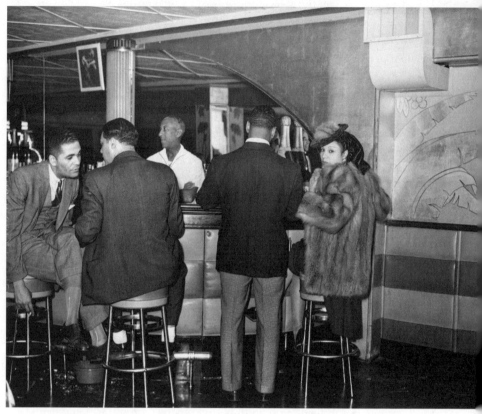

Figure 3.2. Aaron Siskind, "Saloon, Small's Paradise," ca. 1937.
Courtesy of the Aaron Siskind Foundation and the George Eastman House.

and a woman gathered at a bar. The two men on the left chat casually, ostensibly unaware of Siskind's presence as are the other two men, one with his back to the camera and one with his head turned away. However, the woman in the group, with her arm on the man next to her, gazes directly into the camera, as if contesting, or at least questioning, the photographer's presence. The woman's glance serves a double function in the image. Her gaze collapses the distance between the removed position of the camera and the group gathered at the bar—it centers the image, attracting and grounding our attention. Yet, the intensity of her gaze strikes a sharp contrast with the relaxed, hunched poses of the two men chatting on the left side of the photo and lends the picture a feeling of discomfort, as if the photographer has intruded. Like several of the images in *Harlem Document*, this photograph locates its viewers in an ambivalent position. As we look from a distance, our gaze is at one and the same time met and rebuffed, our interest simultaneously sparked and contested. By including glances that question or contest the camera's view within his photographs, Siskind draws attention to the invasiveness of his own documentary practice.

Perhaps *Harlem Document*'s most uncomfortable photograph, and also one of the most emotionally charged, is Siskind's picture of women at a religious service (figure 3.3). This image revolves around a sharp juxtaposition. The photograph centers on four women, three dressed in black, one in white. The woman in the foreground, hands folded serenely in her lap, gazes past Siskind's lens; the woman next to her glances at the third woman, dressed in white with an infant in her arms, whose head is tilted back and her mouth open wide, apparently singing out in response to the service, seemingly undisturbed by the photographer. She is separated by a railing from the fourth woman who gazes directly back across the photo to Siskind, offering him (and thus us) a sneering, almost disgusted, look. Although the emotional energy of the woman in white, who sits in the center of the photo, rivets the viewer, the contentious gaze directed at the camera by the woman on the left side of the photo undercuts the uninhibited expression of the woman in white, unsettling the emotional tenor of the photo and making Siskind's presence seem awkward, intrusive.

Siskind's rendering of the woman holding the infant personifies the stereotype of black woman as pure body: baby in hand, she represents the desexualized maternity of a "Mammy" figure; mouth wide open, she seems to embody corporeal excess and uninhibited religious primitivism. The way in which this image plays into easily recognized demeaning tropes of black female identity lends what Homi Bhabha calls a "fixity" to the woman—

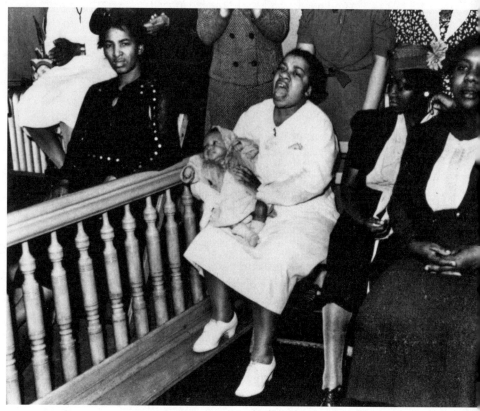

Figure 3.3. Aaron Siskind, "Church Singer," ca. 1937–40.
Courtesy of the Aaron Siskind Foundation and the George Eastman House.

she is so heavily coded as a carnal and uncultured figure that she confirms the privilege of the viewer.[34] However, the easy confirmation that the viewer might receive is undermined by the gaze of the woman on the far side of the banister who looks back at us with disgust. It is this knowing, confrontational gaze—the represented figure returning the glance of the representer—that the stereotype attempts to erase, but which Siskind foregrounds. In this image, Siskind splits the two sides of the stereotype—objectification and the threatened return of the look which that intense focus on the Other makes possible—and places them side by side in an uneasy tension.[35]

As a final comment on this image, it is worth noting that the history of the photograph's publication underscores the unsettling effect of the gaze of the woman on the far side of the banister. When this image was reproduced in a 1940 issue of *Look* magazine (in a photo-essay written in response to Richard Wright's controversial novel *Native Son*, discussed in chapter 6), the figures on either side of the woman holding the child were cropped from the photograph. By excising the woman who confronts the camera, the magazine radically transformed the shot, eliminating the sense of discomfort with which her hostile gaze endows the image. The resulting picture, which contained only a stereotypical figure and no contesting glances, was much less complex, suiting the context in which it appeared—an article that claimed to deliver the "essentials of Negro existence" and that encouraged readers to take what they saw as transparent, and easily consumable, truth.[36]

The sense that Siskind—and by extension the viewer—looks into Harlem as an outsider is foregrounded by a series of five consecutive domestic photographs that appear in *Harlem Document* after the image of the women in church. The first image depicts a lone woman, shot slightly from behind, working in a kitchen; the next depicts the silhouette of a woman, from behind, with a child in a living room; the third depicts a kitchen and a woman knitting in a room off the kitchen's opposite side; the fourth depicts a woman climbing stairs, away from the camera; the fifth depicts a woman and girl sitting at a kitchen table—the girl looks away from the camera at the mother, who glances down at the table. Two elements in these photographs establish a sense of the camera's distance from the persons being photographed. First, none of the five women in these images looks toward the camera—they are either captured from behind or look down and away from the camera. Second, in three of the five images, the human figures are in rooms adjacent to the photographer and are photographed through doorways. The door frames, which partially block and "re-frame" our view,

symbolize the social and cultural "threshold" that Siskind must cross as he enters the apartments of Harlem. If *Harlem Document* is meant to bring white viewers "closer" to Harlem and its residents, to provide an "inside" look, the text at the same time gestures toward the difficulty of this process of intercultural translation. Rather than obfuscating the potential intrusiveness of documentary photography, as critics argue many FSA images tend to do, the photographs in *Harlem Document* make the invasiveness of the documentary enterprise visible.

To achieve a clearer sense of the general uneasiness—the distance and discontinuity between photographer and subject—that characterizes the photographs of women in *Harlem Document*, we might compare Siskind's images to the celebrated 1942 portrait of Ella Watson by African American photographer Gordon Parks (figure 3.4). Commonly referred to as "American Gothic" because it recasts the famous Grant Wood painting of a farm couple, Parks's image depicts Watson, who worked as a nighttime cleaner in the federal building that housed the FSA, where Parks was interning on a fellowship, standing in front of an American flag with a broom and a mop, the tools of her menial labor. Parks met Watson his first evening at the FSA offices and formed a relationship with her, eventually visiting and photographing her and her grandchildren over a series of months.

The tone of "American Gothic" is defined by Watson's conscious participation in the photographic act. She gazes straight into the camera, collaborating in the ironic subversion of the patriotism symbolized by the flag draped behind her. Her eyes pierce the photographic plane; her gaze is serious, steady, and straightforward, almost confrontational. The directness of her look and the solidity of her stance lend her an aura of strength and determination that belie her position at the low end of the occupational spectrum. The frontality of Watson's pose and the eye-level position from which the photograph is taken establish an equality between Watson and the viewer. In contrast, *Harlem Document* does not include a single interior photograph in which the subject looks directly into the camera. The only figures in *Harlem Document* who smile directly at the camera are male shopkeepers posed in front of their stores; the female figures in the book who acknowledge the camera's presence appear remarkably uncomfortable—one woman, pictured sitting in a large chair beneath a lamp with a frilled shade, leans awkwardly away from the camera, as if bracing herself for the click of the shutter; one young woman, photographed sitting outside with what appears to be a parade in the background, gazes squarely but quite anxiously into the lens, her hands clasped stiffly in her lap.

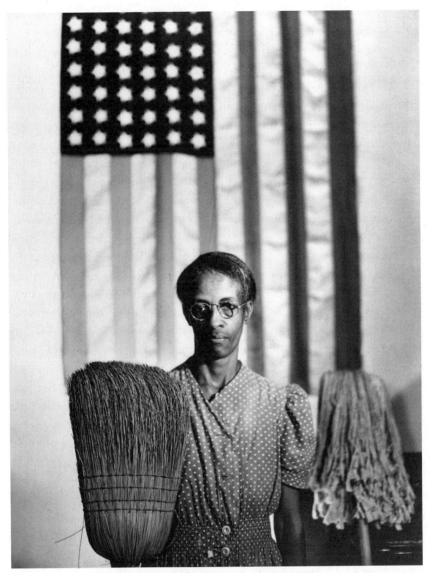

Figure 3.4. Gordon Parks, "Washington, D.C. Government charwoman," 1942. FSA-OWI Collection, Prints and Photographs Division, Library of Congress.

Siskind's fascination with looking, and with the responses of his subjects to the camera's presence, forms the central subject of figure 3.5, a picture of members of the Brotherhood of Sleeping Car Porters at a union meeting. On the one hand, the photograph emphasizes the group's collective identity: the men are seated in rows and wear identical uniforms. On the other hand, the picture highlights discrepancies between the individuals in the group: the angle from which the photograph is taken—cutting diagonally across the rows of seats—and the different postures in which the men align their bodies—some slouching or leaning back slightly, others sitting more rigidly or leaning forward—disrupt the symmetry and uniformity of the audience. Several of the men glance toward the camera, a few somewhat quizzically, others more defensively. One man touches his finger to his chin, as if posing a question in his mind concerning the camera's presence. The variety of the porters' gazes and glances—some toward the front of the hall, others toward the camera—throws the unity of the union members further askew. Read in the context of the other photographs in the text, the interplay of looks—the variety of responses to the camera—emerges as the central subject of the photograph. The photograph does *not* tell us how many persons are attending the meeting, where the gathering is held, who the speaker is, or what the topic of the meeting might be. Instead, the camera's fundamental concern seems to be the responses of the men being photographed to the camera itself. The photograph "documents" the porters' meeting—it offers visual "evidence" of the gathering—but does so in a way that minimizes our understanding of the social and political implications of the event, asking us instead to consider the relationship between the photographer and the persons depicted.

While several of Siskind's photographs present subjects who return the camera's look, other images feature individuals who do not have the opportunity to respond. Figure 3.6, a close-up shot of a young boy's head, is one of the most problematic images in the text. The photograph's collapsed perspective, in which the subject's head consumes virtually the entire frame, serves to focus the viewer's eye on the play of shapes and shadows—the sunlight on the boy's scalp and ear, the glint of light on his nostril and lower lip, the brightness of his white shirt, the contours of his skull—and to efface the context of the boy's existence. What do the starched shirt and tie signify? The blurred background obscures any clue as to where he might be standing or sitting. Is he going to church? To school? Is he alone? The close-up compels us to view his head more for its formal and compositional features than for how the boy relates to his social and material environment, for the

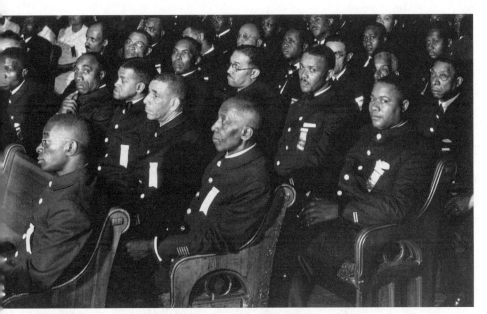

Figure 3.5. Aaron Siskind, "Pullman Porters," ca. 1935.
Courtesy of the Aaron Siskind Foundation and the George Eastman House.

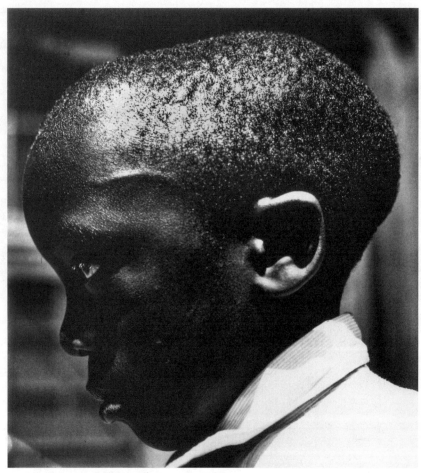

Figure 3.6. Aaron Siskind, "Head," ca. 1933.
Courtesy of the Aaron Siskind Foundation and the George Eastman House.

way he is culturally and politically positioned. In effect, the image represents the boy as a shape; it reduces him to an object of aesthetic contemplation, casting his identity in terms of his biology, decontextualizing and dehistoricizing his subjectivity. In doing so, it recalls late nineteenth-century phrenological science, which judged black subjectivity according to the size and shape of the cranium. Yet, the expression on the boy's face complicates this way of reading him. He gazes straight ahead; an expression of concentration and resolution is outlined on his features. He tilts his head forward slightly, pressing his chin toward his chest, as if lowering his head in silent defiance. His expression suggests he is uncomfortable with, strained by, his pose, and offers a subtle sign of resistance to the camera's objectifying gaze. The strain registered on the boy's face and the awkward angle at which he holds his head serve to challenge the aestheticizing tendencies in Siskind's images and suggest, more broadly, the photographer's willingness to allow for discomfort to be a sustained element of his work in *Harlem Document*.

In a fascinating series of images depicting a black band, black singers, and black dancers performing at a nightclub before a group of white patrons (figure 3.7), Siskind foregrounds questions of white voyeurism. Like many of Siskind's other photographs, these images thematize the politics of white looking, implying that white visual pleasure is frequently achieved through the eroticization and commodification of black bodies. The camera in these shots occupies a removed position, high above the performance floor. This perspective allows viewers to observe the scene from a distance and enlarges the frame to include not only the black performers, but also their white audience. As the floor show progresses, we see the audience members' expressions, positions, and attitudes shift in response. Each of the photos is divided cleanly into two sectors by the post supporting the balcony, which separates the performers from the audience, crowded around a small table. Despite the compositional division, the performance and viewing spaces intersect: the legs and chairs of the white observers encroach onto the dance floor. The images depict white viewing as a counterpoise to black performing, indeed as a type of performance in itself in which the audience strikes poses to complement the movements of the entertainers. (In two of the photographs we also see off-stage performers standing behind the white patrons, further complicating the layers of looking, suggesting that even the audience is unknowingly subject to the glances of the very dancers they objectify). By recording the reaction of white viewers to black performers, these photographs encourage anticipated white viewers to think critically

Figure 3.7.
Aaron Siskind,
Cabaret performers
(left to right):
"Singer,"
"Cabaret Dancers,"
"Cabaret Strip
Dancer," "Cabaret
Strip Dancer,"
ca. 1937.
Courtesy of the
Aaron Siskind
Foundation and the
George Eastman
House.

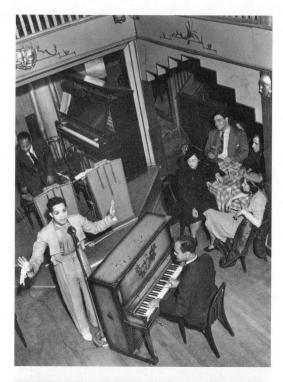

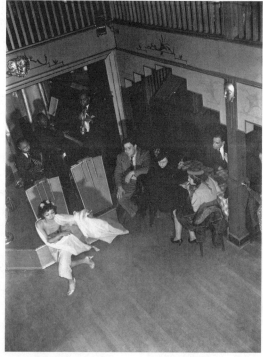

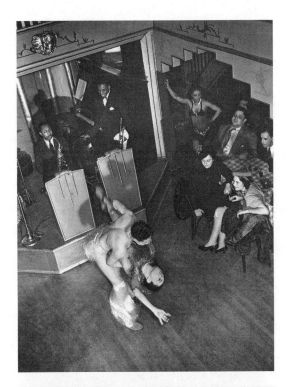

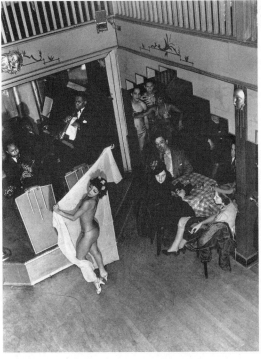

about their own position relative to the African American figures in this scene and throughout *Harlem Document*.

As a series, the images construct a virtual time-lapse narrative that charts the progressive exposure of the naked, black bodies performing for white pleasure. The first photograph presents a fully clothed man; the second, a partially clothed male-female couple; the third, a scantily clad woman; and the fourth, an almost completely naked woman. The carefully composed sequence details the dynamics of culturally prevailing black-white scopic relations, in which black bodies are presented for white entertainment and fantasy. Although white watching and black entertaining are depicted as two sides of the same coin, it is clear who controls the currency—if we consider the audience members as counterpoints to the black performers, the nakedness of the black woman reminds us how unequal the relations portrayed in these images are. However, these photographs not only question these unequal relations; they reinscribe them, reenacting the very striptease being "documented" by following, rather than disrupting or refusing, the suspense and eroticism that constitute the performance.

Siskind's cabaret pictures present the bodies of black dancers as objects of consumption; in a provocative contrast, a photograph taken by African American photographer Morgan Smith titled "Back Stage at the Apollo" depicts the bodies of black dancers from the perspective of the labor they perform. Smith and his twin brother, Marvin, operated a photographic studio in Harlem from the mid-1930s through the 1940s; they published individual photographs as well as photo essays of political rallies and demonstrations, Harlem nightlife, and African American organizations for the black and white press. The photograph captures four female dancers backstage between performances. Two of the women stare blankly ahead; one of them, her head propped on her hand, looks directly into the camera. The third seated woman is engrossed in a book she holds and does not acknowledge the camera's presence. Although the women are dressed in revealing stage costumes, their poses de-glamorize and de-sensationalize their bodies. The three sitting women slouch in their chairs, shoulders sagging, costumes drooping slightly. The harsh lighting accents the blemishes on two of the women's faces and the circles under their eyes. A bare light bulb hangs in one corner of the room and unpainted walls frame the space in which they are gathered. This image strikes a marked contrast to Siskind's portrayal of nightclub dancers in figure 3.7. In Siskind's set of images, the bodies of the dancers appear in dynamic and seductive poses. In addition, our vantage-point is from above and from a distance, which allows us to see without

being implicated in the scene—the figures below are presumably unaware of our presence. In contrast, in the Smith brothers' image we see the Apollo dancers not from above, but at eye-level; the directness of the glance from the seated woman in the rear commands our attention and preempts a voyeuristic gaze from the viewers. By recording the backstage fatigue of these women, the photograph reminds us that performing is *work*, physically exhausting and conducted under demanding conditions. By featuring the performers' bodies at rest, collapsed unglamorously in chairs and crowded together in makeshift quarters, the picture asks us to reinterpret their on-stage performances as complex constructions of beauty and grace created through draining physical labor.

Like Siskind's photographs of the nude female dancer, two other images of dancers included in *Harlem Document* play on long-standing white stereotypes of black bodies. Both images evoke the formal vocabulary of blackface minstrelsy, in which, as Eric Lott argues, caricatures of black bodies were paraded on stage as objects of both white derision and white envy.[37] Figure 3.8 depicts a couple dancing at the Savoy Ballroom. The picture presents the man's body as a grotesque and disruptive form. Like a minstrel dandy, ridiculed for "putting on airs," he does not seem to fit the suit he wears. His face, reared back and shot from a low angle, is dominated by his gaping mouth, stereotypical symbol of black sexual voraciousness and licentiousness. The man's expansive, exaggerated form engulfs and symbolically overpowers the woman with whom he is dancing: his arm obscures her face, and his leg, extended in a phallic position, splices our view of the woman's body in two. The woman's arched back and tiptoed stance emphasize the male figure's massiveness and dominant position; his capacious suit coat seems about to swallow her slender figure. The slit of bare skin above her stocking emphasizes her vulnerability in the hands of the man, whose physical presence determines the tone of the image.

Like the image of the couple at the Savoy, figure 3.9—printed in *Harlem Document* on the page opposite the dancing couple—presents a contorted black body. Shot in the midst of his routine, the performer's body is frozen in a stiff and ungainly, even mechanical, pose, his arms held rigidly before him, his hands locked in fists. His face—chin and lower lip jutting out, eyes bulging—registers a sense of strain. The performer's stilted stance and sharply protruding appendages echo the exaggerated posture of the dancing couple. The iconography of his pose—his awkward position, protruding buttocks—echoes the physical excess and exaggeration of blackface performance. In this photograph, as in the other shots of black dancers, we see the

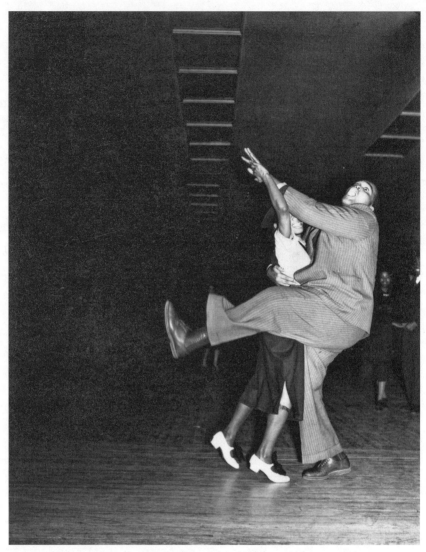

Figure 3.8. Aaron Siskind, "Savoy Dancers," ca. 1937.
Courtesy of the Aaron Siskind Foundation and the George Eastman House.

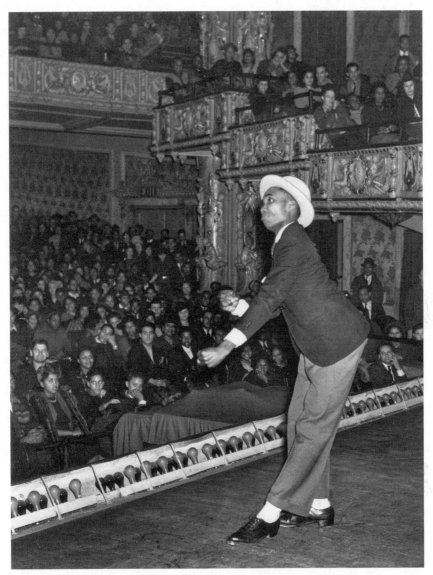

Figure 3.9. Aaron Siskind, "Amateur Performer, Apollo Theater," ca. 1937–40.
Courtesy of the Aaron Siskind Foundation and the George Eastman House

images of disfigured, sensational bodies in Siskind's work, images of bodies bent and distorted not, as in Williams's stories by disease and privation, but by the force of racial prejudice manifested as aesthetic conventions.

It is difficult to know how Siskind might have intended or anticipated that these images would be interpreted, and perhaps even more difficult to imagine how viewers might have actually responded to these two photographs. Eric Lott has argued that blackface minstrelsy expressed a paradoxical fear of and fascination with racial difference, enacting a white "love and theft" of black cultural practices. By alluding to minstrelsy, by drawing on such a well-established discourse of racial stereotype, and by presenting such exaggerated images, Siskind's photographs might be said to create a critical space in which viewers are encouraged to question the way that African Americans are represented in his own photographs and in the culture at large. Given the self-reflexive character of many of Siskind's images, it is likely that the evocation of racial clichés in these photographs was calculated to give viewers cause to pause, to question Siskind's intentions, as well as their own preconceptions about racial representation. However, there is a perilously thin line between the critical exposure of aesthetic conventions and the simple reproduction of them, and, unlike figure 3.3 (the women at a religious service), these images do not include an element or figure (such as the woman glaring with disgust at the camera) that explicitly unsettles our gaze.

The ambivalences about racial representation in Siskind's Harlem oeuvre echo, and are accentuated by, the fundamental formal ambivalence that his images embody. In *Harlem Document*, "race" and racial difference stand for the "social" more generally, the whole world of interpersonal interaction, difference, and conflict with which Siskind admitted he was becoming increasingly uncomfortable during the 1930s. As a form, modernist documentary's conflicting impulses—on the one hand, documentary's engagement with the social in an attempt to convey the fullness of the "real," and, on the other hand, modernism's tendency toward formal autonomy and abstraction—balance, in an uneasy tension, the photographer's divided political and aesthetic commitments.

A Deep Need for Order:
Harlem Document and Beyond

As I have suggested, *Harlem Document* illustrates Siskind's mixed feelings about the documentary enterprise. Even as the Photo League's "Harlem Document" project was receiving its highest level of exposure (in the 1940

article in *Look* and as a prominent part of the photographic exhibition organized by Ansel Adams at the 1940 Golden Gate International Exposition), Siskind had begun to turn his eyes toward new projects—ones that extended the aesthetic concerns of his particular documentary style, but in quite different contexts. Siskind admitted in a 1945 article that "the so-called documentary picture left me wanting something."[38] In 1940, he spent the summer in Martha's Vineyard shooting a series of still lifes of objects in the island's boatyards and on piers: coils of rope, a discarded fish head, a pitchfork, a stray boot. Although stemming in part from what Siskind considered the "very quiet and very formal" quality of his documentary photography, he shifted to a much more abstract aesthetic style: "I noticed that I was photographing objects in a setting. . . . I wiped out deep space and had objects which were organic in a geometrical setting. I was getting away from naturalistic space. . . . I was operating on a plane of ideas. The shift was from description to idea and meaning."[39] His new style, he concluded, "appear[s] to be a representation of a deep need for order."[40] Siskind's newer photographs were organized around the isolation of objects in a "flat, unyielding space," a scenario that, although often still resonant with friction like the images in *Harlem Document*, removes the tension from a heavily charged social encounter (a white man toting his tripod around Harlem taking photographs of African Americans) to an abstract space. Siskind's turn away from documentary work is understandable.[41] The images in *Harlem Document* push the boundaries of the style by exposing exactly what most documentary photographs from the period attempted to mask: the traces of the frequently strained social interaction that transpires between documentarian and subject. In that sense they are unsettling images—photographs that register the uneasiness and invasiveness that most documentary images from the period eschewed. Rather than obfuscating the intrusive potential of documentary practice, Siskind's images productively and provocatively thematize it.

The paradox of "modernist documentary" describes the formal tension Siskind's images embody, a tension and a form that emerged at a particular time and in a particular political context, not only in Siskind's career but also in the culture more generally. In a certain sense, modernist documentary represents the end point of 1930s documentary—documentary stretched to its limit. On the one hand, the form conveys the optimism and confidence of 1930s social analysis and activism (of which the Photo League was an outgrowth) that reality could be captured and, if captured accurately, analyzed and reformed. On the other hand, modernist documen-

tary represents the decline in the late 1930s of that sense of optimism and formal certainty, especially in the face of the rise of fascism in Europe and the threat of fascism in the United States. Couched somewhat differently, modernist documentary points to the instability of the realism-modernism divide. In particular, it suggests that realism's effort to render the "real" frequently breeds a narrative self-consciousness that we recognize as a hallmark of modernism. Siskind's images for the Photo League's "Harlem Document" project expose the social tensions involved in rendering images of the oppressed for a more privileged audience. By encoding this uneasiness, his images ask viewers to question the relations of cultural power that govern the social divide between wealthy and poor, black and white. Out of this tension and reevaluation, more egalitarian modes of representation and seeing have the potential to emerge.

4

A PIECE OF THE BODY TORN OUT BY THE ROOTS

JAMES AGEE, TILLIE OLSEN, WILLIAM FAULKNER, AND THE CONTINGENCIES OF WORKING-CLASS REPRESENTATION

Perhaps no documentary book from the 1930s has been more widely celebrated than James Agee and Walker Evans's 1941 portrait of three Alabama tenant farming families, *Let Us Now Praise Famous Men*. In his groundbreaking study of Depression-era documentary expression, William Stott contends that *Famous Men* "culminates the documentary tradition and breaks its mold."[1] Critics have lauded *Famous Men* in particular for the deeply self-reflexive quality of Agee's writing, evident in the author's expressed frustration with the incapacity of language to represent the full materiality of the sharecroppers' existence. "This is a book only by necessity," Agee insists early in the text. "More seriously, it is an effort in human actuality in which the reader is no less centrally involved than the authors and those of whom they tell."[2] How, Agee asks, can "human actuality" be represented? It can never be fully rendered in text, Agee admits, but he aims to push the limits of the "literary" as far as possible to give readers the most tangible sense possible of the real. "Words cannot embody," he asserts, "they can only describe. But a certain kind of artist . . . continually brings words as near as he can to an illusion of embodiment. In doing so he accepts a falsehood but makes . . . better art" (238). Unlike Walt Whitman, who believed that words are as fleshy as human life, Agee suggests that words are descriptive signifiers of a more vital and

concrete reality toward which the writer can only gesture or refer.[3] Rather than write, Agee states, he would do better to provide a variety of extratex-tual evidence that would overcome the incapacity of language to embody: "If I could do it, I'd do no writing at all here. It would be photographs; the rest would be fragments of cloth, bits of cotton, lumps of earth, records of speech, pieces of wood and iron, phials of odor, plates of food and of excrement" (13). And then, in a sentence given the significance of a full paragraph, Agee states: "A piece of the body torn out by the roots might be more to the point" (13).

What are we to make of Agee's comment that, rather than written text, the most appropriate testimony of the tenants' lives would be a "piece of the body torn out by the roots"? The graphic image Agee paints here—a mangled or disfigured, perhaps bloody, fragment of flesh—is designed to stretch the boundaries of textuality, both to signify the limits of any "book" to capture the materiality of lived existence and to create a figure that, al-though delivered in words, gestures beyond language. The very vagueness of the image (which "piece of the body"? why "torn"?) suggests the insuf-ficiency of language to adequately convey or describe the intimate textures of the sharecroppers' lives. The violence of the image—the dismembered body—implies both the potential violence of representation (to represent the body is to tear it) as well as the physical violence inscribed on the ten-ants' real bodies by harsh labor, frequent hunger, and extreme weather. In addition, Agee's graphic image is clearly engineered to disrupt the easy sympathy that liberal documentary conventionally affords its readers. "Lib-eral documentary," the photographer and critic Martha Rosler argues, "im-plores us to look in the face of deprivation and to weep (and maybe to send money, if it is to some faraway place . . .)."[4] Documentary typically asks readers to feel rather than act, to sentimentalize rather than analyze, a dy-namic that Agee caustically parodies: "This is a book about 'sharecrop-pers,' and is written for all those who have a safe place in their hearts for the laughter and tears inherent in poverty viewed at a distance . . . in the hope that the reader will be edified, and may feel kindly disposed towards any well-thought-out liberal efforts to rectify the unpleasant situation down South" (14). Agee's text represents an explicit attack on the representation of poverty and pain that would afford readers the emotional safety of moral and political "distance." The image of the torn body, calculated to evoke a shudder of dis-ease, is designed to challenge the anticipated complacency of Agee's presumably privileged audience.

Starting with a brief analysis of the textual portion of *Famous Men*, this chapter and the next one examine two novels, respectively—Tillie Olsen's *Yonnondio* and Pietro di Donato's *Christ in Concrete*—that employ sensational images of wounded, disfigured proletarian bodies to critique traditional modes of representing the poor and to fashion alternative aesthetic forms that convey the force of social violence without objectifying or romanticizing the working class. Similar to the way in which Agee invokes the image of a torn body to signify both the possibilities and limits of his own textual practice, spectacular images of disfigured bodies in Olsen's and di Donato's texts serve as allegories of the novels' aesthetic compressions, fractures, and deformations as well as highly charged figures of political protest. Mixing a naturalist emphasis on oppressive social forces with a proletarian insistence on the politics of class and labor with avant-garde techniques of rhetorical innovation and estrangement, Olsen and di Donato create monstrous incarnations of modernism in which experimental formal devices are deployed to narrate the material contradictions of history that high modernism typically seeks to transcend or suppress.

Although Agee, Olsen, and di Donato share a fundamental aesthetic and political project—to render the poor in a noncondescending fashion and to employ experimental linguistic forms to render the contours of political injustice—these writers approach this task from different social locations and labor under different imaginary and rhetorical limits. Agee occupies a position of relative social authority and cultural prestige. A Harvard graduate and an established journalist on assignment for *Fortune*, the question he confronts is how to represent that which is alien, Other—the white working poor of the Southern farm belt. Like Aaron Siskind and William Carlos Williams's doctor-narrators, he is a professional, outside investigator whose work is, in part, a meditation on the problematics of his privilege. Tillie Olsen and Pietro di Donato face a similar question, but from a position of social alterity. For these two working-class authors, the issue is not how to represent that which is unknown, but how to achieve social recognition for that which is familiar and culturally neglected; not how to represent what Carla Kaplan calls "undesirable desire," but how to represent *unfulfilled* desires, dreams, and needs that industrial capitalism fails to satisfy.[5] The task Olsen and di Donato set for themselves is thus double sided: to represent working-class individuals who are desiring subjects while at the same time to do narrative justice to the violence inflicted on those individuals by industrial capitalism. To accomplish this, these authors create unique forms of

radical modernism in which vigorously experimental rhetorical techniques are deployed to narrate the multifaceted quality of social and political duress and struggle, privation and persistence, destitution and desire.

This chapter culminates with my reading of Olsen's incomplete novel *Yonnondio*, which was written in the early 1930s but was lost and not published until 1974. In an effort to measure Olsen's modernism—to grasp the manner in which her work echoes, appropriates, and transforms the discursive techniques of more established modernist writers—I briefly compare her novel to William Faulkner's *As I Lay Dying*, which was published just before Olsen commenced work on *Yonnondio*. Although Olsen and Faulkner held quite different attitudes toward the possibility of collective working-class action and radical social change, these two novels both tell stories of poor people on the move during the early 1930s, and both use forms of highly fractured, stream-of-consciousness narration to render complex the thoughts and feelings of uneducated, ostensibly "simple" people. In doing so, both novels advance modernism's hermeneutic skepticism to question class-coded assumptions, undercutting well-established conventions of depicting the rural poor as noble, sentimental figures of stoic endurance or as pitiful figures whose poverty confirms their innate degeneracy.

Transcendence and Desire in
Let Us Now Praise Famous Men

Since the 1960s, critics have proclaimed Agee's prose portion of *Famous Men* as the apotheosis of sensitive, self-conscious documentary. "An intensely self-reflexive text," one critic announces in a representative comment, "Agee's text repeatedly and obsessively undermines its author's authority."[6] Clearly, Agee is well aware of the intrusive and even potentially exploitative position he holds as investigator, documenter, writer of lives. Much like William Carlos Williams and Aaron Siskind, Agee is a professional who seems quite cognizant of the power and authority he possesses relative to the poor people he observes. He describes himself as "spy" and "burglar," as a "quite monstrously alien human being" (13) who was asked to "pry intimately into the lives of an undefended and appallingly damaged group of human beings" (7). More than any other major documentary text written during the thirties, *Famous Men* makes readers aware both of the inherent limits of literary representation—the fact that no matter how well Agee writes, the tenants exist above and beyond his words—and of the specific forms of social advantage that separate the authors and the text's anticipated readers from the impoverished people whose lives the book aims

to portray. As the critic T. V. Reed has argued, *Famous Men* "can be read as a detailed political allegory about the relations between those of us with the power to represent others and those we claim to represent."[7]

However, certain elements of the text counteract Agee's self-deprecating insistence on the inevitable "inadequacy" of his representational efforts. First, Agee's rejection of "Art" is countered by his occasional lapses into the discourse of aesthetic transcendence; and, second, the stridently democratic tenor that the text generally maintains is contradicted by Agee's remarkable lack of self-consciousness about the sexually aggressive quality of his gaze, a gaze that boldly strips the tenants bare before us, reinforcing (and indeed eroticizing) their vulnerability and undercutting the care and sensitivity with which the writer otherwise treats his human subjects. Both of these dynamics are evident in a section near the end of the book, in which Agee describes two images that to him epitomize the hope and human strength that the tenants embody despite their wretched conditions. The first image is of Mrs. Gudger nursing her son Squinchy. Mrs. Gudger sits in a chair, "her dress open and one broken breast exposed," holding her child, "his mouth intensely absorbed at her nipple as if in rapid kisses," "his face beautific, the face of one in paradise" (441–42). Agee summarizes the image by emphasizing its transcendent quality: "I see how against her body he is so many things in one, the child in the melodies of the womb, the Madonna's son, human divinity sunken from the cross at rest against his mother, and more beside, for at the heart and leverage of that young body, gently, taken in all the pulse of his being, the penis is partly erected" (442). The second image is of Ellen Woods lying asleep on the porch floor, an empty sack over her to protect her from flies. She is, Agee writes, "completely at peace . . . the arms squared back, the palms open loose against the floor, the floursack on her face . . . her blown belly swimming at its navel . . . a snoring silence of flame" (442). Agee asserts that Ellen's serene respiration and "flaming" navel capture an eternal quality of human existence: "and here in this breathing and play of flame, a thing so strong, so valiant, so unvanquishable, it is without effort, without emotion, I know it shall at length outshine the sun" (442).

In several ways, Agee's rendering of these images undermines the progressive cultural work that other, earlier aspects of the text perform. First, these images naturalize and aestheticize the tenants, removing them from the specific historical and social conditions that shape their lives and recasting them as representatives of a universal and eternal "human condition"— "a thing so strong . . . it shall at length outshine the sun." Although Agee's glorification lends the destitute farmers an aesthetic significance and moral

power that readers might have been inclined to deny the lowly sharecrop-pers, the passage does so by abstracting them from the political and material contexts that Agee had earlier gone to great lengths to suggest are essential for understanding their lives. Agee argues for the tenants' moral worth by casting them as personifications of a transhistorical humanity, as represen-tatives of human nature's "eternal" rhythms and drives—the "melodies of the womb" and the force of (phallic) desire Agee that sees in Squinchy's erect penis. Furthermore, in his rendering of these images, Agee's self-consciousness about his privilege disappears.[8] The descriptions inscribe a hierarchy between the narrator, who sees and provides "meaning," and the passive objects of his masterful gaze. In these images the figures of the tenants are silent, essentially sculptural; they exist as mute objects whose meaning is recognized and elaborated by Agee's genius. Agee's recasting of the tenants as embodiments of aesthetic beauty and timeless humanity in this scene suggests that, in addition to being an agonized articulation of the author's hesitations and self-doubt, *Famous Men* is also a self-conscious exercise in literary prowess and expertise—an assertion of the writer's au-thority to lend meaning and significance to the lives of the tenants, who frequently figure as objects of his complex contemplation rather than as partners or participants in their own representation.[9]

Agee's focus on Squinchy's penis and Mrs. Gudger's breast recall other moments in the text where Agee sexually objectifies the tenants. Early in the book, for instance, he describes himself sitting up late at night in a room next to the sleeping Gudgers. Figuratively drifting into the adjacent room, he undresses and inspects the bodies of the sleeping family in a re-markably voyeuristic fashion. The father and the three "harmed" (57) boys receive relatively cursory treatment. Agee describes "George's red body" only briefly, emphasizing the way in which labor has shaped it: "a little squat with the burden of thirty years, knotted like oakwood" (57). However, Agee lingers over the naked bodies of the women in a decidedly erotic manner. Annie Mae's "slender" body, he observes, is "veined at the breast, and the skin of the breast translucent, delicately shriveled, and blue"; "the body of Emma" is "strong, thick and wide, tall, the breasts set wide and high, shallow and round"; Louise's "green lovely body" is noteworthy for "the dim breasts faintly blown between wide shoulders, the thighs long, clean and light in their line from hip to knee" (57). Although Agee is acutely self-conscious of his aesthetic and economic privilege, he demonstrates no self-reflexiveness about the sexually predatory nature of his gaze, especially as it applies to the female sharecroppers. Even the critic Linda Wagner-Martin,

who identifies Agee's "absorption in the sexual," ultimately finds that the erotic quality of his focus on women only adds to the power of the text.[10] For Agee himself, the realm of sexual desire exists beyond the bounds of those facets of perception that must be actively interrogated. The sexually charged quality of his approach goes unremarked, reinforcing the vulnerability of the tenants before his voracious eyes.

In contrast to Agee, for whom the bodies of the tenants serve as objects of his own fascination, symbolic imagination, and sexual desires, Olsen and di Donato present working-class persons as desiring, imagining, creating subjects. Although deeply concerned with working-class consciousness, Olsen and di Donato foreground the material aspects of proletarian existence—the ways in which the body's labor, hunger, illness, mutilation, and desire produce, enable, and limit their characters' psychological and emotional worlds. Olsen and di Donato employ high modernist techniques conventionally used to represent interior, abstract consciousness to narrate the embodied character of working-class life under industrial capitalism. If Agee's text exposes the tenants' bodies for voyeuristic inspection, Olsen's and di Donato's novels imply that the vulnerability of the poor to privileged eyes is a form of political subjugation, a product of social and cultural hierarchies that their writing aims to challenge. Rather than casting the poor as mute, passive objects of middle-class fascination, Olsen and di Donato create arresting images of physical injury and thwarted working-class aspirations that are calculated to interrupt the pleasure or solace that looking down the social scale so often engenders.

Bodies Writing History: 1934 Labor Unrest and Olsen's "The Strike"

In *Starting Out in the Thirties*, Alfred Kazin argues that during the Depression writers from socially disenfranchised communities entered into the mainstreams of American literature in significant numbers for the first time. "The Thirties in literature were the age of the plebs," he writes, "of writers from the working class, the lower class, the immigrant class, the non-literate class, from Western mills and farms—those whose struggle was to survive. When you thought of the typical writers of the Twenties, you thought of rebels from 'good' families—Dos Passos, Hemingway, Fitzgerald, Cummings, Wilson, Cowley. What was new about the writers of the Thirties was not so much their angry militancy, which many shared, as their background; writers now came from anywhere." "The real excitement of the new period," Kazin asserts, "was in the explosion of personal liberation

which such writers [the "plebs"] brought in from the slums, farms and fac-
tories."[11]

Although Kazin's view is overly schematic and romantic, it identifies one
of the central accomplishments of the proletarian movement: the education,
promotion, and publication of writers from groups that before the 1930s
had not produced (many) professional writers.[12] During the decade, the
Left—through writers clubs, journals, magazines, and publishing houses—
helped a generation of young working-class writers find their voices and put
their words into print. According to Kazin, these writers imagined their
task as an extension of, if also a challenge to, the modernist movement:
"What young writers of the Thirties wanted was to prove the literary value
of their own lives, to feel that we had moved the streets, the stockyards, the
hiring halls into literature—to show that our *radical* strength could carry
on the *experimental* impulse of modern literature."[13] This attempt to bring
"into literature" the perspectives of the working poor who inhabit slums
and work in factories and on farms, and to do so in a way that echoes the "ex-
perimental impulse" of modernism, constitutes the common project Olsen
and di Donato share.

Olsen's parents, Samuel and Ida Lerner, were part of the dissident move-
ment in czarist Russia and came to the United States after the failure of the
1905 revolution. They settled in Omaha, Nebraska, where Samuel became
secretary of the state Socialist Party. Although Olsen attended school through
the eleventh grade, her primary learning occurred, she has stated, in the
"college of everyday work," the "college of motherhood," and the "college
of human struggle." From a young age, Olsen worked (as a "tie presser, hack
writer, . . . model, housemaid, ice cream packer, book clerk"),[14] mothered
(her first daughter was born when Olsen was in her early twenties), and
organized (a member of the Young Communist League, Olsen was active in
several strikes and union drives), much of the time as a single parent. Olsen
recalls that she had "fallen in love" with literature at a public library. At the
age of fifteen, she read Rebecca Harding Davis's *Life in the Iron Mills* (1861)
in a bound volume of *Atlantic Monthly*'s bought at an Omaha junk shop.
Davis's work suggested to Olsen that "literature can be made out of the lives
of despised people" and that "you, too, must write."[15] But finding the time
to write was a major challenge for a young working mother; when she was
able to write, it was often in brief moments, stolen during work or between
shifts. Olsen remembers penning snippets of articles or fiction on scraps
of butcher paper or the backs of checks picked up while cleaning floors to
earn a living; some of her notes for *Yonnondio* are scribbled on the reverse

sides of political leaflets.[16] As we will see, the material circumstances of her authorship — her constant battle against the time-consuming responsibilities of working-class motherhood — shape Olsen's writings: the style and form of both her 1934 article "The Strike," which includes an explicit discussion of the compromising conditions of reporting, and her novel *Yonnondio*, a text filled with narrative gaps, testify to the constricting conditions under which they were written.

In 1933, Olsen moved from the Midwest to Stockton, California, and eventually to San Francisco. Her travels were dictated in part by economics: "When you didn't pay your rent you just moved," she explained in an interview.[17] Shortly after Olsen arrived in San Francisco, the city became the site of one of the most explosive and spectacular labor battles of the 1930s. When officials of the newly formed International Longshoremen's Association (ILA) settled a contract with shipping companies that failed to satisfy rank-and-file demands, San Francisco longshoremen went on strike. The strike spread up and down the West Coast, from San Diego to Seattle. In July, two months into the work stoppage, employers and city officials used police, armed with "vomiting" gas, guns, and clubs, to bring in scabs and resume work on the docks. Strikers and police clashed violently on Thursday, July 5, a day workers and sympathizers thereafter referred to as "Bloody Thursday." Two strikers, Howard Sperry, a World War I veteran and ILA member, and Nick Bordoise, a member of Cooks' Union and the Communist Party, were shot by police and killed; hundreds were injured in the fighting.

Newspaper accounts of the July 5th battle underscored the spectacular nature of the violence. The *San Francisco Chronicle* opened its account by stating, "Blood ran red in the streets of San Francisco yesterday."[18] "Don't think of this as a riot," the *Chronicle* remarked, "It was a hundred riots, big and little, first here, now there. Don't think of it as one battle, but as a dozen battles."[19] The opening line of the *Daily News*'s account of the day read: "The National Guard was ordered to San Francisco's waterfront by Gov. Merriam today as riot after riot swept the Embarcadero, swirled around the Ferry Building and gripped the downtown industrial area and Rincon Hill."[20] The rhetoric of swirling, sweeping, and gripping highlighted the turbulent, chaotic quality of the conflict, which took the form of multiple small skirmishes. The *Chronicle* reported: "Hundreds were injured or badly gassed. Still the strikers surged up and down the sunlit streets among thousands of foolhardy spectators."[21] It is impossible to know from this account how those spectators might have felt, but the clash was followed by a citywide general strike that brought San Francisco to a virtual economic stand-

still as more than 130,000 workers walked off their jobs. The strike was short lived, but it resulted in a beneficial contract for the longshoremen.

Before the strike Olsen had been contributing to the *Waterfront Worker*, the ILA newspaper, and for her, as for many people in San Francisco who responded to "Bloody Thursday" by participating in the general strike, the sight of working-class bodies, in open opposition to union leaders and municipal authorities, clearly had a powerful impact. Much as newspaper accounts played up the sensational aspects of the struggle, especially the amount of blood spilled and the bodies injured, Mike Quin, a labor sympathizer who wrote one of the earliest and most extensive narrative chronicles of the strike, punctuated his account of "Bloody Thursday" with sketches of wounded strikers and bystanders:

> Scores of men littered the sidewalk, either lying silently or crawling away painfully on their hands and knees.
> A woman alighting from a streetcar by the Ferry Building screamed and collapsed when a bullet struck her in the temple. A man rushed to her assistance, was struck by another bullet, and crumpled to the street beside her.[22]

As we will see, the arresting depiction of laboring and working-class bodies — male and female, adult and child — becomes a crucial trope in Olsen's work from the mid-1930s. In Olsen's article about the strike, as in the notably fractured and uneven newspaper accounts of it, the aggressive public display of massed proletarian bodies, and the officially sanctioned violence against those bodies, interrupts economic, civic, and literary "business as usual." Olsen's writing suggests that these bodies are engaged in composing an alternative account of history that requires new linguistic techniques to record and new forms of reading to understand.

"The Strike," published in the first issue of *Partisan Review*, offers a snapshot of the ways Olsen combines modernist aesthetic strategies and political radicalism, a combination she extends in *Yonnondio*. The article represents an example of proletarian reportage, a genre defined by Joseph North at the 1935 American Writers' Congress in New York City as an engaged form of journalism designed to move its audience not only intellectually but emotionally and ultimately physically as well. Reportage, North asserted, is "three-dimensional reporting," "both an analysis and an experience, culminating in a course of action."[23] Although written from a proletarian perspective, reportage is, according to the subtext of North's descrip-

tion, a modernist genre—a kind of modernist documentary. North contends that reportage is "characteristic" of the twentieth century, an era marked "by the swiftness of the time. Everywhere we find the old forms breaking up—everywhere we find the new emerging."[24] The emphasis on the "newness" of reportage, on the "swiftness" the genre reflects, and on its emergence amid the collapse of older forms, has a decidedly modernist ring to it. Reportage is born from and dedicated to capturing the accelerated pace of modern existence, "a period of swift, violent action"; matching modernity's tumultuous flux, the genre possesses "almost infinite flexibility."[25] During the thirties, reportage took a variety of different forms—character sketches, first-person workers' reports, short narratives, interviews, letters to President Roosevelt. As a genre, North argues, radical reportage challenges both the political perspective and the formal stability of mainstream journalism. Indeed, proletarian reportage is characterized not only by a political concern for the working classes but also by a penchant for formal experimentation: "We discover from a study of these pieces that boundary lines are being trampled all the time."[26]

"The Strike" stretches what North calls the "flexibility" of reportage close to its rhetorical and ideological limits. In the article, Olsen employs a number of experimental literary techniques—including collage, parataxis, and surrealist imagery—to challenge conventional journalism's rhetoric of objectivity and to dismantle the languages of power through which government and corporate executives attempted to define the strike in public discourse. Like Olsen's fiction, "The Strike" suggests both the discursive nature of politics and the political nature of discursive production, implying on the one hand that the ability to enforce power is contingent on the capacity to shape the way "reality" is perceived, and on the other hand that the ability to shape perception is contingent on the political position and power of a given speaker.

In "The Strike," modernist strategies of collage and syntactical disruption serve a range of discursive and political purposes. First, Olsen uses these techniques to establish a tone and a pace for the piece that mirror the social chaos and political unrest of the events she describes. Just as "the city became . . . a battlefield," Olsen's article becomes contested terrain, on which the voices of strikers, newspapers, city officials, and corporate executives compete for control.[27] The narrator herself admits to "feeling too much in too brief a space of time" (5) and acknowledges that her "words are feverish and blurred" (9). The formal construction of the article—long,

rambling sentences juxtaposed with short, sharp ones; pastiches of quotations from workers, newspapers, and city officials; a mixture of past and present tenses—reenacts the confusion and turmoil of the strike itself.

Second, Olsen employs modernist elements to perform a version of what Fredric Jameson has termed "dereification"—the demystification of dominant cultural discourses, in this case the ideology of objectivity and the cultural authority with which the state's coercive and ideological forces (the police, the courts, the city administration) misrepresent and justify violence against the strikers. Throughout the article, Olsen creates "pictures . . . pieced together from words of comrades, of strikers, from the pictures filling newspapers" (7). By juxtaposing these sources, Olsen insists that the strike has become not simply a contest of individuals but also a contest of texts: "'It was as close to war . . . as actual war could be,' the papers blared triumphantly, but [union leader Harry] Bridges told them, 'not war . . . MASSACRE, armed forces massacring unarmed'" (6). "They called the [national] guard out . . . 'admitting their inability to control the situation,' and Barrows boasted, 'my men will not use clubs or gas, they will talk with bayonets.' . . . With two baby tanks, and machine guns, and howitzers, they went down to the waterfront to take it over, to 'protect the interests of the people'" (7). In these passages, Olsen demonstrates that the struggle is being waged on ideological as well as physical fronts; whether or not the strike will succeed depends at least in part on who defines the strike and how it is defined. The task of the radical reporter—and reader—is to collect, juxtapose, and evaluate the conflicting textual fragments through which the participating parties attempt to give the strike meaning. One of the central tactics Olsen uses to expose discursive contradiction is collage. In one noteworthy example, she intercuts mayoral calls for order with descriptions of strikers who were shot and beaten by the city police:

> LAW—you hear, Howard Sperry, exserviceman, striking stevedore, shot in the back and abdomen, said to be in a dying condition, DEAD, LAW AND ORDER—you hear and remember this Ben Martella, shot in arm, face and chest, Joseph Beovich, stevedore, laceration of skull from clubbing and broken shoulder, Edwin Hodges, Jerry Hart, Leslie Steinhart, Steve Hamrock, Albert Simmons, marine engineer, striking seamen, scaler, innocent bystander, shot in leg, shot in shoulder, chest lacerated by tear gas shell, gassed in eyes, compound skull fracture by clubbing, you hear—LAW AND ORDER MUST PREVAIL— . . . (6)

In this passage, Olsen employs a form of pastiche to juxtapose acts of police violence with the government statements that they are meant to uphold but in fact directly contradict. By surrounding and interrupting the calls for order with descriptions of the injuries to the bodies of strikers, Olsen undermines the legitimacy of the city's directives. Her refusal to employ proper punctuation creates a sense of urgency and chaos that heightens the reader's impatience with the city's hypocrisy. At other points, the narrator intervenes more directly, in one instance deconstructing the ostensible universality of a newspaper statement: "'Life,' the capitalist papers marveled again, 'Life stopped and stared.' Yes, you stared, our cheap executive Rossi [the mayor of San Francisco]—hiding behind the curtains, the cancer of fear in your breast gnawing, gnawing; you stared, members of the Industrial Association, incredulous, where did the people come from, where was San Francisco hiding them . . ." (9). Here, Olsen cuts to the core of the newspapers' bias, asserting that the version of reality, of "life," that they present is written from capital's point of view. Olsen implies that "life" is a contest of representations, that reality is a question of perspective, and that revolution must be waged not only on the streets, but on the discursive terrain of public rhetoric as well.

In addition to undercutting the rhetorical authority of the city's demands for an end to the unrest and the newspaper's presentation of the strike, Olsen destabilizes her own position as narrator, announcing the impossibility of attaining the professional detachment that conventionally defines the position of an impartial observer. Like Agee, Olsen inserts herself as a character into her narrative, undermining any pretensions to objectivity. In fact, she opens the article by asking to be relieved of the duty she has set out to fulfill: "Do not ask me to write of the strike and the terror. I am on a battlefield, and the increasing stench and smoke sting the eyes so it is impossible to turn them back into the past" (3). Olsen insists that she is not simply recording events from a neutral position; on the contrary, as a witness, she is implicated in the action she observes—the fumes issuing from the conflict on the waterfront infiltrate her writing space. Acknowledging the impossibility of escaping the "sting" of the "battlefield," she mocks the narrative conventions that demand the construction of a recognizable, linear story: "If I could go away for a while, if there were time and quiet, perhaps I could do it. All that has happened might resolve into order and sequence, fall into neat patterns of words. I could stumble back into the past and slowly, painfully rear the structure in all its towering magnificence, so that

the beauty and the heroism, the terror and significance of those days, would enter your heart and sear it forever with the vision" (3). Yet Olsen admits that the conditions under which she is writing prevent her from casting the strike into "order and sequence," "neat patterns of words"; she cannot give the events she has seen an epic frame or allow readers to view them in classical, transcendent forms—"magnificence," "beauty," "heroism." On the contrary, she presents her report as provisional, partial, and partisan.

In addition to underscoring the provisionality of "The Strike," Olsen emphasizes both the materiality of language and the language of materiality. To begin with, Olsen implies that writing is a material act conditioned by the circumstances under which it is produced. For example, at one point Olsen interrupts herself to let the reader know her typewriter jammed: "Yes, those days were crescendoing—and the typewriter breaks, stops for an instant—to Bloody Thursday" (5). At the same time as she reminds readers that writing is conditioned by material circumstances, she also insists that aspects of material life have textual meaning: "H-E-L-L C-A-N'T S-T-O-P U-S. Days, pregnant days, spelling out the words" (3). Translating the days of struggle into words—making language embody—is the duty of the witness. Olsen's task, as a writer of history, is "to read the lesson the moving bodies underneath were writing" (5), "to comprehend the lesson the moving bodies were writing" (7). For Olsen, bodies are texts; to comprehend history from a perspective other than the "official" ones offered by the mainstream press and politicians requires that we learn to decipher the message of massed bodies, "not [as] curious spectators, but to stand there, watching, silent, trying to read the lesson the moving bodies underneath were writing" (5). Olsen's modernism, her efforts to forge an experimental language that breaks the bounds of rhetorical convention and expectation, flows from her desire to write an "embodied" prose that can convey the visceral pain and power that bodies contain. It is an aspiration that is quite similar to James Agee's, but rather than find in bodies a kernel of transcendent meaning, her embodied prose aims to transmit the particularities of specific struggles, labors, injuries, and desires—the ways in which bodies shape and are shaped by the contingencies of historical circumstances.

Olsen concludes "The Strike" with an image of a pregnant woman standing on a street corner. Appearing at the end of the rhetorical frenzy and narrative disorientation—the "feverish and blurred" words—that characterizes the piece, this woman represents the clearest image of calm and stability that the article contains: "There was a pregnant woman standing on a corner, outlined against the sky, and she might have been a marble,

rigid, eternal, expressing some vast and nameless sorrow. But her face was a flame, and I heard her say after a while dispassionately, as if it had been said so many times no accent was needed, 'We'll not forget that. We'll pay it back . . . someday'" (9, ellipsis in the original). Initially, the passage suggests that the woman might serve as a cathartic image—a classic, transcendent monument to everlasting human woe. But Olsen quickly undercuts this potential aesthetic resolution to the strike's profoundly political problems. The woman is not a passive object to be cast in bronze as a silent tribute to "nameless sorrow"; rather, she is a speaking subject who bears witness to a specific struggle, vowing both to remember and to redress the atrocities she has seen.

The pregnant woman at the end of "The Strike" might be seen as a metaphorical figure for the narrator of *Yonnondio*. Like the expectant woman, *Yonnondio*'s narrator invokes and then undercuts the possibility of encapsulating the social experience of poor and working peoples in "some vast and nameless sorrow," of containing the material and ideological densities of working-class existence—and all social life—within a "rigid, eternal" form. In contrast to such grand sorrow, *Yonnondio* represents a much more chaotic and uneven form of representation, a composite mode of literary expression that fuses a modernist emphasis on rhetorical experimentation with a materialist focus on social conflict and bodily harm.

Cameos and Contingencies: *Yonnondio's* Radical Modernism

Olsen had begun to write *Yonnondio* in 1932, at the age of nineteen, a year before moving to San Francisco. The text, unfinished and lost until the early 1970s, when it was edited and finally published, narrates the story of the Holbrooks, a working-class family searching to find a stable living during the Depression.[28] The text charts the Holbrooks' migration from a Wyoming mining town to a South Dakota farm and then to a slum adjacent to a packinghouse in an unnamed midwestern city. The first third of the novel—in the mining camp and on the farm—is narrated predominantly through the eyes of Mazie Holbrook, age six. The latter section of the text, which recounts the Holbrooks' struggle to carve out a living in the packinghouse ghetto, is told primarily from the perspective of Mazie's mother, Anna, who, after being raped by her husband, Jim, falls ill and nearly dies.

Like "The Strike," *Yonnondio* is characterized more by narrative fragmentation than by continuity or coherence. The narrative point of view and voice shift several times; the text moves in fits and starts and at different

speeds, at times slowing to record a scene in immense detail, at other points shuttling quickly between several scenes that occur simultaneously. The fragmentation of "The Strike" suggested the contested, provisional quality of representation, the fact that a strike is a struggle among words as well as between bodies and organizations. In such a context, the narrator's voice is merely one (quite partisan and at times apparently unreliable) voice among others, all bearing different levels of social and political power. In what follows, I contend that *Yonnondio*'s formal inconsistency, its fractured shape and texture, represents the convergence of two things: first, the history of the text's production, a history marked by loss and (incomplete) recovery; and second, the text's brand of radical modernism, in which forms of narrative fragmentation and semantic experimentation are used to convey both the quotidian forms of trauma (abuse, overwork, hunger, illness) and the brief moments of resilience and creativity that mark the characters' lives. Although "unfinished," *Yonnondio* remains a deeply dialectical text. Rewriting narratives that objectify, marginalize, or romanticize the poor, the text underscores both despair and hope, subjection and struggle, complicity and resistance. The emblems for these dual impulses are the characters' bodies, sources of desire and energy, on the one hand, and sites of vulnerability and violence, on the other.

Several critics have addressed *Yonnondio*'s unorthodox form and style, but none has offered an extended meditation on the text as a work of American modernism. Critical assessments of the novel have tended to focus on Olsen's blend of feminism and Marxism, and her challenge to the masculine conventions of proletarian writing. Paula Rabinowitz, for instance, argues persuasively that the novel boldly recasts the traditionally male-centered proletarian bildungsroman by giving priority to female desire and disempowerment.[29] The analysis offered here is interested less in the text's dialogue with proletarian fiction than in its implicit conversation with American modernism, that is, in the ways Olsen uses experimental devices often associated with high modernism to render working-class concerns about poverty, oppression, and labor.

The dualities—of presence and absence, aspiration and injury—that animate the novel are embedded in its very title, which poses a tension between permanence and contingency. *Yonnondio*'s title derives from Walt Whitman's elegy for American Indians, a portion of which Olsen quotes as an epigraph to the book. Written as a "lament for the aborigines," the poem proposes an act of witness for a radically persecuted population that the poet fears is vanishing without recognition, leaving no record of its existence: "No pic-

ture, poem, statement, passing them to the future: / Yonnondio! Yonnon-
dio!—unlimn'd they disappear."[30] The poet faces a problem—the lament he
utters is itself a form of "limning," but one inadequate to the task of "pass-
ing them to the future." The poem can only testify to the tribe's disappear-
ance, utter what the poet calls a "muffled sonorous sound," but is unable
to keep the sound itself from dissipating: "A wailing word is borne through
the air for a moment, / Then blank and gone and still, and utterly lost." The
poem itself can do no more than testify to the *lack* of a "poem, statement"
adequate to lending the Indians a future, to the *gap* between existence and
representation.

The sense of loss, textual inadequacy, and aesthetic impermanence that
structures Whitman's poem also haunts Olsen's novel, the uncompleted
manuscripts of which were abandoned at the time of their initial writing in
the early 1930s, then lost for almost forty years before being rediscovered,
edited, and finally published. As Olsen explains in a note that precedes the
novel, the published text is a patchwork of remnants—"odd tattered pages,
lines in yellowed notebooks, scraps"—that apparently represent only part
of the original writings.[31] "Other parts, evidently once in existence," she
notes, "seem irrevocably lost" (v). Although Olsen insists that the novel
"is all the old manuscripts—no rewriting, no new writing," the process of
reconstruction was arduous: "The first four chapters, in final or near-final
form when fitted together, presented only minor problems. The succeeding
pages were more difficult to reclaim. There were usually two to fourteen
versions to work with: 38 to 41 year-old penciled-over scrawls and fragments
to decipher and piece together" (v). If Olsen's novel is, like the poem for
which it is named, a "lament," it mourns not only the cultural invisibility
of working-class people like the Holbrooks, neglected by the grand narra-
tives of historical record and the dominant canons of literature, but also the
very possibility of its own textual completion. Like Whitman's poem and
"The Strike," *Yonnondio* is a text that foregrounds the epistemological dif-
ficulty of its own project. *Yonnondio* suggests that "limning" is not a matter
simply of including that which has been previously occluded from dominant
discourse, of merely "representing" the "truth" of an "authentic" "experi-
ence." Rather, it is a highly complex rhetorical act, a piecing together of
various, and at times conflicting, discursive modes and registers, a process
inevitably incomplete and structured by loss.

Despite the absence of a complete, original manuscript, unpublished
notes left by the young writer provide insight into her initial objectives.
One note, a typed page housed with the manuscript scraps, suggests that

the novel was designed to contest prevailing conventions through which the poor were seen and represented:

> They like to think that the poor have their compensations that out of nothing they make their own happiness and blessings, it helps, it makes them feel more comfortable, but to show what it is they really endure out on the playground, the wind knived playground, so bare, so gray, the children played, and the smell that came in, came down from the packinghouses, the lessons, the so follish [sic], so fuitel [sic] lessons, what could they teach these children of poverty, what could these lessons given them that wasn't known, and how cold they were most of the time, how miserable with their running noses, and the no handkerchiefs and the clothes that did not protect, the handmedowns, and chiarity [sic] clothes, and the mothers so worried, the burden on them, the heavy burden of home and worry, and helplessness, the utter helplessness, the lice, the shame over the lice. [A]ll of it, all of it, what it means, to make them feel too, and shudder at it . . .[32]

In this passage, Olsen explains that she wrote the novel to illustrate to those who "like to think that the poor have their compensations" "what it is they [the poor] really endure." The text was composed not merely to compensate for a lack of representation of working-class persons in literature, but also to contest the ways in which working-class culture and subjectivity have been previously depicted, to destabilize ways of seeing and reading that allow readers to "feel more comfortable." In an effort to make readers "feel too, and shudder at it," Olsen creates here a language that "shudders," that, in listing the painful quotidian circumstances of poverty, overruns the bounds of conventional syntax. Her prose quivers with a sense of desperation, mirroring the way the myriad daily frustrations, shames, and pains suffered by working-class persons compound one another, "all of it, all of it," converging in a sense of disempowerment, suggested in this passage by the way in which the length and pace of the writing overwhelm the reader.

In large part, *Yonnondio*'s experimentalism represents an effort to somehow give voice to the pleasures and pains of working, hungry, and neglected bodies. Indeed, in Olsen's fiction, as in "The Strike," bodies are texts; as the critic Mara Faulkner observes, for poor people like the Holbrooks, who have been historically silenced and culturally marginalized, "one must read the stories of lives transcribed on bodies or miss them altogether."[33] Quite often, these stories are tales of terror: men injured at work, women wounded by domestic abuse and rape as well as by labor, children debilitated by hun-

ger and neglect. Describing a mine accident early in the novel, the narrator emphasizes the horrid impact of industrial violence on laboring bodies and counters the potential for readers to transform such images of pain into objects of aesthetic pleasure:

> And could you not make a cameo of this and pin it to your aesthetic hearts? So sharp it is, so clear, so classic. The shattered dusk, the mountain of culm, the tipple; clean lines, bare beauty. . . .
>
> Surely it is classic enough for you—the Greek marble of the women, the simple, flowing lines of sorrow, carved so rigid and eternal. Surely it is original enough—these grotesques, this thing with the foot missing, this gargoyle with half the face gone and the arm. In the war to live, the artist, Coal, sculpted them. It was his master hand that wrought the intricate mosaic on this face—splintered coal, inlaid with patches of skin and threads of rock. . . . And inside it carve the statement the company is already issuing. "Unavoidable catastrophe . . . (O shrink, super's nephew, fire boss that let the gas collect) . . . rushing equipment . . . bending every effort. . . ."
>
> (*Dear Company. Your men are imprisoned in a tomb of hunger, of death wages. Your men are struggling for breath—the walls of your company town have clamped out the air of freedom. Please issue a statement; quick, or they start to batter through with the fists of strike, the pickax of revolution.*)
>
> A cameo of this, then. Blood clot of the dying sunset and the hush. No sobs, no word spoken. Sorrow is tongueless. Apprehension tore it out long ago. (20–21)

This passage contains many of the formal and thematic elements that characterize the text's sensational and radical modernism. First, the passage is both didactic and experimental, employing techniques associated with both proletarian and modernist modes of narration. Like a paradigmatic proletarian novel, the scene delivers an explicit critique of industrial violence and corporate power, tracing the workers' injuries to the coal company's malignant neglect of dangerous working conditions. However, this social critique is presented in the prototypical modernist form of a montage, in which the narrator's voice is interspersed with excerpts from letters to and from the company. This scene, as Constance Coiner notes, functions as a Brechtian-like estrangement effect, in which the narrative is interrupted and the audience is offered an experimental metacommentary on the conditions under which the action is taking place.[34] The form of the passage, like the text as a whole, represents what Fredric Jameson calls a "modal heterogeneity of nar-

rative registers," a combination of conventionally distinct and discrete literary forms (in this case modernism and proletarian realism).[35] Furthermore, the passage critiques not only the literal violence inscribed on the bodies of the miners, but also the representational violence inherent in what the text calls "classic" aesthetics. The passage suggests that the "classic" mode transforms a horridly mangled body—"this thing with the foot missing"— into "simple, flowing lines," reducing and recontaining the anguish of the scene, transforming injury into art, terror into "bare beauty." The "classic" extracts and abstracts the accident from its immediate historical context, rendering it "rigid and eternal," timeless rather than timely and thereby eliminating the event's political urgency and specificity.

In contrast to the "classic" rendering of the scene in static, rigid terms, Olsen's rendition offers a far more "grotesque" view that, like Agee's image of a "body torn out by the roots," refuses to diminish the horror and the conflict of the situation. The disfigurements of the sensational wounded body that the scene describes—"this gargoyle with half the face gone and the arm"—are echoed in the experimental shape of the passage. The "broken" quality of the text—the interlacing of textual fragments that gives the passage its montage effect—mirrors the "broken" quality of the mangled body the passage describes. Like the wounded body, described as an "intricate mosaic," the scene itself is an unresolved patchwork of elements (the letter to the company, the company's public statement, the narrator's voice) that do not, finally, cohere. *Yonnondio* is, as Christopher Wilson argues, a resolutely anticathartic text, a work of art that rejects the tendency of traditional aesthetics to obtain ideological closure, to "fix" an event for all time, to turn political injustice into "flowing lines of sorrow" that offer emotional release and consolation.[36] Like forms of testimony described recently by cultural theorists, this passage—and the text as a whole—narrates events in bits and pieces rather than providing an ostensibly comprehensive account or an infallibly omniscient perspective.[37]

Countering the tendency of classical art to abstract and minimize social injustice, the cameo scene explicitly links economic arrangements—the corporation's power over and knowing endangerment of the workers' health and safety—to aesthetic forms that romanticize the poor, thereby depoliticizing the circumstances of their lives and minimizing the pain of industrial harm. Forms of aesthetic obfuscation enable and legitimize forms of economic oppression, the text suggests; in turn, economic inequalities create the conditions—and the necessity—for such aesthetic productions. Furthermore, the cameo scene connects the mutual implication of economics and aesthetics to

gender. The cameo and the "aesthetic heart" are clearly coded feminine: the cameo is a piece of woman's jewelry; the "aesthetic heart" is the putatively "compassionate" soul of the well-to-do woman. Here, the text implicates (wealthy) women in forms of oppression perpetuated primarily by men—the cameo serves as a kind of public cover for exploitative corporate operations. In contrast to the cameo—polished, static, miniature, delicate—the text itself represents a radically different form of feminine discourse, more akin to what Jim derisively refers to as "'woman's blabbin'" (2), a mode of conversation through which the miners' wives collectively confront, discuss, and process the trials and horrors of living in a mining community: the constant potential for the death of husbands and sons, the poverty and lack of resources, the possibilities for mutual, if limited, assistance. Like the cameo scene itself and the text as a whole, "woman's blabbin,'" is a dialogue, an interplay of voices rather than a single story or perspective.[38] An allegory for the novel, it implies that the critique of capitalism and the representation of the poor require a multifaceted, experimental approach, a complex art of the everyday that blends diverse literary registers and modes of speech.[39]

The cameo scene is the first in a series of moments in which hegemonic relations between the poor and the privileged—relations in which the poor serve as objects of scrutiny against which the privileged measure and confirm their own well-being and aesthetic refinement—are invoked and critiqued. In the first of the narrator's five interpolations, for instance, she states that the mine "takes [the miners'] dreams that a few may languidly lie on couches and trill 'How exquisite' to paid dreamers" (6). In another commentary, the narrator condemns the tendency of privileged readers to avoid the presence and pain of poverty: "Perhaps it frightens you as you walk by . . . the man sitting on the porch, menacing weariness riding his flesh like despair. And you hurry along, afraid of the black forsaken streets, the crooked streets, and look no more. But there are those who have looked too much through such windows, seeing the pain on everything" (72). When, in a scene that might have been lifted out of a short story by William Carlos Williams, a doctor arrives to attend to Anna after her miscarriage, the text reveals his private thoughts, betraying the disgust he maintains for the persons he is hired to heal: "(Damn fools, they ought to sterilize the whole lot of them after the second kid)"; "(Pigsty the way these people live)" (77). Finally, near the end of the novel, Mazie performs a brief act of resistance against the moral condescension to which the Holbrooks are subjected: "A lady in a car stopping at the corner held up a handkerchief to her nose, real delicate. Mazie picked up a corncob from the gutter and threw it hard at

the car" (121). Sprinkled throughout the text, these brief scenes together expose and critique the dynamics of avoidance and disdain with which privileged persons habitually treat the poor.

As the cameo scene indicates, the novel's narrative texture is manifold and varied, ranging from relatively straight realism to documentary montage to stream-of-consciousness monologues. In one instance, as Mazie flees the house after her mother's miscarriage, she is overwhelmed by a flood of violent associations, memories of incidents and sights that run together in a bizarre tangle: "Running, so much ugliness, the coarse hair, the night bristling, the blood and the drunken breath and the blob of spit, something soft, mushy, pressed against her face, never the farm, even baby's cryin, get away from me ya damn girl, the faint vapor of river, run, run, but it scares you so, the shadows the lamp throws in the wind" (77–78). Here, Mazie's thoughts flash before her in an undigested pastiche of painful memories. A series of damaging, frightening events converge in a flow of horrible associations—Anna's miscarriage, the "blob of spit" that grazes Mazie's cheek as she falls in the street (69), the anxiety encoded in baby Bess's cries, Will's harsh rejection of Mazie, which crystallizes for the first time the gender difference between them ("get away from me ya damn girl"). The reader is challenged to recollect and connect disparate scenes that have preceded this moment, and to discern links between the varied moments of violence brought into collision through the novel's experimental narrative method. We are brought directly into Mazie's memory, invited to participate actively in the construction of her point of view rather than observe her from a distance.

Olsen's deployment of experimental formal techniques to narrate incidents of political oppression and social violence turns the traditional structure of high modernism on its head. Several critics have contended that elite modernists typically "dislocated the primary site of subjectivity from the realms of politics and everyday life to that of highly stylized literary works," "bracketing off the real social world" and imaginatively isolating themselves in an "impermeable space" of psychological interiority and aesthetic detachment.[40] In contrast, Yonnondio employs modernist techniques—stream-of-consciousness, sentence and narrative fragmentation, interior monologues, surrealist descriptions—to narrate precisely the material aspects of modern, industrial existence that most elite modernists typically sought to avoid—the pain of physical labor, economic destitution, the determining power of social and political forces. What makes the world Olsen depicts "unreal" (58) is not the distance or isolation of individual consciousness from the

social realm, but its very embeddedness in the social world, the very vulnerability of individuals to social violation and harm. Like *Christ in Concrete*, discussed in the next chapter, *Yonnondio* redeploys the experimental aesthetic techniques of high modernism to explicitly political ends, using forms of narrative fragmentation to render the contradictions and cruelties of material inequity and oppression.[41]

Yonnondio's modernism represents a language designed to render the immense, deformative power of industrial capitalism—the "uneven rhythms" that rack the "shoddy houses" of the poor, "jerking the skeleton children," as "monster trucks shake by, streetcars plunge, machinery rasps and shrieks" (47). These violent industrial rhythms reach a crescendo during the novel's last chapter, in which a steam pipe bursts in the meatpacking plant, scorching the workers, a catastrophe narrated through the minds of one of the laborers: "steamed boiled broiled cooked *scalded*, I forgot *scalded*" (125). The scene of disaster, in which boiling water and steam burn the assembly line butchers, is surreal ("Is it a dream, is it delirium?" [125]), both terrible and disorienting: "When the door to the hog room, always kept closed against the Casing stench, the Casings heat, is flung open, the steam boils in so triumphantly, weds with the hog-vat vapors to create such vast clouds, such condensation, the disembodied scalded figures of horror (human? women?) seem disembodied flickering shadows gesturing mutely back to whence they have fled" (125–26). If surrealism is an aesthetic that evokes the unconscious dream world to convey modernity's hidden meanings, *Yonnondio* offers what might be called an explicitly anticapitalist surrealism, employing the language of the subconscious to narrate the insane workings of large-scale industry, in which production (of meat products) becomes destruction (of the workers' health and safety), in which human bodies become "disembodied scalded figures of horror."

Yonnondio proceeds by violence and interruption, by shock, catastrophe, and pain, interspersed by brief moments of calm and pleasure. The novel's plot is punctuated by episodes of violence: Jim's abuse of Anna and her subsequent abuse of the children; Sheen McEvoy's attempt to throw Mazie into the mine; Jim's rape of Anna and her ensuing miscarriage; the bursting of the steam pipe in the factory where Jim works. Echoing the scenes of violence, disfigured bodies litter the text: "the hunchback" miner, Andy Kavertnick, "stretched and tense as a corpse" at the bottom of the mine shaft (5); the "skeletons of starved [miners'] children" (6); the Holbrook siblings, bruised from beatings by Jim and Anna; Sheen McEvoy's "writhing" "jelly face," deformed by a mine explosion (11); the body of young Erina, who

haunts the dump, with "bad bruises" and a "stump arm ending in a little knob" (120, 112); Anna's "body . . . that tired so quickly and quivered like a naked nerve; this stranger self" (90). More than a coherent, fluid narrative, the novel is a series of scenes or set pieces, what the novel calls at one point "a frieze" (77), flashpoints of struggle and agony. Like Walter Benjamin's angel of history, the text seems to "progress" through the accumulation of debris. These piles of debris—the junk heaps that dominate the landscape of the packinghouse slum—become the resource ground for the children of the poor who sift through and redeem the neglected material (103).

Likewise, the novel itself was pulled from the scrap heap, revived after forty years of abandonment, cobbled together from what Olsen describes as "odd tattered pages, lines in yellowed notebooks, scraps" (v). Like the voices of the poor, drowned out by the immense clamor of industrial production and omitted from the pages of official history, the novel itself was nearly lost forever, written in the early 1930s, but "long since thought destroyed or lost" (v). "Only fragments, rough drafts, outlines, scraps remain," Olsen states in a note at the end of the text, "to tell what might have been and never now will be" (135). Published yet partial, Olsen's novel is both a resurrection of pages from the ashes of history and a memorial to the completed text that never was written.

The novel's fragmentation not only stems from the patchwork nature of its construction, but it also reflects the interplay of opposing forces that drive the text: production and destruction, desire and injury, aspiration and oppression. These dualities can be seen in the novel's opening pages, as Mazie's view of the mine is depicted in a stream-of-consciousness format:

> "I am a-knowen things. I can diaper a baby, I can tell ghost stories. I know words and words. Tipple. Edjication. Bug dust. Supertendent. . . ." A phrase trembled in her mind, "Bowels of earth." She shuddered. It was mysterious and terrible to her. "Bowels of earth. It means the mine. Bowels is the stummy. Earth is a stummy and mebbe she eats the men that come down. Men and daddy goin' in like the day, and comin' out black. . . . That's one thing I'm not a knowen. Day comes and night comes and the whistle blows and payday comes. Like the flats runnin on the tipple they come—one right a-followen the other. Mebbe I am black inside too. . . . The bowels of earth. . . . The things I know but am not knowen." (4)

The form of stream-of-consciousness narrative that Olsen uses allows readers to understand both the lyricism and the limits of Mazie's conscious-

ness, both her confidence ("I am a-knowen things") as well as her confusion ("am not knowen"). Mazie comprehends too little and too much. On the one hand, she knows "words and words." She has a rich and poetic grasp of the mine and its significance, as well as firsthand knowledge of men dying due to the conditions of their labor. Yet she lacks basic insight into how the mine actually works and what kind of labor actually takes place inside it.

The duality of the representation of Mazie's consciousness (both expressive and stunted) echoes the double-sided nature of Olsen's comments about both the text and identity. When she had initially commenced work on the novel, Olsen had envisioned *Yonnondio* as an agit-prop novel, an exposé and condemnation of "this goddamn system." However, as the novel progressed, the rendering of working-class subjects and the portrayal of their resiliency and agency took increasing priority. "I was writing about created beings who were growing increasingly real to me," she asserted in an interview.[42] Ultimately, the novel is both an indictment of the ways in which industrial capitalism oppresses the working poor and a testament to personal creativity and persistence in the face of such oppression. In interviews, Olsen has stated that she believes that all persons possess inherent potential, an innate "Core of Self." However, she has been equally insistent that social and material factors condition consciousness: "It is irrelevant to even talk of a Core of Self when circumstances do not sustain its expression or development, when life has tampered with it and harmed it."[43] Any notion of innate potential only comes to have meaning through the social, cultural, and political context in which individuals exist. "What matters to me," she maintains, "is the kind of soil out of which people have to grow, and the kind of climate around them; circumstances are the primary key and not the personal quest for identity."[44]

The double-sided quality of Olsen's comments about "identity" (identity stems from a "core" but only has meaning in context) and her sense that the novel conveys both the subjugation and the resilience of its proletarian characters are echoed in the novel's ambivalence about language, which functions in the Holbrooks' lives as a source of both empowerment and oppression. On the one hand, language provides the possibility of transcendence, the potential for escape from the brutal confines of workaday existence. Mazie, for instance, expresses a joy in words ("I am a-knowen things . . . I know words and words" [4]) and absorbs her school lessons, devouring the words put before her in the classroom: "the lessons came easy—the crooked white worms of words on the second-grade blackboard magically transforming into words known and said" (34). Books, Anna informs Mazie, enable

the expansion of the self through the acquisition of otherwise unavailable knowledge: "'That's what books is: places your body aint never been, cant ever get to go'" (96). Likewise, *Yonnondio* itself, as a speech act, offers the possibility of permanence for the Holbrooks, transporting them to places the body "cant ever get to go."

On the other hand, the novel, much like "The Strike," demonstrates the ways in which words and textuality structure regimes of domination and subjugation. Paraphrasing Jim, the narrator criticizes Tracy, the young ditchdigger who proclaims he will quit his job rather than perform unreasonable tasks. The narrator remarks, "Tracy was still young . . . and he believed the bull about freedomofopportunity and a chancetorise and if youreallywanttoworkyoucanalwaysfindajob and ruggedindividualism and something about pursuitofhappiness" (62). Using Dos Passos's technique of compressing clichéd phrases to mock their meaning, Olsen suggests the power of words as carriers of ideology, as potentially reified signs that mystify the material realities of oppression. Elsewhere, the narrator asserts that writing has been used to enforce the cultural invisibility and social inferiority of the working class: "Is it not through books, the printed word, or so it seemed, that they had been judged poor learners, dumb dumb dumb? Told: what is in us has nothing to do with you" (107). At other points, the novel suggests that the capacity for expression is stifled by the material conditions of working-class life: "*[T]he day at Cudahy's has thieved Pop's text . . . And when Anna comes out, her apron front still wet from doing dishes, it is too late for texts*" (110, italics in original). Here, we see that the Holbrooks' ability to compose and communicate, to shape their experience into narrative, has been compromised by their exhausting labor at the packinghouse and in the kitchen. Compounding this problem, the environment in which the Holbrooks live, dominated by the noise of industrial production, virtually drowns out human speech: "far underneath" the industrial din, we are told, "thinly quiver human voices—weeping and scolding and tired words that slip out in monosyllables and are as if never spoken" (47). The interior of the packinghouse itself reverberates with thundering sounds, a harsh mechanical rhythm that articulates a chilling message: "Music by rasp crash screech knock steamhiss thud machinedrum. Abandon self, all ye who enter here. Become component part, geared, meshed, timed, controlled" (114); "Clawing dinning jutting gnashing noises, so overwhelming that only at a scream pitch can the human voice be heard" (115). The spaces these working people inhabit, and the daily demands of labor and childcare, conspire

to silence them, leaving only fragile, if still potent, sources of resilience and resistance.

Although the preponderance of bodily images in *Yonnondio* depict bodies wounded or incapacitated, the text does contain several glimpses of potentially redemptive or resistant bodies. If the bodies of the poor are objects of capitalist accumulation, resources from which corporations extract profit as well as the surface on which the immense violence of industrial production is inscribed, those same bodies, the novel suggests, also constitute potential wellsprings of hope and pleasure.[45] The images of revolution the text contains, for example, are cast in corporeal terms: the "fists of strike" (21) that threaten the mining company's indifference; the "day millions of fists clamped in yours, and you could wipe out the whole thing" (64); "the day that hands will find a way to speak this: hands" (79). These speaking hands, images of an impossibly corporeal language—a language that could, as Agee says, "embody"—are echoed on the novel's final page, as baby Bess slams a jar lid on a table. Her action, a sign of creativity and persistence amid the squalor of the Holbrooks' house and the heat of the 106-degree weather, constitutes a form of self-realizing bodily expression: "I can do. Bang! I did that. I can do. I!" (132). Likewise, when Anna caresses Mazie as the two sit under a catalpa tree, the novel offers a utopian image of the body's expressive potential. Anna's touch soothes the pain of physical and psychic harm, lending Mazie a renewed sense of security and selfhood: "The fingers stroked, spun a web, cocooned Mazie into happiness and intactness and selfness. Soft wove the bliss round hurt and fear and want and shame—the old worn fragile bliss, a new frail selfness bliss, healing, transforming" (102). Anna, too, is affected, and "Mazie felt the strange happiness in her mother's body" (101). The healing contact is disrupted, however, when the wind shifts, bringing the stench from the packinghouse, a reminder of the economic conditions that dominate their lives. The restorative scene that Olsen depicts here is compelling, but brief; although the text provides glimpses of bodies that heal, express, and revolt, these images are outnumbered by the scenes of physical harm and fatigue.

Inhabiting an environment in which their own voices are drowned out by the din of industry, the Holbrooks and their neighbors produce the meaning of their lives in unusual, unorthodox ways, crafting an alternative culture in the gaps and interstices of capital's dominance. Although, as Mazie complains, "'I don't have no place'" (123), the children who live in the shadow of the packinghouse transform the local dump, fashioning dream

worlds of possibility from the industrial and commercial debris. Through acts of imaginative "will," a young girl named Jinella remakes the degraded and discarded rubbish of the commercial realm—"greening curtain rings, feathers, fish lures, dress beadings, glass bits"—into "lavish jewelry Tiffany's would never recognize" (109). Like Jinella, other children forge complex structures from the detritus of industrial production: "Children—already stratified as dummies in school, condemned as unfit for the worlds of learning, art, imagination, invention—plan, measure, figure, design, invent, construct, costume themselves, stage dramas"; "On the inexhaustible dump strange structures rise: lookout towers, sets, ships, tents, forts, lean-tos, clubhouses, cities and stores and train tracks, cabooses, pretend palaces" (103). Here, the novel delineates resilient forms of creativity that require alternative modes of recognition to be adequately understood—the "inventiveness" and "intelligence" of these children can only be comprehended *outside* the conventional parameters of scholastic achievement and measurement. Through what Michel de Certeau calls "tactics of consumption," these children create meaning by reading against the grain, by lending unforeseen connotations to hegemonic scripts.[46] Bricoleurs, the children endow discarded, debased objects with new and unlikely significance, constructing an alternative landscape out of industrial modernity's scrap heap. These "strange structures" are allegories of the novel itself: a series of alternative, provisional forms and "designs," *Yonnondio* fails to meet normative expectations of aesthetic integrity and wholeness.

As I hope I have made clear, *Yonnondio*'s aesthetics of contingency, disfigurement, and bricolage strike a noted contrast to the dominant epistemological tendencies of high modernism. In his memoir of the 1920s, Malcolm Cowley contends that members of the "lost generation" imagined that the goal of modern art was to transform the sordid circumstances of everyday life into monuments of aesthetic perfection. He writes, "Although our lives might be dingy and cluttered, they had one privilege: to write a poem in which all was but order and beauty, a poem rising like a clean tower above the tin cans and broken dishes of their days."[47] In sharp contrast to the phallic "tower" of literary transcendence that Cowley proposes as the apotheosis of modernism, *Yonnondio* offers a modernism built out of "dirty dishes"—a modernism of discarded objects and of neglected people. Early in the novel, the narrator surveys the packinghouse landscape and sees what we can read as an allegory for Olsen's own aesthetic: "Yes, it is here that Jim and Anna Holbrook have come to live. . . . Over the cobbled streets . . . past the human dumpheap where the nameless FrankLloydWrights of the proletariat have

wrought their wondrous futuristic structures of flat battered tin cans, fruit boxes and gunny sacks, cardboard and mother earth" (48). Like the twisted structures patched together from the refuse of industrial society by these neglected working-class architects, the novel's own modernism is monstrous and unruly, forged from images of poverty, disintegration, and decay.

Shapes to Fill a Lack: *Yonnondio* and *As I Lay Dying*

A sense of social and aesthetic disintegration similar to the one that preoccupies *Yonnondio* also permeates William Faulkner's *As I Lay Dying*, which tells the story of the Bundren family's nine-day journey to bury Addie, wife to Anse and mother to Cash, Darl, Jewel, Dewey Dell, and Vardaman. Told in fifty-nine discrete monologues, the novel is at once a tale of literal decomposition—as the Bundrens travel, Addie's unembalmed corpse begins to decay—and a text that is itself structured by significant formal disintegration, held delicately together by the interplay of the characters' voices, unframed by an omniscient narrator. Briefly, I want to explore some connections between Olsen's and Faulkner's novels, considering in particular how the texts' common emphasis on disintegration may point to similar strategies for undoing prevailing conceptions of the Depression-era poor.

First, let me say a word about placing *As I Lay Dying* and *Yonnondio* side by side. On the face of it, Faulkner and Olsen make an unlikely pairing. The two are usually identified with opposing formal movements—Faulkner with high modernism and Olsen with proletarian realism—and contrasting political stances—in Faulkner's case, a Jeffersonian liberalism, and in Olsen's, a socialist feminism. Yet *As I Lay Dying* and *Yonnondio* possess some striking similarities.[48] Both novels depict the desperate journeys of destitute working-class families, driven by catastrophe and plagued by economic need. In both narratives economic vulnerability is echoed by sexual vulnerability, as female characters confront unwanted pregnancies and sexual exploitation. Both novels foreground grotesque maternal bodies— *Yonnondio*, the ill and abused body of Anna Holbrook, and *As I Lay Dying*, the fetid corpse of Addie Bundren, which her husband and children travel to bury. Both novels emphasize the voices of children and, through them, the power of mass culture to shape desire. In addition, and for the purposes of this study most significant, both novels are radically decentered texts whose authors use multiple, heterogeneous perspectives and stream-of-consciousness narration to render the thoughts of impoverished characters in their own words, unmediated by an omniscient narrator. While *Yonnondio* includes sections of third-person narration of the kind that is notably absent

from *As I Lay Dying*, and which serve to ground the characters' stories and voices firmly within a realist matrix of social and political circumstances, in many of the novel's most innovative segments Olsen uses streaming prose to portray the perceptual consciousness of the novel's characters, much as Faulkner does. While I have no evidence that Olsen had read *As I Lay Dying* before starting *Yonnondio* in 1932, recognizing the formal resemblances between Olsen's and Faulkner's work helps us to see the fluidity of thirties literary culture, in which categories often taken to be discrete and distinct, such as "modernism" and "proletarianism," were in fact quite porous, as ideas and techniques usually associated with one movement were taken up by writers usually affiliated with another. Looking briefly at *As I Lay Dying* in the context of Olsen's novel allows us to grasp more clearly both the aesthetic complexities of Olsen's highly political prose and the politics of Faulkner's formal innovations.

As I Lay Dying is Faulkner's most thoroughly decentered narrative, a novel that expands the stream-of-consciousness technique developed in *The Sound and the Fury* to create an even more cacophonous mosaic: fifteen voices speaking in fifty-nine separate chapters. In addition to being one of his most formally daring novels, it is also one of Faulkner's most socially and politically responsive novels, a text written in the immediate aftermath of the 1929 crash that takes the plight of the poor in the face of immense loss as its central concern. Indeed, given the timing of its composition as well as its preoccupation with the lives of working-class people in the face of disaster, *As I Lay Dying* can convincingly be considered America's first Depression-era novel.[49] As Joseph Blotner explains, Faulkner started writing the book immediately after the stock market collapsed: "On October 25, 1929, the day after the panic had broken out on Wall Street, [Faulkner] took [a blank sheet of paper] and wrote at the top in blue ink, 'As I Lay Dying.' Then he underlined it twice and wrote the date in the upper right-hand corner."[50] Faulkner composed the novel in spare moments while he worked shoveling coal for the University of Mississippi's campus generator, literally feeding the massive industrial machine that, as one historian explains, "symbolized the University's entrance into the technological age of the twentieth century."[51] Given these circumstances, it is reasonable to see the novel, which Faulkner wrote in a six-week burst, as an allegory of contemporary current events: the nation was cast into turmoil by the near-collapse of the industrial-economic system, much as the Bundren family was cast into chaos by the death of Addie. In addition to being a (self-professed) modernist tour de force, *As I Lay Dying* is also, in John Matthews's words, a "fable of social upheaval,"

a story about the crisis of southern modernization as experienced by those most vulnerable to its social and economic transformations.[52]

As such, *As I Lay Dying* sets the stage for Faulkner's other 1930s writings that focus on social conflicts stemming from economic disparity and class difference. Indeed, several of his writings display a remarkably astute grasp of class politics, as Myra Jehlen, Sylvia Jenkins Cook, and Matthews have argued. Cook contends that, "in his treatment of poor whites and of southern society generally, Faulkner is as acutely class-conscious as any Marxist and as prone to patterns of economic sympathy and class allegiance."[53] In particular, Faulkner's stories "Wash" and "Barn Burning," as well as the narrative of Sutpen in *Absalom! Absalom!*, expose the ways in which class conflicts subtend and complicate racial dynamics, as the poor white figures in these narratives recognize that white racial unity is undercut by class hierarchies. The origin of Sutpen's "design," for instance, is located at the moment when, as a young boy, he recognizes the facts of class difference as he is refused entry by a black servant at the front door of a plantation house. "He had learned the difference," we are told, "not only between white men and black ones, but he was learning there was a difference between white men and white men not to be measured by lifting anvils or gouging eyes or how much whisky you could drink then get up and walk out of the room."[54] This knowledge was "like an explosion—a bright glare that vanished and left nothing."[55] Here, we can see Faulkner linking the aesthetic and the social-political, as Sutpen's epiphany about the realities of class distinction is cast as a moment of modernist cognitive shock—an "explosion" that decisively reorients his sense of the world. A similar connection between formal rupture and the cultural displacements of class-inflected social injustice marks both *As I Lay Dying* and *Yonnondio*.

Faulkner possessed a keen awareness of inequality and discrimination, but his politics were relatively conservative. Although he sympathized with the plight of the poor, he certainly kept his distance from the Left, and from Roosevelt as well. He opposed the centralization and collectivism that formed the ideological basis of New Deal planning and retained an allegiance to the foundational precepts of classical American liberalism, including self-reliance, local control, and individual property rights. Faulkner's political ambivalences may have reflected the ambiguities of his own economic circumstances. In 1930, he purchased the estate that he would later name Rowan Oak, an acquisition that allowed him some stability after the penury he suffered during the 1920s. Yet his financial situation during the thirties was marked by serious difficulty due not only to fluctuating income

but also to imprudent investments and family obligations.[56] As Ted Atkinson observes, Faulkner's Depression-era fiction often expresses "noticeable sympathy for the dispossessed and disenfranchised small farmers and sharecroppers and an acute awareness of the systematic oppression that compounds their suffering" while also displaying "a chronic anxiety over dissident impulses that could produce civil unrest and, in turn, fundamental changes in the existing social order."[57]

Echoing his anxiety about social change, Faulkner rejected the notion that fiction is, or should be, expressly political. "If one begins to write about the injustice of society," he stated, "then one has stopped being primarily a novelist and has become a polemicist or a propagandist. The fiction writer is not that, he will use the injustice of society, the inhumanity of people as a—as any other tool in telling a story, which is about people, not about the injustice or inhumanity of people but of people, with their aspirations and their struggles and the bizarre, the comic, and the tragic conditions they get themselves into simply coping with themselves and one another and environment."[58] *As I Lay Dying* is certainly filled with the bizarre, the comic, and the tragic, and the combination of those elements generates an uneasy mixture of pathos, laughter, and social insight.

Some of the novel's black humor clearly comes at the expense of the Bundrens, whose journey to bury Addie in many ways constitutes, in Darl's words, a "monstrous burlesque."[59] The image of the destitute family towing a rotting, reeking corpse for days in the hot sun, followed by a passel of buzzards, is pitiful to the point of being absurd. Several episodes, such as the casting of Cash's injured leg in wet cement and Vardaman drilling holes through the coffin lid into Addie's face, generate a macabre comedy out of the family's pathetic situation. In addition, rather than being motivated purely or even primarily by solemn feelings of filial obedience and respect, several of the family members are driven by their own self-centered concerns: Vardaman wants to see a toy train; Cash wants to purchase a gramophone; and Anse wants to buy some false teeth. In depicting the Bundrens as unsophisticated and impulsive, the novel evokes long-standing regional stereotypes of poor farmers as "white trash." Anse, in particular, is portrayed as duplicitous, lazy, and egocentric.[60] His first comments after Addie's death are: "God's will be done . . . Now I can get me them [false] teeth" (52), a statement that epitomizes his selfishness. Anse is known for his resistance to sweating ("I have never seen a sweat stain on his shirt," Darl remarks [17]), and thus to hard labor, and he seems to have no qualms about selling Jewel's horse for a mule team without his son's consent, or about rummaging through

Cash's pockets to steal the money Cash had saved for a gramophone. Rather than an industrious personification of Jeffersonian virtue, then, Anse comes across, in Ted Atkinson's formulation, "as a shifty and acquisitive 'cracker' who is out to take full advantage of circumstances to gain profit."[61] Moreover, physical descriptions of Anse seem to confirm his degenerate, almost subhuman nature. Darl notes that he "looks like a figure carved clumsily from tough wood by a drunken caricaturist" (163). Dewey Dell likens him to a "steer" (61) while Darl describes Anse as "dangle-armed, humped" (51), his hand "as awkward as a claw" (52).

Yet other comments complicate the image of Anse as an innately degraded figure. After noting the deformations in Anse's body, Darl explains that the disfigurements stem from the hard labor he performed as a child: "Pa's feet are badly splayed, his toes cramped and bent and warped, with no toenail at all on his little toes, from working so hard in the wet in homemade shoes when he was a boy" (11). Rather than physical markers of intrinsic inferiority, Anse's scars testify to the difficulties he has endured. Other characters, too, temper their often disdainful attitude toward Anse with more complex assessments. Armstid asserts that Anse is a "durn fool" (192) yet also admits that Anse's dogged persistence is compelling: "I be durn if Anse don't conjure a man, some way" (193). Furthermore, while several of the Bundrens are driven by what may seem to be petty desires for mass consumer goods such as a phonograph or a toy train, these desires also remind us of the privation the family has suffered, which prevents their access to even rather modest modern commodities. Vardaman in fact realizes that his inability to buy a train is related to the family's poverty: "When [the train] runs the track shines on and off. Pa said flour and sugar and coffee costs so much. Because I am a country boy because boys in town. . . . 'Why ain't I a town boy, pa?' I said" (66). In addition, what might be considered the selfishness of the Bundrens' consumer longings is countered by several notable acts of self-sacrifice, such as Jewel's sale of his beloved horse to Flem Snopes for a team of mules to replace those lost in the river crossing and his near-suicidal retrieval of the coffin from the burning barn. Anse's wish for a new set of teeth is matched by his insistence on fulfilling his obligation to bury Addie as she desired. "'I give my promise,' he says. 'She is counting on it'" (140).

Other aspects of the novel also complicate one-dimensional or reductive assessments of the Bundrens. In particular, many of the text's most daring and often surprising monologues undermine the image of the poor farmers as simple-minded, inarticulate folk. Faulkner places words and images of

unusual beauty not only in the mind of Darl, the character many critics see as a protomodernist figure of the artist, but in the thoughts of other family members, such as Vardaman's bizarre and bracing imagistic formulation "my mother is a fish" (84), and the lyrical sensualism of Dewey Dell's encounter with the cow she milks: "The cow breathes upon my hips and back, her breath warm, sweet, stertorous, moaning. The sky lies flat down the slope, upon the secret clumps. Beyond the hill sheet-lightning stains upward and fades. The dead air . . . lies dead and warm upon me, touching me naked through my clothes . . . I feel like a wet seed wild in the hot blind earth" (63–64). Dewey Dell's rapturous, poetic account of the beauty of the landscape and the erotic quality of the cow's breath and the hot air belies her public inarticulateness, reminding us that her seeming lack of sophistication is countered by a rich, complex sense of self and beauty.

In the end, the novel's multifaceted, even contradictory, portrait of the Bundrens refuses a sense of closure. Neither inherently virtuous nor depraved, the Bundrens defy reductive characterization. They are at once flawed and valiant, foolish and courageous, cruel and compassionate. And it is in recognizing the fundamentally unresolved, continually fluctuating depiction of these poor people that we can see how the novel's politics and form converge. By making his most resolutely working-class novel his most radically polyvocal text, Faulkner uses modernism's hermeneutic skepticism to challenge reductive images of the poor as either degraded (and comic) incompetents who are to blame for their own difficulties or virtuous embodiments of republican independence. The politics of perception rise to the novel's surface in several places. In one passage, Cash reflects on Darl's setting fire to Gillespie's barn. He states, "Sometimes I think it aint none of us pure crazy and aint none of us pure sane until the balance of us talks him that-a-way. It's like it aint so much what a fellow does, but it's the way the majority of folks is looking at him when he does it" (233). Here, Cash questions the dynamics of labeling, asserting that insanity, rather than being an absolute truth, is a socially determined category, in this case one used to contain the social and political implications of Darl's wild act of defiance. In an earlier scene, as the Bundrens enter Jefferson, Darl notes the silent, but palpable social condemnation to which the family, trailing buzzards and escorting a fetid corpse, is subjected: "We mount again while the heads turn with that expression which we know" (231). Darl's comment suggests that the public understanding of the Bundren family and their journey has been determined before the family is in fact encountered. Social expectations, the novel in effect tells us, predetermine the way in which the family

is perceived, closing down possibilities for more complex forms of cultural and interpersonal comprehension. Elsewhere, the novel demonstrates how the Bundrens' neighbors view the family through a similarly discriminatory lens. Tull, a farmer who lives near the Bundrens but is financially better off, tacitly compares them to monkeys in a racialized remark that plays on the family's reputation as white trash. "They would risk the fire and the earth and the water and all," he states, "just to eat a sack of bananas" (140). Moseley, the drugstore clerk who takes sexual advantage of Dewey Dell, describes the cruel ridicule to which townspeople subject the Bundrens' procession as it enters Jefferson: "It must have been like a piece of rotten cheese coming into an ant-hill, in that ramshackle wagon that Albert said folks were scared would fall all to pieces before they could get it out of town" (203). In these passages, the novel illustrates the protocols of prejudice and demonization that shape the way people in and around Jefferson view the struggling Bundrens. For many of their neighbors, the Bundrens serve as debased aliens against whom more well-to-do persons bolster their own sense of identity and community.

The novel's emphasis on the power of prejudicial social conventions to shape perception is extended by a critique of linguistic reference and stability, articulated most forcefully by Addie, whose lone chapter links her profound sense of isolation and resentment to a deep distrust in words. For Addie, a life given over to child-rearing and sacrifice for her husband constituted a crushing negation of her individual desires. As she explains, her relationship with Anse was a loveless exchange governed by maternal obligation: "I gave Anse the children. I did not ask for them. I did not even ask him to give me what he could have given me: not-Anse. That was my duty to him, to not ask that, and I fulfilled it" (174). Her estrangement from the normative expectations of familial duty leads to her affair with Reverend Whitfield, which generates a child, Jewel, for whom Addie ironically feels obligated to compensate Anse by bearing Dewey Dell. Addie's sense of oppression and her alienation both from other characters and from hegemonic conceptions of motherhood and female sexuality engender a deep skepticism about the language—especially the rhetoric of love and sin—that maintains and naturalizes patriarchal culture. Words, she states, are hollow signifiers, inadequate to the experiences and sensations they claim to denote. Words "are no good," she contends, and "don't ever fit even what they are trying to say at" (171). The word "love," which Anse uses to enforce Addie's sense of commitment to him, is, she explains, "like the others: just a shape to fill a lack; . . . when the right time came, you wouldn't need a word for that

anymore than for pride and fear" (172). As Annette Wannamaker suggests, "Through her awkward attempts to express the inexpressible, we see the way language fails to convey Addie's existence."[62] In Addie's chapter, the novel seems to be saying that understanding her experience, and by extension that of the other Bundren characters, requires trying to think beyond or outside of words, questioning the very terms and conventions—linguistic, social, and ideological—through which we are accustomed to grasping the world and people before us. Here, social critique is linked to aesthetic instability and innovation, as modernism acquires a decidedly critical dimension.

Addie's account of her maternal burdens echoes the experiences of Anna Holbrook, who is raped by Jim and almost dies of a miscarriage, "the two lifeless braids of hair framing her face like a corpse" (75). Like Addie, Anna is "bound" (88) by the obligations of motherhood, responsibilities that expand to subsume all her energies and aspirations, "loom[ing], gigantic beyond her, impossible ever to achieve" (88). Much as Addie expresses her alienation from her children and husband, *Yonnondio* emphasizes the sense of estrangement that Anna and her children feel for one another, as well as Anna's deeply strained relationship with Jim. Moreover, as Addie tries to express unrealized desires that are seemingly beyond the power of words to name, female figures in *Yonnondio* frequently find language inadequate to their feelings. Jinella, the young girl who roams the local dump, collecting discarded movie posters, becomes "sick with an older feverish longing, *unutterable*, to be other than she is" (127, my emphasis). Mazie, accosted and almost raped by Sheen McEvoy, can only express her pain in "fragments of sentences, incoherent words" (15). Both novels, then, suggest that established modes of linguistic expression cannot accommodate either the pain or the desire that these impoverished women experience. Olsen's novel clearly gives substantially greater space and significance to female (especially maternal) subjectivity than does Faulkner's text, in which Addie's voice is restricted to a single chapter, but both books suggest that attention to class and gender demands a reconsideration of established forms of discursive expression and representation. For Olsen, the effort to craft an experimental form of language in which to convey the perspective of its working-class female protagonists is *the* primary aesthetic challenge. While Faulkner limits Addie's voice to one chapter, she articulates the novel's most ambitious critique of linguistic certainty.

Although Faulkner is not in any conventional sense a working-class writer, neither is *As I Lay Dying* an "outsider's" narrative, like William Carlos Wil-

liams's short fiction, Agee's documentary text, or Aaron Siskind's Harlem photography. Rather, it tells the story of working-class people in their own voices and thoughts, underscoring the depth and diversity of their thinking. As Sylvia Cook contends, figures whose public expression is limited to rudimentary forms are permitted "in their mental language a range of philosophical speculation and colorful and complex imagery that emphasizes a degree of activity and sensitivity not to be expected from their actions and conversations alone."[63] *As I Lay Dying* is a highly experimental, self-consciously "modern" work of art, yet it also bears the stamp of a Depression-era documentary impulse, a desire to set forth the unadulterated "actuality" of working-class thought and feeling. It is, in other words, a form of documentary modernism, a type of art that aims to break with realist conventions by blending fragments of "reality" in a wildly eccentric manner. The open-ended quality of the novel's structure, and its focus on isolated individual perspectives, does not, like *Yonnondio*, identify class conflict as the primary source of working-class trouble in the world. Faulkner's novel does not link the Bundrens' poverty to the wealth of others, exposing the larger structures of exploitation that govern their lives. It is not, in this sense, a politically radical text. Yet its form, which privileges a chorus of working-class voices, lends working-class experience a layered depth and internal complexity that it was most often denied both in the comic regional traditions that the novel recasts and in the larger canons of American literature and popular culture. In refusing to privilege a single, authoritative narrative perspective, Faulkner gives the poor the final word. His novel lends power to the Bundrens' individual voices and, by placing those voices in dialogue with one another, creates what one critic refers to as a "community of consciousness" that implicitly refutes the one-dimensional quality of caricature and stereotype.[64]

Eric Sundquist has argued provocatively that as a fractured novel without a "center" or presiding authorial voice, *As I Lay Dying* is itself, much like Addie's body, a "corpse," "a narrative whose form is continually on the verge of decomposition" "in which the authorial 'I' also lies dying."[65] (And, as I have suggested, if the crash signaled a crisis of social authority, Faulkner's novel, which lacks an omniscient narrative "author"(ity), can also be read as a meditation on this historical predicament.) *Yonnondio*, too, is a textual corpse, a book that was given up for dead, buried and lost, the publication of which constituted an act of (admittedly incomplete) resurrection. Both novels teeter on the edge of incoherence, caught in tension between formal integration and disintegration.[66] And both are marked by grief and

loss, grounded in the problem "of articulating what is lost but lingering on the verge of memory," trying to voice "what will never be but *might have been*," as Sundquist says of *As I Lay Dying* (or, as Olsen puts it in a line cited above, "what might have been but never now will be").[67] The sections of Faulkner's novel, Sundquist asserts, are like orphans, detached figures that float alone, in tenuous connection to their textual siblings, much the way the Bundren children themselves are locked in isolation even as they are bound by a shared predicament. Olsen's novel, too, is a form of mourning for the separation and isolation of family members, who have been driven apart by the alienating culture of capitalist patriarchy. It is precisely this pervasive sense of loss—the loss of narrative completeness that was sacrificed when the novel was misplaced in the 1930s, as well as the dissolution of interpersonal, familial attachment in the face of the demands of work and poverty—that makes *Yonnondio*, like *As I Lay Dying*, so profoundly modernist. Both novels constitute "shape[s] to fill a lack," to use Addie's words, shapes that are not themselves whole, but in fact structured by the very lack they aim to fill. We might be able to identify several sources of this lack, but one of them, I believe, is the historic invisibility of working-class culture, which had been overlooked and excluded by the vast majority of American writers and artists, but which became newly visible during the 1930s. The crisis of that decade, while greatly debilitating, did create new avenues and possibilities for the emergence of new aesthetic forms, new political initiatives, new civic and cultural subjectivities. The Depression put working people on the move—from South to North, from country to city, from Oklahoma to California, in continual circulation in search of work and a sustainable existence. *Yonnondio* and *As I Lay Dying* narrate such migrations, testifying to the pain and potential that working people carried with them as they traversed the country. More significantly, the two texts insist on the internal complexity of working-class perspectives and the impossibility of fully or objectively rendering working-class life and subjectivity. These texts are knowingly incomplete, full of conflicting voices and fragmentary points of view. They depict journeys marked by hesitation, catastrophe, injury, and incomplete success, testifying at times obliquely and (especially in *Yonnondio*'s case) at times directly to the environmental obstacles, social prejudices, and economic injustices that their rural proletarian characters are forced to confront.

Yonnondio contains conflicting, contradictory impulses and themes. It aspires to artistic permanence, but underscores its own contingency; it tries to

ascribe a "voice" to the Holbrooks, but realizes that their speech has been drowned out by the immense noise of capitalist production; it longs for the possibility of a revolutionary language, but can only gesture vaguely toward the shape such a language might take. In the novel, "beauty" is interlaced with terror, "classicism" with violence and domination. Like the text itself, a pastiche of partial manuscripts, the dynamic interplay of these forces is unresolved. Indeed, the book's last page is not in any sense final; rather, the concluding section of the current edition of the text is composed of loose fragments appended to the 1974 version of the text, fragments that suggest the very *absence* of a definitive ending. Rather than a finished product, the novel is a rehearsal, a draft that was never completed, a series of "fragments, scraps," in Olsen's words, that do not cohere into a polished artifact. If Agee's text is a work that cannot shed its "mastery," *Yonnondio* is a self-consciously unmasterful work, a text that deforms or disestablishes the very notion of aesthetic "mastery."[68] As the narrator in the cameo scene contends, "classic" aesthetics represent a mode of achieving rhetorical and ideological closure. In contrast, *Yonnondio*, much like "The Strike," presents the social world as a contentious site of ideological conflict and gross material disparities. The novel consciously and conspicuously resists aesthetic and ideological finality; it responds to conventions of catharsis, to various tendencies to romanticize, sentimentalize, or "beautify" the poor, not by presenting the poor as righteous, glorious, defiant figures, but rather by putting into play the contradictory rhetorical positions the poor inhabit and by making visible the ruptures and inadequacies of social and semantic representation. Similarly, Faulkner's *As I Lay Dying* is a deeply dialogic text that refuses closure. Rather than a single, definitive, or even "objective" account of the lives of the poor, it offers a resolutely unresolved narrative of the Bundrens' journey, told from multiple, often conflicting, points of view.

In the final two images of *Let Us Now Praise Famous Men*, Agee attempts to locate in the prone and passive bodies of the sharecroppers a vision of spiritual and aesthetic transcendence that is "so strong, so valiant, so unvanquishable" that it will "at length outshine the sun." In contrast, *Yonnondio* insists on the inevitably contingent quality of language and representation, on the place of writing and art within a larger social struggle for power and meaning. The history of the novel's production, a process of loss and incomplete recovery, suggests the limits of such glorification of the poor. As the text represents a testament to its author's fortitude and resilience, it also serves as a reminder of its own mortality: "Only fragments, rough drafts, outlines, scraps remain—to tell what might have been and never will be

now." This sense of loss haunts not only the text as a whole, but also the Holbrook family, whose life on the "dump" and whose incapacity to speak above the din of the industrial landscape underlines their cultural invisibility.

The kind of reading that *Yonnondio* encourages is one predicated on taking what Thomas Keenan calls "responsibility." "By 'reading,'" Keenan states, "I mean our exposure to the singularity of a text, something that cannot be organized in advance, whose complexities cannot be settled or decided by 'theories' or the application of more or less mechanical programs. Reading, in this sense is what happens when we cannot apply the rules. This means that reading is an experience of responsibility, but that responsibility is not a moment of security or of cognitive certainty. Quite the contrary: the only responsibility worthy of the name comes with the removal of grounds."[69] Like other works of modernism, *Yonnondio* removes the aesthetic and cognitive grounds that make reading easy and comfortable. But more than that, the novel suggests that the existence and survival of a text depends on the political conditions in which it is produced and received. The text's refusal to offer catharsis is a refusal to let its readers "off the hook," a refusal to let us put the book down and move on. The text invites a reader who is not only, as in many modernist texts, "active" but also an activist reader, one who comprehends the textual forms of social power as well as the social conditions of textual production, who recognizes both the power and fragility of language, the capacity of texts to create conditions for subjection as well as possibilities for revolution.

5

MON/TROU/ MODERNI/M
LABORING BODIES, WOUNDED WORKERS, AND NARRATIVE HETEROGENEITY IN PIETRO DI DONATO'S CHRIST IN CONCRETE

In her introduction to the 1940 essay collection *The Cultural Approach to History*, Caroline Ware asserted that traditional methods of historical interpretation had reached a crisis point. Previous generations of historians had worked with a common set of assumptions and materials that Ware argued was no longer adequate for capturing the diversity and density of historical events. Early historians had limited their sources to public written records, their methods to approaches derived from the natural sciences, and their objects of inquiry to national rather than local issues and figures. In the twentieth century, several developments—including the "sight of historians becoming propagandists in war time," challenges to long-standing ideologies of scientific progress and objectivity, the growth of the social sciences, and, most significant, the "crisis of Western Civilization, whose values had provided the main basis for the historical writing of the nineteenth century"—challenged the very foundations of previously accepted modes of historical inquiry and raised perplexing questions: "Which facts should be used? How should those facts be interpreted? What conceptual tools could the historian bring to the search for and arrangement of his data?"[1] These questions sparked several developments, including the growth of the "new social history," in which historians adopted tools from social scientific disciplines such as psychology, anthropology, and sociology, and the recognition that previous historical accounts had neglected society's nonelites.

To incorporate these new facets of historical study, Ware proposed a cultural approach, the study of a given society as an "integral—though not necessarily a completely integrated—whole."[2] The cultural approach, Ware notes, allows historians to see a society's grounding assumptions and points of commonality as well as points of difference and discord: "Though implying that all parts of a society are functionally interrelated, the concept of culture does not imply a necessary harmony, either among aspects of society or among the cultural patterns of the several groups of which society is being composed."[3]

Taking the absence of a "necessary harmony" among social groups as its starting point, Ware's second contribution to the volume, an essay titled "Cultural Groups in the United States," issues a call for "history from the bottom up." As Ellen Fitzpatrick notes, "The cultural approach Ware advocated attempted to shift the focus of historical analysis from institutions and elites to social realities among Americans often lost in the story of the nation's past."[4] In "Cultural Groups in the United States," Ware contends that historians have neglected the lives of immigrants who have shaped an array of new, alternative cultures in American cities. "The melting pot," Ware contends, "has not, in fact, performed the function expected of it"; rather than fostering nationalist sentiment, the pressure to "Americanize" has produced a growth of ethnic "group consciousness" and the "stratification of society, especially of urban society, into a series of economic-occupational-nationality groups."[5] It is the experiences and values of these "new Americans" that historians must study if they hope to obtain a comprehensive view of American modernity. "In the still unexplored history of the non-dominant cultural groups of the industrial cities," Ware argues, "lies the story of an emerging culture that represents the dynamic cultural frontier of modern America."[6]

Echoing Randolph Bourne's 1916 essay "Trans-National America," which also posited the failure of the "melting pot" and the challenge posed by immigrants to Anglo-Saxon cultural values, Ware's emphasis on cultural stratification is remarkable for coming in the wake of the Depression and on the eve of the Second World War, a period in which significant governmental energy was focused on fostering a sense of national "unity" to fight both poverty and fascism, and in which the idea of the "people" emerged so forcefully, as Warren Susman has argued.[7] In sharp contrast to the New Deal rhetoric of national common cause and to the celebration of an American "folk," Ware asserts the growing disparity between "dominant" and "non-dominant" groups, especially in urban, industrial areas. Moreover, Ware in-

sists, "ethnic" differences overlap with differences in social class: "The issue of the status of cultural minorities is the issue of the status of workers. The emerging patterns of their lives, their attitudes, values, habits, are the patterns, attitudes, and habits of workers in an industrial society."[8] Placing immigrant, working-class culture at the forefront of historical research, Ware points out, entails a radical reorientation of the landmarks through which historical time and experience are marked: "It is to Ellis Island rather than to Plymouth Rock that a great part of the American people trace their history in America. More people have died in industrial accidents than in subduing the wilderness and fighting the revolution. It is these people, rather than the frontiersmen who constitute the real historical background and the heroic tradition of the mass of urban Americans."[9]

While these new urban Americans were entering the landscape of historical scholarship for the first time in the thirties and forties, they were at the same time emerging onto the literary scene. As literary historians have recently highlighted, the period between the twenties and the forties witnessed an outpouring of ethnic and immigrant fiction, including works by Anzia Yezierska, Daniel Fuchs, Jerre Magione, John Fante, Louis Adamic, Carlos Bulosan, José Garcia Villa, Toshiro Mori, and many others.[10] Like Ware's scholarship, which "searched for a way of integrating ethnicity, industrial labor, urbanism, gender, and class into the country's sense of itself,"[11] these novels collectively suggest, as Werner Sollors has argued, that American modernity was in large part an ethnic phenomenon, that "assimilation and modernization take place in ethnic and ethnocentric forms."[12] One of the most powerful and discursively innovative literary texts to emerge from the "new, urban, ethnic, industrial culture" that Ware describes is Pietro di Donato's *Christ in Concrete* (1939), an incendiary novel that blends modernist rhetorical strategies with naturalist and allegorical modes to narrate the life of a young Italian American bricklayer in New York City. Based on a short story published to great acclaim in *Esquire* in 1937, *Christ in Concrete* was chosen over *The Grapes of Wrath* as a Book-of-the-Month Club main selection in 1939. A novel about construction work, di Donato's text offers an especially acute anticipation of Ware's assertion that more Americans have died in industrial accidents than died fighting the Revolution; in *Christ in Concrete*, the wounded and dead bodies of immigrant workers encapsulate the brutal convergence of modernity and ethnicity that Ware, in 1940, sought to place at the forefront of American cultural understanding. In what follows, I situate *Christ in Concrete* in a particular tradition of American ethnic writing, analyze the reception of the novel, and offer a reading of

the text that focuses on the dynamic form of radical modernism di Donato fashions in order to render, in sensational fashion, both the labor process and the injuring of working bodies. I conclude by discussing the figure of "Christ in concrete," reading it as a prismatic symbol that condenses the complex and conflicting social, ideological, and formal registers that animate this multifaceted and volatile text.

Ethnic Proletarian Modernism

Christ in Concrete fits within a literary tradition that might be called ethnic proletarian modernism, a constellation of works—such as *Dr. Sax*, Jack Kerouac's surrealist novel about growing up in a French Canadian community in Massachusetts, and *Black Spring* by Henry Miller—that employ experimental modernist techniques to imagine ethnic, working-class stories. One of this tradition's hallmark novels is without doubt Henry Roth's *Call It Sleep* (1934), a text that possesses some remarkable affinities with *Christ in Concrete*.[13] Roth's novel narrates young David Schearl's attempts to create a framework for understanding his immigration to the United States and the formation of his Jewish American identity. In contrast to his parents, whose identities are grounded in concrete memories of life in a rural community and the well-formed religious teleology they bring with them from Europe, David has only fragmentary recollections of the culture and place that his family left behind. Existing in a state of almost constant cognitive dissonance—caught between tenuous and fading attachments to the Old World and a New World he finds utterly disorienting—David is left to find a new network of affiliations and associations with which to mold his sense of self, blending Jewish and urban American references to craft a resolutely "modern" subjectivity and adjust to the realization that "this [new, urban, industrial] world had been created without thought of him."[14]

The novel culminates in its most ambitious and self-consciously "modernist" moment—the depiction of the blast of light and power that David induces when he plunges a milk ladle onto electric trolley tracks in chapter 21. The form of the chapter echoes Joyce's stream of consciousness and T. S. Eliot's poetic fragmentation, vacillating among a wildly profane and multifarious constellation of voices—a clock-winder, a bartender and patrons, prostitutes, a train conductor—that speak in an array of languages and accents—Yiddish, Irish, Italian, English. David's perspective, rendered in poetic form in italics and indented for emphasis, provides a continuous thread that weaves the jumble of voices together. The chapter peaks in a moment of physical crisis and rhetorical excess. As the electricity from the

tracks jolts David's body, electrocuting him, his consciousness explodes in a "fatal glory":

> *Power! Power like a paw, titanic power,*
> *ripped through the earth and slammed*
> *against his body and shackled him*
> *where he stood*
> *The hawk of radiance raking him*
> *with talons of fire, battering his skull with*
> *a beak of fire, braying his body with*
> *pinions of intolerable light.*[15]

This explosive scene, which describes the infliction of excruciating pain as well as an infusion of liberating energy, crystallizes two of ethnic, proletarian modernism's recurring dynamics, dynamics that also give force, as we will see, to *Christ in Concrete*. First, in this scene, the formative redemption of the ethnic subject occurs through a violent encounter with modernity's industrial power. David's effort to meld the varied, and often conflicting, components of his existence into a sense of self is accomplished not through a "return" to a stable, discrete "ethnic" tradition, but through a dynamic "cymbal-clash" of modern electric energy that symbolizes a convergence of the diverse sources of David's identity.[16] David's plunging of the ladle into the trolley rails enacts the turbulent collision of elements and images—Christian and Jewish, sacred and profane, sexual and social, fearful and triumphant, revolutionary and Oedipal—that form the parameters of the young boy's world. In addition, David's audacious thrust is rendered through Roth's use of aesthetic techniques rarely connected with—and often perceived to be antagonistic to—ethnic culture: modernism. David's electric vision of light, power, and modernity echoes Roth's own use of modernist techniques to narrate his immigrant tale.[17]

In addition to allegorizing the intersection of ethnicity and modernity that organizes Roth's text, the scene also revolves around a trope that recurs throughout the forms of countermodernism that this book interrogates: a sensationalized image of bodily disfigurement—history "flash[ing] up at a moment of danger," in Walter Benjamin's words—that represents both social critique and, in this instance, social possibility.[18] On the one hand, the scene suggests the violence that industrial capitalist modernity frequently inflicts on the bodies of poor and ethnic persons—the electricity "shackles" and "batters" David, "ripping" and "piercing" his body. Like a giant bird or bear, the electric current punctures and slashes the young boy's body and

consciousness. Yet this moment of bodily destruction also becomes a scene of unity in which individual and (multilingual, multicultural) social narratives converge. David's personal experimentation and agony spark the formation of a collective subject as the diverse speakers who inhabit the early portion of the chapter assemble around David's injured body: "'W'at?' / 'W'ut?' / 'Va-at?' / 'Gaw Blimey!'"[19] David becomes both Isaiah, cleansed by Angelic coal, and Christ ("Christ, it's a kid!"), whose crucifixion unites a multifarious assortment of individuals into a spiritual community.[20] This scene of personal injury is ripe with overtones of rebellion ("Machine! Liberty! Revolt! Redeem!"), suggesting that the "pinions of intolerable light" that batter David might also spark a potentially revolutionary social transformation.[21]

For several reasons, it makes sense that certain ethnic writers such as Roth and di Donato turned to modernism to narrate the experience of immigration and the creation of American ethnic identities. If modernism represents, in the most general sense, an artistic response to the social and political transformations that are typically signified by the term "modernity"—the accelerated consolidation of capital and the intensification of industrialism, the growth of consumerism and the emergence of mass culture, and the increasing fluidity of national boundaries due to new forms of travel and communication, among other things—immigrant Americans, often arriving from rural European settings, undoubtedly felt modernity's "shock" at least as intensely as, if not more acutely than, native-born Americans. In addition, if modernism aspires to make language "new," bilingual immigrants clearly possessed rich resources for semantic innovation. Yet ethnic modernists were relatively rare. Modernism in the Anglo-American context was predominately the province of "native" elites, a movement led by highly educated, primarily privileged artists. As Marcus Klein has noted, to a remarkable extent, American modernists—from William James to Ezra Pound to T. S. Eliot to Gertrude Stein to F. Scott Fitzgerald to Nathanael West—had Ivy League educations.[22] As a discourse, modernism frequently constituted a language of difficulty, an erudite and opaque rhetoric analogous to the languages of expertise through which America's professional classes consolidated and restricted access to social and political authority during the early part of the twentieth century.[23] Roth himself entered the world of modernism through contact with the world of higher education— the copy of Joyce's *Ulysses* he read was smuggled back from France by his lover, the New York University professor Eda Lou Walton.

As prime manifestations of a neglected countertradition of American lit-

erature, *Call It Sleep* and *Christ in Concrete* can be compared to one another in instructive ways. Both novels employ modernist devices to narrate the developing consciousness of ethnic boys, both use spectacular images of disfigured bodies to narrate the inscription of modernity on the ethnic subject, and both refashion traditional religious iconography to signify the fusion of ethnicity and modernity. Despite these similarities, however, the novels differ significantly in at least two fundamental ways. First, Roth's modernism is a highly self-conscious form of literary echoing—a direct result of Roth's encounter with the canonical modernisms of Eliot and Joyce, which Roth then recast through the lens of his own ethnic, working-class story.[24] In contrast, *Christ in Concrete*'s rhetorical experimentations emerged not from di Donato's study of established modernism—literature he insists he had not read at the time he wrote the novel—but through his own personal attempt to craft a prose that could capture the sounds and rhythms of the immigrant street speech around him and also convey the unique power and logic of industrial capitalism's impact on the ethnic working-class. Second, Roth's story is cast through an Oedipal lens. The tale of David's ascendance into adulthood is structured as a rite of sexual and familial passage—his detachment from his mother and confrontation with his father's dominance in the family. Although *Christ in Concrete* is built around a similar family story—young Paul's emergence as the head of the household in the wake of his father's death—the narrative of Paul's personal development and the larger drama of the Italian community in which he lives are told through a narrative framework structured not primarily by psychological categories, but by questions of labor and class conflict. Di Donato's modernism, like Tillie Olsen's, is a radical one, the central concerns of which revolve around the fate of working bodies confronting what the novel describes as "the facts of undernourishment, illness, eviction and despair."[25]

Throbbing with Reality: Ethnicity, Class, and the Assumption of "Authenticity"

Christ in Concrete narrates the story of Paul, an Italian American whose father, Geremio, a master bricklayer, is killed when a building he is working on collapses on Good Friday; Paul is twelve years old at the time. The oldest of six children, Paul takes up bricklaying to support his family after they are refused compensation from the construction company and aid from the Catholic Church and the city government. In the course of the novel, Paul's uncle, Luigi, loses a leg during a construction accident and Paul's godfather, Nazone, falls off a scaffold to his death. Paul abandons the Church, much to

his mother's dismay, but she blesses him and entrusts her younger children to his guidance as she passes away in the novel's final pages. Structurally, the novel is divided into five sections. The first and last, "Geremio" and "Annunziata," are named for Paul's parents and narrate the transference of generational authority. The middle three sections represent the central aspects of Paul's existence—"Job," the construction industry in which Paul earns his living; "Tenement," the multiethnic space where Paul's family makes its home; and "Fiesta," the symbol of the Italian Catholic traditions shared by the community in which Paul grows up.

Critics and commentators have celebrated di Donato as an untutored genius, a precocious raw talent who used literature to express the frustrations and satisfactions of life as an uneducated worker. At the time he wrote *Christ in Concrete*, di Donato had received no formal literary training and very little formal education. Like the novel's protagonist, he had left school at the age of twelve to work as a bricklayer after his father was killed suddenly on the job. He had written the short story that became the novel's opening chapter in 1937, when he was twenty-five and living temporarily on public relief on Long Island, where he had been spending his free time at the local public library. An advance from the publishing house Bobbs-Merrill, which agreed to release the novel based on the success of the short story, allowed him to complete the book.[26]

Reviews of the novel emphasized its closeness to the smells, sounds, and feels of the construction site and its lack of literary sophistication. In the *Saturday Review of Literature*, Louis Adamic, one of America's most prominent immigrant intellectuals during the thirties, argued that several parts of the novel are "ill planned, shooting out in vague directions . . . even ill-defined and formless."[27] However, despite the lack of formal cohesion, Adamic asserts that "the words are powerful. They carry sounds and smells. The sentences are held together by a muscular vitality."[28] Adamic also compares di Donato's writing to bricklaying: "Sometimes one feels as though bricks and stones and trowelfuls of mortar have been thrown on the pages and from them have risen words. The book is a sincere, honest job."[29] Similarly, Louis Salomon, who reviewed the book for the *Nation*, drew a connection between the novel's style and manual labor: "His own terse style . . . throbs with reality, with the feel of brick and mortar, the smells of labor. . . . Only a man whose muscles and stomach have felt the fatigue and hunger of hard manual labor can paint them with such blunt, convincing strokes."[30] Several reviews included a photograph of di Donato on the job with trowel in hand.

The depiction of di Donato as brawny worker-cum-scribbler rather than as an entirely self-possessed or self-conscious artist no doubt facilitated *Christ in Concrete*'s favorable reception in the mainstream press. *Christ in Concrete* was lionized by the literary establishment: *Esquire*, which initially published the short story that evolved into the novel, lauded di Donato as the magazine's most important literary "discovery" of the previous three years. As was mentioned earlier, when the full-length novel was published in 1939, it was added to the Book-of-the-Month Club list. Stressing di Donato's identity as an immigrant worker rather than an accomplished writer encouraged readers to see the novel as a picturesque community study rather than an ambitious literary work. The *New York Times* reviewer argued condescendingly that di Donato "is attempting to portray life and work as experienced by his own people and does not attempt to tackle mental concepts impinging on working people from the outside."[31] The same review characterized di Donato as an "untutored sensuous artist" and contended that the chapter "Fiesta" is "as innocent as it is hearty" and the last chapter "as lovely as it is sad."[32] Along similar lines, *Time* magazine's reviewer framed the novel as an expression of an immigrant's primitive emotions, contending that the novel "is a passionate, humorous, pathetic story of peasant Italians in the U.S., at work, in tenements, in animal anguish and animal high spirits."[33] In sum, although reviewers acknowledged the book's visceral power, they frequently invoked class and ethnic stereotypes to explain the novel to potential readers, downplaying the potential ideological or intellectual power of the text. *Christ in Concrete*, reviewers implied, is emotionally potent, but formally and philosophically unsophisticated.

More recent commentators have also tended to emphasize the "authenticity" of di Donato's account of the "ethnic experience" at the expense of the novel's literary qualities. One critic, for example, claims that the text "manages to convey a true ethnic identity" and suggests that di Donato's genius resides in his capacity "for transferring his observations with a minimum of adulterations."[34] Emphasizing the literary transparency and ethnic genuineness of *Christ in Concrete* leads the same critic to denigrate the text's formal experimentations as "stylistic inconsistencies" rather than calculated aesthetic decisions: "There is nothing in these pages that pretends to literary innovation."[35]

As these reviews indicate, *Christ in Concrete* has been perceived as the product of the author's native genius, his naïveté, rather than as a work of self-conscious artistry. In framing the novel this way—as a work of spontaneous combustion, of pure ethnic "authenticity" poured onto the page

with an absolute minimum of literary pretension—reviewers and critics have encouraged readers to romanticize, sentimentalize, and ultimately de-politicize the text, to see it as a transparent story of immigrant experience instead of an ambitious and sophisticated form of cultural expression. In what follows, I offer a contrasting reading of the novel, contending that it challenges, through its formal heterogeneity and its monstrously sensational scenes of human destruction, the relatively simple and reassuring reception it appears to invite.

Modernism, Labor's Body, and Literary Form

Like *Yonnondio*, and, albeit in different ways, like the short fiction of William Carlos Williams and the Harlem photography of Aaron Siskind, *Christ in Concrete* suggests that social power and prestige are functions of vision, manifested through ways of seeing. When Annunziata and her children appear before the public workers' compensation board to apply for assistance, the municipal officials seem to view the immigrants with a gaze designed to stereotype and regulate them. The chambers of the city building are dominated by "casually opulent" men, attorneys and judges who "bear transparent distant eye like policemen" (129). From Paul's point of view, the relation of these men to the lives of the poor is highly speculative; to them, the persons seeking compensation—the "battered poor," "the maimed and crippled and bandaged and blind workers" (128)—appear "transparent," immanently visible and decipherable. The lawyers and officers occupy the position of spectators in naturalist fiction, as characterized by June Howard. According to Howard, naturalist fiction is structured by an antinomy between a disembodied, privileged spectator and an inarticulate, degraded, lower-class "brute" onto which the dominant order projects its social anxieties. In naturalism's "ideology of brutality," Howard argues, "the Other is imagined as necessarily inarticulate, incapable of reciprocal naming since he is unable to achieve self-awareness or self-expressive speech."[36] Similarly, di Donato's novel suggests that men in positions of power see the poor as debased creatures to be contained, regulated, "policed"; these men possess "smiles that made [Annunziata and Paul] feel they had undressed in front of these gentlemen and revealed dirty underwear . . . smiles that made them feel they were un-Godly and greasy pagan Christians" (133). Recently, Paula Rabinowitz has proposed that "the scene of class domination is the same as the scene of voyeurism."[37] Class power, she contends, is enforced and inscribed through the authority of privileged subjects to visually violate the privacy of the poor without letting the poor contest or return such

an invasive gaze. In di Donato's novel, class subordination is manifested through feelings of visual transparency and shame; the gaze of the powerful "fixes" Geremio's family, closing them within a predetermined narrative of ethnic naïveté.[38] "The Eyetalians are good workers," states one of the foremen defending the construction company against Annunziata's claims, "[but] careless like children" (132). The visual and rhetorical processing of the poor, through which Annunziata and Paul are figuratively exposed and inspected by the glances of the city officials and through which Geremio's death is contained within a ready-made narrative of immigrant ignorance and infantilism, is precisely what di Donato's novel is written to oppose.

In addition to writing against the power of the "transparent distant eye" that contains and "polices" the poor, di Donato also hoped the novel would speak to working-class readers. Di Donato had joined the Communist Party at the age of sixteen on August 23, 1927, the night Sacco and Vanzetti were executed, and he was known by many of his fellow bricklayers as "Pete the Red." His outrage against the inequities of the capitalist system increased after the onset of the Depression, which the narrator of *Christ in Concrete* refers to as "the cataclysm of unemployment" (207–8). During the early 1930s he wrote several impassioned letters to Roosevelt, asking him to "lead the poor and hungry, the old and ill, the oppressed unemployed out of the Valley of Economic Despair."[39] He purchased a ticket to the Soviet Union and considered joining the Lincoln Brigade to fight in the Spanish Civil War, but in both cases decided to stay at home to support his younger siblings. *Christ in Concrete*'s stirring depiction of fatigue, injury, and death on the job was clearly designed to demonstrate the lethal dangers that industrial capitalism posed to immigrant workers. "The scaffolds are not safe," Paul proclaims in the novel's final pages, "for the rich must ever profit more" (228). Di Donato stated that while writing the text, he was "bitter in [his] heart against the money system, the capitalists' world."[40] He hoped that by reading the novel "the thinking of sensitive readers would become emotionalized against the constrictions and the oppressive nature of the environment to which the immigrant and the poor were subjected."[41] In his speech at the 1939 American Writers' Congress, di Donato asserted that the text was directed at working persons who participate, as the author saw it, in their own subjugation: "I am not interested in writing for class-conscious people. I consider the class-conscious person something of a genius. . . . I say to the worker, you are the guys that are permitting this, and you are hurting me, too. How to reach them and tell them that they are permitting it. What makes them submit, what makes them embrace suffering? . . . How

to show him something different, to make him discontent, to show what life can be."[42] Di Donato rejects the romance of the worker as an innately class-conscious revolutionary—only the rare "genius" naturally recognizes the terms of social conflict in capitalist society. For the vast majority of working people, class consciousness needs to be created, produced. A first step in that process is a form of estrangement, the effort to make readers "discontent," to "show him [sic] something different" in the hopes of reshaping the way readers see the world.

The desire to destabilize readers' habitual ways of seeing the world helps explain why *Christ in Concrete*, like *Yonnondio*, is a disjointed novel, a patchwork of multiple, at times conflicting voices, styles, themes, and ideological registers that together offer a polymorphic rather than seamless vision of social life. As Arthur Casciato has suggested, this novel about bricklaying is also a work of bricolage.[43] Perhaps the most visible aspect of the novel's formal hybridity, and the feature of the novel that has received the most critical attention, is its fusion of Italian and English, manifested most visibly in di Donato's habit of translating the characters' speech into English, but retaining the metaphors and rhythms of their native Italian.[44] For example, the threat of being fired is rendered in Geremio's idiom as " 'If he writes out slips, someone won't have big eels on Easter table' " (5). Similarly, the Italian phrase "per piacere," is rendered not as "please" but as "for pleasure."[45] In both of these instances, the text's two languages are fused, creating what Fred Gardaphé describes as "a language that is neither Italian nor English, but an amalgam of the two."[46]

In addition to its linguistic combinations, *Christ in Concrete* straddles and complicates several generic and formal boundaries, blending realist, naturalist, proletarian, and modernist modes to narrate the lives of its working-class Italian immigrant characters, the "cheated fragment selves" of the "polyglot worker poor" (234). Like many realist texts, *Christ in Concrete* strives to portray society as a totality, a complex whole of intersecting social forces, and to ground that vision in concrete details of everyday life; like a conventional naturalist novel, it focuses on the power of social forces to determine the lives of individuals caught in their flow; like a paradigmatic proletarian text, the novel offers an explicit critique of industrial capitalism from a working-class perspective. However, as *Christ in Concrete* evokes these literary modes, it also disrupts each of them in crucial ways. The realist transparency effect is destabilized by the introduction of allegorical emblems and modernist devices such as stream of consciousness, surreal sequences, and syntactical fragmentation;[47] the naturalist antinomy between

spectator and mute brute is disrupted by the novel's point of view, which allows the "brutes" to speak in their own words and on their own behalf; the proletarian emphasis on class politics is crosscut by the presence of what William Boelhower calls "ethnic signs," ethnically marked narrative and symbolic elements that lend the text's political calculus a specifically "immigrant" dynamic.[48]

Through these forms of literary fusion, and the unorthodox use of modernist techniques of narrative fracture and experimentation discussed in detail below, di Donato creates a monstrous modernism designed to narrate both the horrid conditions under which the text's working-class characters live and a utopian potential for political and spiritual redemption. The monstrosity of di Donato's novel registers the fundamentally contradictory, even perverse quality of the social world seen from the perspective of the Italian American workers who are the text's protagonists, the sense that the "reality" of life in America undercuts the nation's "promise," that, as Nazone asserts, "this land has become a soil that has contradicted itself" (211). The overwhelming power of social and political contradiction places Paul and his family in an untenable position in which, as Geremio explains, "to rebel is to lose all of the very little. To be obedient is to choke" (13). Lacking meaningful political or social agency, the laborers are literally and figuratively crushed beneath the weight of industrial capitalism, twisted and deformed into inhuman figures embodied in the monstrous image of Christ in concrete, of workers buried in industrial mud. Through this composite figure, this paradoxical image of bodily destruction and spiritual redemption, the novel asks us to see "Christ" in "concrete," to recast the Christian ideal of brotherly love as pagan identification with the "polyglot worker poor," to ground spiritual outrage in the inequities of material existence, to link spiritual salvation to social revolution. The model for this fusion of spirit and politics is the text itself, which uses high modernism's language of abstraction and consciousness to underscore material forms of degradation and oppression.

Christ in Concrete employs a variety of experimental narrative techniques that we typically associate with modernism, techniques that resist or subvert the immediate contact with "reality" that the codes of realism appear to supply.[49] However, *Christ in Concrete* differs significantly from conventional forms of high modernism, which many critics have suggested typically attempts to seek refuge from a social world that is in the process of being industrialized and rationalized by constructing a heightened aesthetic space outside the social realm. In contrast, *Christ in Concrete*'s aesthetic

innovations derive from the effort to narrate the very processes of industrialization that high modernism seeks to deny or avoid. Like *Yonnondio*, *Christ in Concrete* renders working-class modernity not by achieving what Quentin Anderson calls, in his description of high modernism's aestheticizing tendency, "secular transcendence"—the escape from the confines of the body and material necessity—but rather by employing modernism's formal devices to underscore the very materiality of modern experience, to perform what Fredric Jameson describes as "a materialist regrounding of the dominant ideology of modernism."[50] *Christ in Concrete*'s "modernism"— its stream of consciousness, its fragmented narrative voice, its moments of formal and epistemological crisis—thus represents not sublimation, the transformation of the social world into the private languages and aesthetic productions of the psychological self, but, rather, an effort to narrate the cultural and political contradictions that condition the lives of the text's impoverished immigrant characters. More like the radical experimental texts produced by the historical avant-gardes, *Christ in Concrete* opposes the aesthetic autonomy of art that renders it separate from the social world. As Peter Bürger has argued, avant-garde art "intends the abolition of autonomous art by which it means that art is to be integrated into the praxis of life."[51] Similarly, di Donato's novel is a political modernism, a work of art that insists on the pressing social agency and urgency of the artistic enterprise. Bürger writes that in avant-garde art "it is no longer the harmony of the individual parts that constitutes the whole; it is the contradictory relationship of the heterogeneous elements" (82). Likewise, *Christ in Concrete* is a resolutely heterogeneous work, composed of conflicting discourses, perspectives, and thematic impulses. The contradictions of di Donato's novel are captured most powerfully by the experimental, sensationalized renderings of workers' wounded and deformed bodies. These bodies, disfigured and shattered into bloody piles of fleshy debris, serve both as analogues of the novel's chaotic form and as spectacular figures of social protest.

Christ in Concrete's deployment of sensational images of bodily destruction as emblems of narrative interruption and political critique can be seen in the opening section of the text, which is narrated from the perspective of Paul's father, Geremio, a master bricklayer and construction site foreman. The novel's first two chapters depict two work days and the thoughts that occupy Geremio as he oversees the construction of a tall building: his pride in his newly purchased house, his love for his family, his concerns about the integrity of the building (which are allayed by the construction managers). The reader's introduction to Geremio and his world, however, is dramati-

cally disrupted when the partially constructed building collapses, crushing Geremio beneath steel beams and smothering him in wet concrete. A rush of rhetorical speed, semantic excess, and exceedingly graphic imagery ensues. The "floor vomited" as "frozen men went flying explosively" — "Walls, floors, beams became whirling, solid, splintering waves crashing with detonations that ground man and material in bonds of death" (14). In a dreamlike sequence, the familiar forms of the material world are transformed into a shattered array of component parts and pieces: another worker's face becomes "grisly sharp bones . . . [a] gluey, stringy, hollow mass, yielding as wet macaroni" (14); Geremio's own "bones cracked mutely and his sanity went sailing distorted in the limbo of the subconscious" (16). Impaled on the structure's half-built foundation, "his blue swollen face pressed against the form and his arms outstretched, caught securely through the meat by the thin round bars of reinforcing steel" (14), Geremio is reduced to pure, shredded flesh.

In this scene, the world has been turned upside down and inside out: construction has become destruction; the integrity of the body — and of the novel's narrative texture — has been shattered, fractured into a kaleidoscopic swirl of organs and fluids. The continuity and coherence of perspective that traditionally mark realist narrative, as well as the expectations of linear progress that undergird narratives of ethnic *bildung*, explode, as the novel casts the point of view with which the text opens into violent chaos. Like the whistle's blast that opens *Yonnondio*, the building's collapse and the detailed depiction of violent dismembering sound an alarm to the reader, signaling an epistemological and political break. As the literary critic Michael Kowalewski has argued, such "vividly evoked scenes of violence [can] offer a crucial means by which a novelist can shatter social complacency or literary convention."[52] In the scene of Geremio's death, the quotidian tone of the opening pages — a familiar narrative of a man working his way up in the world, improving his lot, and providing for his family — is radically interrupted. The linearity of both conventional realist narratives and conventional immigrant narratives (in which the ethnic subject gradually "assimilates" through hard work and perseverance) is ruptured by a sudden, unexpected catastrophe that crystallizes the uneven structures of power in Geremio's world, in which workers suffer for managerial negligence. Geremio's violent demise also represents a challenge to conventional modes of novelistic identification, in which readers gradually develop deep emotional investment in a text's protagonist. Geremio's death obviously undercuts readers' identification with him in a definitive and, given the spectacular quality of the description, shocking fashion. Furthermore, the

fact that Geremio's death is narrated from his own point of view such that readers hear his final thoughts as he drowns in concrete challenges their potential passivity or indifference to proletarian pain. The scene's chilling depiction of Geremio's final, mad moments places us in what Janet Zandy describes as a "no-comfort zone," foreshadowing the fact that the book as a whole provides its readers no neutral ground in the intense contest being waged on "Job."[53] Reading, the text implies, is a polemical activity, a political as well as aesthetic process.

The surreal lyricism employed in the description of Geremio's death inaugurates the novel's use of modernist devices, which take many forms and perform several functions. These include linguistic innovation that conveys prejudice ("'Lissenyawopbastard!'" [9]); the sheer semantic simplicity that exposes the brutally unforgiving arithmetic of poverty: "Paul Annina Lucia Giorgio Joseph Adela Johnny Geremio two onions four potatoes" (51); the Dos Passos–like captioning of "official" discourse that cuts a cruel irony against the family's failure to secure any compensation or assistance after Geremio's death ("MUNICIPAL BUILDING / JUSTICE / EQUALITY" [53]); the interior monologues that convey the consciousness of the novel's central characters: "Stupid world. Indifferent. He would have had earth embrace him. Equality. Justice" (232); and the stream-of-consciousness depiction of industrial work ("Snoutnose steamed through ragged mustache whiplashing sand mixer Ashes-ass dragged under four-by-twelve beam Lean clawed wall knots jumping in jaws masonry crumbled dust billowed thundered choked" [9]). Most resoundingly, di Donato's modernism constitutes a strategy for narrating the contradictions of heavy industrial construction labor—brutality and exhilaration, pain and power, what the novel calls the "terror of production" (13), "the screaming movement of Job" (143).

Di Donato's rendering of labor's "screaming movement" makes use of modernist rhetorical techniques, but is grounded in a materialist analysis of the working body. Much recent scholarly work on the history of the modern body has tended to employ either psychoanalytic or Foucauldian theories to explain the body as a subject of sexual discourse or an object of disciplines.[54] Other scholarship has emphasized the body's status as an object of fashion, appearance, and consumer culture.[55] In his survey of self and society in the late modern age, for instance, Anthony Giddens argues that the body is a crucial element of identity construction and contends that the central categories for analyzing the relationship between the body and selfhood include appearance, demeanor, sensuality, and the various "regimes" to which bodies are subject.[56] Absent from Giddens's argument, which is set in terms

that emphasize the body as a medium of social presentation, and from most other discussions of the cultural construction of the modern body, is the question of labor—the body as an instrument and element of production. By obscuring the body's role in the labor process and the ways in which work shapes the modern experience of corporeal existence, studies such as Giddens's unwittingly reinforce the very terms of consumer-oriented culture—in which the body is imagined first and foremost as an object of personal actualization, adornment, and display—which they so often set out to question or critique.[57]

Rather than prioritizing the bodily demands and possibilities established by modern consumer culture, di Donato emphasizes the complex and often contradictory ways in which the body is shaped by industrial labor. Not surprisingly, perhaps, given di Donato's political radicalism, the novel's deeply materialist depiction of laboring bodies echoes crucial elements of Marx's theory of labor value. Marx presumed that, at the most fundamental level, human labor and social production more generally are materializations of the human body. In *Capital*, Marx asserts that commodities are "embodied" units of human labor power, the extension of bodily form and force into objects of use and exchange.[58] Products of labor—from coats, to bread, to buildings—represent the force of the human body materialized—"congealed quantities of homogenous human labor," "accumulated" human labor.[59] Products have use value because they objectify human labor, giving concrete and transferable form to bodily exertion, energy, and form: "Tailoring and weaving, although they are qualitatively different productive activities, are both a productive expenditure of human brains, muscles, nerves, hands, etc., and in this sense both human labor."[60] Tailoring and weaving—and the products resulting from those activities—are extensions of the very lineaments of the human body, a notion explained by Elaine Scarry in her reading of Marx. Scarry states that, according to Marx, civilization as a whole—the aggregate structures of social wealth, exchange, and reproduction—is an extension of corporeal needs and powers, the social objectification of the human body: "Capital is . . . the projected form of bodily labor and needs."[61] "In civilization," she says, glossing Marx, "the body is turned inside out and made sharable."[62]

As Scarry explains, the actions of labor—in which the body's needs, shapes, and capacities are projected outward into concrete objects of utility and, in the case of capitalism, exchange—are reciprocal. Through the labor process, in which human bodies reshape base materials into products, the bodies of the producers are themselves in turn transformed. "Throughout

his writings," Scarry argues, Marx "assumes that the made world is the human being's body and that, having projected that body into the made world, men and women are themselves disembodied, spiritualized."[63] In a process Scarry describes as "the double consequence of creation," the human body makes artifacts, which are extensions of bodily form, and the human body, in turn, is remade into an artifact.[64] Under capitalism, however, the reciprocal aspects of creating—the projection of the body into artifice and the concomitant remaking of the body—are split and separated. "For Marx," Scarry explains, "the contemporary system of production deconstructs the imagination's own structure of activity by bringing into relation two groups of people (one very large, the other very small) who in their lifelong memory as well as cultural and philosophic negotiations will forever confront one another across the central fact that one of them is deeply embodied and the other is disembodied."[65] "One [the proletariat] suffers, desires, and risks in his [*sic*] body and the other [the capitalist] suffers, desires, risks in 'his' artifice."[66] Capitalists are defined, Scarry argues, by having a relation to the system of production that allows them to exist and prosper without risking their bodies—the capitalist's body and his or her consciousness and desires are freed from the system of production for other arenas.[67] In contrast, the desires, consciousness, and capacities of the proletariat are absorbed more intensively and directly into the system of production; their bodies are projected into artifice, but are not in turn re-created as artifacts, resulting in a condition of "heightened embodiedness."[68] The unreciprocated character of working-class labor means that workers possess a "magnified body."[69] It is the overly embodied status of labor that *Christ in Concrete* depicts—the acute vulnerability, as well as the productive power, manifested in the bodies of the working poor. The novel's prosaic experiments—forms of semantic innovation typically employed by high modernists to delineate the depths of "disembodied" consciousness—are instead used to render the ways in which desire, pain, and creativity are expressed through the "magnified" bodies of the text's laboring characters. These working bodies, depicted in a manner designed to startle and discomfit readers, are the novel's sensational bodies—shocking figures that condense the inequities and injustices of class difference, ethnic prejudice, and physical injury.

In *Capital*, Marx underscores the contradictory forces to which industrial capitalism subjects working bodies. On the one hand, capitalism's ceaseless drive to improve the speed and rate of production requires great flexibility from workers: "Modern industry never views or treats the existing form of a production process as the definitive one. . . . By means of machinery, chemi-

cal processes and other methods, it is continually transforming not only the technical basis of production but also the functions of the worker and the social combinations of the labor process."[70] Large-scale industry, Marx asserts, "necessitates variation of labor, fluidity of functions, and mobility of the worker in all directions."[71] At the same time, however, the relations of production remain hierarchical, rigid: "On the other hand, in its capitalist form [large-scale industry] reproduces the old division of labor with its ossified particularities. . . . This absolute contradiction does away with all repose, all fixity and all security as far as the worker's life-situation is concerned."[72] As David Harvey has argued, Marx's analysis suggests that "the exigencies of capitalist production push the limits of the working body—its capacities and its possibilities—in a variety of different and often fundamentally contradictory directions": "While subservience and respect for authority (sometimes amounting to abject submission) is paramount, the creative responses, spontaneous resources, and animal spirits necessary to the 'form-giving fire' of the labor process must also be liberated and mobilized."[73] The combination of flexibility and discipline that characterizes the system of production, Harvey contends, is complex and unstable, and, as di Donato's novel suggests, can produce deadly contradictions.

The experimental semantic forms that di Donato employs to narrate the labor process articulate these contradictions. On the one hand, the descriptions of labor highlight the brutalizing force of industrial production, the power of work to twist, cripple, and exhaust the body, draining every ounce of human productive capacity. On the other hand, di Donato describes labor as an avenue of self-expression, bodily fulfillment, and empowerment. To convey the significance of labor, the novel personifies it, describing work as a figure of immense power and persuasion, a personality, "Job," that dominates Paul's psychological and emotional vistas. Paul's relationship to Job is fundamentally ambivalent: Job is both the site where Paul's primary energies and ambitions are expressed and a space where uneven social relations, in which workers risk their bodily health for the profit of owners and managers, take material form. Di Donato describes Job in language that blends both excitement and danger, coordination and confusion in "an inferno of sense-pounding cacophony":

Compression engines snort viciously—sledge heads punch sinking spikes—steel drills bite shattering jazz in stony-stone excitedly jarring clinging hands—dust swirling—bells clanging insistent aggravated warning—severe iron cranes swivel swing dead heavy rock high—clat-

tering dump—vibrating concussion swiftly absorbed—echo reverberat-
ing—scoops bulling horns in rock pile chug-shish-chug-chug aloft—hiss
roar dynamite's boomdoom loosening petrified bowels—one hundred
hands fighting rock—fifty spines derricking swiveling—fifty faces in set
mask chopping stone into bread—fifty hearts interpreting labor hurling
oneself down and in at earth planting pod-footed Job. (36)

This passage's vigorous stylistics, which echo the frenzied tone of futur-
ism, illustrate the text's ambivalence about the shape and force of indus-
trial labor. Through a cubistlike explosion of the scene into an array of per-
spectives, the sequence suggests both the enthralling dynamism and the
overwhelming violence of large-scale construction work. The long, broken
sentence, which stumbles from one tumultuous image to another, conveys
speed and energy, forces that converge in a bebop rhythm ("shattering
jazz," "vibrating concussion," "bulling horns"), while di Donato's use of
alliteration and onomatopoeia give the passage momentum and punch. But
the scene's vitality is both rigidly orchestrated and extremely violent. The
first half of the passage is devoid of human figures—engines, sledge ham-
mers, drills, dust, bells, and cranes animate the site, providing the motion
and action that make Job run. When workers do appear, they figure as seg-
ments and pieces—hands, spines, faces, hearts—rather than whole persons.
Laborers have become component parts, much as the individual phrases
di Donato uses to describe the scene—incomplete or broken sentences on
their own—are embedded in a larger, multifaceted image. And if the human
elements of Job have been dehumanized, the inorganic elements take on
animal-like characteristics—they snort, bite, and punch.

To convey Job's speed, tension, and pressure, di Donato constructs a
unique brand of narrative experimentalism—a labor modernism—that
strips the description of work and the construction site of conjunctions and
punctuation to craft crowded, confusing sentences that overwhelm standard
syntax. Di Donato describes Job as a "symphony of struggle" (8): "The
men were transformed into single silent beasts. Snoutnose steamed through
ragged mustache whiplashing sand into mixer Ashes-ass dragged under four-
by-twelve beam Lean clawed wall knots jumping in jaws masonry crumbled
dust billowed thundered choked . . ." (9). Here, the modernist explosion of
the sentence is used to convey proletarian exploitation. The absence of punc-
tuation underscores the relentlessness of labor's pace; Job does not hesitate
or rest, but moves with a seemingly self-perpetuating and overpowering mo-
mentum ("billowed thundered choked"). Like Job, di Donato's prose is a

"balanced delirium" (180), combining naturalism's emphasis on gritty details with a Joycean-like stream of consciousness. Here, as elsewhere in the novel, the deformation of conventional syntactical arrangements dovetails with the writing of labor; the narration of construction work as a process of not only production but also destruction and death is reflected and reinforced in the undoing of standard semantic patterns.

Throughout the novel, di Donato outlines the ways in which Job compels and consumes laborers, dismantling and subsuming their bodies, their voices, and their desires into its seemingly inexorable workings until "our bodies are no longer meat and bone of our parents, but substance of Job" (142). A remarkably flexible machine of accumulation, Job swallows the powers of the persons and cultures that enter its sphere of influence: "The multitudinous voices of a civilization rose from the surrounding and melted with the efforts of the Job" (8). Before his death, Geremio reflects on Job's relentlessness, lamenting its ability to structure his own desires and drives: "He felt a searing bitterness and a fathomless consternation at the queer consciousness that inflicted the ever mounting weight of structures that he had to! had to! raise above his shoulders" (8). Here, the text suggests that Job's power is both material (a "mounting weight of structures") and psychological ("the queer consciousness"). Job ingests the energies of the "surrounding" "civilization"; what remains is "the language of worn oppression and the despair of realizing that his life had been left on a pile of bricks" (8).

In *Christ in Concrete*, labor is an enduring state of struggle in which the worker's body is twisted, contorted, and deformed. Job wounds and splinters Paul's skeleton, stripping his nervous system bare: "His neck was split and yet connected. . . . He rolled over on his side, his lower back shooting fire all over him and screaming of a spine of broken cords connected by a thread that would sever any second" (82–83); "His back . . . broke and seemed to come apart. The bending point severed and became a gap connected with trickling, shocking electrical flashes" (143). Near the end of his first week of work, Paul's body begins to disintegrate under the strain of Job's relentless pressure: "He thought he could convince his body to accept his duty, but now everything within had broken apart and was trickling away" (93). In these passages (which recall the dynamic techno-poetry of Chapter 21 of *Call It Sleep*) Paul's corporeal integrity dissolves as the pain of labor transfigures him into a monster—a disfigured industrial cyborg, a bundle of "broken cords," "split" and "severed" components, linked by "shooting fire" and "shocking electrical flashes." As elsewhere, the form

of di Donato's experimental prose underscores the thematic thrust of the text: with snapshots and violent images strung together by loose syntactical connections and conjunctions, di Donato's writing mirrors the physical fractures caused by the back-breaking labor.

As Paul's skill progresses and his responsibility on the job grows, Job's influence over his life expands, distracting and dominating his thoughts during his hours away from the construction site. "Three nights a week he went to school," the narrator explains. "Often while listening to the instructor his world would float from him and an indistinct pressure stood by him whispering: Walls—bearing—job—twenty-inch footings—upward thrust—diagonal tension . . . the job—that Job garage job apartment job brick job job *job*. . . ." (163, ellipsis in original). Again, di Donato's rendering of labor's pervasive presence emerges as a form of modernist experimentation, a breakdown of conventional syntax. Modernism is deployed here to describe the way work haunts Paul, invading and overwhelming his mind as the word "job" disrupts and overtakes the sentence that narrates the phenomenon.

However, although Job is a dominant, coercive force, workers' relationships with their labor are not one-sided or uniformly negative. Job not only crushes; it also paradoxically sustains and empowers the bricklayers: "Brick and mortar was to become for Paul as stuff he could eat, and the constant motion from brick pile and tub to wall was to become a motion that fed upon itself" (142). Job has a dual impact—it is a source of not only pain but also pride, not only impairment but also empowerment. Labor is the process of world building, of transforming hope and desire into concrete reality. "It was an actual corner. It was real" (70), Paul thinks to himself, surveying his work. Although performed within the matrix of Job's coercive system, laying brick "thrilled him. It felt like one of his dreams where he had raced an incredible distance at terrific speed on a road that stretched beyond the earth" (142). Here, labor seems to offer, however temporarily, the possibility of transcendence, of stretching "beyond the earth." Paul "gloried in his body's labor" (169); work is an "Olympic contest" (177) that Paul finds "thrilling" (179). Within Job's repressive regime, then, the working body is not only fractured, but also extended and empowered. Bricklaying is skilled work and di Donato's novel displays a craftsman's labor aesthetic.[74] Paul's "first fleshy sense of Job" (69) not only inducts him into the system of capitalist production, but also provides a gratifying sense of individual achievement: "Dabbing mortar on the head of another brick he laid it down and pressed it up against the end of the first brick and tapped it down into the

soft mortar until it seemed level with the first brick; and then he did the same with four more bricks" (70). The experience is a revelation: "O God you have heard me—*I have laid brick!*" (70). For Paul, Job is both the brutalizing extraction of human energy—the "soul's sentence to stone" (143), "a brick labyrinth that would suck him in deeper and deeper" (142)—and a metric of personal power, a potentially revolutionary realization of spiritual and physical energy: "Paul was now bricklayer-worker . . . welded to the hands whose vibrations could shatter the earth" (143, ellipsis in the original).

The novel's depictions of laboring bodies echo yet also subtly challenge the heroic images of muscular workingmen that were so prevalent in the Depression era. The art historian Erika Doss has argued that American muralists, painters, and lithographers frequently used images of brawny male workers to symbolize the nation's imagined recovery from the depths of economic crisis.[75] Similarly, many writers and artists on the Left frequently used an iconography of white, masculine physical prowess—burly bodies, rigid postures, unwavering gazes—to promote a reassuring sense of working-class power in the face of massive unemployment. Doss observes that the male working body depicted in American art during the decade was "defined in overtly heterosexual terms" which "reinforced the stereotype of the muscle-bound heterosexual he-man, the straight male worker."[76] *Christ in Concrete* reproduces many of these representational conventions. As Paul learns his trade, his body swells: "In the sun Paul tanned deeply, and his breast muscles showed rounder" (169). For the workers in the novel, bricklaying is a decidedly manly craft that demands strength, skill, and endurance. In response to another worker's complaint about working in cold weather, the crew leader, Fausta, says, "Tell me—what are we Christians, men or not?" (155). The novel frequently casts labor in erotic terms, portraying work as an act of virile assertion. Urging the bricklayers on, Fausta proclaims, "Now then . . . make love to it! . . . Push into it my children, for this is the money wall!" (141). As the men labor, "Job became noisier expanding organism—banging, groaning, thudding and pushing UP!" (142). While the novel depicts workers as embodiments of virility and physical power, it feminizes the representatives of the ruling class, suggesting they lack the qualities of authenticity and physical potency associated with manual labor. The corporate officers who visit the construction site are described as "glaze-skinned, white-fingered men who looked like painted mustached women dressed in tailored men's clothes" (182).

Yet the novel does not blindly reproduce conventional images of working-

class virility. Rather, *Christ in Concrete* conveys immense anxiety about masculine—and human—power in an industrial age of capitalist production. Walter Kalaidjian and Paula Rabinowitz have argued that the aggressive icons of male vigor that dominated Left cultural discourse about work in the 1930s in fact belie the very lack of confidence they were designed to assuage. Kalaidjian maintains that the "typical images of proletarian solidarity [such as] . . . the assertive upraised fist, . . . the muscle-bound torso, the strained but determined visage . . . stand not so much as phallic icons of working-class hegemony but as uncanny symptoms of its absence."[77] In contrast to many works of art from the period, *Christ in Concrete* demonstrates a subtle but persistent awareness of the fragility of the images of masculine worker bravado that it promotes. For instance, while the novel celebrates the bawdy rituals of male bonding that take place among men at the construction site, it also lends those dynamics a foreboding dimension. In one scene, at the close of a cold day just before Christmas, the bricklayers gather in a small shack on the site "at the foot of Job" (156) to drink and carouse. At first, the assembly of hardy male workers—"the strong-muscled chests and emphatic arms, the smell of tough bodies and full-throated voices"—is described as "Paradise" (156). But as the men drink to excess, the scene turns bizarre. "Lust spread[s] as scalding enema in bowels," and the men visit a nearby brothel and return, at first remorseful, then more raucous (159). As Nazone continues to decry their sexual exploit, the other men surround and undress him, then hoist him, a mock Christ, onto a hastily made cross of studded planks and proceed to tickle him. The scene, teeming with homoerotic overtones, ends with a series of bodily eruptions, as Nazone "yelled unintelligibly until he gulped and vomited gushes of sour wine and lunch into Fausta's face. Then tight reeling muscles pushed out storms of open throated laughter stomach kicking laughter fist clenching laughter" (161). While the scene is clearly comic, its carnivalesque quality suggests that the group's behavior is in some significant measure a compensatory ritual, a release of tension and frustration in an effort to ward off a feeling of abjection on the job. As the men converse, they conjure up imaginary buildings, raising and dismantling the structures in a fantasy of control and power that is denied them in their everyday work lives: "On the floor of the shanty imaginary buildings were built, recalled, and kicked around" (157). Moreover, the playful crucifixion of Nazone ironically foreshadows his untimely death, lending the scene a certain seriousness: even in the midst of hilarious escape from work, the lethal presence of Job looms ominously. Finally, the homoerotic tenor of the festivities indicates that the rigid heterosexuality

(and homophobia) that subtended so much of the era's rhetoric of mascu-line strength was much more porous than its proponents might have liked to believe.

The quotidian trials and triumphs of work are punctuated and contextu-alized by violent catastrophe. Indeed, the scenes of daily labor occur within the shadow cast by spectacular scenes of deadly accidents that underscore the bricklayers' acute physical vulnerability and the indifference of capital to the well-being of the laborers who build the steel and stone monuments that give physical form to the triumph of corporate power. Scenes of violent injury punctuate the opening and close of the novel, as Geremio's death at the beginning prefigures Nazone's death near the end. Unlike Geremio's death, Nazone's fall from the scaffold is narrated from Paul's perspective. Paul gazes with a "ghastly fascination" (218) at Nazone's broken body, which looks like a shattered, bony vegetable:

> A brilliant red wet overalled pulp splotched over broken terra-cotta. . . .
> His head, split wholely through by a jagged terra-cotta fragment, was an
> exploded human fruit. His top skull was rolled outward, with the scalp,
> underlayers, and cartilage leafing from it, and his face halved exactly
> down the centerline of nose, with the left nostril suspended alone at the
> lip-end, curled out and facing the right nostril. . . . The crescent of his
> mouth and teeth was wide askew, and mingled over the sweat of his stubble
> were the marine contents of his blood and brains that spread as quivering
> livery vomit, glistening on the burning flesh a tenuous rainbowed flora of
> infinite wavering fibrins. . . . (218–19, last ellipsis in original)

This passage is remarkable for the tensions embedded in the prose. On the one hand, di Donato describes Nazone's burst body in lyrical phrases and images that lend the scene a virtually inspirational quality. This moment of physical and epistemological collapse is conveyed with remarkable mastery: in sharp contrast to the frenetic feel that marks much of di Donato's prose, the scene is rendered slowly, in painstaking detail. The narrative gaze lin-gers on each disfiguration, delineating it in highly aesthetic terms. The rhe-toric of illumination ("brilliant," "glistening," "rainbowed") and of organic metaphors ("fruit," "flora," "pulp") generates an ironic splendor, suggest-ing the possibility of finding literary "beauty" or transcendence amid the pain being described. Yet the lyrical potential of the prose is undermined by its very excess: it would be absurd to calmly portray such a scene in romantic, pastoral, or even measured terms. Nazone's physical being is here reduced to the base, organic materials of which it is composed—not only

nostrils and lips, each separate from the face they join to create, but also "cartilage," "fibrins," "blood." His body has been destroyed, his physical integrity blasted into a jumble of blood, bone, and tissue. This scene of extreme violation—not merely death, but complete physical obliteration—reinforces Job's power to literally "unmake" the world, to reverse the process of human development.[78] And as material production (the construction of a building) has become destruction (the death of a laborer), so literary production (the writing of coherent sentences) veers toward rhetorical dissolution (a surplus of horrific images and details that overwhelms the very language employed). Di Donato's prose is stretched to the breaking point, loaded with such a density of rhetorical figures, minute particularities, and abstract language ("a tenuous flora of infinite wavering fibrins") that it begins to collapse under its own weight, mimicking the very bodily collapse the scene describes.

Di Donato's detailed and at times disorienting focus on the ignominious details of proletarian abjection resonates with the mixture of surrealism and Marxism articulated in the 1930s by the French writer and philosophical thinker Georges Bataille who, like di Donato, was fascinated by ritual, religious belief, and physical degradation. In his essay "The Notion of Expenditure," Bataille argues that images of debasement and impurity can be used by the oppressed to undermine the authority of dominant cultural discourses. "Short of revolt," Bataille claims, "it has been possible for the provoked poor to refuse all moral participation in a system in which men oppress men; in certain historical circumstances, they succeeded, through the use of symbols even more striking than reality, in lowering all of 'human nature' to such horrifying ignominy that the pleasure found by the rich in measuring the poverty of others suddenly became too acute to be endured without vertigo."[79] Bataille's provocative assertion reverberates with *Christ in Concrete*'s scenes of workers' deaths in compelling ways. The excessive textuality of Nazone's death represents something like the attempt to create a symbol "even more striking than reality." In the passage, the action slows to a crawl, as the narrative eye lingers over the graphic details of the broken body. The slowness and deliberateness of the passage are unique within the novel—they represent the text's most intricate moment of description, a moment that surpasses the semantic texture of "reality" that characterizes the rest of the book. In addition, Bataille's notion of a vertigo-inducing image also applies to Nazone's and Geremio's blasted bodies, the depictions of which induce, as the novel notes, "ghastly fascination," a paradoxical

combination of voyeuristic absorption and horror-filled disgust. The perspective that Bataille delineates is mirrored in the way the novel destabilizes the conventional naturalist point of view, that of the spectator who looks down on the brutalized poor from a position of social privilege and security. The hyperbolic rendering of Nazone's dismembered body serves as an implicit rebuke to what the critic Mark Seltzer has described as naturalism's will-to-see, its desire to render "interior states" visible and legible.[80] In the scene describing Nazone's corpse, everything "interior" is made visible— his body has literally been turned inside out. However, the shocking quality of the passage serves to confound the invasive gaze. The narrative invites us to look with scrutiny over each detail, but in the process turns our stomach and prompts us to avert our eyes. In this scene, voyeurism has been turned against itself; the fascination that accompanies and drives the act of looking at the bizarre or unseemly is extended to the point of self-reflexivity and placed in the context of specific political injustices. The depiction of Nazone's blasted corpse is spectacular—but the spectacle is designed to spark political outrage rather than a gratuitous thrill.

Peter Stallybrass and Allon White have contended that modern cultural regimes construct meaning through a series of high/low oppositions. These distinctions are inscribed on a culture's conception of a normative body, a "classificatory body" in Stallybrass and White's words. "The classificatory body of a culture," they argue, "is always double, always structured in relation to its negation, its inverse."[81] Within this symbolic economy, Nazone's shattered body—bloodied and broken by its fall from the heights of industrial construction—represents the "inverse" of the modernist body of consumer perfection, the strong, flawless fantasy body advocated by advertising and, ultimately, idealized by fascism. Nazone's broken body is capitalist modernity's abject body, the body that is no longer a body, no longer an integral organic form, but an amalgam of fluids and tissues, shattered by the negligence of corporate power. Nazone's crushed corpse is a version of what Paul Gilroy calls a "willfully damaged sign," a discursive figure underscoring the pain and barbarism that subtend modernity's "enlightenment" and social "progress."[82]

Di Donato's depiction of work on a skyscraper strikes a noteworthy comparison to the period's best-known portrayal of big-building construction labor, Lewis Hine's *Men at Work: Photographic Studies of Modern Men and Machines* (1932), almost half of which is dedicated to pictures of men working on the Empire State Building. Hine's book, as he explains on the

first page, celebrates the "courage, skill, daring and imagination" of the men who make and work with machines: "Some of them are heroes; all of them persons it is a privilege to know."[83] Hine's images of the Empire State Building—such as his celebrated picture called "Skyboy" (figure 5.1)—are paeans to the aerial daring and individual talent of the workers and to the colossal height of the building. His portrait of the construction is underscored by the liberal, progressive idea that skilled men of courage produce monumental achievements. Hine's workers are often captured in sturdy, balanced poses (figure 5.2), cool and confident in their abilities. The hallmarks of these men—calm gazes, steady postures, chiseled muscles—suggest they are in complete control of their labor. They project, as Joshua Freeman notes, "a strong sense of dignity and self-possession."[84] These elements are echoed in the formal features of Hine's photographs, which are marked by compositional symmetry, bold lines, and a human scale that gives priority to the workers rather than the massive structure they are building.

Like Hine, di Donato seeks to impress on readers the skill and craftsmanship of the men working on Job, and the fact that buildings rise only because workers construct them girder by girder, brick by brick. But his depiction of construction labor punctures the liberal belief in human progress that subtends Hine's book. Rather, the vertiginous images of Geremio's, Luigi's, and Nazone's smashed bodies insist that the monumentality of buildings is achieved at the cost of human lives. While Hine emphasizes the "careful teamwork" and constant surveying of "every part of the growing structure" to "protect the workers and the people below in the street,"[85] di Donato highlights the absurd death of skilled workers, sacrificed to corporate profit. Alan Trachtenberg notes that *Men at Work* "celebrates industrial workers as modern heroes, and the explicit message finds its realization in the display of the working body in motion, in acts of concentration, muscular coordination, balance, strength—a repertoire of spontaneous gestures that show the body's experience, skill, training."[86] Yet in foregrounding the competence and integrity of the individual working body, Hine downplays the arrangements of power and control that shape the conditions under which the men labor. Hine's text, Trachtenberg asserts, "makes the [corporate] system seem either inevitable or unimportant—certainly allows no inkling that the economic forces represented in the Empire State Building are about to collapse and traumatize the nation."[87] While di Donato's text carefully delineates workers' skill and ability, the novel also underscores the terrifying power of the capitalist system to set the conditions of, and ultimately destroy, the work and lives of the men toiling on "Big steel" (176).

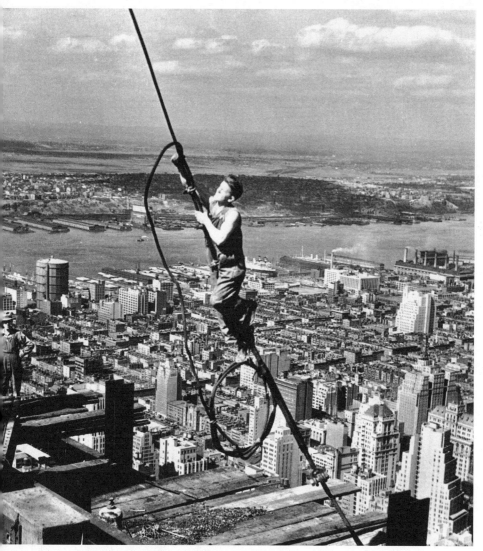

Figure 5.1. Lewis Hine, "Skyboy," 1930–31.
Courtesy of the Avery Architectural and Fine Arts Library, Columbia University.

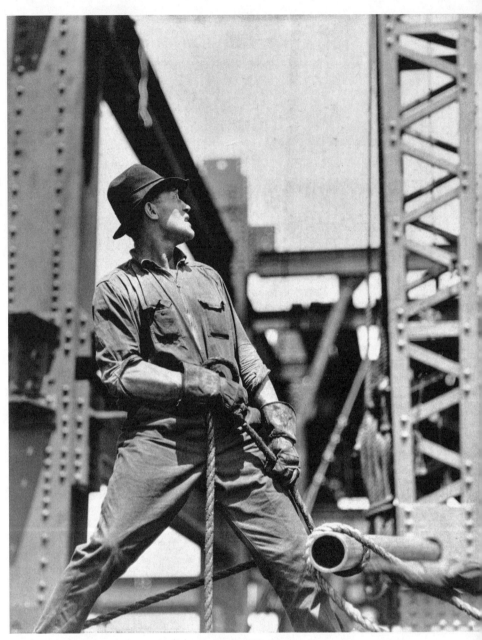

Figure 5.2. Lewis Hine, "A derrick man," 1930–31.
Courtesy of the Avery Architectural and Fine Arts Library, Columbia University.

Christ in Concrete: Ethnicity, Religion, and Revolution

To conclude, I want to return briefly to questions of ethnicity in order to explain how they relate to the issues of labor and class that have been at the core of my analysis. I take this turn because in contemporary critical discourse di Donato's novel is read primarily as an Italian American rather than a proletarian (never mind a modernist) novel. By placing emphasis on what I call the novel's labor experimentalism, I do not mean to deny its status as a work of ethnic fiction. Rather, I want to suggest that comprehending the full dimensions of the novel's cultural vision requires that we explore how the text's labor and ethnic politics intersect and converge.

In *Yonnondio*, the presence of "ethnicity" as a salient category of identity is buried, confined to small traces, manifest only as residue. Except for a brief allusion to Anna's memory of a childhood Jewish ritual, the Holbrooks are ethnically "generic," a version of the anonymous "people" celebrated in thirties culture.[88] In sharp contrast, *Christ in Concrete* is a much more explicitly ethnic novel in which the characters' "Italianness" is embedded in the narrative's prose, plot, and themes. In addition to the text's linguistic fusion, in which traces of Italian are woven into the novel's semantic texture, the presence of ethnicity is represented in the novel's depiction of ritual and domesticity, tradition and religion. One of the most potent images of Old World Italian culture in the book, for instance, is the tarantella, the festive dance performed during the wedding fiesta. The description of the dance is one of the few non-labor-specific aspects of the text rendered in di Donato's frenetic, punctuationless modernist prose: "twisting swaying torso pushing ahead and circle gay friendly lusty bump of buttocks away and around to face and skip forward and circle and now bent frontward and now fall backward and stamp Tarantell!" (202). A form of precapitalist ritual, the tarantella represents a version of unalienated physical activity. Like bricklaying, it is rendered as a "balanced delirium," a glorious frenzy that overruns conventional syntax. But unlike bricklaying, it is an activity free of utility and unincorporated into the economy of Job. Robert Orsi has suggested that Italian American festivals "constituted a challenge to and offered freedom from the world of work in a number of ways."[89] One of these central elements of freedom was the expenditure of physical energy removed from the routines of regimented labor. Orsi argues: "The festa offered an occasion for the display of energy and enthusiasm not appropriate or possible in the work place; it was as though the people of Italian Harlem were declaring: See! We are still alive!"[90] In *Christ in Concrete*, bricklaying often provides a sense of bodily pride and freedom, but always within the confines of Job's

demands. In contrast, the tarantella represents a carnivalesque celebration of the body's mobility, desires, and energies, liberated from the dictates of labor-time-discipline: the "hypnotic movement" (202) of "unconscious desire" (190) in which laboring bodies are freed from the demands of the scaffold: "swing and kick and rub of Job manflesh with soft hip of Home" (202).

Although the dance provides glorious relief, delivering the workers and their partners "Away! Farther Away!" (204) from the burdens and terrors of the workaday world, the respite, Paul realizes, is temporary. "Life would never be dear music, a festival, a gift of Nature. Life would be the torque of Wall's battle that distorted straight limbs beneath weight in heat and rain and cold" (143). Annunziata, too, realizes the moment of the Fiesta is fleeting; in her eyes, the dance is transformed from an expression of joy to a "never ceasing burdenous strain—" (234), a figuration of the endless rounds of toil required to maintain the family's tenuous welfare. Ethnic culture—domestic rituals, family affiliations, religious commitments, community—is ultimately overshadowed by Job. Ethnic culture provides essential emotional and material resources, but ones that are finally insufficient to contest Job, to protect workers, to support a family. Although ethnic culture sets the terms on which experience in the private sphere occurs, the presence and meaning of ethnicity in the public world of labor is secondary to the logic of Job. Ethnicity unites the Italian construction workers into a workers' fraternity, but those affiliations are subject to the laws of Job, which reduces individuals to component parts, anonymous units of muscle and flesh. In Paul's life, ethnicity and labor are not mutually exclusive; they are mutually constitutive. However, they constitute one another through conflict, each transforming the other in an ultimately uneven struggle.

Although several critics cite *Christ in Concrete* as an "authentic" transcription of ethnic experience, it is more accurate to see the novel as a depiction of the way in which the meaning and significance of ethnicity is transformed across generations. For Geremio, religious faith forms the backbone of his ethnic identity and provides him with the spiritual strength to persevere in the face of oppression. "Who am I to complain when the good Christ himself was crucified!" (4), he announces after a hard day's work. Geremio's religious convictions provide resources for adjustment—methods and narratives from "outside" capitalism's ideologies for persisting within a capitalist economy. "Well, with the help of God I'll see this job through" (5), Geremio reassures himself. "Home," too, offers relief and rejuvenation for Geremio. At home, "the mad day's brutal conflict is forgiven, and strained

limbs prostrate themselves so that swollen veins can send yearning blood coursing and pulsating deliciously as though the body mountained leaping streams" (6). "Home" offers the promise of a pastoral relief from urban, industrial pain—a sense of (perhaps built on a literal memory of) rural existence, soothing streams and inspiring mountains. For Paul, however, a logic of sacrifice based on deferred religious promises offers an insufficient narrative for dealing with Job's monstrosity. "I want justice here! I want happiness here! I want life here!" he proclaims to his mother, denouncing the crucifix hanging on her wall (230). In addition, "home" does not represent for Paul the refuge it provided for Geremio—Job follows him into the domestic sphere, invading his dreams, haunting his most private moments.

But *Christ in Concrete* is not, as Paul's vehement condemnation of the crucifix might suggest, a wholesale rejection of Catholic-inflected values; rather, the novel recounts—and itself represents—a complicated refashioning of those values. In particular, di Donato's text affirms a central component of Catholic ideology, its materialism. Catholicism in general—and Italian Catholicism in particular—has long been condemned by Protestants for its emphasis on elaborate ritual and its use of material representations of divinity.[91] Di Donato described himself as a "sensualist" who "respond[ed] to the sensuality of the Holy Roman Catholic Church, its art, its music, its fragrances, its colors, its architecture, and so forth—which is purely Italian. We Italians are really essentially pagans and realists."[92] Imbued with a sense of what Robert Orsi describes as the "graphic, material" quality of Italian-American Catholic worship,[93] di Donato crafted a hybrid figure of revolutionary hope akin to the composite symbolic forms described by Georges Bataille. Writing shortly before the publication of *Christ in Concrete*, Bataille contended that in certain instances the dispossessed have conjoined symbols of immense degeneracy and filth to symbols of purity and brilliance, creating "myths [that] associate social ignominy and the cadaverous degradation of the torture victim with divine splendor. In this way, religion assumes the total oppositional function manifested by contrary forces, which up to this point had been divided between the rich and the poor, with the one group condemning the other to ruin."[94] Like the myths that Bataille describes, the novel's figure of Christ in concrete grounds "divine splendor" in "cadaverous degradation," recasting Annunziata's longing for spiritual transcendence "in the next world" as Paul's cry for "justice," for "salvation now!" (230). The image of "Christ in concrete," of "comrade-worker Christ" (137), represents both a radical, pagan, labor-inflected transfiguration of the central Christian image of redemption *and* a rearticulation of anticapitalist

ideology through an ethnic-religious lens. In di Donato's recasting of this myth, salvation becomes a question of worldly, political justice; through the figure of "Christ in concrete," the text turns Christianity's metaphoric vehicle for transcendence into an allegory of material pain and a demand for social equality.[95] The challenge the text presents to readers is to comprehend this blending, to understand that the contradictions of Paul's world demand an alternative, compound epistemology, one that can recognize the redemptive in the degraded, the demand for revolution in sensational figures of revulsion.

6

NO MAN'S LAND
RICHARD WRIGHT, STEREOTYPE, AND THE RACIAL POLITICS OF SENSATIONAL MODERNISM

Motifs of vision pervade Richard Wright's 1940 novel *Native Son*.[1] As critics have long recognized, seeing is one of the novel's most significant metaphors. The most obvious, and perhaps most symbolic, manifestation of the topos of sight in the text is Mrs. Dalton's blindness, a condition that symbolizes the incapacity of liberal whites to comprehend the lives of poor blacks such as Bigger Thomas. In addition to tropes of sight and blindness, images of the visual media, notably film and photography, also permeate the text, serving in large part to emphasize the dynamics of projection and misrecognition that the novel suggests govern American race relations. Bigger, for example, gets his first glimpse of Mary Dalton in a newsreel he watches before seeing the jungle adventure film *Trader Horn*, which presents "pictures of naked black men and women whirling in wild dances."[2] Bigger's own image is transfigured and distorted by the press, which portrays him—in words and pictures—as a rapacious, ruthless brute. Again and again, the novel suggests, whites and blacks view each other through the lenses provided by the visual culture of the modern mass media.

Yet while the text proposes that the racial spectacles presented by these visual technologies are responsible for propagating immense cultural misconceptions, Wright's view of modern visual culture was by no means entirely negative. In fact, in his most extensive essay on *Native Son*, "How 'Bigger' Was Born," written shortly after the novel's release, Wright, who had worked briefly in a Memphis movie theater and was an admitted film buff, uses

cinematic metaphors to explain his own literary techniques and aspirations. He states, "I wanted the reader to feel like the novel is happening *now*, like a play upon the stage or a movie unfolding upon the screen."[3] "Wherever possible," he continued, "I told of Bigger's life in close-up, slow-motion. . . . I wanted the reader to feel that there was nothing between him and Bigger; that the story was a special premiere given in his own private theater" (HBWB 537). Film, Wright suggests, provides an urgency and immediacy that surpass the contemplative, detached experience of traditional art, serving as inspiration for a kind of experimental writing that could propel its protagonist into the eyes and consciousness of its readers with particular force.[4]

If any actual film influenced Wright's sense of cinema's potential as a metaphor for the literary method he used in writing *Native Son*, it was probably not *Trader Horn*, a relatively formulaic adventure picture, but *King Kong* (1933), one of the Depression era's decisive texts of misbegotten desire, racial difference, and social crisis. Critics have tended to agree with the film historian Robert Walker that Kong's rampage through Manhattan and his scaling of the nation's preeminent architectural symbol of capitalism, the Empire State Building, "served to release the pent-up anger and frustration and fear of the millions who had been pitched headlong into the Great Depression."[5] Yet the film clearly cast its allegory of social crisis in acutely racialized terms: the menacing, marauding, simian figure of Kong, wrested from his jungle habitat among the "savages" of Skull Island, clearly referenced potent associations of blacks with primitive, premodern cultures, as well as with irrationality, sexuality, and violence. Several aspects of Wright's novel, which engages many of these same racist associations, echo the film quite closely.[6] Bigger himself, whose name suggests the larger-than-life quality he assumes in the eyes of whites after his presumed rape and accidental murder of a young white woman, takes on a monstrosity similar to Kong, whose transgression also involves his supposed sexual contact with a white woman, Ann Darrow. (Significantly, both Bigger and Kong are innocent of the sexual violations that they are assumed to have performed.) Similar to the manner in which Kong famously flees his public exhibition by promoter Carl Denham and climbs to the summit of the Empire State Building, from which he is gunned down by circling airplanes, Bigger attempts to elude his captors by scaling a water tank on the roof of a tenement building, only to be surrounded and "shot" down by water hoses. In this scene, Bigger in fact becomes a version of Kong, as some of the men who capture him shout, "Kill that black ape!" (314). This sentiment, which is reiterated by the white mob outside the courthouse where Bigger is being tried, as well as by the

prosecutor, Buckley, during the trial itself, makes it seem quite likely that Wright had in mind the image of Kong's massive, dark body striding boldly across New York, terrifying the city's residents, as he penned Bigger's story. Describing the film's significance, James Snead notes that there "are few instances in the history of Hollywood cinema in which the color black has been writ so large and intruded so powerfully into the social plane of white normality."[7] For Wright, who aimed to write a novel that would startle, even horrify, white readers, *King Kong* must have provided a powerful model.

Both Bigger and Kong represent monstrous embodiments of white guilt and fear who condense many of white America's most potent anxieties (and stereotypes) about racial difference and sexual transgression. Yet what is remarkable about *King Kong*, and what I think may have made the film an especially appealing text to Wright, is that although it is perhaps most memorable for Kong's transformation of New York, the iconic symbol of urban modernity, into a realm of mass terror (much as the crash had, four years before, turned America's seemingly ever-expanding economic machine into a shambles of bank failures, farm foreclosures, and mass unemployment), the film actually invites viewers to sympathize with the colossal primate even as they fear him and applaud his demise. In fact, the film depicts Kong as a victim as well as a perpetrator, as both a tragic and a horrific figure. Specifically, the film makes it clear that it is Denham's imperialist entrepreneurial ambitions—what the film refers to as his "reckless" desire to use Kong to "make the greatest picture in the world"—rather than Kong's lust for Ann Darrow that brings the ape to New York where he meets his end.[8] Indeed, Kong's interest in Ann is marked by curiosity and affection more than sexual avarice or aggression. Throughout, he treats Ann gently and protectively, reserving his violence for those who attack him. Moreover, as Cynthia Erb points out, the deft stop-action animation rendering of Kong "helps to 'humanize' the beast, defining him through an alternation between gentleness and force, love and violent resistance."[9] Thus, while the film clearly codes Kong as a racialized, savage figure who possesses deeply antisocial, even insurrectionary desires—and leaves little room or reason to question the state-sponsored violence that brings Kong plummeting from the top of the Manhattan skyscraper—the film does establish a fundamental ambivalence in viewers' relationship with Kong, encouraging them to identify with him even as they dread what he represents. It is this ambivalence toward Kong that can, I think, broaden our understanding of the cultural project in which Wright was engaged in the late 1930s in writing *Native Son*, a novel that has since its publication been criticized by many commentators

for reinforcing racial stereotypes. Similar to the manner in which *King Kong* in fact destabilizes the simple equation of black ape and unmitigated racial-sexual alterity and terror, *Native Son*, I argue below, undermines the racial stereotypes of Bigger that it conjures up.

The charge that *Native Son*'s depiction of Bigger reinforces racist perceptions of African Americans as irrational, inarticulate, and depraved was leveled most famously, and trenchantly, by James Baldwin. Wright's novel, Baldwin asserted in his well-known essay "Many Thousands Gone," "finds itself . . . trapped by the American image of Negro life."[10] Bigger, he claims, "is the monster created by the American republic, the present sum of awful generations of oppression; but to say that he is a monster is to fall into the trap of making him subhuman" (41). Baldwin argues that *Native Son* depicts Bigger as the white image of the savage black man who seemingly possesses no consciousness of his own motivations and emotions: "Bigger has no discernable relationship to himself, to his own life, to his own people, nor to any other people . . . and his force comes, not from his significance as a social (or anti-social) unit, but from his significance as the incarnation of a myth" (34). Baldwin finds the failure of protest fiction such as *Native Son* to provide complex black figures dispiriting not only in its own right, but also because it signals the inability of Americans, black and white, to adequately and fully express themselves across cultural lines. *Native Son*, Baldwin argues, demonstrates "that Americans . . . have therefore no way of assessing the experience of others and no way of establishing themselves in relation to any way of life which is not their own" (41). To do this, according to Baldwin, would require acknowledging not only the "hatred" that motivates black-white relations, but also "accept[ing] how much it contains of the force and anguish and terror of love" (42). Black and white identities, Baldwin implies, are inextricably and intricately interwoven, formed in a deeply rooted, dialectical fashion. For whites to deny, evade, or overlook the "resolutely indefinable, unpredictable" complexity of blacks is to deny the complexity of themselves. Only in acknowledging the "beauty, dread, power" of those different from us, Baldwin asserts, can we "find at once ourselves and the power that will free us from ourselves," the power to build what he describes in another essay as a world "without majorities."[11]

In what follows, I suggest that Wright was quite likely more aware of the dilemmas Baldwin describes than Baldwin seems to have recognized. Specifically, I propose that there is a deep-seated ambiguity at the heart of the novel's depiction of Bigger as a racial monster, an ambiguity that ultimately unsettles the racial stereotypes that the novel appears to reinforce.

Recently, critics have noted the fundamentally ambivalent quality of the stereotype, a form of identification that on the one hand asserts an ontological certainty and predictability, but on the other hand needs to be constantly repeated, a fact that indicates the very insecurity of the trope in the first place.[12] Wright's writing from the late 1930s, I contend, plays fast and loose with racial stereotypes, simultaneously evoking and undercutting their hermeneutic capacity.

To support this proposition, I begin with an analysis of the two works that chronologically surrounded *Native Son*, *12 Million Black Voices*, the 1941 documentary "folk" history of African Americans that Wright produced in collaboration with photographer and layout artist Edwin Rosskam using images taken primarily from the Farm Security Administration file, and *Lawd Today!*, a novel written during the mid-1930s, although not published until 1963. Despite its occasionally strident rhetorical tone and its seemingly crude use of hard, social scientific facts, *12 Million Black Voices* provides an often lyrical and persistently subtle analysis of the arbitrary nature of racial meanings. In particular, Wright's meditation on the visual, specular nature of racial subjectivity reflects his awareness of the deeply contingent and dialectical quality of racial identity, which is, the text implies, a social projection as well as a historical reality. Looking back at *Native Son* from the pages of *12 Million Black Voices* helps us to see the novel differently, to foreground its examination of the manner in which racial images are produced through a complex visual economy that generates, even as it seems to reflect, the ontological naturalness of race. *Lawd Today!* sets the stage for *Native Son* in its evocation of racial stereotypes. Wright's most boldly experimental work of fiction, *Lawd Today!* presents a protagonist, postal worker Jake Jackson, who is at least as manifestly stereotypical as Bigger Thomas. However, the novel inflates the stereotype to such an extent that it emerges as an overblown, specious trope, which the text implies fails to adequately elucidate Jake's most fundamental desires and to truly capture the complexities of his subjectivity. Examining *Native Son* in the wake of Wright's earlier novel allows us to see that, in the middle and late 1930s, Wright was undertaking a sophisticated, delicate, and sustained meditation on racial stereotypes, using his prose to interrogate and challenge the cultural production of reductive racial images.

My analysis of *Native Son* explores Wright's adoption and delicate alteration of pulp narratives, which Wright had devoured as a young reader and which possessed great currency in the 1930s, and the racial (and racist) logic that those narratives frequently embody. On the one hand, sensationalism—

what Wright called the "bloody thunder of pulp narratives" — provided him with a powerful language for conveying the terrifying violence of racial subjection.[13] On the other hand, however, sensational fiction's economy of cultural shorthand typically traded on racial stereotypes, which Wright clearly aimed to contest. I contend that, in its depiction of Bigger Thomas, *Native Son* undercuts, even as it invokes, the logic of racial stereotypes in two ways. First, the text provides a detailed analysis of the ways in which stereotypes are culturally produced by the mass media, especially through photojournalism's misrepresentations of Bigger as a bestial killer. Indeed, *Native Son* provides an incisive examination of the camera's complicity in the process of racial coding. Second, the text creates a deeply unstable position for the reader to inhabit, a narrative space in which he or she is aligned with Bigger's point of view, allowed access to his inner thoughts, and yet also granted critical distance from him, able to see Bigger and his circumstances in a way the character himself cannot. Wright calls this ambivalent space "No Man's Land," a terrain of existential and ontological liminality in which racial clichés are at once invoked and repudiated.

Despite its name, "No Man's Land" is by no means a feminist space, and Wright's challenge to stereotypes of black men raises troubling questions about his depiction of white and black women, in particular Mary Dalton, whom Bigger decapitates, and Bessie Mears, whom Bigger rapes and bludgeons to death. In explaining his motives in writing *Native Son*, Wright made disparaging comments about female sentimental readers, stating that the shape of *Native Son* was influenced in part by the sentimental reception of his 1938 collection of short stories, *Uncle Tom's Children*. "When the reviews of that book began to appear, I realized that I had made an awfully naïve mistake," Wright asserted. "I found that I had written a book which even bankers' daughters could read and weep over and feel good about. I swore that if I ever wrote another book, no one would weep over it; that it would be so hard and deep that they would have to face it without the consolation of tears" (HBWB 531). *Native Son*, of course, offers a strikingly direct response to the dilemma posed by the reception of *Uncle Tom's Children*: the figure of the sentimental reader — in *Native Son* a real estate magnate's daughter rather than a banker's daughter — is smothered, beheaded, and then incinerated by the very object of her sympathy, Bigger Thomas. This sensational turn suggests that part of pulp fiction's attraction for Wright was its masculine, phallic dimension — its capacity to deliver a story sufficiently "hard and deep," as he put it, to turn tears into terror. Yet similar to the manner in which the novel invokes racist images in the interest of dismantling them,

Wright's use of overtly sexist scenarios in *Native Son* serves in the end, I believe, to suggest the ways in which race and gender are knitted together to produce exceedingly durable and damaging structures of oppression that harm black women as well as black men.

Visual and Racial Indeterminacy in *12 Million Black Voices*

Taking its place alongside other photo-texts from the late 1930s, such as *Let Us Now Praise Famous Men* and *You Have Seen Their Faces*, *12 Million Black Voices* aims, in Wright's words, to "compete with mighty artists: the movies, radio, the newspapers" which "have painted one picture [of black life]: charming, idyllic, romantic."[14] To counter this sentimental "picture," Wright's narrative, which begins with the arrival of Africans via the slave trade and progresses in rough chronological fashion through the post–Civil War, Jim Crow era, the Great Migration, and a discussion of contemporary urban life, underlines the immense social and physical violence to which African Americans have been subject. In particular, the narrative describes the development of a "code of casual cruelty . . . that has . . . grown, spread and congealed into a national tradition that dominates . . . all black and white relations . . . [to] this day" (18). Yet the text's aim is not only critical, or negative. In addition to offering an alternative to traditional accounts of history that elide racial terror, Wright also aims "to seize upon that which is qualitative and abiding in Negro experience, to place within full and constant *view* the collective humanity whose triumphs and defeats are shared by the majority" (xx, my emphasis).

Some critics have condemned *12 Million Black Voices* as a reductive, dogmatic book that portrays African Americans as hapless, abject victims of modern society. Nicholas Natanson decries Wright's decision to tell a bottom-up "folk" history, arguing that the text offers a one-dimensional portrayal of African American culture and that Wright's use of the first-person plural voice for narration represented "a fundamental act of cultural suppression," collapsing the diversity of black experiences into a single perspective: "Ironically, the white tendency that had proved so stultifying over the years, that of treating black millions as a monolithic mass, was repeated in 1941 by a black author who knew much better."[15] Natanson contends that, despite Wright's well-documented debts to Horace Cayton and Robert Park, Wright "would have no part of the multi-tiered black reality presented by sociologists," but rather "wanted his reality in strictly black and white terms."[16] In contrast, I want to suggest that many of the oppositions that at

first appear to organize the text—in particular, between black and white, text and image, writer and photographer—are delicately, productively destabilized. The result is to encourage readers to adopt a stance of self-conscious skepticism toward photographic meaning, visual-verbal relations, and the supposedly unconditional nature of racial differences.

From the first sentence, the text marks itself as a self-reflexive narrative, insisting that familiar appearances frequently contain hidden and multiple meanings. Addressing presumably white readers, the text opens: "Each day when you see us black folk upon the dusty land of the farms or upon the hard pavement of the city streets, you usually take us for granted and think you know us, but our history is far stranger than you suspect, and we are not what we seem" (10). In this passage, Wright suggests the unreliability of visible racial markers, the potential fallacies of familiar sights, the fundamental "strangeness" of what seems self-evident. The challenge to visual and racial expectations embedded in the text's opening sentence is echoed by the book's first two photographs. The first, by Dorothea Lange, depicts a sharecropper's well-tanned and weather-worn hands holding a hoe (figure 6.1). On close inspection it becomes evident that the farmer is white, but, because the print is cropped just below the man's head—effectively decapitating him—and because his hands are darkened by sun and grime, he could appear at first glance to be black. Whether we are supposed to accept him as black or white is unclear; rather, the image unsettles our assumptions that race can be clearly and definitively captured on film in the first place. The next picture, on the reverse page, presents the head of an elderly black man with a white beard and hair, as if it is the head of the headless figure from the previous page, further complicating our reading of the initial image (figure 6.2). Together, these two images—the headless white, but dark body and the bodiless black, white-haired head—form a bizarre, biracial Frankenstein that undercuts conventional certainties about the absolute nature of racial differences and the discrete quality of racial identity. Moreover, by encouraging viewers to connect the two photographs, this pairing also draws attention to photographic cropping and framing, reminding us that images are always cut—fragments that obscure a larger, and invariably inaccessible, whole. Perhaps surprising for a text that some critics have lambasted for its reductive depiction of a transcendental racial subject, the hybridized figure that opens the book suggests both the potential fallibility of visual images as well as the interdependency of black and white identities.

Wright's sense of the contingent, rather than absolute, nature of race is

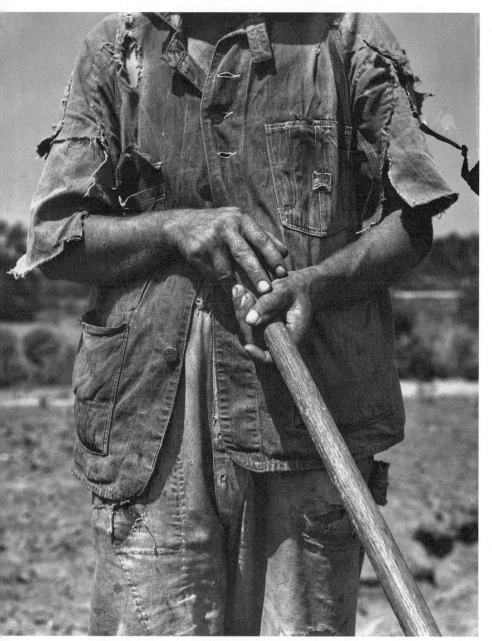

Figure 6.1. Dorothea Lange, "Hoe culture. Alabama tenant farmer near Anniston [Alabama]," 1936. FSA-OWI Collection, Prints and Photographs Division, Library of Congress.

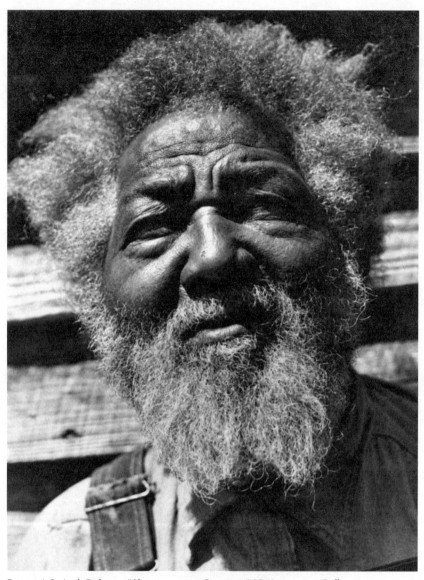

Figure 6.2. Jack Delano, "Sharecropper, Georgia," 1941. FSA-OWI Collection, Prints and Photographs Division, Library of Congress.

reinforced both in his notes for the text and in the book itself. In unpublished notes, Wright commented that "the Negro's position in America" is the result of a "historical and not biological phenomenon."[17] In one of the most existential passages in 12 *Million Black Voices*, Wright affirms the idea that the meaning of race is socially produced: "The word 'Negro,' the term by which . . . we black folk in the U.S. are usually designated, is not really a name or a description, but a psychological island whose objective form is the most unanimous fiat in all of American history; . . . a fiat which artificially and arbitrarily defines, regulates, and limits in scope of meaning the vital content of our lives" (30). Wright's emphasis on the provisional, if powerful, quality of race is reinforced in other statements in which he explicitly denies the biological basis of race: "I discovered that blood and race alone were not sufficient to knit a people together in a community of feeling. . . . I knew it was not the myth of blood but continued associations, shared ideals and kindred intentions that make a people one."[18] Here, Wright asserts the limits of "race" as a hermeneutic and ontological category. "Race" and "blood" do not forge a community or provide a sense of kinship; only "continued associations," cultural contact and affiliation, can create a common identity.

In their work on 12 *Million Black Voices*, Wright and Rosskam, a German-born Jew who had worked for the FSA and *Life* magazine, took responsibility for different aspects of the book, but the final product is a result of interactive collaboration. Although Rosskam selected the photographs, Wright accompanied Rosskam and Russell Lee on a trip to Chicago during which several of the images were taken, and, contrary to some mistaken claims by critics, Wright had indeed seen the images for the book before he finished his writing.[19] Although Wright composed the verbal narrative, Rosskam used fragments of Wright's prose as captions for some of the images, thereby highlighting elements of the written text and altering the way we read it. These elements of creative crossover, in which each artist enters the territory that belongs primarily to the other, suggest the permeability and interdependency of the two realms—the fact that, in this book, visual images and verbal text stand neither in stark isolation, as in *Let Us Now Praise Famous Men*, nor in strict complicity, as they do in *You Have Seen Their Faces*, but in a continually changing, at times quite ambiguous, dialogue.

Indeed, the relation of the photographic images to the written text is constructed not according to a straightforward logic of documentary "evidence," as at least one critic has claimed, but rather as a montage, a virtually filmic suturing in which the writing and pictures speak to one another

in unpredictable, at times uncertain ways.[20] In places, the relation between text and image is essentially illustrative, as if the photos are meant to mirror the written word. For instance, Wright's comment that "even in times of peace some of the neighborhoods in which we live look as though they had been subjected to an intensive and prolonged aerial bombardment" (114), faces a matching image (figure 6.3), which seems to serve as a transparent "document" supporting the verbal text. Elsewhere in the book, however, discontinuities between text and image emerge. At the end of chapter 1, Wright contends that "we black men and women in America today, as we look upon scenes of rapine, sacrifice, and death, seem to be children of a devilish aberration" (27). While this line, like others in the chapter, suggests the possibility that black culture has been damaged by the history of racial oppression—or, as Wright states elsewhere, "blasted," "stripped" and "hollowed out" (15)—the image that accompanies the text (figure 6.4) sends a countervailing message of subjective strength and integrity. Similar verbal-visual tensions appear throughout the book. A photograph by Ben Shahn (figure 6.5), for instance, appears in the midst of two pages that offer no direct textual reference. Rather than anchoring the visual in the verbal to create a secure, instrumental circuit of meaning, this two-page spread poses the relation between image and text as an open question. Likewise, an image of a man kneeling in a field (figure 6.6) possesses an uncertain relation to the adjacent written text. On the one hand, the picture "illustrates" the accompanying caption, "We labor in farm fields" (82). On the other hand, the photograph's tight focus is less on labor (the larger context of his work, including the field and the other workers, is obscured by the close perspective) than the man himself and his relation to the camera. The camera is positioned so that we look down on him, and he is crouched, almost defensively. But he looks assertively, if enigmatically, into the lens, as if contesting, or at least questioning, our presence. The image thus presents him less as a simple representative of a larger economic condition than as an individual whose attitude toward the camera raises more questions than answers.

Other elements of the book's formal design, such as the layout, suggest that the photographs were meant to be read as complex, relatively independent visual statements rather than as transparent, "documentary illustrations." Rosskam frequently gave the images a page unto themselves, uncircumscribed by print. He also bled many of the images to the edges of the book, eliminating borders and boundaries and thereby giving the pictures a symbolic force and autonomy.[21] Rather than suppressing or ignoring the

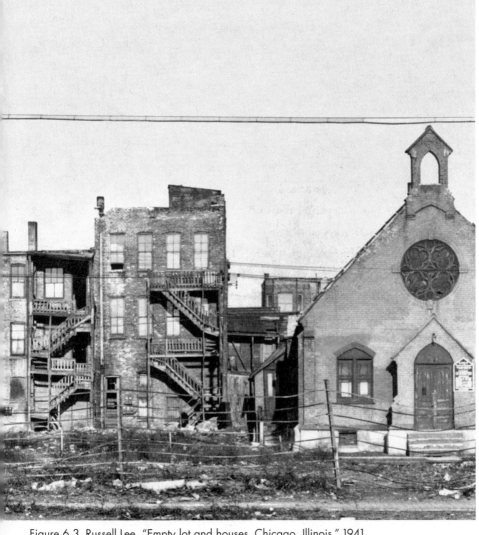

Figure 6.3. Russell Lee, "Empty lot and houses, Chicago, Illinois," 1941.
FSA-OWI Collection, Prints and Photographs Division, Library of Congress.

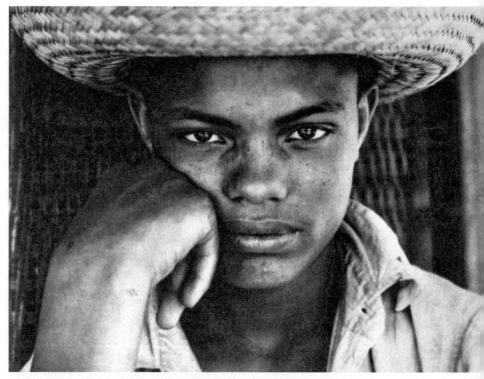

Figure 6.4. Jack Delano, "Sharecropper's son," 1941.
FSA-OWI Collection, Prints and Photographs Division, Library of Congress.

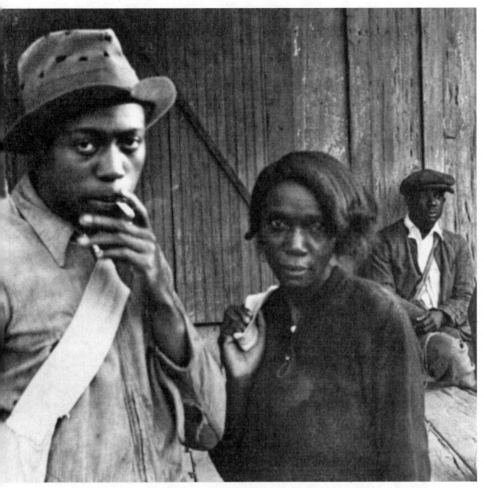

Figure 6.5. Ben Shahn, detail from "Cotton pickers, Pulaski County, Arkansas," 1935.
FSA-OWI Collection, Prints and Photographs Division, Library of Congress.

Figure 6.6. Jack Delano, "Migrant potato picker, North Carolina," 1940.
FSA-OWI Collection, Prints and Photographs Division, Library of Congress.

malleability of photographic meaning by insisting that visual images are merely indexical "evidence" to support Wright's written text, the book's composition acknowledges, even emphasizes, that still photographs and printed words have what Stuart Culver calls "an ambivalent cohabitancy," a relation that W. J. T. Mitchell describes as a "dialectic of exchange and resistance."[22]

The text's emphasis on the interdependency of image and word is echoed by its insistence on the reciprocal, if radically unequal, relationship between blacks and whites. Wright's writing suggests that blacks possess what Paul Gilroy calls a "hybrid identity," "caught somewhere between the promises and the curses of occidental modernity."[23] For instance, 12 *Million Black Voices* connects the traffic in black slaves to the rise of Western modernity forcefully and directly. Stating that "the trade in our bodies bred god-like men who exalted honor" (16), Wright proposes that Euro-America's Enlightenment liberalism was literally founded on the theft of black bodies and the exploitation of black labor. Occupying such a highly paradoxical position, as the source of Western modernity's (labor) power and the object of its most atrocious violence, blacks possess a perspective on Western culture that is at once representative and also highly particular and critical. "We black folk," Wright insists, "our history and our present being, are a mirror of all the manifold experiences of America. What we want, what we represent, what we endure is what America *is*" (146). African Americans are oppressed, yet they also represent the fullest expression of America's ambitions and aspirations; they are, 12 *Million* submits, both the West's most abject and its most quintessential citizens: "Brutal, bloody, crowded with suffering and abrupt transitions, the lives of us black folk represent the most magical and meaningful picture of human experiences in the Western world" (146).

Wright's emphasis on the intersectionality of black and white identities is captured in one of the concluding, and most lyrical, passages in 12 *Million Black Voices*: "The differences between black folk and white folk are neither blood nor color and the ties that bind us are deeper than those that separate us. . . . Look at us and you will know yourselves, for *we* are *you*, looking back at you from the dark mirror of our lives!" (146). These remarks prefigure Wright's engagement with Jean-Paul Sartre and Simone de Beauvoir, whose renowned theories of the gaze's formative role in the development of the self emerged in subsequent years. For Sartre and Beauvoir, one's subjectivity is formed through the gaze of another; in becoming a "Self," one simultaneously becomes an "Other." Here, Wright anticipates this idea and lends

it a specifically racialized significance, proposing that the power of white culture to cast blacks as the paradigmatic "Other" of white identity lends African Americans a unique insight into the white imagination. If whiteness is formed in opposition to blackness, Wright implies, it is also formed in conjunction, even collaboration, with it; if the white gaze subjugates African Americans, it also establishes a resemblance, a "tie that binds." Wright suggests that the formation of racial subjectivity is both specular and spectacular, occurring at a certain level through the intersection of gazes and the projection of images. Wright's insistence on the importance of visual and psychic imagery in the production of racial identity helps explain his extended mediation on the most insidious of racial images—the stereotype—in his two earliest novels, *Lawd Today!* and *Native Son*.

Lawd Today! and the Dilemmas of Identification

Wright's first novel, the posthumously published *Lawd Today!*, is the author's most formally experimental work of fiction, a mix of gritty naturalism and avant-garde techniques drawn from James Joyce, T. S. Eliot, John Dos Passos, and other European and American modernists. Although dismissed by some critics as an "apprentice" novel, the text represents an ambitious effort to fuse black vernacular and high modernism, Cab Calloway and Gertrude Stein, the dozens and Dada-esque dreamscapes.[24] The interplay of humorous satire and dark, gothic naturalism that characterizes the novel is captured in the book's title expression, "Lawd today!," which serves both as a comic exclamation, uttered at the height of the dozens' hilarity and as a sincere expression of desires, both satisfied and unfulfilled. As a phrase, "Lawd today!" accommodates humor and horror, desire and deferral.

The influence of canonical modernism in the novel is readily apparent and ubiquitous. For instance, as an account of twenty-four hours in life of Jake Jackson, a Chicago postal worker, the novel represents a black working-class rewriting of Joyce's *Ulysses*. Moreover, the novel is punctuated by documentary-style excerpts of radio broadcasts and newspaper headlines, which Wright adopted from John Dos Passos, whose *U.S.A.* trilogy he regarded highly. The novel's three sections are introduced with quotations from Van Wyck Brooks, Waldo Frank, and T. S. Eliot, avatars of Anglo-American modernism. Wright's use of these and other experimental elements should come as no surprise. In several essays, Wright argued that high modernism could be used as a lens for viewing African American culture and that African American writers should make use of modernist techniques. In his introduction to Horace Cayton and St. Clair Drake's *Black*

Metropolis, for instance, Wright asked provocatively, "What would life on Chicago's South Side look like when seen through the eyes of a Freud, a Joyce, a Proust, a Pavlov, a Kierkegaard?"[25] Similarly, in "Blueprint for Negro Writing," Wright asserted, "Eliot, Stein, Joyce, Proust, Hemingway, and Anderson . . . no less than the folklore of the Negro himself should form the heritage of the Negro writer."[26] Despite the important influence of social science and Marxist theory on his writing, Wright also maintained a belief in what he called the "autonomy of craft," the irreducible nature of the imagination and personal style in the production of literature.[27]

Perhaps the most daring of Wright's textual experiments in *Lawd Today!* is his depiction of the protagonist, Jake Jackson, a figure who is even more brutish and inarticulate than his more well-known fictional cousin, Bigger Thomas. Arnold Rampersad notes that the "lack of broad, deep characterization" was a persistent reason publishers rejected *Lawd Today!* in the late thirties.[28] As Granville Hicks observed in his review of the novel, Jake is "a contemptible person. He treats his wife brutally and indulges his appetites with outrageous selfishness. He is improvident, gullible, superstitious, and lazy. Although hatred of white discrimination is bred in his bones, he has no sense of racial solidarity . . . and he regards as fools those Negroes who work for the betterment of the people."[29] Jake stands as a defiant refutation of conventional fictional protagonists—he is deceitful, indolent, and selfish; he does not "develop" as a character, and is seemingly devoid of self-awareness.

However, several features of the novel discourage readers from dismissing Jake as an utterly debased, less-than-fully-formed figure. What makes Jake particularly challenging to readers is not his atavistic nature, which in a traditional naturalist setting would tend to confirm by contrast the reader's "enlightened" status, but Wright's complicated reworking of conventional naturalist narrative parameters, which allows readers surprisingly intimate access to Jake's inner thoughts. Like many naturalist protagonists, Jake embodies an excess of disparate desires. Yet in sharp contrast to the paradigmatic naturalist novel, *Lawd Today!* presents Jake's consciousness unmediated by a commanding narrator who looks down at Jake and the other characters from a critical distance. Instead, the narrator conveys the story from Jake's point of view; as a result, readers see from his perspective and hear his interior thoughts:

He wanted a little more sleep. But he knew it was useless. *How come Lil leave that door open? How come she turn that radio on so early?* . . . He

sighed, looking aimlessly around the room. . . . His attention centered on his scheme rack, a little honeycomb wooden case before which were piled hundred and hundreds of tiny white cards. *Lawd, I ain't fooled with that scheme in almost a month now. And I got to go up and pass a test on it in about two weeks.* . . . Well, he would try to study a little after breakfast. After he had eaten a good meal his mind would be fresh and keen. (8)

Here, in a unique form of free indirect discourse, the narrator's perspective overlaps very closely with Jake's: the scene is narrated from Jake's point of view and the narrator's words paraphrase or approximate Jake's thoughts ("He wanted a little more sleep. But he knew it was useless"). Jake's thoughts are recorded not in quotation marks, marked off as separate from the narrator, but in italics as another form of the narrator's voice, as if Jake could speak through the narrator, rather than the narrator recording his speech from a distance. The result of such ambiguous narration is to position readers in remarkably close proximity to a character who embodies the basest stereotypes. Jake is resolutely "Other"—a figure the novel describes in explicitly degrading terms—but at the same time becomes familiar to readers in a way that the "brute" in conventional naturalist fiction does not.[30]

In his construction of Jake, Wright was clearly well aware of the vicious stereotypes he was working with. The novel's opening pages introduce Jake by evoking longstanding clichés about the black male body, but they do so in such a hyperbolic, comic manner that Wright draws attention to the images as conventions, effectively exposing them as spurious tropes. As he wakes for the day, Jake "smack[s] his lips softly, as though over a dainty and dissolving morsel" (5); his eyes are "piggish" (6); from "his half parted lips" escape "low growls" (6). His Adam's apple jumps like a "monkey on a string" (6). His mouth suggests a voracious appetite: "His mouth gaped, revealing two rows of gleaming gold. It gaped wider. Wider. Wider still" (7). He emits a "hippopotamic grunt" (7), "wipe[s] his nose and eyes on the sleeves of his redgold pajamas, and groan[s]" (8). His "fat black feet" spread "like cobraheads on the carpet" (9). His face is an admixture of stereotypical features: "round as a full moon and dark as a starless night," "an oily expanse of blackness" riveted by "two cunning eyes" (9). His features are anchored by "a broad nose squatted fat and soft, its two holes gaping militantly frontward like the barrels of a shotgun." His lips are "full, moist, and [droop] loosely" (9). Far from a straight-forward rendering of a stereotypical figure, Wright's depiction of Jake as an amalgam of animalistic

and debased features functions as a form of subversive comedy—a parody of the crudest white images of African American men as savages. Wright's portrait of his protagonist is a critique executed through exaggeration: Jake embodies well-worn stereotypes so excessively that he draws attention to racial identity as a convention.

Yet if on one level Jake is a walking stereotype of the black man as inarticulate brute, the novel also indicates that he possesses a subjective excess, a residue of desires, sorrows, and ambitions that surpasses the stereotype's explanatory power. While the novel demonstrates Jake's seeming lack of psychological interiority, it simultaneously suggests that he is animated by a longing for an "unattainable satisfaction" (203)—a deep-seated, utopian form of yearning that is at odds with the hollowness of the stereotype. He "had been thirsting, longing for something" (6), we are told, "feeling a haunting and hungering sense of incompleteness" (51); "He wanted something, and that something hungered in him, deeply" (68); "he had a feeling he was missing something, but what it was he did not know" (115); "He did not know any other way things could be, if not *this* way. But he longed for them *not* to be this way" (142). The play of unfulfilled desires is given its most stunning representation in the conversation between Jake and his co-workers at the post office. The dialogue, in which individual speakers are not identified, ranges from baseball and boxing to existential questioning ("Jesus, all this must have been made for *something*" [164]), touching on a host of topics in between, including race relations and race violence ("I saw 'em hang a man once" [181]); migration and the differences between North and South ("The only difference between the North and the South is, them guys down there'll kill you, and these up here'll let you starve to death" [180]); gender and sex; politics and social change. These twenty-five pages of uninterrupted dialogue, which blend the dozens with a Joycean stream of consciousness, conjure up the deeply rooted presence of commonly held aspirations and longings ("their common feelings were a common knowledge" [108]), a complex collective consciousness that contravenes the portrayal of Jake and his friends as brutes.

In the end, the novel's allusions to Jake's often unarticulated but persistent desires suggest two things: first, that some element of his subjectivity is not encompassed by, is incommensurate with, his apparently stereotypical aspects; and second, that our ability to understand the full range of Jake's motivations and aspirations is inadequate, as if the manner in which he is represented prevents us—and even the narrator—from comprehending the full scope and complexity of his desires. *Lawd Today!* thus evokes and then

complicates a racial caricature: it exaggerates Jake's stereotypical qualities, yet insists that the reader inhabit his point of view; it underscores Jake's lack of self-consciousness, of interior "depth," only to suggest that the view of Jake we receive masks more profound, if not fully formed, yearnings. The deeply dualistic, even contradictory, manner in which Jake is portrayed pre-figures the more elaborate and nuanced fashion in which racial stereotype is treated in Wright's 1940 best seller, *Native Son*.

Pulp Culture, Visual Politics, and Racial Stereotype in *Native Son*

In his 1940 review of *Native Son* in *Opportunity*, the poet Sterling Brown contended that the novel's "greatest achievement" is its characterization of Bigger Thomas. "It took courage to select as a hero, a wastrel, a sneak thief, a double-killer," Brown asserted.[31] "Most writers of minority groups select as heroes those who disprove stereotypes. Here is the 'bad nigger' set down without squeamishness, doing all that the 'bad nigger' is supposed to do."[32] Although Brown does not elaborate on his assertion, his remark captures the paradox at the heart of Wright's depiction of Bigger: Bigger is both "hero" (the protagonist, the point of view with which the reader is aligned) and stereotype, the "bad nigger." Bigger is the native son for whom the novel is named, the character whose story the narrative recounts and from whose perspective we see events unfold. At the same time, however, he is, like Jake Jackson, the embodiment of long-standing clichés about working-class black men—a misogynist, a gullible devotee of mass culture, a reactionary sensualist driven by instinct: "That was the way he lived; he passed his days trying to defeat or gratify powerful impulses in a world he feared" (47).

Brown's description of Bigger as thief and killer also reminds us that Wright's novel is not only a work of literary naturalism, but also a sensa-tional thriller that adopts several narrative and thematic staples of 1930s pulp fiction, including violent crime, suspense, and a hard-boiled protago-nist. Despite their centrality to the text, however, the pulp aspects of *Native Son* have been neglected by scholars, who, even as they have firmly and jus-tifiably established Wright as one of the twentieth century's most ambitious social and political writers, have overlooked the importance of "low" and "popular" culture to his writing. To understand the cultural context for Wright's literary engagement with racial stereotypes, however, it is neces-sary to comprehend his relationship to the traditions of pulp writing that *Native Son* mimics and recasts. Wright was well versed in Euro-American

realism and modernism, but he was also an avid reader of mystery, crime, and adventure fiction. According to Michel Fabre, Wright possessed an "inordinate love of melodrama [and] murder stories" that he nourished with a steady diet of "detective [tales], dime novels, and popular fiction."[33] While writing *Native Son*, Wright was reading not only literary criticism by Henry James and H. L. Mencken, stories by Hemingway, and *Man's Fate* by André Malraux, but also, according to Hazel Rowley, "an array of detective novels."[34]

While the pulp properties of *Native Son* have been overlooked by most scholars, Wright's contemporaries recognized his debt to—and his daring redeployment of—sensational conventions.[35] In a 1940 letter to Wright, for instance, novelist Nelson Algren described *Native Son* as "the best detective story I've ever read."[36] Although noting that the book could (and should) be read as a political novel, a horror story, or "for its sociology," Algren argued that the unique power of the text stemmed from its use of spectacular criminal violence to generate cultural critique: "It's the first book I ever came across wherein gruesomeness served a social purpose," Algren stated.[37] Like Algren, contemporary reviewers, while noting the force of the novel's political and social commentary, emphasized the novel's evocation of popular sensational culture. The *New York Sun*'s reviewer, for instance, contended that "nothing on the list of current crime fiction is half so engrossing" as the novel Wright has crafted from events that on the surface qualify as "a regular tabloid sensation in cheap melodrama."[38] Similarly, another reviewer asserted that what is "extraordinary" about the book is that it approaches difficult questions of race "through a criminal who commits such atrocities as are dealt with only in the most sensational tabloids."[39]

While the pulp dynamics of *Native Son* are especially pronounced, the novel is by no means Wright's only work of fiction that is indebted to sensational culture. Indeed, popular narratives of crime and violence served as a reservoir to which Wright returned again and again throughout his career to confront questions of race, violence, and culture. For instance, the idea for his novella "The Man Who Lived Underground" was taken from a story in the August 1941 issue of the tabloid *True Story* about several 1931 robberies committed by Herbert C. Wright, a white man who entered stores after hours through the sewer system.[40] Wright's story "The Man Who Killed a Shadow" is based on the case of Julius Fisher, a black janitor who killed a white librarian in 1944.[41] Similarly, his novel *Savage Holiday* (1958) was inspired in part by the story of Clinton Brewer, a black jazz musician who spent decades imprisoned in the Tombs for the murder of a woman.[42] And,

as Paula Rabinowitz has demonstrated, *The Outsider*, Wright's 1953 novel about Cross Damon, an African American postal worker who commits a murder in the course of faking his own death, uses the hard-boiled rhetoric of film noir to explore racial difference and discrimination.[43]

Wright's interest in sensational fiction dates from his childhood. As a young boy, he recognized the narrative power of pulp narratives to project readers into fantastic and far-flung imaginative vistas. According to his autobiography, *Black Boy*, pulp fiction offered Wright his first glimpse of the world beyond the South, a vision that fed his hunger for "a different life, for something new," preparing him to leave the region and pursue a life of writing and radicalism (BB 142). Young Wright devoured magazine tales that recounted "the outlandish exploits of outlandish men in faraway, outlandish cities. For the first time in my life I became aware of the life of the modern world, of vast cities, and I was claimed by it" (BB 142). "The cheap pulp tales" that he read as a young man, Wright insisted, "enlarged my knowledge of the world more than anything I had encountered so far. . . . They were revolutionary, my gateway to the world" (BB 142). Moreover, the fantastic tales helped Wright psychologically accommodate and resist the brutalities of Jim Crow existence. Confronting a culture in which "there existed . . . men who could violate my life at will" (BB 83), Wright found refuge in fantasies of nihilistic, tough-guy action that echoed the pulp stories he read: "If I were ever faced with a white mob," the young black boy tells himself, "I would let go with my gun and kill as many of them as possible before they killed me" (BB 84). Such melodramatic images of violent retribution—in this case echoing a typical 1930s story of a doomed gangster surrounded by the police—helped Wright survive the daily material and emotional trials of life in the segregated South, providing what he calls, in another context, "compensatory nourishment" (HBWB 512). "My fantasies," Wright explains, "were a moral bulwark that enabled me to feel that I was keeping my emotional integrity whole" (BB 84).[44]

Yet while these fantastic, hard-edged tales provided inspiration, they also brought Wright face to face with the white racist imaginary. A friend of the family informed Wright that the newspapers containing the pulp stories that Wright so eagerly consumed "preach . . . Ku Klux Klan doctrines" (BB 145). As evidence, the man showed Wright a political cartoon from the current issue of the paper: "the picture of a huge black man with a greasy, sweaty face, thick lips, flat nose, golden teeth, sitting at a polished, wide-topped desk in a swivel chair. . . . On the floor at the side of the desk was a spittoon overflowing with mucus" (BB 144). With a cigar in his mouth and

his feet propped on the desk, the man lounges under a portrait of Abraham Lincoln. The cartoon's caption reads: "The only dream of a nigger is to be president and to sleep with white women!" (BB 144). If Wright and his African American neighbors were haunted by what he describes as the "white-hot face of terror that we knew loomed somewhere above us" (BB 64), this atavistic caricature was that terror's dark double: a manifestation of the grotesque visual and narrative misrepresentations that maintain and naturalize white supremacy.

Sensationalism thus proved to be a double-edged resource for Wright. On the one hand, it represented a potent fictional rhetoric that could be used to imagine and narrate the dramatic and often grisly dynamics of racial discrimination, violence, and resistance. On the other hand, sensationalism's formulaic tendencies made it amenable to insidious forms of cultural and racial stereotype that Wright sought to challenge.

Wright's evocation of pulp plots was self-conscious and carefully considered. Indeed, in his writing, Wright consistently interweaves sensational elements with more experimental literary registers, filtering his adaptations of pulp narratives through his modernist sensibilities. In a remarkable document—an unpublished lecture given shortly after *Native Son* was released— Wright in fact uses the language of sensationalism to describe his own avant-garde theory of authorship. Wright asserted that "today literature has been roped off and policed; no aesthetic gangsters sneak in and pull off quick raids . . . no daring technical hold-ups take place, no structural absconding with plot occurs, no sudden beams of light are thrown upon the familiar to make it seem strange—even though literature has taught us nothing if it has not taught us that familiar reality is the strangest reality of all."[45] Here, in the image of the "aesthetic gangster," Wright boldly bridges what Andreas Huyssen calls the "great divide" between mass culture and modernism, adopting the tropes of formula fiction to describe the assertively disruptive, even destructive, attitude that he felt novelists must take toward literary convention. Embracing the challenge he himself describes, Wright created in *Native Son* an unorthodox combination of "high" and "low," blending a pulp plot, a naturalist emphasis on social determinism, and a modernist experiment in point of view.

Wright's 1940 novel takes up sensationalism in a complex and contradictory fashion, simultaneously deploying and dismantling its organizing tropes and tendencies. At the most basic level, the text appropriates the plot lines of a sensational crime story not only to attract a broad popular audience but also to create a tale that would shock white readers, evoking potent para-

digms of racial fear that could undermine the sentimental reception that Wright had felt greeted *Uncle Tom's Children*. *Native Son*'s gruesome tale of racial crime, culminating in Bigger Thomas's decapitation of Mary Dalton and cold-blooded rape and slaying of Bessie Mears, is designed to generate fear and amazement, but not tears of catharsis. Moreover, by fashioning a self-consciously monstrous protagonist—a tough-talking, tenement-dwelling, misogynistic murderer—Wright engaged white culture's most virulent stereotypes about African American men. As he claimed in a letter to the radical writer Mike Gold, "I drew Bigger just as white America had been taught to expect him," a figure designed to strike at the heart of white America's most perverse racial fears and fantasies.[46]

Bigger is a delinquent, disaffected, and hard-boiled young man who recalls the urban tough guys of thirties crime literature. Frustrated by his inability to lift his family from poverty, Bigger, we are told, "denied himself and acted tough" (9), fabricating a rough exterior as a form of social protection. As Wright explains in "How 'Bigger' Was Born," the real-life Bigger Thomases on whom he modeled the fictional character were united by a deep-seated alienation that bred desperation and a penchant for violence. Products of a civilization that "had created no culture which could hold and claim [their] allegiance and faith" (HBWB 520), Biggers are "men who lived by violence, through extreme action and sensation," Wright observes (HBWB 521). The cynical, action-oriented demeanor that Bigger adopts, Wright suggests, is a reaction to—and ultimately against—oppressive structures of power. In Bigger's eyes criminal action constitutes potential resistance to white dominance; he imagines that the robbery of Blum's delicatessen, which is planned yet later aborted due largely to Bigger's fear, would be a "real hold-up, in more senses than one"—"a symbolic challenge to the white world's rule over them" (14). Faced with unemployment, discrimination, and the burden of helping to support his family, Bigger's "entire body hungered for keen sensation, something exciting and violent to relieve the tautness" (39). The appeal of sensational action to Bigger stems from the fact that, as Wright contends, he is "the product of a dislocated society; he is a dispossessed and disinherited man" (HBWB 521), inhabiting "a world whose fundamental assumptions could no longer be taken for granted" (HBWB 521). Bigger's world is devoid of metaphysical meaning and cultural grounding, a "highly geared world whose nature was conflict and action" (HBWB 521). Sensationalism—with its emphasis on shock, contrast, violence—is precisely this language of "conflict and action," a rhetoric for narrating the visceral urgency, psychosocial insecurity, and furious fric-

tion—"the fear, the hate, the impatience, the sense of exclusion, the ache for violent action" (HBWB 522)—that characterizes Bigger's life. If, as critics have long contended, naturalism is the discourse Wright employs to emphasize the sweeping cultural and political forces constraining and governing Bigger's life, then sensationalism is the language Wright uses to narrate the explosive violence, fear, and action to which Bigger is driven: naturalism for conveying the pulverizing conditions of black life, sensationalism for narrating the incendiary (melo)drama those conditions generate.

Yet by rendering Bigger and his crimes in a manner shocking enough to disable the kind of sentimentalism with which Wright felt readers responded to *Uncle Tom's Children*, the text risks producing a character whom readers would simply reject as a dehumanized racial beast. As one reviewer warned, "The naïve reader is likely to remember the gruesome murders and the exciting chase long after he has forgotten the evils of race prejudice to which the author attributes the crime, while those who believe Negro character is essentially primitive or bestial will feel that the book confirms their opinion."[47] Using the narrative drama and racial formulas of pulp fiction to challenge stereotypes about African Americans was a risky endeavor—one that could quite easily confirm rather than disable racist preconceptions. However, even as *Native Son* invokes racist expectations, it also demonstrates their speciousness, undermining the central conventions of the pulp narrative on which the text draws. In what follows, I examine two of these strategies for subversion. The first is the manner in which the novel carefully and deliberately charts sensational mass culture's complicity in the production of racial stereotypes, demonstrating the role played by newspapers and photojournalism in the production and maintenance of a racist hegemony.

A Vast but Delicate Machine

More than one contemporary review of the novel noted the remarkably careful manner in which the text traces the logic and method of newspaper crime reporting. "The technique of the novel," one reviewer observed, "follows the journalistic effect so closely that its plot might be a literal transcription of any one of half a hundred horror stories recently played up in the papers."[48] Wright in fact did draw directly from the newspaper accounts of the trial of Robert Nixon, a young African American accused of murdering a white woman in Chicago when Wright was in the midst of composing *Native Son*. The *Chicago Tribune* described Nixon as an "early link in the species,"[49] and in virtually identical phrasing, newspapers in *Native*

Son refer to Bigger as "an earlier missing link in the human species" (323). But the text does not merely adopt language from the press coverage of the Nixon case; it demonstrates the manner in which newspapers systematically distort and misrepresent the accused and the crime. During the 1930s and early 1940s, tabloid crime photography deployed a relatively standardized visual logic, one typically engineered to provide unequivocal documentation of the abject defeat of the criminal and the authority of the police force. Designed to promote an image of the gangster as the "reviled 'other'" of civil society, according to the cultural historian Sandra Phillips, crime reportage depicted the gangster's body as "at once threatening and debased, fabricated within broad stereotypical categories of representation to show the criminal as captured, dangerous, shamed, punished, or murdered."[50] *Native Son* both illustrates and critiques these conventions of representation, highlighting the ocular technologies and techniques used by the police and the press to portray Bigger as a brutal black killer.

In one striking scene, Bigger is driven to the Daltons' house where reporters, with cooperation from the police, demand that he reenact his alleged crimes against Mary for the journalists' cameras: "They led him into [Mary's] room. It was crowded with armed policemen and newspapermen ready with their bulbs" (388). After being urged by a reporter to "'go through the motions you went through that night,'" Bigger "backed against a wall, his eyes lowered in a baleful glare" (388). "Then he blinked his eyes; the flashlights went off and he knew in the instant of their flashing that they had taken his picture showing him with his back against a wall, his teeth bared in a snarl" (389). Here, Wright carefully delineates the camera's role in the fabrication of mass media stereotypes. The scene suggests that flashbulbs are analogous to the police pistols, violent instruments used to capture and imprison Bigger in a punitive matrix of racist and criminal signification. Ironically, it is precisely Bigger's attempt to refuse and avoid the reporters' ploy that makes him vulnerable to the cameras' transformation of him into a snarling brute.[51]

The scene Wright describes here recalls the two photographs of blacks dancing in Aaron Siskind's *Harlem Document*, discussed in chapter 3. Those images—one of a couple dancing at the Savoy (figure 3.8) and one of a man dancing on stage (figure 3.9)—both capture their subjects in extraordinarily awkward postures that evoke the physical antics and exaggerations of blackface minstrelsy. While I suggested that those two photographs, when viewed in the context of the other images in *Harlem Document*, invite viewers to question the way black figures are represented, both in Siskind's oeuvre and

in the culture at large, the images are lacking a verbal frame to direct our interpretation and could be seen to enforce rather than challenge stereotypes of the black body. In contrast, Wright's novel takes the perspective of the black figure being photographed, offering a trenchant critique of the way in which visual images can be manipulated to support racist misperceptions. Wright, who commented in a 1951 *Ebony* magazine article that "perhaps there is no human faculty so prone to be duped as sight," was clearly aware of the potential of visual images to deceive and mislead.[52] Bigger himself realizes that the apparatus of visual and narrative production epitomized by the newspapers is "a vast but delicate machine" (429), calibrated to produce images that are distorted and disciplinary. On entering the county morgue for the inquest, Bigger is instantly stunned by the specular machinery marshaled to confront, contain, and represent him: "The compact array of white faces and the constant flashing of bulbs for pictures made him stare in mounting amazement" (318). Faced with the battery of faces and cameras, subject to what Maurice Wallace describes as "the paralyzing shock of the racial glare,"[53] Bigger realizes that "his defense of indifference could no longer protect him" (318), that "they were determined to make his death mean more than a mere punishment; they regarded him as a figment of that black world which they feared and were anxious to keep under control" (318). It becomes clear that Bigger's "Fate," the title of novel's final section, is very much a matter of images. As Buckley says to Bigger during an interrogation, "'Boy, when the newspapers get a hold of what we've got on you, you're cooked'" (353). Just as he incinerates Mary's corpse in the Daltons' furnace, so Bigger is metaphorically "cooked," the novel suggests, in the white-hot fires of the mass media's inflammatory, racist coverage of his case.

The novel's attention to the media's production of racial imagery is no doubt a product of Wright's sophisticated understanding of visual culture's power to shape social relations. In his introduction to St. Clair Drake and Horace Cayton's *Black Metropolis* (1945), Wright argues that racial identity is in large measure a question of social visibility and identification. Citing William James's assertion that "a man has as many social selves as there are people who recognize him," Wright argues that, through the circulation of derogatory images, white Americans impose on African Americans a virtual social death: "The American Negro has come as near to being the victim of a complete rejection as our society has been able to work out, for the dehumanized image of the Negro which white Americans carry in their minds . . . exclude[s] the contemporary Negro as truly as though he were kept in a

steel prison."[54] *Native Son* is, among other things, a careful study in the so-cial production of what Wright calls "dehumanized images." As Bigger real-izes while contemplating the "anti-Negro epithets" used to depict him in the press, "To those who wanted to kill him he was not human" (328). Through the constant play of newspaper images, the text (especially books 2 and 3 of the novel) becomes as much a story of Bigger's public (mis)representation as of his actual crime and punishment. In book 3, Bigger is less an agent than a spectator at his trial, a trial being waged not only in the courtroom but also in the media. As Michael Bérubé contends, *Native Son* is "less concerned with Bigger's representativeness than with Bigger's multiple representa-tions, and what these might tell us about the processes by which blackness is constructed and consumed."[55] The novel forcefully underscores both the cultural authority of the newspapers' reporting as well as the monstrous ex-aggerations the papers employ to sensationalize the case and galvanize racist opinion. Moreover, in the description of the trial, the novel demonstrates the currency and credibility that the hideous media images acquire in the world of civic discourse. In his courtroom presentation, the chief prosecu-tor, Buckley, fluently adopts and inflates the newspaper depiction of Big-ger, referring to Bigger as a "black lizard" (476), a "black mad dog" (477), a "rapacious beast" (478), a "maddened ape," and an "infernal monster" (480). The text thus demonstrates the process through which the bestial image of Bigger as savage killer is staged, produced, and circulated, flowing seamlessly from the point of photographic capture to the newspapers' front pages to the heart of the criminal justice system.

While the novel aims to expose and undercut the racist images of black manhood deployed by Buckley and the newspapers, the text's portrayal of women—black and white—is less progressive, as many critics have noted. Indeed, by incorporating the masculine conventions of pulp fiction, which frequently feature aggressive male action and submissive female characters, the novel depicts women more as foils for Bigger than as equivalent char-acters.[56] Yet if women in the novel are, as Alan France insists, "objects of [male] appropriation," in some important ways the text depicts female sub-ordination in order to critique rather than simply reinforce it.[57] Perhaps most significant, the novel reverses and dismantles the traditional interracial rape plot that was used historically to justify lynching—and does so to illus-trate the way that plot penalizes not only black men but also black women. Charging a black man with raping a white woman as an excuse for extralegal violence, the rape plot, especially as it was deployed by whites in the post-Reconstruction era, fabricated the violation of white women while making

invisible the actual rapes of black women.[58] Turning this narrative on its head to expose what it usually obscures—the violation of black women— Wright has Bigger rape Bessie rather than Mary. When Buckley invokes the conventional rape myth during the trial—"Mind you, your honor, the central crime here is [Mary's] *rape!*" (481), he proclaims, stoking public fury by asking jurors to imagine how Mary "must have pled on bended knee, with tears in her eyes, to be spared the vile touch of his horrible person!" (480)— the irony becomes quite clear. Bigger will be killed for raping Mary, a crime he did not commit, while his rape of Bessie will go unpunished by the judicial system. Moreover, although Bigger kills Mary accidentally, the reigning cultural logic dictates that he will be treated as if he had performed the act intentionally: "He was black and he had been in a room where a white girl had been killed; therefore he had killed her" (119). In contrast, Bigger *does* kill Bessie in a premeditated, deliberate, and cold-blooded manner. Yet the novel reminds us—and Bigger clearly realizes—that the violence committed against Bessie is of no concern to prosecutors, the court, or the white public: Bigger "knew when they killed him it would be for Mary's death; not Bessie's" (351). "The black girl," whose destroyed body is carted into the courtroom for display, "was merely 'evidence'" (383).

Robyn Wiegman has argued persuasively that Bigger does not see what he does to Bessie as rape; rather, he sees rape as an act of white supremacist violence against black men.[59] At the same time, however, readers are able to see Bigger's violation of Bessie as the rape that it is. Specifically, readers see both Bessie's resistance ("Bessie's hands were on his chest, her fingers spread *protestingly* open, pushing him away" [270, my emphasis]) and Bigger's refusal to acknowledge her verbal and physical objections. As Sondra Guttman has argued, the differences between the violent deaths of Mary and Bessie—and the way those deaths signify (or, in Bessie's case, the way her death fails to signify) in the public realm—suggest that "at least part of Wright's intent in representing such violence was to draw attention to the historical invisibility of black women's rapes and of their continuing devaluation in American society."[60] Rather than reinforcing or naturalizing Bessie's subordination, the novel in fact positions us to see it critically, as we first watch Bigger violate her and then witness how the justice system refuses to acknowledge his rape and killing as a crime worthy of prosecution. In fact, in contrast to Eileen Boris's claim that *Native Son* "erase[s] black female bodies," Bessie's body—and the spectacular violence Bigger commits against it—is given significant emphasis in the novel.[61] While the decapitation of Mary is rendered graphically, the gory quality of that scene

is surpassed by the depiction of Bessie's smashed head, the utter destruction of which recalls Nazone's blasted body in *Christ in Concrete*: "He lifted the brick again and again, until in falling it struck a sodden mass that gave softly but stoutly to each landing blow. Soon he seemed to be striking a wet wad of cotton, of some damp substance whose only life was the jarring of the brick's impact" (274). While Mary is beheaded, Bessie is utterly obliterated, reduced to a "sodden mass." Here, the novel seems to be emphasizing not only the horror of Bessie's death, which is even more gruesome than Mary's, but also the horror of the fact that Bigger does not recognize what he does as rape. Bigger here literally dehumanizes Bessie, dismantling her body until it is a mere coagulation of tissue and flesh. Wright seems to be using the conventions of sensationalism—in this case, the graphic depiction of extreme violence—to draw attention both to Bigger's misogyny and to the sanctioned dehumanization of black women in white-dominated patriarchal society.

Stereotype and Narrative Indeterminacy

If *Native Son*'s critical interrogation of mass culture's capacity to create a racial monster encourages readers to question the validity of racial clichés, the novel's experimental narrative voice likewise challenges the stereotypes its seems to affirm. Blending a third-person voice with a largely first-person point of view, the narrative delicately undermines the brittle rigidity of the stereotype, which reduces, essentializes, and naturalizes social "difference" by constructing stark boundaries between Self and Other. As Stuart Hall explains, stereotyping is "a practice of 'closure' and exclusion. It symbolically fixes boundaries, and excludes everything which does not belong."[62] However, the process of producing and maintaining stereotypes is never smooth or complete. Because stereotypes are a form of symbolic splitting and projection, in which elements of the Self are cast onto the image of abject Others, the stability of the stereotype continually threatens to break down.[63] *Native Son*, I contend, undermines the very stereotype it presents by destabilizing the symbolic boundaries that are the source of the stereotype's exclusionary power. Through its insistently ambivalent mode of narration, which at moments invokes and at moments undercuts the narrator's (and reader's) distance from and superiority to Bigger, the novel makes fluid precisely what stereotypes are designed to keep inflexible—the borders between Self (reader) and Other (Bigger).

At first glance, *Native Son*'s third-person narration reproduces what June Howard identifies as naturalism's defining dichotomy between a privileged,

"scientific" narrator and a degraded brute "Other" who is hopelessly subject to social forces that the narrator has the power to analyze.[64] As a spectacle of determinism, Bigger is frequently objectified by the very narrative voice that recounts his story. Early in the text, for instance, the narrator asserts: "These were the rhythms of his life: indifference and violence; periods of abstract brooding and periods of intense desire; moments of silence and moments of anger—like water ebbing and flowing from the tug of a far-away, invisible force" (31). Here, the narrator describes Bigger in a way that Bigger would not describe himself, could not see himself—a creature at the whim of "rhythms" and "forces" that the narrator, but not Bigger, can grasp. This is the *Native Son* Baldwin emphasized—the novel in which Bigger is an angry, brooding, lustful figure depicted with cool objectivity by a superior narrator.

Yet although the narrative at times objectifies Bigger, the novel is restricted to his perspective and filtered through his consciousness. *Native Son* aligns the reader closely with Bigger's viewpoint through the use of a modified form of free indirect discourse, in which the text simulates his thoughts while maintaining the third-person voice. According to Wright, he aimed "to explain everything only in terms of Bigger's life, and, if possible, in the rhythms of Bigger's thought" (HBWB 536). We can see this dynamic in a passage that appears early in the text: "He hated his family because he knew that they were suffering and he was powerless to help them. He knew that the moment he allowed himself to feel the fullness of how they lived, the shame and misery of their lives, he would be swept out of himself with fear and despair" (9). At first glance, this passage presents the image of Bigger and his family as passive victims of their poverty, trapped by the circumstance of their lives—the image against which Baldwin protested. Yet the passage is presented as Bigger's knowledge. Although written in the narrator's words, the text insists that what we are being told is what Bigger "knew," suggesting that, rather than a mindless ruffian, Bigger is quite cognizant of his material/social situation as well as his own emotional tendencies—and we as readers are positioned not to condescend to or belittle his knowledge, but to take it seriously. Moreover, by allowing readers relatively direct and intimate access to Bigger's consciousness, the text blurs the naturalist division between "knowing" narrator and ignorant "brute," undercutting the rigid and racist narrative structure that the novel nominally adopts.[65]

In "How 'Bigger' Was Born," Wright asserts that this seemingly contradictory blending of perspectives—Bigger's and the narrator's—is inten-

tional. Wright states, "I tried to write so that, in the same instant of time, the objective and subjective aspects of Bigger's life would be caught in a focus of prose" (HBWB 536). Wright explains that his intention was to make Bigger both "a symbol of the all larger things I felt and saw in him" and "a living personality" (HBWB 524), both a social type and a singular individual. To present the dual nature of Bigger's character—composite symbol and unique human subject—Wright employed a variety of narrative devices: "I'd sometimes find it necessary to use a stream of consciousness technique, then rise to an interior monologue, descend to a direct rendering of a dream state, then to a matter-of-fact depiction of what Bigger was saying, doing, and feeling" (HBWB 536). All the while, however, Wright "restricted the novel to what Bigger saw and felt, to the limits of his feeling and thoughts, even when I was conveying *more* than that to the reader. . . . I kept out of it as much as possible, for I wanted the reader to feel that there was nothing between him and Bigger" (HBWB 537). If Wright's comments here seem contradictory, that is because he is describing a very carefully balanced mode of narration, one in which we are aligned with Bigger's point of view ("nothing between [the reader] and Bigger") and yet in which that point of view is conveyed through an array of devices that provide information Bigger does not possess or use a language that differs from Bigger's. To borrow Wright's words for describing the need for literature to disrupt our traditional patterns of seeing, we might say that Bigger is simultaneously "strange" and "familiar"—he is an object of sociological scrutiny and also the reader's point of identification, the lens through which we see the novel unfold. Bigger is both stereotype and protagonist, "wastrel" and "hero" (in Sterling Brown's words), a symbolic figure of racial anxieties, misperceptions, and misdeeds and a complex individual with whose point of view readers are aligned. Portrayed in a manner that both evokes and unsettles the realist and naturalist frameworks through which the "lowly" have conventionally been depicted in American literature, Bigger is what Wright called, in his correspondence with Mike Gold, a "test symbol," a figure that challenges our capacity to see beyond the stereotype even as we look directly into it.[66]

The deep-seated ambiguity at the heart of *Native Son*'s narrative voice is part and parcel of the novel's formal and generic instability, which is marked by the range of literary techniques and tendencies that Wright blended into a multifaceted text. From pulp fiction, he drew from a stress on spectacle, sexual tension, and violent action; from naturalism, an emphasis on the determining power of social forces; from the sociology of the Chicago School, an emphasis on psychosocial estrangement and marginality; from the mod-

ernism of Joyce and Stein, an emphasis on the experimental, multiperspectival representation of consciousness; from proletarianism, an emphasis on American society's structural inequalities.[67] Wright's use of these contrasting modes produced an uneven text that defies conventional continuities of style, characterization, and point of view. Both the form of the novel itself and the text's depiction of Bigger are marked by discontinuity, gaps, and contradictions, fissures that suggest that the dominant traditions for representing racially subordinate persons demand what Houston Baker calls deformation.[68] In Baker's terms, *Native Son* not only demonstrates a mastery of form (an ability to mimic Dreiser, Joyce, and James), but also a deformation of mastery—an exposure of the insufficiency of prevailing discursive modes. As Wright himself asserted, he adopted yet disfigured canonical fictional styles: "I took [the techniques of white novelists], these ways of seeing and feeling, and *twisted* them, *bent* them, *adapted* them, until they became *my* ways of apprehending the locked-in life of the Black Belt areas" (HBWB 517, last italics in original). For Wright, writing is a process of disfigurement—of twisting and bending established rhetorical forms to fit the particularities of his own outlook and his protagonist's experience. Wright's multifaceted depiction of Bigger underscores the inadequacy of traditional, discrete literary modes: the use of a modified stream of consciousness to give a first-person feel to Bigger's thoughts undercuts naturalism's tendency to objectify and debase the lowly; the naturalistic emphasis on social forces in turn disqualifies modernism's tendency toward aesthetic and psychological solipsism. By intermingling divergent literary registers and approaches—naturalism, modernism, and sensationalism—Wright produced a text and a protagonist that resist traditional forms of coherence, closure, and fullness. The ensuing aesthetic lapses, contradictions, and occasional excesses invite readers to question the terms in which socially despised and marginalized figures such as Bigger have traditionally been rendered.

Other elements of the text prompt readers to question the image of Bigger that at first seems most evident. For instance, although the text depicts Bigger as sullen, violent, and inarticulate, it also highlights both Bigger's desire to be understood and the social and cultural barriers that inhibit such understanding. As the novel makes abundantly clear, Bigger is deeply estranged from the persons and institutions around him. The social world seems sealed off from Bigger, dominated by persons and forces he does not comprehend and that do not seem to comprehend him. The novel is suffused with images of blindness, walls, barriers, veils, and curtains separating Bigger from his family, the Daltons, the police, and the public. In "How

'Bigger' Was Born," Wright contends that what unites the various real-life Bigger Thomases, white and black, is a "deep sense of exclusion": "this intolerable sense of feeling and understanding so much, and yet living on a plane of social reality where the look of a world which one did not make or own struck one with a blinding objectivity and tangibility" (HBWB 518). Bigger is in the world, but not of it; he lives a life of abject powerlessness, subject to the misperceptions, misrepresentations, and misdeeds of the persons and institutions that govern the segregated society he inhabits. Bigger's state of psychic isolation not only prefigures Wright's assertion in 12 *Million Black Voices* that "the term 'Negro'" describes a "psychological island," but also illustrates Wright's engagement with high modernism, a movement dedicated to narrating the agonies of alienation and anomie. In this light, Bigger appears as a modernist figure cast in the center of an otherwise largely naturalist novel.[69]

Yet the novel insists that Bigger's isolation from other persons and his incapacity to communicate are socially determined rather than innate: "He had lived outside the lives of men. Their modes of communication, their symbols and images, had been *denied* him" (493, my emphasis). Bigger, we learn, "wanted to tell how he had felt when Jan had held his hand; how Mary had made him feel when she asked him about how Negroes lived; the tremendous excitement that had hold of him during the day and night he had been in the Dalton home—but there were no words for him" (358). Here, the novel stresses that Bigger has something vital to communicate, that he is more than a reactionary jumble of instincts and impulses, more than an intellectual and emotional cipher. But the text also maintains that Bigger's lack of verbal expression and internal coherence derives from the racially oppressive culture he inhabits. Bigger suffers from a "lack of inner organization which American oppression has fostered in him" (HBWB 523); he "is the *product* of a dislocated society" (HBWB 521, my emphasis). One of Wright's aims in writing the novel was to demonstrate how the material, social, and political conditions of American society in fact strip the disadvantaged of the very capacities they need to contest their subjugation. In one of the most illuminating comments in "How 'Bigger' Was Born," Wright explains: "I had to show . . . how oppression seems to hinder in the victim those very qualities of character which are so essential for an effective struggle against the oppressor" (529).

Caught within the crazy confines of a racially divided and deeply discriminatory society, Bigger, like Jake Jackson, lacks the forms of psychological continuity and coherence that conventionally endow novelistic char-

acters with emotional depth.[70] He is not an integrated personality, but, in the words of Kimberly Benston, "a site of multiple positions of subjection and subjectivity," a cultural matrix on which different characters project their desires, fears, and insecurities.[71] Bigger is not only estranged from others, black and white; he also suffers from feelings of internal fissure and discontinuity. Living in a society structured by racial misperception, Bigger experiences a form of internal splitting: "There were two Biggers" (292), we are told at one point. Elsewhere, the narrator asserts, "Never in all his life, with this black skin of his, had the two worlds, thought and feeling, will and mind, aspiration and satisfaction, been together" (278). Bigger's personality is ontologically ruptured, divided by the impossibility of realizing his most basic hopes and ambitions. A constellation of conflicting tendencies and energies rendered in a range of narrative styles, Bigger baffles readers; he is at once monster and victim, a totalizing presence (the figure whose story the novel tells) and a subjective absence (a persona whose motives and make-up are never fully explained).

In underscoring the fractured, disunified, and finally inaccessible quality of Bigger's subjectivity, the novel seems to be asserting the impossibility of fully "articulating" Bigger, hinting at the incapacity of existing literary modes to make him legible. As Craig Werner contends, "Both Wright and Bigger inhabit a world which offers no vocabulary capable of expressing the particular Afro-American experience of the modernist situation."[72] In the end, the novel does not provide a comprehensive accounting for Bigger, his motives, and actions; he remains elusive. In fact, the potential "explanations" the novel does offer, most notably the courtroom speech delivered by Bigger's attorney, Max, prove inadequate. Max's speech is not only interminably long, challenging readers' patience, but also utterly "scientific" in tone and reasoning, affording us no insight into how Bigger's experience appears from his perspective. Indeed, we are informed that Bigger "had not understood [Max's] speech" (473). Rather than a progressive unveiling of Bigger's motives and actions, then, the novel represents the continual failure of explanatory frameworks; rather than a consistent style, the novel invokes several styles, only to expose each of them—including the language of liberal social science, often accepted by readers as the source of authorial "truth," the culminating statement of Wright's philosophical determinism—as insufficient.

In "How 'Bigger' Was Born," Wright asserts that Bigger "is a snarl of many realities": "The most I could say of Bigger was that he felt the need for a whole life and acted out of that need; that was all" (HBWB 526, 527). Yet if

Bigger, like Jake Jackson, feels a "need for a whole life" — what the novel describes as "his deep yearning for a sense of wholeness" (294) — then his subjectivity is in fact animated by a series of profound aspirations, ambitions, and motivations. That "need for a whole life" is an integration of thought and feeling, of Self and Other: "[This is] what he wanted: to merge himself with others and be a part of this world, to lose himself in it so he could find himself, to be allowed a chance to live like others, even though he was black" (278). The achievement of such interpersonal union is obstructed by the lack of mutual knowledge whites and blacks have of one another. To African Americans, whites represent an alien, elemental presence rather than a community of individuals: "To Bigger and his kind white people were not really people; they were like a sort of great natural force, like a stormy sky looming overhead, or like a deep swirling river stretching suddenly at one's feet in the dark" (129). Similarly, in the eyes of even the most "sympathetic" whites, Bigger represents an object of curiosity more than a social equal. For instance, although Mary initially treats Bigger with a form of respect that he had never received from a wealthy, white person ("She responded to him as if he were human, as if he lived in the same world as she. And he had never felt that before in a white person" [74]), her interest in Bigger and African American culture is ultimately patronizing ("They have so much emotion! What a people! . . . Say, Bigger, can you sing?" [88]) and invasive ("Again she was looking inside of him and he did not like it" [92]).

Bigger's desire for unity culminates in a vision he has while alone in jail. The vision is sparked by the "recognition of his life, of his feelings, of his person" (417) that he feels is implied in the way that Max questioned him. This "new sense of the value of himself" (418) prompts a provocative image of community: "If he reached out with his hands, and if his hands were electric wires, and if his heart were a battery giving life and fire to those hands . . . would there be a reply, a shock? . . . And in that touch, response of recognition, there would be union, identity; there would be a supporting oneness, a wholeness which had been denied him all his life" (419–20). Then, Bigger imagines "a strong blinding sun sending hot rays down and he was standing in the midst of a crowd of white men and black men and all men, and the sun's rays melted away the many differences, the colors, the clothes, and drew what was common and good upward toward the sun" (420). These visions, in which Bigger dreams a relationship of equality and commonality with the people in the world around him, are the utopian seeds embedded in Wright's novel, and they echo — and suggests Wright's debts to — the images of solidarity that punctuate many Depression-era texts, especially texts that

spring from the proletarian tradition, with which Wright, who participated actively in the Chicago John Reed Club, was quite familiar.[73] However, the language in which the vision is conveyed betrays the impossibility of its realization. The passage's metaphors—of wires, batteries, shocks—are electric and mechanical, ironically *de*humanizing the vision of human connection. The passage also quickly jumps from Bigger to a deindividualized sense of unity, a vague and ethereal picture of interpersonal assocation, in which individuality vanishes in the face of collectivity. The sun that unites also "blinds," and the potential insight the image offers is undercut by visual incapacity. The vision of solidarity is nebulous, metaphoric, and fleeting—an obscure image of a utopian scenario, the opacity of which suggests its lack of viability.

No Man's Land

The novel's complex narration, in which we are simultaneously inside and outside Bigger's consciousness—aligned with his perspective, yet able to see and comprehend more than he knows—places readers in an ambiguous position. Wright refers to this interstitial space as "No Man's Land," a concept he mentions both in "How 'Bigger' Was Born" and in the novel itself. In the essay, Wright describes "No Man's Land" as a liminal space: "What made Bigger's social consciousness most complex was the fact that he was hovering unwanted between two worlds—between powerful America and his own stunted place in life—and I took upon myself the task of trying to make the reader feel this No Man's Land" (HBWB 527). Here, "No Man's Land" is the isolated, indeterminate realm in which Bigger wavers, unaffiliated, caught between a white supremacist society and his own unrealized and unarticulated critique of it. Wright imagines that his task as a writer is to make the reader "feel" this space, to sense its solitude and insecurity, if only briefly. In the novel, Wright invokes the concept of "No Man's Land" to describe Bigger's disorientation when Jan insists that Bigger not refer to him as "sir," a gesture that Bigger finds suspicious and that paradoxically makes him more, rather than less, self-conscious about the racial difference between the two men: "He felt no physical existence at all right then; he was something he hated, the badge of shame which he knew was attached to black skin. It was a shadowy region, a No Man's Land, the ground that separated the white world from the black that he stood upon. He felt naked, transparent; he felt that this white man, having helped to put him down, having helped to *deform* him, held him up to look at him and be amused" (76, my emphasis). Several things about this passage are worth noting. First

is the feeling of transparency that Bigger experiences, as if he is a specimen held up for inspection or entertainment. This feeling recalls the sense of shame and nakedness that strikes Paul in *Christ in Concrete* when his family visits the city offices seeking compensation for Geremio's death. It is similar to the imperialist gaze assumed by the doctor-narrator of William Carlos Williams's short stories, who feels that the bodies and lives of his impover-ished, immigrant patients are immanently legible to his discerning eye. It is, in other words, a version of the visual scrutiny by which the socially power-ful assert their privilege and dominance, and Wright concurs with other sen-sational modernists that being subject to such scrutiny is experienced as a kind of deformation. It is also a form of disorientation and dislocation — Big-ger feels as if he is being held up for examination, literally ungrounded. No Man's Land, as Wright explains it, is a decidedly uncomfortable space, the ground of separation in which Bigger flutters between the shoals of stable racial realms. In this passage, Bigger paradoxically enters this "shadowy region" precisely at the moment in which he feels most racially defined or "fixed"—the moment of maximum racialization is also the moment of racial ambiguity, the moment when the process of racial identity formation becomes visible. Bigger may appear to be the most rudimentary of racial figures—a savage, unfeeling, black beast, an embodiment of the most long-standing and overdetermined cultural stereotypes—but both Wright's essay and the novel itself suggest that Bigger is in fact drifting, hovering, waver-ing between established racial zones and stable racial identities. "No Man's Land" is a transitional space in which the seeming security of racial subjec-tivity is exposed as a process, an elaborate social production. It is similar to what Homi Bhabha calls "culture's in-between," the "uncanny space and time between two moments of being," between "disavowal and designation," Self and Other, the space in which identity appears in process and flux.[74] It is the place in which readers see the stereotype and see beyond it as well, a vantage point from which we recognize both the power and the poverty of racial clichés.

The ambiguity at the heart of the novel's depiction of Bigger is never resolved. In contrast to many critics, I contend that the novel does not end with Bigger's achievement of a meaningful "voice" or an autonomous, fully realized subjectivity. John Reilly claims that by "signifying" on the stereo-type Wright endows Bigger with a "clandestine subjectivity, the right to be a free human agent."[75] Reilly describes the novel as a play of contrasting voices and discourses, "all of them qualifying and redrawing the portrait of Bigger Thomas until the novel makes room for Bigger himself to speak."[76]

This seems to be wishful thinking; although Bigger articulates a logic to his story in the last scene, in which he states, "What I killed for, I *am*" (501), his assertion is incomplete and cryptic, a partial and enigmatic illumination more than a comprehensive, culminating statement that makes sense of what has come before. As Wright himself acknowledged, "Bigger did not offer in his life any articulate verbal explanations" (HBWB 528). Rather than a coherent delineation of an alternative or oppositional subjectivity, *Native Son* performs a metafictional critique of the conventions under which African American subjectivity is typically rendered. Wright challenges his readers by stripping Bigger of the normative qualities of depth, coherence, and internal intelligibility that we traditionally expect of novelistic characters and compelling us, nevertheless, to see the world of the novel through Bigger's eyes. Instead of making room for Bigger to speak, to finally and fully enunciate the meaning of his experience in his own words, the novel clears out an indeterminate narrative space, a No Man's Land, into which readers are invited to step and, perhaps by design, lose their footing. The uncertainty of this space, in which stereotypes are both invoked and destabilized, is surprisingly similar to what James Baldwin, in his critique of Wright, describes as the "web of ambiguity, paradox, this hunger, danger, darkness [in which we] can find at once ourselves and the power that will free us from ourselves."[77] Baldwin's insistence on the fundamental "ambiguity" and "paradox" of racial identity is not, finally, so different from Wright's notion of No Man's Land, of Bigger's desire, expressed during the deep isolation of his long flight from the police quoted earlier, to "merge himself with others and be a part of this world, to lose himself . . . so he could find himself" (278). Like Baldwin, Wright seems to be suggesting that addressing the full scope and complexity of racial difference and injustice requires opening spaces in which we, along with Bigger, might lose ourselves in order to find ourselves anew.

CONCLUSION

MODERNISM, POVERTY, AND

THE POLITICS OF SEEING

I have used the term "sensational" in this book to describe a mode of formal and epistemological disturbance. In the sensational aesthetics I have analyzed, Depression-era artists deploy striking, often spectacular, motifs of illness, harm, and stereotype in an effort to destabilize the discourses of sentimentality and scrutiny frequently used to frame socially disenfranchised figures in modern American fiction and photography. To disrupt prevailing protocols of representation, sensational modernists use forms of aesthetic exaggeration and distortion as well as tropes of disfigurement and violence that echoed the boisterous, unruly, and shock-inducing dynamics of early twentieth-century sensational mass culture. Aiming to undermine attitudes of detachment, condescension, and pity, and motivated by a deep sense of affinity for the poor people about whom they write and whom they photograph, these artists use the experimental techniques of avant-garde modernism to craft astonishing aesthetics of extremity that address the gritty materialities of life on the nation's social and political margins during the 1930s.

The work of these artists encourages us to rethink some significant critical categories and questions. One of these is the concept of spectacle. In contemporary critical parlance, spectacle typically carries a pejorative connotation, describing a process of visual objectification and commodification. To make a spectacle of something or someone is to transform it/him/her into an exchangeable item, to reduce it/him/her to the status of a mere, reproducible thing. A spectacle, many theorists have argued, is a false, hollow representation, a shallow and illusionary rendition of a complex original. Moreover, critics have suggested that by substituting the representation of a thing or event for the actual experience of it, spectacle reduces audiences to passive spectators, making us consumers rather than participants.[1] Complicating such narrow lines of critique, sensational modernists use forms of spectacle to create active rather than passive readers and viewers. These artists use spectacular images of injury and prejudice to interrupt and disable traditional forms of sentimental, realist, naturalist, and documentary

representation, insisting on the uncertainty and instability of social understanding and the vexing problematics of cross-cultural engagement. Rather than confirming what we already know or expect, these works of art make the familiar unfamiliar, suggesting that our knowledge about persons living on the other side of significant social boundaries is less secure than we tend to think. Indeed, in the hands of sensational modernists, spectacle becomes a form of "unknowing" rather than a facile confirmation of socially sanctioned assumptions.[2] However, as I have maintained, the attempt to use graphic and spectacular tropes for the purposes of disabling hegemonic assumptions is a very uncertain and risky enterprise, one that walks a fine line between challenging and reproducing the narrow tropes of pity, romance, and abjection that characterized the manner in which economically disenfranchised and racially marked persons were most commonly represented in early twentieth-century American culture.

In 1966, journalist and historian Caroline Bird described the Great Depression as an "invisible scar," a wound inflicted on the national imagination and the national body that persisted for decades even though its most tangible effects were alleviated by the economic recovery that accompanied World War II.[3] In this project, I have examined the work of artists who sought to make visible some of the scars of the 1930s, using experimental forms of fiction and photography to create unconventional and unsettling depictions of poverty and illness, ethnic and racial prejudice, class conflict and industrial injury. I have called the process of aesthetic undoing and recomposition that these artists perform—a process Richard Wright characterized as "twisting" and "bending"—disfiguration.[4] Disfiguration describes sensational modernism's aesthetic innovations and also represents its signature motif. In these works, depictions of disfigured, damaged, and distorted bodies echo the experimental aesthetic forms sensational modernists create. Weegee's images of bloody and mangled bodies, for instance, are captured in a frenzied, proto-surrealistic style that upsets the assumptions of indexicality that subtended most thirties-era documentary photography. Likewise, in her depiction of a miner's crushed body, Tillie Olsen combines heterogeneous literary modes in an unruly, Brechtian-like form of anticapitalist, feminist modernism. In these instances, and others I have examined, physical disfigurement is mirrored and reinforced by formal disfigurement. The depiction of bodily disfiguration reflects generic and stylistic disfiguration, as conventional aesthetic modes are deformed and then recombined in a process that creates unprecedented experimental languages of critique and expression. Disfiguration, then, is more than a form of critique, a way

of rendering (and protesting) harm. It is also a kind of bricolage, an act of creative innovation that takes depictions of injury or inequality as opportunities to break with conventional modes of representation and to forge alternative, unorthodox styles of expression that offer previously unseen or unarticulated perspectives and claims on the social realities of modern America.

Working within yet against established narrative and visual forms that they find confining, sensational modernists create works that are ripe with tensions. Disfiguration, as both a trope and a formal strategy, opens up a space of ambiguity and flux, a momentary standstill in an interplay of opposing forces: identity and difference, astonishment and empathy, social protest and personal vision, documentary realism and artistic play, fracture and continuity, high culture and low culture. It is at the intersections of these forces that sensational modernism can most fruitfully and fully be located and understood. We can see several of these tensions, and the manner in which they converge uneasily, in a photograph by Weegee that opens the chapter on Harlem in *Naked City* (figure C.1). Like so many of his photos, this image contains several distinct, if overlapping, aesthetic and ideological strands. Clearly, one of these strands is documentary, evident in the picture's stark realism. The photograph's straightforward angle, balanced composition, and human focus all evoke the liberal documentary tradition prominent in the 1930s, especially as that tradition was manifested in the work of FSA photographers. This brand of documentary photography asks us to identify with and feel for the unfortunate insofar as they represent a universalized common humanity. Documentary humanism is closely related to a second aesthetic strand, sentimentalism, which the picture invokes through the iconography of mother and child, a trope that pervades the FSA file.[5] Here, Weegee uses the Madonna-and-child motif to represent the vulnerability and nobility of an entire social group, inviting us to sympathize with these Harlem residents by invoking long-standing conventions of maternal suffering and love. The picture's sentimentalism, however, is crosscut by a third aesthetic strand—its sensationalism. Several features of this photograph—including the traces of violence implied by the shattered glass, the logic of exposé manifested in the harsh lighting, and the dynamics of boundary crossing symbolized by the door frame—give this photograph a visceral intensity that disturbs the image's documentary sentimentalism, unsettling what otherwise might be a relatively unexceptional portrait of the "worthy poor." Finally, what I would describe as the uneasy intersection of the documentary, the sentimental, and the sensational is related to a fourth

Figure C.1. Weegee, "Mrs. Berenice Lythcott and her one-year-old son Leonard look out a window through which hoodlums threw stones," 1943. Courtesy of Getty Images.

aesthetic element: modernism, present in the way the broken glass and the inclusion of the door frame within the shot echo the glass of the camera lens and the process of photographic framing, thereby lending the image a subtle self-reflexiveness. This is, in some measure, a picture about taking pictures, in the tradition of so many modernist texts that allude to the terms or process of their own construction.

To understand the ends to which these various aesthetic threads are woven together, we need to turn to the text that accompanies the image. The short verbal narrative that faces the image opens: "Discrimination . . . that's the one ugly word for it."[6] Although Weegee admits that he doesn't know the "solution" for discrimination, he asserts that "one of the reasons for race riots [is] . . . a poor white neighborhood."[7] "Poorly paid white people," he continues, "themselves get pushed around all day by people they come in contact with in their work and by their straw bosses. So colored people, crowded out of their own colored sections, come looking for rooms in their neighborhood. So the ones that get pushed around themselves, now started pushing the others around by throwing rocks into the windows of the colored occupants."[8] This text implies that the door in the photograph has been shattered by rocks thrown by white rioters, angry at blacks who have moved into a traditionally white neighborhood. Although in referring to black neighborhoods as "their own colored sections" Weegee's prose implicitly reinforces the naturalness of separate black and white spaces, his economic analysis of discrimination is remarkably forthright. Moreover, the combination of the text and image underscores both the violent force of racial prejudice and the emotional strength of individuals whom viewers might otherwise be accustomed to seeing as abject or pitiful "victims." The sensational aspects of the image—the shattered glass, the harsh lighting, and deep shadows— catch our attention and suffuse the picture with violence, underscoring the brutality of what has taken place here. But the way in which the image borrows the conventions of 1930s documentary portraiture gives this pair of figures an iconographic strength. The woman stands squarely, facing forward, and both she and the child gaze directly into the lens. Rather than being invited to pity them, to look down at them, or to exoticize them—three well-established conventions for framing African Americans in American visual culture—the image encourages us to see them as dignified, even courageous, if also in some measure vulnerable, figures. Their stances and facial expressions, and the way they are framed and positioned, endow them with subjective integrity, casting them as the viewers' social equals rather than inferiors. In constructing this axis of recognition, however, the image does

not simply reinforce a facile humanism. The presence of the door frame and the shards of glass (and the shadows cast by them), which subtly distort the faces of the two figures, hold the pair at a degree of remove, complicating just slightly the vectors of identification and short circuiting any totalizing impulse to assimilate the woman and child as abstract embodiments of a universal humanity. This form of complex identification is akin to what Kaja Silverman terms "identity-at-a-distance"—a type of seeing that balances sameness and difference, Self and Other.[9] It is a version of what Philip Weinstein, in describing modernism's challenge to realist protocols of knowing, calls "*acknowledgement*—the other not objectified and mapped, but encountered nevertheless."[10] Shot through with competing aesthetic strains, Weegee's photograph thus works in complicated ways: it asks viewers to see these two individuals as victims, but not as people whose dignity or power has been stripped. We are positioned to "feel" for them, but also—through the written text that accompanies the image—to balance an emotional response with a political understanding that takes into account larger social and economic dynamics. They are placed squarely before our eyes, but we are reminded that our gaze is being framed and that our looking, which takes place across a literal and metaphoric threshold, is in some measure inevitably partial and incomplete.

In this image, then, sensational aesthetics are mixed with elements of modernism, sentimentalism, and documentary in order to do more than simply shock. What I have been calling the aesthetic of astonishment does not just startle; it invites readers and viewers to identify with the socially despised in ways that do not belittle, condescend, exoticize, or romanticize them. Such an ideal form of identification—in which socially inferior figures are posed as equals, but not wrapped into the dubious cloak of a universal humanism that vacates politics in the name of an abstract essentialism—is in reality never fully achieved or realized. It remains an ideal. The photograph by Weegee, for instance, leans perilously close to a humanist embrace that would erase the specificities of the mother and child's social and material circumstances. But the text that accompanies the image, as well as the visual cues reminding viewers of racial violence, hold such an embrace—and the evacuation of political realities that attends it—at bay.

This book was written against the critical current that sees seamless links between literary form, technologies of vision, and the cultural domination of marginalized populations. Several critics have argued, for instance, that FSA photography should be seen as a part of a national system of disciplinary surveillance, as an inventory of images that collectively police the poor, en-

closing them in what Allan Sekula calls a "shadow archive."[11] Some literary critics have similarly contended that the realist effort to make the lives of the poor visible served as a form of social regulation.[12] I have argued instead that efforts to narrate, document, and photograph the experience and conditions of impoverishment, privation, and prejudice often generate ideological and formal crises, and that these crises in turn ignite an acute self-consciousness about artistic style and approach as well as unorthodox, often unpredictable forms of aesthetic experimentation. In a recent effort to theorize the presence of poverty and the poor in American literature, Gavin Jones has proposed that such cognitive crises quite frequently accompany artistic attempts to comprehend those living in circumstances of destitution. "Epistemological and ideological decentering," he claims, is "never far from the self-conscious literary responses to the contentious position of poverty within US political and social discourse."[13] Examining Herman Melville's determined focus on material misery, Jones argues that poverty frequently challenges linguistic and narrative competence. As a topic of literary narrative and inquiry, it possesses a "power to upset social conventions and hierarchies rather than to confirm them."[14] I have argued something similar. The effort, often "realist" in intent, to encode poverty in narrative and visual forms—an enterprise that acquired particular saliency and urgency during the Depression—created cognitive ruptures that were registered in tropes of disfigurement and in departures from conventional aesthetic techniques and styles. Sensational modernism is, in a sense, a poverty modernism, the experimentalism of which stems either from the attempt to write and take photographs amid the constricting conditions of overwork and material privation or from the effort to put into visual or narrative form the particularity of poverty as a category of social being that is not wholly reducible to the social structures of class and race.

In a way, modernism is by nature sensational. It aims to unsettle and to transgress, to renew our vision by challenging, often in bold and deeply disturbing ways, established boundaries and conventions. Moreover, high modernism's fascination with the "exotic" and "primitive," with the taboo and deviant, frequently lends a sensational flavor to modernist art. Modernism has traditionally been considered an aesthetic response to the shock of the new—new technologies, new economic arrangements, new urban spaces, newly mobile peoples. Sensational modernism is a response to the shock of social division and exclusion that emerged during a period of broad cultural crisis and uncertainty, the Great Depression. Sensational modernists are distinguished not only by their formal innovations, their often daring

reconfiguration of realist conventions, but also by their political commitment to upsetting and undermining prevailing modes of representing the nation's poor and disenfranchised populations, especially the tropes of sentiment and scrutiny. I continue to believe in modernism's potential to break frames, to startle us, and, in so doing, to prompt us to see the world in new ways. As Astradur Eysteinsson has argued, modernism is a pedagogic project, a "mode of skeptical hermeneutics, critical of habitualized practices handed down to us by tradition."[15] The shock that often accompanies modernist efforts to overturn these habitualized practices, however, does not in and of itself lead in any given ideological direction; indeed, shock is politically nonspecific and uncertain. As I have suggested, sensationalism and shock are volatile techniques that can foster forms of social detachment or indifference rather than invite nonreductive forms of cultural identification or spark critical social reflection. Sensational modernists use shocking motifs and images not, as many other modernists did, in an effort to circumvent or transcend historical and political conflicts, but to engage those conflicts. They sought to use modernism's interruptive devices to call into question the frameworks through which social and material inequalities are conventionally viewed and, quite often, made palatable, even perversely pleasurable, to contemplate. Indeed, it is the effort to grapple with cultural conflicts and inequalities that triggers these artists' aesthetic innovations in the first place. I hope that these works, produced by artists who aimed to use modernism's tactics of shock and disorientation to confront some of the Depression era's most pressing social and political concerns, might offer new insight into modernism's power, flexibility, and critical potential, and continue to inform, inspire, and astonish us, even in this postmodern age.

Introduction

1. Pietro di Donato, *Christ in Concrete* (New York: Penguin Books, 1996), 129.

2. Ibid., 133.

3. James Agee and Walker Evans, *Let Us Now Praise Famous Men* (Boston: Houghton Mifflin, 1980), 14.

4. Ibid., 11.

5. See, for instance, Mark Seltzer, *Bodies and Machines* (New York: Routledge, 1992), and June Howard, *Form and History in American Literary Naturalism* (Chapel Hill: University of North Carolina Press, 1985). Howard argues that naturalism's rigid dichotomy between omniscient narrator and lower-class, "brute" characters echoes the top-down structure of Progressive-era reform.

6. Maren Stange, *Symbols of Ideal Life: Social Documentary Photography in America, 1890–1950* (Cambridge: Cambridge University Press, 1987), xii.

7. Peter Nicholls, "Masters, Slaves, and Modernists: Two Versions of an Aesthetic," *West Coast Line* 27, no. 3 (Winter 1993–94), 98. Nicholls asserts that in canonical modernism "the self's relation to the other is construed as one of domination," irony, and mastery (96). Elsewhere, Nicholls wonders, "It is too much to say that this grounding of the aesthetic in an objectification of the other would constitute *the* recurring problem of the later modernisms?" Nicholls, *Modernisms: A Literary Guide* (Berkeley: University of California Press, 1995), 4.

8. Arguments about high modernism's defensive cultural anxiety and its consequent tendency to exoticize or demean various social "others" — workers, women, sexual dissidents, Jews, and African Americans — frequently take T. S. Eliot's *The Waste Land* as a central text. Gregory Jay asserts: "Characteristic of much modernism, *The Waste Land* tends to shore up an anxious personal and cultural identity by casting the Other in representations that connote the primitive, the carnal, or the degenerate." Gregory Jay, "Postmodernism in *The Waste Land*: Women, Mass Culture, and Others," in *Rereading the New: A Backward Glance at Modernism*, ed. Kevin Dettmar (Ann Arbor: University of Michigan Press, 1992), 235. Eric Shocket contends that Eliot's poetry manifests a modernist "aesthetics of management" that attempts to contain, in the realm of artistic form, the potentially disruptive dissonance of class divisions and working-class agency in much the same way that Taylorism attempted to contain potential class conflicts in the realm of production. See Shocket, "Modernism and the

Aesthetics of Management, or T. S. Eliot's Labor Literature," in *Left of the Color Line: Race, Radicalism, and Twentieth-Century Literature of the United States*, ed. Bill Mullen and James Smethurst (Chapel Hill: University of North Carolina Press, 2003). On Eliot's unapologetic anti-Semitism and the depiction of Jews in his poetry (especially Bledstein from the drafts of *The Waste Land*) as grotesque embodiments of the decadence and corruption of modernity, see Anthony Julius, *T. S. Eliot, Anti-Semitism, and Literary Form* (Cambridge: Cambridge University Press, 1995). Much recent criticism, on which my own study builds, has also suggested that the disgust or anxiety that Eliot (and other high modernists) display toward figures of alterity and difference is mixed at various moments and to varying extents with desire and identification. See, for example, Harriet Davidson's reading of Eliot's poem, which argues that the text blurs the boundaries between the very identities and voices that it also anxiously tries to maintain. Davidson, "Improper Desire: Reading *The Waste Land*," in *The Cambridge Companion to T. S. Eliot* ed. A. David Moody (Cambridge: Cambridge University Press, 1994), 121–31.

9. In the seventeenth and eighteenth centuries, "sensation" generally referred to forms of sensory perception: "the operation or function of the senses . . . the subjective element in the operation of the senses; physical 'feeling,'" according to *The Oxford English Dictionary*. Over the course of the nineteenth century, the term came to connote a startling impression, often precipitated by the apprehension of lurid or shocking images; as *The Oxford English Dictionary* states: "a strong impression (e.g. of horror, admiration, surprise, etc.) produced in an audience or body of spectators." In the United States, sensationalism emerged, especially in the press, as an attempt to arouse strong reactions through the presentation of images and scenes of social contrast, danger, or extreme and indelicate behavior. On nineteenth-century U.S. sensationalism, see Michael Denning, *Mechanic Accents* (New York: Verso, 1987); Shelley Streeby, *American Sensations: Class, Empire, and the Production of Popular Culture* (Berkeley: University of California Press, 2002); David Anthony, "The Helen Jewett Panic: Tabloids, Men, and the Sensational Public Sphere in Antebellum New York," *American Literature* 69, no. 3 (September 1997): 487–514; and Christopher Looby, "George Thompson's 'Romance of the Real': Transgression and Taboo in American Sensation Fiction," *American Literature* 65, no. 4 (December 1993): 651–72. In *American Sensations*, Streeby asserts astutely that sensationalism "emphasizes materiality and corporeality, even or especially to the point of thrilling or horrifying readers" (31).

10. The traffic I am describing between the sensational and modernism is

by no means one-way; in fact, the categories themselves are not discrete, as the work of a figure like Weegee suggests. Weegee might be considered a modern sensationalist as well as a sensational modernist. I have opted to categorize him as a modernist because the publication of *Naked City* (1945) demonstrates his ambition to have his tabloid work recognized as aesthetically complex and viable "Art," and to have himself recognized as an artist, not just a hack photographer. But again, while modernists absorb themes and aesthetic conventions central to sensational culture, popular artists and cultural workers—journalists, graphic artists, and advertisers—borrow from modernism.

11. John Matthews offers a succinct summary of this position: "Elitist modernism retreats into the cultural sphere from the specter of social transformation inherent in the emancipatory advances of modernization." Matthews, "Faulkner and the Culture Industry," in *The Cambridge Companion to William Faulkner,* ed. Philip M. Weinstein (Cambridge: Cambridge University Press, 1995), 71.

12. For recent revisionist scholarship on American modernism, see Paula Rabinowitz, *Black and White and Noir: America's Pulp Modernism* (New York: Columbia University Press, 2002); Michael Szalay, *New Deal Modernism: American Literature and the Invention of the Welfare State* (Durham, N.C.: Duke University Press, 2000); Michael Thurston, *Making Something Happen: American Political Poetry between the Wars* (Chapel Hill: University of North Carolina Press, 2001); Michael Trask, *Cruising Modernism: Class and Sexuality in American Literature and Social Thought* (Ithaca, N.Y.: Cornell University Press, 2003); Michael Denning, *The Cultural Front* (New York: Verso, 1996); Edward M. Pavlic, *Crossroads Modernism: Descent and Emergence in African-American Literary Culture* (Minneapolis: University of Minnesota Press, 2002); George Hutchinson, *The Harlem Renaissance in Black and White* (Cambridge, Mass.: Harvard University Press, 1995); Houston Baker, *Modernism and the Harlem Renaissance* (Chicago: University of Chicago Press, 1987); Werner Sollors, *Beyond Ethnicity: Consent and Descent in American Culture* (New York: Oxford University Press, 1986), especially chap. 8, and "Ethnic Modernism," in *The Cambridge History of American Literature*, vol. 6, ed. Sacvan Bercovitch (Cambridge: Cambridge University Press, 2003); Ann Douglas, *Terrible Honesty: Mongrel Manhattan in the 1920s* (New York: Noonday Press, 1995); Douglas Mao and Rebecca L. Walkowitz, eds., *Bad Modernisms* (Durham, N.C.: Duke University Press, 2006). For overviews of modernism that emphasize the diversity and range of artistic and cultural formations within the larger American modernist movement, see Nicholls, *Modernisms*; Walter Kalaidjian, ed., *The Cambridge Companion to American Modernism* (Cambridge: Cambridge University Press, 2005); and Sara

Blair, "Modernism and the Politics of Culture," in *The Cambridge Companion to Modernism*, ed. Michael Levenson (Cambridge: Cambridge University Press, 1999), 157–73. *Sensational Modernism* also extends recent scholarship on the intersection of modernism and mass culture. Although a standard definition of modernism asserts that the movement defined itself in opposition to mass culture, several recent studies suggest that the relationship between the two was much more fluid than has previously been acknowledged. See Andres Huyssen, *After the Great Divide: Modernism, Mass Culture, Postmodernism* (Bloomington: University of Indiana Press, 1986); Rita Barnard, *The Great Depression and the Culture of Abundance: Kenneth Fearing, Nathanael West, and Mass Culture in the 1930s* (Cambridge: Cambridge University Press, 1995); Thomas Strachyz, *Modernism, Mass Culture, and Professionalism* (Cambridge: Cambridge University Press, 1993).

13. The distinction I draw between high modernism and sensational modernism is based not so much on the relationships of these movements to mass culture, but on the larger social and political values embedded in these different traditions. While works of high or elite modernism often borrow motifs or techniques from mass culture (*The Waste Land*, which incorporates vernacular speech and popular song, is a prime example of this), they tend to privilege a set of conservative aesthetic and political values—cultural unity, hierarchy, and social order—to which sensational modernism, with its interest in social conflict and bodily harm, stands largely in opposition.

14. For my reading of a set of late nineteenth-century texts that address similar dynamics, see Joseph Entin, "'Unhuman Humanity': Bodies of the Urban Poor and the Collapse of Realist Legibility," *Novel: A Forum on Fiction* 34, no. 3 (Summer 2001): 313–37.

15. My sense of the period between the 1929 crash and the Second World War as an era of hegemonic crisis and transition is indebted to Denning, *Cultural Front*. For Gramsci's discussion of hegemony, see Gramsci, *Selections from the Prison Notebooks of Antonio Gramsci*, ed. and trans. Quintin Hoare and Geoffrey Nowell Smith (New York: International Publishers, 1971). For more on the theory of hegemony, especially on notions of crisis, transition, and reconsolidation, see Stuart Hall, *The Hard Road to Renewal: Thatcherism and the Crisis of the Left* (London: Verso, 1990).

16. Warren Susman, "The Culture of the Thirties," in *Culture as History: The Transformation of American Society in the Twentieth Century* (New York: Pantheon Books, 1984), 164.

17. Alan Brinkley, *Culture and Politics in the Great Depression* (Waco, Tex.: Markham Press Fund, 1999), 38.

18. Terry A. Cooney, *Balancing Acts: American Thought and Culture in the 1930s* (Boston: Twayne, 1995).

19. This point is made by Michael Rogin in "How the Working Class Saved Capitalism: The New Labor History and *The Devil and Miss Jones*," *Journal of American History* (2002) <http://www.historycooperative.org/journals/jah/89.1/rogin .html> (July 15, 2005).

20. S. K. Ratcliffe, "Hard Times in America," *Contemporary Review* 137 (1931): 702–709. Gilbert Seldes, one of the nation's premier cultural critics, asserted in 1933, "God's country, this land of simple faith and buoyant optimism had turned sour, cynical, and disbelieving." Seldes, *The Years of the Locust (America, 1929–1932)* (Boston: Little, Brown, 1933), 4.

21. Alfred Kazin, *On Native Grounds: An Interpretation of Modern American Prose Literature*, abridged ed. (Garden City, N.Y.: Doubleday, 1956), 281.

22. Robert S. McElvaine, *The Great Depression: America, 1929–1941* (New York: Times Books, 1993), 337. Caroline Bird states that the Depression "challenged our Conventional Wisdom of progress, individual initiative, thrift, free enterprise, limited government—even our Conventional Wisdom of love and marriage." Bird, *The Invisible Scar* (New York: David McKay, 1966), xiv.

23. Edward Dahlberg, *Bottom Dogs* (New York: Simon and Schuster, 1930). On the cultural centrality of figures and images that depict persons and things that are socially marginalized, see Peter Stallybrass and Allon White, *The Politics and Poetics of Transgression* (Ithaca, N.Y.: Cornell University Press, 1986). On the interest in "waste" during the decade, see Cooney, *Balancing Acts*, 159–60; and Miles Orvell, *The Real Thing: Imitation and Authenticity in American Culture, 1880–1940* (Chapel Hill: University of North Carolina Press, 1989), especially the epilogue.

24. Morris Dickstein, "Depression Culture: The Dream of Mobility," in *Radical Revisions: Rereading 1930s Culture*, ed. Sherry Linkon and Bill Mullen (Urbana: University of Illinois Press, 1996), 230.

25. Paula Rabinowitz contends that "erasing the space between social others— the middle class from the poor and working class, Jews from Gentiles, blacks and whites from each other—became an aesthetic as well as a political imperative by the 1930s." Rabinowitz, "Social Representations within American Modernism," in Kalaidjian, *Cambridge Companion to American Modernism*, 267.

26. See Marcus Klein, *Foreigners: The Making of American Literature, 1900– 1940* (Chicago: University of Chicago Press, 1980).

27. On the insurgency of the unemployed, see Frances Fox Piven and Richard Cloward, *Poor People's Movements: Why They Succeed, How They Fail* (New York: Vintage, 1977), chap. 2.

28. McElvaine, *Great Depression*, 225; Frederick Binder and David Reimers, *All the Nations under Heaven: An Ethnic and Racial History of New York City* (New York: Columbia University Press, 1995), chap. 6.

29. Eric Foner, *The Story of American Freedom* (New York: W. W. Norton, 1998), 204.

30. McElvaine, *Great Depression*, chap. 8; Cheryl Greenberg, *Or Does It Explode? Black Harlem and the Great Depression* (New York: Oxford University Press, 1991).

31. See Greenberg, *Does It Explode?*; Robin Kelley, *Hammer and Hoe: Alabama Communists during the Great Depression* (Chapel Hill: University of North Carolina Press, 1990); Mark Naison, *Communists in Harlem during the Great Depression* (New York: Grove Press, 1985); and Jacqueline Jones, *The Dispossessed: America's Underclass from the Civil War to the Present* (New York: Basic Books, 1992), 217–21.

32. On the 1930s roots of the civil rights movement, see Harvard Sitkoff, *A New Deal for Blacks: The Emergence of Civil Rights as a National Issue* (Oxford: Oxford University Press, 1981); and Nikhil Pal Singh, *Black Is a Country: Race and the Unfinished Struggle for Democracy* (Cambridge, Mass.: Harvard University Press, 2004), chap. 2.

33. Walter Kalaidjian has argued for the presence of a historically overlooked "communal tradition of revisionary critique," a "social modernism." Kalaidjian, *American Culture between the Wars: Revisionary Modernism and Postmodern Critique* (New York: Columbia University Press, 1993), 20. See also Denning, *Cultural Front*; Laura Browder, *Rousing the Nation: Radical Culture in Depression America* (Amherst: University of Massachusetts Press, 1998); Paul Lauter, "American Proletarianism," in *The Columbia History of the American Novel*, ed. Emory Elliot (New York: Columbia University Press, 1991), 331–56; and Cary Nelson, *Repression and Recovery: Modern American Poetry and the Politics of Cultural Memory, 1910–1945* (Madison: University of Wisconsin Press, 1989).

34. Barnard, *Great Depression and the Culture of Abundance*, 8. See also Strachyz, *Modernism, Mass Culture, and Professionalism*.

35. Günter Lenz, "The Radical Imagination: Revisionary Modes of Radical Culture in Thirties America," in *Looking Inward, Looking Outward: From the 1930s through the 1940s*, ed. Steve Ickringill (Amsterdam: Vu University Press, 1990), 95.

36. For an insightful reading of Dos Passos's debts to experimental Russian filmmaker Sergei Eisenstein, see Carol Shloss, *In Visible Light: Photography and the American Writer, 1840–1940* (Oxford: Oxford University Press, 1987), chap. 4.

37. Alfred Kazin, who set the terms within which literary critics have long understood the period, described the decade as one that saw a return to naturalism. Kazin, *On Native Grounds*, chap. 12.

38. Bram Dijkstra, *American Expressionism* (New York: Harry N. Abrams, 2003), 41.

39. On surrealism in America, see Dickran Tashjian, *A Boatload of Madmen: Surrealism and the American Avant-garde, 1920–1950* (New York: Thames and Hudson, 1995).

40. Kenneth Burke, *Attitudes toward History*, vol. 1 (New York: New Republic, 1937), 160.

41. See Timothy Libretti, "'What A Dirty Way of Getting Clean': The Grotesque in Proletarian Literature," in *Literature and the Grotesque*, ed. Michael J. Meyer (Amsterdam: Rodopi, 1995), 171–90; and Denning, *Cultural Front*, 118–23.

42. Mark Fearnow, *The American Stage and the Great Depression: A Cultural History of the Grotesque* (Cambridge: Cambridge University Press, 1997), 6.

43. On the philosophical meanings and origin of sensationalism, see Paul Edwards, ed., *The Encyclopedia of Philosophy* (New York: Macmillan, 1967), 407–18.

44. This culture of modern spectacle included a variety of cultural forms and institutions. On burlesque, see Robert Allen, *Horrible Prettiness: Burlesque and American Culture* (Chapel Hill: University of North Carolina Press, 1991). On dance, see Lewis Erenberg, *Steppin' Out: New York Nightlife and the Transformation of American Culture, 1890–1930* (Chicago: University of Chicago Press, 1981). On freak shows, see Rachel Adams, *Sideshow U.S.A.: Freaks and the American Cultural Imagination* (Chicago: University of Chicago Press, 2001); and Robert Bogdan, *Freak Show: Presenting Human Oddities for Amusement and Profit* (Chicago: University of Chicago Press, 1981). On advertising, see Roland Marchand, *Advertising and the American Dream* (Berkeley: University of California Press, 1985); and William Leach, *Land of Desire: Merchants, Power, and the Rise of a New American Culture* (New York: Pantheon Books, 1993). Marchand notes that, in advertisements from the 1920s and 30s, distortion of the human figure was not uncommon: "Women in the [advertising] tableaux, as symbols of modernity, sometimes added more than a foot to their everyday heights and stretched their elongated eyes, fingers, legs, arms and necks to grotesque proportions" (181–82).

45. The preeminent theorists of metropolitan modernity as a revolution in perception are, of course, Georg Simmel, Siegfried Kracauer, and Walter Benjamin. Simmel, for example, contended that urban modernity generated

"an intensification of nervous stimulation": "The rapid crowding of changing images, the sharp discontinuity in the grasp of a single glance, and the unexpected onrushing impression: These are the psychological conditions which the metropolis creates." Georg Simmel, "The Metropolis and Mental Life," in *The Sociology of Georg Simmel*, trans. and ed. Kurt H. Wolff (New York: Free Press, 1950), 410. Likewise, in "Some Motifs in Baudelaire," Walter Benjamin asserts that the modern metropolis is characterized by a rhythm of shocks that revolutionizes human perception. "Moving through [big city] traffic involves the individual in a series of shocks and collisions. At dangerous intersections, nervous impulses flow through him in rapid succession, like the energy from a battery." Benjamin, *Illuminations*, trans. Harry Zohn (New York: Schocken Books, 1968), 175.

46. Ben Singer, "Modernity, Hyperstimulus, and the Rise of Popular Sensationalism," in *Cinema and the Invention of Modern Life*, ed. Leo Charney and Vanessa R. Schwartz (Berkeley: University of California Press, 1995), 88. On the contemporary popular culture of disaster, see Mark Seltzer, "Wound Culture: Trauma in the Pathological Public Sphere," *October* 80 (Spring 1997): 3–26.

47. John F. Kasson, *Houdini, Tarzan, and the Perfect Man: The White Male Body and the Challenge of Modernity in America* (New York: Hill and Wang, 2001), 13, 18.

48. For an introduction to the tabloids, see Frank Luther Mott, *American Journalism* (New York: Macmillan, 1950), chap. 39; and John D. Stevens, *Sensationalism and the New York Press* (New York: Columbia University Press, 1991).

49. By 1922, the *Daily News* boasted a circulation of 400,000; by the early 1940s, that number had swelled past 2 million.

50. Daniel Czitrom, "The Tabloid Tradition in American Culture," unpublished paper, no date, 2.

51. According to Michael Schudson, the yellow press "benefited from the experience of city life as a spectacle, and they contributed to it. They provided their readers a running account of the marvel and mysteries of urban life." Schudson, *Discovering the News: A Social History of American Newspapers* (New York: Basic Books, 1978), 105. On the dramatic impact of the advent of the hand-held camera and the halftone method of photographic reproduction on the press, see Michael L. Carlebach, *The Origins of Photojournalism in America* (Washington, D.C.: Smithsonian Institution Press, 1992), chap. 5; and Carlebach, *American Photojournalism Comes of Age* (Washington, D.C.: Smithsonian Institution Press, 1997), chap. 1.

52. David Nasaw, *The Chief: The Life of William Randolph Hearst* (New York: Mariner Books, 2000), 102.

53. See Joel Dinerstein, *Swinging the Machine: Modernity, Technology, and African American Culture between the Wars* (Amherst: University of Massachusetts Press, 2003), chap. 1.

54. James Truslow Adams, *The Tempo of Modern Life* (New York: Albert and Charles Boni, 1931), 77.

55. Ibid., 85, 89.

56. Robert S. Lynd and Helen Merrell Lynd, *Middletown in Transition: A Study in Cultural Conflicts* (New York: Harcourt, Brace, 1937), 491.

57. Ibid.

58. Mary Ann Weston, "The *Daily Illustrated Times*: Chicago's Tabloid Newspaper," *Journalism History* 16, nos. 3–4 (Autumn–Winter 1989): 79, 80. Perhaps the most creative, indeed audacious, use of photographic technologies by the tabloids could be found in the *Daily Graphic*'s "composograph," a collage of actual, altered, and staged images, arranged to provide an overview of a story or to offer a reconstruction of a notorious event as it "might have happened."

59. For scholarship on the nineteenth-century tradition of sensational literature about the urban underside, see Denning, *Mechanic Accents*; Stuart Blumin's introduction to George Foster, *New York by Gaslight* (1850; repr., Berkeley: University of California Press, 1990); Streeby, *American Sensations*; and David Reynolds, *Beneath the American Renaissance: The Subversive Imagination in the Age of Emerson and Melville* (Cambridge, Mass.: Harvard University Press, 1988).

60. In the words of James E. Murphy, the tabloids affirmed an idea of the city as a "wonderfully terrible" place, at once dangerous and exciting, foreboding yet alluring. Murphy, "Tabloids as Urban Response," in *Mass Media Between the Wars: Perceptions of Cultural Tension, 1918–1941*, ed. Catherine Covert and John D. Stevens (Syracuse: Syracuse University Press, 1984), 64.

61. Czitrom, "Tabloid Tradition," 3.

62. Samuel Taylor Morse, "Those Terrible Tabloids," *Independent* 116, no. 3953 (March 6, 1926): 264.

63. Ibid.

64. Ibid., 265.

65. For more on Benjamin, modernity, vision, and "astonishment," see Susan Buck-Morss, *The Dialectics of Seeing: Walter Benjamin and the Arcades Project* (Cambridge, Mass.: MIT Press, 1993); David McNally, *Bodies of Meaning: Studies on Language, Labor, and Liberation* (Albany: State University of New York Press, 2001), chap. 5; and Miriam Hansen, "Benjamin, Cinema, and Experience: 'The Blue Flower in the Land of Technology,'" *New German Critique* 40 (Winter 1987): 179–224. On Brecht, see *Brecht on Theatre: The Development of an Aesthetic*, trans. and ed. John Willett (London: Methuen, 1964); and Fredric

Jameson, *Brecht and Method* (New York: Verso, 1998). My emphasis on "aston-ishment" is also indebted to Tom Gunning, "An Aesthetic of Astonishment: Early Film and the (In)Credulous Spectator," in *Viewing Positions: Ways of See-ing Film*, ed. Linda Williams (New Brunswick, N.J.: Rutgers University Press, 1995).

66. Walter Benjamin, "What is Epic Theater?," in Benjamin, *Illuminations*, 150.

67. Ibid.

68. For more on the "pedagogical" aspects of Brecht's epic theater, see Jameson, *Brecht and Method*, esp. 35–58.

69. Hansen, "Benjamin, Cinema, and Experience," 210, 211.

70. "Cognitive explosiveness" is Susan Buck-Morss's phrase; see *Dialectics of Seeing*, 251. Describing the astonishment effects generated by the "cinema of attractions," Tom Gunning notes: "The spectator does not get lost in a fictional world and its drama, but remains aware of the act of looking, the excitement of curiosity." See Gunning, "Aesthetic of Astonishment," 125.

71. Gunning, "Aesthetic of Astonishment," 124. Tom Gunning, "The Cinema of Attractions: Early Film, Its Spectator and the Avant-Garde," in *Early Cinema: Space, Frame, Narrative*, ed. Thomas Elsaesser (London: BFI, 1990), 56–62.

72. On the historical avant-gardes, see Peter Bürger, *Theory of the Avant-Garde* (Minneapolis: University of Minnesota Press, 1984); Huyssen, *After the Great Divide*; Kalaidjian, *American Culture between the Wars*; and Richard Mur-phy, *Theorizing the Avant-Garde: Modernism, Expressionism, and the Problem of Postmodernity* (Cambridge: Cambridge University Press, 1998). The quotation is from Murphy, *Theorizing the Avant-Garde*, 37–38.

73. André Breton, "Second Manifesto of Surrealism," in *Manifestoes of Sur-realism*, trans. Richard Seaver and Helen R. Lane (Ann Arbor: University of Michigan Press, 1969), 123.

74. Raymond Williams, *Marxism and Literature* (Oxford: Oxford University Press, 1977), 126.

75. Ibid.

76. Barbara Melosh argues that the image of the manly worker "spoke to a [post–World War I] crisis of masculinity experienced both by working-class and middle-class audiences." This crisis was obviously accentuated during the mass unemployment of the Depression era. Barbara Melosh, *Engendering Cul-ture: Manhood and Womanhood in New Deal Public Art and Theater* (Washing-ton, D.C.: Smithsonian Press, 1991), 30. See also Jonathan Weinberg, "I Want Muscle: Male Desire and the Image of the Worker in American Art of the 1930s," in *The Social and the Real: Political Art of the 1930s in the Western Hemisphere*,

ed. Alejandro Anreus, Diana Linden, and Jonathan Weinberg (University Park: Pennsylvania State University Press, 2006), 115–34.

77. On Curry's depiction of white male bodies, see Dijkstra, *American Expressionism*, 53–54.

78. Erika Doss, "Looking at Labor: Images of Work in 1930s American Art," *Journal of Decorative and Propaganda Arts* 24 (2002): 257.

79. For this reading of Gellert, see Kalaidjian, *American Culture between the Wars*, 144–45.

80. William Solomon, *Literature, Amusement and Technology in the Great Depression* (Cambridge: Cambridge University Press, 2002), 5–6.

81. Susan Sontag, *Regarding the Pain of Others* (New York: Farrar, Straus and Giroux, 2003), 102–3.

82. For a very sensitive reading of the reception of *You Have Seen Their Faces*, see John Raeburn, *A Staggering Revolution: A Cultural History of Thirties Photography* (Urbana: University of Illinois Press, 2006), 213–18.

83. William Stott, *Documentary Expression and Thirties America* (Chicago: University of Chicago Press, 1986), 220.

84. Erskine Caldwell and Margaret Bourke-White, *You Have Seen Their Faces* (New York: Viking Press, 1975), 187.

85. Ibid., 75.

86. Ibid., 39.

87. Ibid., 185.

88. Terry Smith, *Making the Modern: Industry, Art, and Design in America* (Chicago: University of Chicago Press, 1993), 286.

89. Paula Rabinowitz, *Black and White and Noir*, 106 and passim.

90. Ibid., 112.

91. "Vital contact" is the phrase Christine Stansell uses to describe the middle-class bohemian interest in communion with lower-class and immigrant city dwellers. See Stansell, *American Moderns: Bohemian New York and the Creation of a New Century* (New York: Henry Holt, 2000).

92. See Douglas, *Terrible Honesty*.

93. Wendy Kozol, "Madonnas of the Fields: Photography, Gender, and 1930s Farm Relief," *Genders* 2 (Summer 1988): 13.

94. Stott, *Documentary Expression*, 57.

95. Ibid., 49.

96. Roland Barthes, "The Photographic Message," in *A Barthes Reader*, ed. Susan Sontag (New York: Hill and Wang, 1982), 196.

97. W. J. T. Mitchell, *Picture Theory* (Chicago: University of Chicago Press, 1994), 281.

98. Ibid., 95.

99. John Berger, "Understanding a Photograph," in *Classic Essays on Photography*, ed. Alan Trachtenberg (New Haven: Leete's Island Books, 1980), 292.

100. For a powerful exploration of photography as "an interpretive code through which to read and receive written texts," see Shloss, *In Visible Light*, 14. Shloss argues that the thorny questions of intersubjective engagement and exchange that facilitate the taking of photographs can serve as a heuristic for thinking about writing: "Once seen, it is impossible not to continue to see that one of the most pressing problems in our literary history is the problem revealed to us by the camera: the problem of coming-upon, of approach, of the politics enacted in and through art—not as something that precedes creativity or that stands to the side of it, but as something enacted through the creation of a text and something that remains embodied in it" (15). In foregrounding the ways in which sensational modernists thematize the problems of cultural boundary-crossing—and the issues of power at stake in those crossings—my own work echoes Shloss's, even as my focus on frame differs from her focus on "approach."

101. On the "punctum," see Roland Barthes, *Camera Lucida: Reflections on Photography* (New York: Hill and Wang, 1981), 27 and passim. For Benjamin's views on photography, see "A Short History of Photography," in Trachtenberg, *Classic Essays on Photography*, 199–216.

102. Buck-Morss, *Dialectics of Seeing*, 290.

103. My analysis of literary "failure" is indebted to Rita Barnard, who argues that the failures of poet Kenneth Fearing and satirist Nathanael West to enter the established literary canon stem from the writers' resistance to the dichotomy between high art and mass culture through which "Literature" has traditionally been defined. Barnard contends that "the 'failed' poets may preserve for us an alternative and subversive sense of what literature may be and what cultural work might do." Barnard, *Great Depression and the Culture of Abundance*, 59.

Chapter 1

1. On the eugenic resonance of Fitzgerald's text and on the interpenetration of 1920s modernism and nativism more generally, see Walter Benn Michaels, *Our America: Nativism, Modernism, Pluralism* (Durham, N.C.: Duke University Press, 1995). On modernism's obsession with racial "types," see Carla Kaplan, "Undesirable Desire: Citizenship and Romance in Modern American Fiction," *Modern Fiction Studies* 43, no. 1 (Spring 1997): 144–69; Bill Brown, "Identity Culture," *American Literary History* 10, no. 1 (Spring 1998): 164–84.

2. F. Scott Fitzgerald, *The Great Gatsby* (New York: Scribner Paperback Fiction, 1995), 11; hereafter cited in the text parenthetically by page number.

3. I am indebted to a lecture by Vera Kutzinski for her undergraduate course at Yale on American modernism in the spring of 2000 for drawing my attention to this scene and for sparking my reading of it.

4. Recent scholarship on realism and naturalism has tended to argue for the extremely problematic nature of attempts to imagine those modes of writing as coherent genres or discrete literary forms. Alan Trachtenberg notes that "realism" names "not so much a single consistent movement as a tendency among some painters and writers to depict contemporary life without moralistic condescension." Trachtenberg, *The Incorporation of America: Culture and Society in the Gilded Age* (New York: Hill and Wang, 1982), 182. Amy Kaplan observes that in the late nineteenth century "Realism simultaneously becomes an imperative and a problem in American fiction." Kaplan, *The Social Construction of American Realism* (Chicago: University of Chicago Press, 1988), 8–9. Michael Bell argues that attempts to define "realism" or "naturalism" are not only futile but finally less productive than studying the history of the varied *ideas* of realism and naturalism: "I do not believe that the works conventionally assembled under the umbrella of 'American realism' (or American 'naturalism') constitute in any sense a tradition of realism (or naturalism) or, for that matter, *any* coherent tradition. But the terms 'realism' and 'naturalism' . . . have nevertheless played a conspicuous and sometimes confusing role both in the production of American literature and in the construction of American literary history." Michael Davitt Bell, *The Problem of American Realism: Studies in the Cultural History of a Literary Idea* (Chicago: University of Chicago Press, 1993), 4.

5. Mark Seltzer, "Statistical Persons," *diacritics* 17, no. 3 (Autumn 1987): 84. See also the elaboration of this argument in Seltzer, *Bodies and Machines* (New York: Routledge, 1992). I am invoking Seltzer's argument here because it is one of the most aggressive and ambitious efforts to understand realism and naturalism through a Foucauldian lens as disciplinary technologies. As I hope it becomes clear (later in this chapter and in the chapters that follow), while I am sympathetic to many aspects of this argument, I find the alignment of writing with "power" one-sided. Realistic writing is, like any discourse, shot through with multiple ideological registers and open to functioning in ways that resist as well as reinforce social discipline. The texts on which *Sensational Modernism* focuses try, with varying degrees of success, to break or disrupt the link between writing, photography, and surveillance.

6. Seltzer, "Statistical Persons," 84.

7. June Howard, *Form and History in American Literary Naturalism* (Chapel Hill: University of North Carolina Press, 1985), 104.

8. Ibid., 131. Amy Kaplan also connects realism to Progressive reformers'

efforts to order and engineer an increasingly fragmented and dense urban social landscape: "The realists do not naturalize the social world to make it seem immutable and organic, but, like contemporary social reformers, they engage in an enormous act of construction to re-organize, re-form, and control the social world." Kaplan, *Social Construction of American Realism*, 10.

9. Peter Nicholls, "Masters, Slaves and Modernists: Two Versions of an Aesthetic," *West Coast Line* 27, no. 3 (Winter 1993–94): 92.

10. Ann Douglas, *Terrible Honesty: Mongrel Manhattan in the 1920s* (New York: Noonday Press, 1995).

11. On the connections between modernism and Taylorist/Fordist efforts to assert managerial control over workers through various forms of surveillance, inspection, and sociological study, see Terry Smith, *Making the Modern: Industry, Art, and Design in America* (Chicago: University of Chicago Press, 1993); Martha Banta, *Taylored Lives: Narrative in the Age of Taylor, Veblen, and Ford* (Chicago: University of Chicago Press, 1993); and Stephen Knapp, *Literary Modernism and the Transformation of Work* (Evanston: Northwestern University Press, 1994).

12. Bell, *The Problem of American Realism*, 6.

13. See Nicholls, "Masters, Slaves and Modernists."

14. Peter Stallybrass and Allon White, *The Politics and Poetics of Transgression* (Ithaca, N.Y.: Cornell University Press, 1986), 191.

15. Ibid.

16. Ibid., 6.

17. For more on Fitzgerald and the Hall-Mills case, see Henry C. Phelps, "Literary History / Unsolved Mystery: *The Great Gatsby* and the Hall-Mills Murder Case," *ANQ* 14, no. 3 (Summer 2001): 33–39.

18. On the persistence of the romantic in a literary era traditionally thought to be decidedly antagonistic to romance, see Kaplan, "Undesirable Desire."

19. Suzanne Clark argues that modernism "reversed the increasing influence of women's writing, discrediting the literary past and especially sentimental history." "In the United States," she continues, "this reversal against the sentimental helped to establish beleaguered avant-garde intellectuals as a discourse community, defined by its adversarial relationship to domestic culture." However, she contends that "modernism rejected the sentimental, because modernism *was* sentimental," albeit about texts more than about persons. Suzanne Clark, *Sentimental Modernism: Women Writers and the Revolution of the Word* (Bloomington: Indiana University Press, 1991), 1, 5.

20. Shirley Samuels, ed., *The Culture of Sentiment: Race, Gender, and Sentimentality in Nineteenth-Century America* (Oxford: Oxford University Press, 1992), 3.

21. The term "cultural work" comes from Jane Tompkins, whose argument for the positive power of *Uncle Tom's Cabin* forms one side of the now "classic" debate over the politics of sentimental literature. Ann Douglas's *The Feminization of American Culture*, which condemned the politics of sentiment, served as the occasion for Tompkins's defense of Stowe. See Tompkins, *Sensational Designs: The Cultural Work of American Fiction, 1790–1860* (New York: Oxford University Press, 1985); and Douglas, *The Feminization of American Culture* (New York: Alfred A. Knopf, 1977).

22. Phillip Fisher, *Hard Facts: Form and Setting in the American Novel* (Oxford: Oxford University Press, 1985), 99.

23. Ibid., 118.

24. Elizabeth Barnes, *States of Sympathy: Seduction and Democracy in the American Novel* (New York: Columbia University Press, 1997), 4.

25. Ibid., 17.

26. Laura Wexler argues that sentimentalism has historically been intimately intertwined with imperialist strategies of social control. "The energies [sentimentalism] developed were intended as a tool for the control of others, not merely as an aid in the conquest of the self. . . . [Sentimental discourse] aimed at the subjection of different classes and even races." Sentimentalism, Wexler suggests, provided both the essential "stuff" of bourgeois selfhood and a remarkably subtle tool of social governance. Laura Wexler, "Tender Violence: Literary Eavesdropping, Domestic Fiction, and Educational Reform," in Samuels, *Culture of Sentiment*, 15.

27. John Steinbeck, *The Grapes of Wrath* (New York: Penguin Books, 1976), 580–81.

28. Michael Szalay, *New Deal Modernism: Modern American Literature and the Invention of the Welfare State* (Durham, N.C.: Duke University Press, 2000). Szalay offers a detailed and persuasive reading of Steinbeck's sentimentalism as a model for a paternalist, state-sponsored form of social security. Szalay says that "women in *The Grapes of Wrath* are taught by the anxious men around them to not distinguish between strangers and blood relations, to extend even the most personal forms of maternal aid to those who are not kin but are nevertheless compatriots in a national enterprise" (181).

29. The images I am describing here echo the dominant paradigms within which working women were portrayed during the 1930s by the Left—either as "proletarian girls" or "revolutionary mothers." See Paula Rabinowitz, *Labor and Desire: Women's Revolutionary Fiction in Depression America* (Chapel Hill: University of North Carolina Press, 1991), 45–58.

30. Although the personalities of Jordan, Daisy, and Gatsby all appear to

be manifest in their physical forms, their bodies are marked by lightness, motion, and transcendence, qualities that seem to defy corporeal limitation even as they are signified by the body. Tom's heaviness is a clear sign of his inherent crudeness; in an effort to valorize the moral legitimacy of the midwestern middle classes, Fitzgerald's novel condemns not only the licentiousness of those persons, like Myrtle, on the bottom of the social scale, but also of those, like Tom, on the top.

31. Robyn Wiegman, *American Anatomies: Theorizing Race and Gender* (Durham, N.C.: Duke University Press, 1995), 49.

32. Ibid.

33. Ibid., 6.

34. Cara Finnegan, *Picturing Poverty: Print Culture and FSA Photographs* (Washington, D.C.: Smithsonian Institution Press, 2003), 220.

35. Ibid., 170.

36. Smith, *Making the Modern*, 296.

37. Ibid., 328.

38. Quoted in Smith, *Making the Modern*, 306.

39. William Stott, *Documentary Expression and Thirties America* (Chicago: University of Chicago Press, 1973), 15.

40. Ibid., 8, 9.

41. James Curtis, *Mind's Eye, Mind's Truth* (Philadelphia: Temple University Press, 1989), chap. 3.

42. Wendy Kozol, "Madonna of the Fields: Photography, Gender, and 1930s Farm Relief," *Genders* 2 (Summer 1988): 14. See also the discussion of Lange's image in Finnegan, *Picturing Poverty*, 99–101.

43. In a provocative essay examining Lange's focus on the body, Sally Stein argues that her "photography deemphasized the social and environmental context in order to focus upon the body alone as site of social formation and deformation." Stein suggests that Lange occupied one end of the spectrum of documentary photography that, rather than situating the individual in relation to his or her social environment, "appeared to universalize, perhaps inadvertently, the nature of alienation by embodying it in rather general terms." Sally Stein, "Peculiar Grace: Dorothea Lange and the Testimony of the Body," in *Dorothea Lange: A Visual Life*, ed. Elizabeth Partridge (Washington, D.C.: Smithsonian Institution Press, 1994), 63.

44. For more on the complicity of photography with the techniques of social regulation, police work, eugenics, and worker discipline, see Allan Sekula, "The Body and the Archive," *October* 39 (Winter 1986): 3–64; John Tagg, *The Burden*

of *Representation* (Minneapolis: University of Minnesota Press, 1993); Suren Lalvani, *Photography, Vision, and the Production of Modern Bodies* (Albany: State University of New York Press, 1996). By drawing attention to this photograph, I do not mean to suggest it is representative or typical of Evans's work. On the contrary, Evans's images—including the bulk of the images of the families included in *Let Us Now Praise Famous Men*—are generally noteworthy for the space they give to his subjects to respond to the camera.

45. John Pultz, *The Body and the Lens: Photography 1839 to the Present* (New York: Harry N. Abrams, 1995), 90.

46. Weegee, *Naked City* (New York: Da Capo Press, 1973), 5.

47. Allan Sekula, "Body and the Archive."

48. Weegee, *Naked City*, 243.

49. William McCleery, foreword to *Naked City*, by Weegee, 7.

50. Miles Orvell, "Weegee's Voyeurism and the Mastery of Urban Disorder," *American Art* 6, no. 1 (Winter 1992): 19–41.

51. For biographical information I have drawn on Miles Barth, "Weegee's World," in *Weegee's World*, ed. Miles Barth (Boston: Bullfinch Press, 1997).

52. J. Hoberman, "American Abstract Sensationalism," *Artforum* 19 (February 1981): 43.

53. Ellen Handy, "Picturing New York, the Naked City: Weegee and Urban Photography," in Barth,*Weegee's World*, 155.

54. Miles Orvell also notes the parallel between Weegee and West. Orvell, "Weegee's Voyeurism," 39.

55. Quoted in Jay Martin, *Nathanael West: The Art of His Life* (New York: Hayden Book Company, 1970), 183.

56. Jonathan Veitch, *American Superrealism: Nathanael West and the Politics of Representation in the 1930s* (Madison: University of Wisconsin Press, 1997), xvii. Rita Barnard asserts that the "radically citational" writing of Kenneth Fearing and Nathanael West "seems to foreshadow the work of postmodern artists." Barnard, *The Great Depression and the Culture of Abundance: Kenneth Fearing, Nathanael West, and Mass Culture in the 1930s* (Cambridge: Cambridge University Press, 1995), 8.

57. Martin, *Nathanael West*, 164.

58. Nathanael West, *Miss Lonelyhearts*, in *Miss Lonelyhearts and the Day of the Locust* (New York: New Directions, 1969), 26; hereafter cited in the text parenthetically by page number.

59. Nathanael West, "Some Notes on Violence," *Contact* 1 (October 1932): 132.

60. Nathanael West, "Some Notes on Miss L.," in *Nathanael West: A Collection of Critical Essays*, ed. Jay Martin (Englewood Cliffs, N.J.: Prentice-Hall, 1971), 66.

61. On this point, see Barnard, *Great Depression and the Culture of Abundance*, chap. 8.

62. Veitch, *American Superrealism*, xiii.

63. Quoted in Martin, *Nathanael West*, 334.

64. Martin, *Nathanael West*, 164.

65. Ibid.

66. Ibid.

67. James Agee and Walker Evans, *Let Us Now Praise Famous Men* (Boston: Houghton Mifflin, 1980), 13.

68. Meridel Le Sueur, "I Was Marching," in *Ripening: Selected Work, 1927–1980*, ed. Elaine Hedges (Old Westbury, N.Y.: Feminist Press, 1982), 158; hereafter cited in the text parenthetically by page number.

69. See Jameson, *"Ulysses* in History," in *James Joyce and Modern Literature*, ed. W. J. McCormack and Alistair Stead (London: Routledge and Kegan Paul, 1982), 126–41.

70. Dalton Trumbo, *Johnny Got His Gun* (New York: Bantam Books, 1989); hereafter cited in the text parenthetically by page number.

71. The notion of "breaking the frame" of reference is taken from Dori Laub, "Bearing Witness, or the Vicissitudes of Listening," in Shoshana Felman and Dori Laub, *Testimony: Crises of Witnessing in Literature, Psychoanalysis, and History* (London: Routledge, 1992), 62.

72. Hemingway would have agreed heartily with Trumbo's attack on "abstraction," yet Trumbo would certainly have found problematic Hemingway's rendering of his own prose as an act of violence made beautiful.

73. Ernest Hemingway, *The Sun Also Rises* (New York: Macmillan, 1986), 168.

74. Felman and Laub, *Testimony*, 5.

75. Rosemarie Garland Thompson argues that disabled bodies challenge the central tenets and expectations of liberal democratic society. She writes: "Disability's indisputably random and unpredictable character translates as appalling disorder and persistent menace in a social order predicated on self-government. Furthermore, physical instability is the bodily manifestation of political anarchy, of the antinomian impulse that is the threatening, but logical, extension of egalitarian democracy." Thompson, *Extraordinary Bodies: Figuring Physical Disability in American Culture and Literature* (New York: Columbia University Press, 1997), 43. For a reading that argues for the novel's anticipation of various

postmodern tropes and dynamics, see Tim Blackmore, "Lazarus Machine: Body Politics in Dalton Trumbo's *Johnny Got His Gun*," *Mosaic* 33, no. 4 (December 2000): 1–18.

76. Tim Armstrong, *Modernism, Technology, and the Body* (Cambridge: Cambridge University Press, 1998), 2.

77. Ibid., 3.

78. On modern regimes of bodily discipline and the production of docile-productive bodies, see Michel Foucault, *Discipline and Punish: The Birth of the Prison*, trans. Alan Sheridan (New York: Vintage Books, 1979).

79. On the notion of "willfully damaged signs," see Paul Gilroy, *The Black Atlantic: Modernity and Double Consciousness* (Cambridge: Harvard University Press, 1993), 37–38.

80. Walter Benjamin, "Theses on the Philosophy of History," in *Illuminations*, trans. Harry Zohn (New York: Schocken Books, 1968), 257.

81. Agee's comment occurs in Agee and Evans, *Let Us Now Praise Famous Men*, 14.

82. The first quotation is from Tyrus Miller, review of *Modernisms: A Literary Guide*, by Peter Nicholls, *Modernism/Modernity* 4, no. 1 (1997): 176; the second and third quotations are from Terry Eagleton, "Capitalism, Modernism, and Postmodernism," in *Against the Grain: Collected Essays* (London: Verso, 1986), 140.

83. Sara Blair, "Modernism and the Politics of Culture," in *The Cambridge Companion to Modernism*, ed. Michael Levenson (Cambridge: Cambridge University Press, 1999), 162.

84. Ibid., 163.

85. Quentin Anderson, "The Emergence of Modernism," in *Columbia History of the American Novel*, ed. Emory Elliot (New York: Columbia University Press, 1988), 704.

86. For a discussion of "emergent" cultural forms, see the introduction.

Chapter 2

1. Williams recounts the interview in his autobiography. See William Carlos Williams, *The Autobiography of William Carlos Williams* (New York: New Directions, 1967), 311.

2. Michael North has argued that immigrant and African American "dialects" served as languages through which high modernists such as Eliot, Pound, and Stein imagined their own rhetorical experimentations. See North, *The Dialect of Modernism: Race, Language, and Twentieth-Century Literature* (New York: Oxford University Press, 1994). On the centrality of socially marginalized figures to the

work of various modernist writers, see Edward Said, "A Note on Modernism," in *Culture and Imperialism* (New York: Knopf, 1994); Carla Kaplan, "Undesirable Desire," *Modern Fiction Studies* 43, no. 1 (Spring 1997): 144–69; Walter Benn Michaels, *Our America: Nativism, Modernism, Pluralism* (Durham, N.C.: Duke University Press, 1995); Ann Douglas, *Terrible Honesty: Mongrel Manhattan in the 1920s* (New York: Noonday Press, 1995); and George Hutchinson, *The Harlem Renaissance in Black and White* (Cambridge: Harvard University Press, 1995). For a powerful theoretical assertion of the notion that what is socially marginal is culturally central, see Peter Stallybrass and Allon White, *The Politics and Poetics of Transgression* (Ithaca, N.Y.: Cornell University Press, 1986).

3. "To Elsie" was initially included as an untitled segment of *Spring and All*. It was later included as a free-standing poem, with the title, in *Selected Poems of William Carlos Williams* (New York: New Directions, 1985), 53–55.

4. Recently, historian of anthropology James Clifford has argued that "To Elsie" represents an instance of what he terms "ethnographic modernity." Clifford defines ethnography as "diverse ways of thinking and writing about culture from the standpoint of participant observation. In this expanded sense a poet like Williams is an ethnographer." James Clifford, *The Predicament of Culture: Twentieth-Century Ethnography, Literature, and Art* (Cambridge, Mass.: Harvard University Press, 1988), 9. Although Clifford's case for Williams as an ethnographer is provocative, "To Elsie" invokes other cognitive and epistemological traditions that are closer to Williams's own interests as a writer-doctor: one, the long-standing and highly developed tradition of American literary sympathy; and, two, modern practices of medical examination. Although Williams did not possess a strong affinity for or knowledge of anthropology, he was operating within a literary field in which sentimental discourse and the calculus of sympathy were dominant modes available for imagining relations between self, other, and nation. Williams was wrestling with this tradition, attempting to fashion alternative ways to conceive these relations. In addition, Williams was a practicing physician at a point in time, as I explain later in the chapter, in which methods of medical examination and diagnosis were changing rapidly, providing new ways of assessing the body and its pathologies.

5. William Carlos Williams, *The Collected Stories of William Carlos Williams* (New York: New Directions Press, 1996), 131. Further citations to Williams's stories are from this edition and are given parenthetically by page number in the text.

6. Brian Bremen, *Williams Carlos Williams and the Diagnostics of Culture* (Oxford: Oxford University Press, 1993), 86. Bremen contends that Williams's ethnic writing represents a form of "empathetic 'identification'" (98). In the

only extended study devoted entirely to Williams's short fiction, Robert Gish argues that the narrator "is so moved to empathy that he passes beyond voyeur to participant through the telling and retelling of [his patients'] lives." "Williams empathizes with these individuals, with their predicament, with their humanity in a caring, far from condescending way, even through his own status in life could easily distance him from them, and cause him to be disparaging rather than empathetic." Gish, *William Carlos Williams: A Study of the Short Fiction* (Boston: Twayne, 1999), 66, 67.

7. See Jonathan Veitch, "'lousy with pure / reeking with stark': Nathanael West, William Carlos Williams, and the Textualization of the 'Real,'" *Prospects: An Annual of American Cultural Studies* 21 (1996): 123–48.

8. My sense of identity formation as an ever-shifting process of identification and association is indebted to Stuart Hall, "Introduction: Who Needs Identity?" in *Questions of Cultural Identity*, ed. Stuart Hall and Paul du Gay, (London: Sage Publications, 1996), 16.

9. William Carlos Williams, *I Wanted to Write a Poem* (New York: New Directions, 1978), 49.

10. Cited in Michael Denning, *The Cultural Front* (New York: Verso, 1996), 228.

11. My thinking about Williams's politics and his relationship to the larger social and political context in which he was working is indebted to Mike Weaver, *William Carlos Williams: The American Background* (Cambridge: Cambridge University Press, 1971).

12. Williams, *I Wanted to Write a Poem*, 112.

13. Cited in Dickran Tashjian, *William Carlos Williams and the American Scene, 1920–1940* (New York: Whitney Museum of American Art, 1978), 116.

14. Kenneth Burke, *Permanence and Change: An Anatomy of Purpose* (New York: New Republic, 1935), xiii.

15. The thirties also prompted Williams's engagement with various forms of surrealism. For the history of this engagement, see Weaver, *William Carlos Williams*, and Tashjian, *William Carlos Williams and the American Scene*.

16. Bob Johnson, "'A Whole Synthesis of His Time': Political Ideology and Cultural Politics in the Writings of William Carlos Williams, 1929–1939," *American Quarterly* 54, no. 2 (2002): 184.

17. The phrase "jumbled wreckage, human and material," is from Williams's review of Walker Evans's *American Photographs*, which originally appeared in the *New Republic* in 1938 and was reprinted in Williams, *A Recognizable Image: William Carlos Williams on Art and Artists* (New York: New Directions, 1978), 137.

18. For the history of nativism and white attitudes toward foreign peoples at home and abroad, see John Higham, *Strangers in the Land: Patterns of American Nativism, 1860–1925* (New Brunswick, N.J.: Rutgers University Press, 2002), and Matthew Frye Jacobson, *Barbarian Virtues: The United States Encounters Foreign Peoples at Home and Abroad, 1876–1917* (New York: Hill and Wang, 2000).

19. Madison Grant, *The Conquest of a Continent; or, The Expansion of Races in America* (New York: Charles Scribner's Sons, 1933), 237–38. Grant also wrote an introduction to Lothrop Stoddard, *The Rising Tide of Color against White World-Supremacy* (New York: Scribner, 1920).

20. For Williams's use of the discourse of cultural and racial purity, see Michaels, *Our America*.

21. Williams, "A Beginning on the Short Story (Notes)," in *Selected Essays of William Carlos Williams* (New York: Random House, 1954), 300.

22. Hartley quoted in Tashjian, *William Carlos Williams and the American Scene*, 100.

23. On the 1913 Strike and pageant, see Anne Tripp, *The I.W.W. and the Paterson Silk Strike of 1913* (Urbana: University of Illinois Press, 1987); Morris Schonbach, *Radicals and Visionaries: A History of Dissent in New Jersey* (Princeton, N.J.: D. Van Nostrand, 1964); and Martin Green, *New York 1913: The Armory Show and the Paterson Strike Pageant* (New York: Scribner, 1988).

24. For more on the 1926 strike, see Schonbach, *Radicals and Visionaries*, 72–81; and Paul L. Murphy, *The Passaic Textile Strike of 1926* (Belmont, Calif.: Wadsworth, 1974); and <http://www.scc.rutgers.edu/njwomenshistory/Period_5/woolen.htm> (June 15, 2005).

25. Mary Heaton Vorse, "The Battle of Passaic," *New Masses* 1, no. 1 (May 1926): 14.

26. *New Masses* 1, no. 2 (June 1926): 11.

27. William Carlos Williams, "The Five Dollar Guy — A Story," *New Masses* 1, no. 1 (May 1926): 19.

28. Paul Starr, *The Social Transformation of American Medicine* (New York: Basic Books, 1982), 81–89.

29. Ibid., 110.

30. Stanley Joel Reiser, *Medicine and the Reign of Technology* (Cambridge: Cambridge University Press, 1978), 29.

31. Ibid., 28.

32. A good example of these changes in medical examination is the use of X-rays, which directly challenged the use of touch in diagnosis. In addition, X-rays produced results that could be examined and evaluated, even debated, by

a group of physicians without the presence of the patient. The patient's physical system, abstracted and rendered as a series of images, was thus available for diagnosis separate from his or her actual body.

33. Reiser, *Medicine and the Reign of Technology*, 38.

34. See Michel Foucault, *The Birth of the Clinic: An Archaeology of Medical Perception*, trans. A. M. Sheridan Smith (New York: Vintage Books, 1994).

35. Michel Foucault, *Discipline and Punish: The Birth of the Prison*, trans. Alan Sheridan (New York: Vintage Books, 1979), 190–91.

36. Williams, *Autobiography*, 356. Subsequent citations are given by page number parenthetically in the text.

37. For "immediate contacts" with the artist's "locality," see Williams, "Comment on Contact," in *Recognizable Image*, 67. "The inexplicable, exquisite, vulgar thing" is from Williams, "Five Dollar Guy," 19. Williams's emphasis on the low and the local as the locus of artistic truth had an implicit ideological and aesthetic agenda—to combat the philosophical abstraction and academic allusiveness of Eliotic high modernism. Williams was outspoken in his distaste for Eliot's brand of modernism, going so far as to pronounce *The Waste Land* "the great catastrophe to our letters." Williams, *Autobiography*, 146. Williams insisted that Eliot's 1922 epic "gave the poem back to the academicians," that it attempted a "reinflation" of outworn tropes and antiquated themes rather than drawing its essence from the urgency and vitality of local conditions. Ibid., 146; William Carlos Williams, "Caviar and Bread Again: A Warning to the New Writer," in *Selected Essays*, 103.

38. My argument about *In the American Grain* bears similarities to Vera Kutzinski's contention that Williams's text "asserts the possibility of exploring not only similarities and continuities but also, at the same time, differences and discontinuities in order to emphasize cultural interpenetration rather than assimilation." See Kutzinski, *Against the American Grain: Myth and History in William Carlos Williams, Jay Wright, and Nicholas Guillen* (Baltimore: Johns Hopkins University Press, 1987), 12.

39. William Carlos Williams, *In the American Grain* (New York: New Directions, 1955), 63. Further citations are given by page number parenthetically in the text.

40. Williams, "Baroness Elsa Freytag Von Lovinghoven," Yale University Beinecke Rare Book and Manuscript Library, Yale Collection of American Literature, William Carlos Williams Papers, Za Williams 22, 2.

41. Williams's promotion of touch as a form of cross-cultural "marriage" or "hybridity" reinforces the problems of considering Williams, as Walter Benn

Michaels does, a nativist. According to Michaels, "The first defining characteristic of nativist modernism is thus its deep hostility to assimilation, its repudiation of . . . miscegenistic ambitions. And the second defining characteristic is . . . the desire of aliens to remain alien." Michaels, *Our America*, 136–37.

42. Several of Williams's own comments about his craft suggest that a measure of violence is often integral to his brand of modernist writing. In "Kora in Hell," Williams contends that "it is in the continual and *violent refreshing* of the idea that love and good writing have their security." Here, Williams implies that to wipe the slate clean, to clear out the old to make room for the new and the "modern," is a violent act. Similarly, Williams acknowledges that "contact" can quite easily be destructive or damaging. "The speed of the emotions is sometimes such that in thrashing about in a thin exaltation or despair many matters are touched but not held, more often broken by the contact." William Carlos Williams, "Kora In Hell: Improvisations," in *Imaginations* (New York: New Directions, 1970), 22, 16 (my emphasis). Williams's violent tendencies frequently resound with misogynist overtones. In a letter to Alva N. Turner, he noted that "my liking is for an *unimpeded thrust* right through a poem from beginning to the end, without regard for formal arrangement." Here Williams suggests that writing is a form of aggressive (masculine) sexuality, a forceful lunge. Although his comment concerns poetry, Williams's short fiction frequently has a similar feel—a rushed, spontaneous aesthetic, direct and unpretentious, often invasive and inconsiderate. Williams, *Selected Letters of William Carlos Williams* (New York: New Directions Press, 1984), 50.

43. Williams, "Five Dollar Guy," 19.

44. Williams, "The Torturous Straightness of Chas. Henri Ford," in Williams, *Selected Essays*, 235.

45. Williams, "A Beginning on the Short Story," 300.

46. Ibid., 309.

47. Ibid., 301.

48. Ibid.

49. William Carlos Williams, "Spring and All," in *The Collected Poems of William Carlos Williams*, vol. 1: *1909–1939* (New York: New Directions, 1991), 178.

50. Fred Miller, review of *Life along the Passaic River* in the *New Republic*, April 20, 1938, reprinted in *Williams Carlos Williams: The Critical Heritage*, ed. Charles Doyle (London: Routledge and Kegan Paul, 1980), 153.

51. Eda Lou Walton, review of *Life along the Passaic River* in the *Nation*, March 19, 1938, reprinted in Doyle, *Williams Carlos Williams*, 151.

52. Ibid., 150.

53. Arthur M. Kay, review of *The Farmers' Daughters* in the *Arizona Quarterly* 17 (Winter 1962), reprinted in Doyle, *William Carlos Williams*, 332.

54. Walton, review of *Life along the Passaic River*, 150.

55. Irving Howe, review of *The Farmers' Daughters* in the *New Republic*, November 13, 1961, reprinted in Doyle, *William Carlos Williams*, 329.

56. Walton, review of *Life along the Passaic River*, 151.

57. Ibid.

58. N. L. Rothman, review of *Life along the Passaic River* in the *Saturday Review*, March 19, 1938, reprinted in Doyle, *William Carlos Williams*, 152.

59. Ibid., 152–53.

60. Walton, review of *Life along the Passaic River*, 151.

61. Ibid., 150, 151.

62. Sherwin B. Nuland, introduction to *The Collected Stories of William Carlos Williams*, xii.

63. I have borrowed this phrase from Dori Laub. See Laub, "Bearing Witness, or the Vicissitudes of Listening," in Shoshana Felman and Dori Laub, *Testimony: Crises of Witnessing in Literature, Psychoanalysis, and History* (New York: Routledge, 1992), 62.

64. Marjorie Perloff, "The Man Who Loved Women: The Medical Fictions of William Carlos Williams," *Georgia Review* 34 (1980): 844.

65. Richard Brodhead, *Cultures of Letters: Scenes of Reading and Writing in Nineteenth-Century America* (Chicago: University of Chicago Press, 1993), 21.

66. Robert Coles, *William Carlos Williams: The Knack of Survival in America* (New Brunswick, N.J.: Rutgers University Press, 1983), 19.

Chapter 3

1. Walter Benjamin, "The Author as Producer," in *Reflections: Essays, Aphorisms, Autobiographical Writings*, trans. Edmund Jephcott and ed. Peter Demetz (New York: Harcourt Brace Jovanovich, 1978), 229, 229–30, 230.

2. Paula Rabinowitz, *They Must Be Represented: The Politics of Documentary* (New York: Verso, 1994), 43.

3. Maren Stange, "'Symbols of Ideal Life': Technology, Mass Media, and the FSA Photography Project," *Prospects: An Annual of American Cultural Studies* 11 (1987): 98.

4. Ibid., 98.

5. Rabinowitz, *They Must Be Represented*, 51.

6. Maurice Berger, *How Art Becomes History* (New York: Icon Editions, 1992), 18.

7. Stange, "'Symbols of Ideal Life,'" 96.

8. Aaron Siskind, "The Drama of Objects," *Minicam Photography* 8 (1945), reprinted in *Photographers on Photography*, ed. Nathan Lyons (New York: Prentice-Hall, 1966), 97.

9. Ibid., 96.

10. Aaron Siskind, "Credo," *Spectrum* 6 (1956), reprinted in Lyons, *Photographers on Photography*, 98.

11. Aaron Siskind, "In 1943 and 1944 a Great Change Took Place," *Quarterly of the Friends of Photography* 7/8 (July–August 1974), reprinted in *Photography: Essays and Images*, ed. Beaumont Newhall (New York: Museum of Modern Art, 1980), 305; Siskind, "Drama of Objects," 97.

12. Siskind, "Credo," 98.

13. Ibid., 98.

14. For information on Siskind's biography and early photography, I have relied on Carl Chiarenza, *Aaron Siskind: Pleasures and Terrors* (Boston: Little, Brown, 1982).

15. On Pollock's career, and early radicalism, see Peter Wollen, "The Triumph of American Painting: 'A Rotten Rebel from Russia,'" in *Raiding the Icebox: Reflections on Twentieth-Century Culture* (Bloomington: Indiana University Press, 1993).

16. Elizabeth McCausland, "Documentary Photography," *Photo Notes*, January 1939, 6.

17. Louis Stettner, "Cezanne's Apples and the Photo League: A Memoir," *Aperture* 112 (Fall 1988): 32.

18. Ibid., 35.

19. See Anne Tucker, "A History of the Photo League: The Members Speak," *History of Photography* 18, no. 2 (Summer 1994): 174–84; Leah Ollman, "The Photo League's Forgotten Past," *History of Photography* 18, no. 2 (Summer 1994): 154–58.

20. Chiarenza, *Aaron Siskind*, 27.

21. *Photo Notes*, August 1938, 1.

22. Stettner, "Cezanne's Apples," 24.

23. Siskind, "In 1943 and 1944 a Great Change Took Place," 306.

24. Siskind, "Drama of Objects," 97.

25. Chiarenza, *Aaron Siskind*, 33.

26. Ibid., 30.

27. "Harlem," *Fortune* 20, no. 1 (July 1939): 78.

28. Ibid.

29. Critical scholarship on the Harlem Renaissance is diverse and expansive.

See especially David Levering Lewis, *When Harlem Was in Vogue* (New York: Oxford University Press, 1981); Nathan Huggins, *The Harlem Renaissance* (New York: Oxford University Press, 1971); and George Hutchinson, *The Harlem Renaissance in Black and White* (Cambridge: Harvard University Press, 1995). An insightful overview of the Renaissance is provided in David Levering Lewis, "Harlem Renaissance," in *Encyclopedia of African American Culture and History*, ed. Jack Salzman, David Lionel Smith, and Cornel West (New York: Macmillan Library Reference, 1996).

30. Frederick Binder and David Reimers, *All the Nations under Heaven: An Ethnic and Racial History of New York City* (New York: Columbia University Press, 1995), 179, 185. See also Cheryl Greenberg, *Or Does It Explode? Black Harlem in the Great Depression* (New York: Oxford University Press, 1991); and Mark Naison, *Communists in Harlem during the Depression* (New York: Grove Press, 1985).

31. The commission is quoted in Binder and Reimers, *All the Nations under Heaven*, 192.

32. Rabinowitz, *They Must Be Represented*, 25.

33. This point is made astutely by Diane Dillon in her excellent article "Focusing on the Fragment: Asymmetries of Gender, Race, and Class in the Photographs of Aaron Siskind," *Yale University Art Gallery Bulletin* (1990), 53–54. Dillon's article focuses primarily on Siskind's later, abstract photography, but she does read several of Siskind's *Harlem Document* images as well. Although combining several theoretical perspectives, Dillon is particularly indebted to psychoanalytic methods and focuses less than I do on the cultural and political context in which Siskind's photography was produced.

34. Homi Bhabha argues that stereotypes aspire to achieve "fixity," to freeze their subjects in a bed of overdetermined connotations. However, Bhabha asserts, such fixity is always ultimately unstable and incomplete. See Bhabha, *The Location of Culture* (London: Routledge, 1994), 75.

35. Bhabha argues that any attempt to "capture" the image of an "Other" risks having the object of the gaze return the look. He writes, "In the objectification of the scopic drive there is always the threatened return of the look." Bhabha, *Location of Culture*, 81.

36. "244,000 Native Sons," *Look*, May 21, 1940, 8.

37. Eric Lott, *Love and Theft: Blackface Minstrelsy and the American Working Class* (Oxford: Oxford University Press, 1993).

38. Siskind, "Drama of Objects," 96.

39. Siskind, "In 1943 and 1944 a Great Change Took Place," 305.

40. Siskind, "Drama of Objects," 97.

41. Ibid., 97.

Chapter 4

1. William Stott, *Documentary Expression and Thirties Culture* (Chicago: University of Chicago Press, 1986), 266.

2. James Agee and Walker Evans, *Let Us Now Praise Famous Men* (Boston: Houghton Mifflin, 1980), xvi. Further citations are given parenthetically by page number in the text.

3. On Whitman's aesthetics of embodiment, see Karen Sanchez-Eppler, *Touching Liberty: Abolition, Feminism, and the Politics of the Body* (Berkeley: University of California Press, 1993), chap. 2.

4. Martha Rosler, "In, Around, and Afterthoughts," in *The Contest of Meaning*, ed. Richard Bolton (Cambridge, Mass.: MIT Press, 1989), 307.

5. Carla Kaplan, "Undesirable Desire: Citizenship and Romance in Modern American Fiction," *Modern Fiction Studies* 43, no. 1 (Spring 1997): 144–69.

6. Michael Staub, *Voices of Persuasion: The Politics of Representation in 1930s America* (Cambridge: Cambridge University Press, 1993), 35, 34.

7. T. V. Reed, "Unimagined Existence and the Fiction of the Real: Postmodernist Realism in *Let Us Now Praise Famous Men*," *Representations* 24 (Fall 1988): 157.

8. In addition, as Paula Rabinowitz has argued in her insightful article on *Famous Men*, Agee's focus on sexual difference surreptitiously "orders" his record of the tenants' lives. Rabinowitz argues: "If the objects Agee has presented throughout the book resist 'ordering' within the norms of bourgeois culture . . . his 'images' of sexual difference reposition these things with the seemingly stable representations of sexual difference that order bourgeois culture." "Voyeurism and Class Consciousness: James Agee and Walker Evans, *Let Us Now Praise Famous Men*," *Cultural Critique* 21 (Spring 1992): 161. In addition, I would suggest, the highly sexualized quality of his gaze legitimates—by naturalizing—his voyeurism.

9. On the vicissitudes of ethnographic projection, exchange, and collaboration, see James Clifford, *The Predicament of Culture: Twentieth-Century Ethnography, Literature, and Art* (Cambridge, Mass.: Harvard University Press, 1988).

10. Linda Wagner-Martin, "*Let Us Now Praise Famous Men*—And Women: Agee's Absorption in the Sexual," in *James Agee: Reconsiderations*, ed. Michael Lofaro (Knoxville: University of Tennessee Press, 1992), 44–58. She contends that "some of the exquisite far-reaching quality of *Let Us Now Praise Famous*

Men accrues from Agee's shaping his love of the tenant farmers in the form of a classic romantic fable: giving his love for them a sexual dimension that enthralls, arouses, and convinces the reader" (57).

11. Alfred Kazin, *Starting Out in the Thirties* (1965; repr., New York: Vintage Books, 1980), 12, 13.

12. On the Left's education and promotion of ethnic and working-class writers, see Michael Denning, *The Cultural Front* (New York: Verso, 1996).

13. Kazin, *Starting Out in the Thirties*, 15 (my emphasis).

14. This list of occupations is from a brief self-portrait Olsen wrote in the 1930s, which is cited in Deborah Rosenfelt, "From the Thirties: Tillie Olsen and the Radical Tradition," *Feminist Studies* 7, no. 3 (Fall 1981): 58.

15. Cited in Rosenfelt, "From the Thirties," 59.

16. Most of the information included here about Olsen's life is derived from a conversation I had with her in October 1997. For additional biographical information, see Rosenfelt, "From the Thirties"; Erika Duncan, "Coming of Age in the Thirties: A Portrait of Tillie Olsen," *Book Forum* 6 (1982): 207–22; and Constance Coiner, *Better Red: The Writing and Resistance of Tillie Olsen and Meridel Le Sueur* (Oxford: Oxford University Press, 1995).

17. Mickey Pearlman and Abby Werlock, *Tillie Olsen* (Boston: Twayne, 1991), 19.

18. Article by Royce Brier, *San Francisco Chronicle*, July 5, 1934, <http://www.sfmuseum.org/hist/thursday2.html> (July 1, 2005).

19. *San Francisco Chronicle*, July 5, 1934, ibid.

20. "3 Killed, 31 Shot in Widespread Rioting. SCORES INJURED, GASSED AS POLICE BATTLE MOBS; CARGO MOVING CONTINUES," *San Francisco Daily News*, July 5, 1934, <http://www.sfmuseum.org/hist4/maritime17.html> (July 1, 2005).

21. *San Francisco Chronicle*, July 5, 1934, ibid.

22. Mike Quin, *The Big Strike* (1949; repr., New York: International Publishers, 1979), 114.

23. Joseph North, "Reportage," in *American Writers' Congress*, ed. Henry Hart (New York: International Publishers, 1935), 121.

24. Ibid.

25. Ibid., 122.

26. Ibid., 123.

27. Tillie Lerner [Olsen], "The Strike," *Partisan Review* 1 (September–October 1934): 5. Further citations are given parenthetically by page number in the text.

28. For a superb examination of *Yonnondio*'s status as a "recovered" text, see

Christopher Wilson's essay, "'Unlimn'd They Disappear': Recollecting *Yonnon-dio: From the Thirties*," in *The Power of Culture*, ed. Richard Fox and Jackson Lears (Chicago: University of Chicago Press, 1993), 38–63.

29. Paula Rabinowitz, *Labor and Desire: Women's Revolutionary Fiction in Depression America* (Chapel Hill: University of North Carolina Press, 1991).

30. Walt Whitman, "Yonnondio," quoted in Tillie Olsen, *Yonnondio: From the Thirties* (New York: Dell, 1974), vii.

31. Tillie Olsen, "A Note about This Book," in *Yonnondio*, v. Further citations from the "Note" and from the novel itself are from this edition and are given parenthetically by page number in the text.

32. From notes collected with the original manuscript of *Yonnondio*, Berg Collection, New York Public Library, n.p.

33. Mara Faulkner, *Protest and Possibility in the Writing of Tillie Olsen* (Charlottesville: University Press of Virginia, 1993), 134.

34. See Coiner, *Better Red*, 183.

35. Fredric Jameson, *The Political Unconscious: Narrative as a Socially Symbolic Act* (Ithaca, N.Y.: Cornell University Press, 1981), 192.

36. Wilson, "'Unlimn'd They Disappear.'"

37. On testimony, see Shoshana Felman and Dori Laub, *Testimony: Crises of Witnessing in Literature, Psychoanalysis, and History* (London: Routledge, 1992); and Judith Lewis Herman, *Trauma and Recovery* (New York: Basic Books, 1997).

38. Constance Coiner contends similarly that "woman's blabbin'" serves as a figure of the novel's "heteroglossic impulses." Coiner, *Better Red*, 181.

39. *Yonnondio* has long been described as a socialist feminist text that challenges the masculinist tenets of much proletarian literature. See Rosenfelt, "From the Thirties"; Rabinowitz, *Labor and Desire*; and Coiner, *Better Red*.

40. Tyrus Miller, review of *Modernisms: A Literary Guide*, by Peter Nicholls, *Modernism/Modernity* 4, no. 1 (1997): 176; Terry Eagleton, "Capitalism, Modernism, and Postmodernism," in *Against the Grain: Collected Essays* (London: Verso, 1986), 140.

41. On the intersection of modernism and radicalism, see, to begin with, Mark Schoening, "T. S. Eliot Meets Mike Gold: Modernism and Radicalism in Depression-Era American Literature," *Modernism/Modernity* 3 (1996): 51–68; Denning, *Cultural Front*; and Anthony David Dawahare, "American Proletarian Modernism and the Problem of Modernity in the Thirties: Meridel Le Sueur, Tillie Olsen, and Langston Hughes" (Ph.D. diss., University of California, Irvine, 1994).

42. Conversation with the author, October 1997.

43. Quoted in Duncan, "Coming of Age in the Thirties," 211.

44. Quoted in Rosenfelt, "From the Thirties," 86.

45. On the body as "an accumulation strategy," see David Harvey, *Spaces of Hope* (Berkeley: University of California Press, 2000), chap. 6.

46. Michel de Certeau, *The Practice of Everyday Life*, trans. Steven Rendall (Berkeley: University of California Press, 1984), introduction and chap. 3.

47. Malcolm Cowley, *Exile's Return: A Literary Odyssey of the 1920's* (New York: Viking Press, 1956), 101–2.

48. John Matthews also notes a "tantalizing connection" between these two novels in his essay "Faulkner and Proletarian Literature," in *Faulkner in Cultural Context*, ed. Donald Kartiganer and Ann Abadie (Jackson: University Press of Mississippi, 1997), 187.

49. For an elaboration of this argument, see Ted Atkinson, *William Faulkner and the Great Depression: Aesthetics, Ideology, and Cultural Politics* (Athens: University of Georgia Press, 2006), 194.

50. Joseph Blotner, *Faulkner: A Biography* (New York: Random House, 1974), 1:633.

51. Quoted in Joseph Blotner, "How *As I Lay Dying* Came to Be," in *Readings on William Faulkner*, ed. Clarice Swisher (San Diego: Greenhaven Press, 1998), 113.

52. John T. Matthews, "*As I Lay Dying* in the Machine Age," *boundary 2* 19, no. 1 (1992): 83. Faulkner himself proclaimed the novel a triumph, stating: "I set out deliberately to write a tour-de-force. . . . Before I began I said, I am going to write a book by which, at a pinch, I can stand or fall if I never touch ink again." Quoted in Blotner, *Faulkner*, 634.

53. Sylvia Jenkins Cook, *From Tobacco Road to Route 66: The Southern Poor White in Fiction* (Chapel Hill: University of North Carolina Press, 1976), 40.

54. William Faulkner, *Absalom! Absalom!* (New York: Vintage International, 1990), 183.

55. Ibid., 192.

56. See Atkinson, *Faulkner and the Great Depression*, esp. chap. 1.

57. Ibid., 175.

58. Quoted in Joseph Blotner and Frederick Gwynn, eds., *Faulkner in the University: Class Conferences at the University of Virginia* (New York: Vintage, 1959), 177.

59. William Faulkner, *As I Lay Dying* (New York: Vintage International, 1990), 78. Further citations are given parenthetically by page number in the text.

60. For more on the depiction of Anse and the other Bundrens, see Julia

Leyda, "Reading White Trash: Class, Race, and Mobility in Faulkner and Le Sueur," *Arizona Quarterly* 56, no. 2 (Summer 2000): 37–64.

61. Atkinson, *Faulkner and the Great Depression*, 180.

62. Annette Wannamaker, "Viewing Addie Bundren through a Feminist Lens," *Teaching Faulkner* 7 (1995), <http://www6.semo.edu/cfs/tfn_online/dying_wannamaker.htm> (June 15, 2006).

63. Cook, *From Tobacco Road to Route 66*, 44.

64. Philip Hanson, "Rewriting the Poor White Myth in *As I Lay Dying*," *Arkansas Quarterly* 2, no. 4 (October 1993): 309.

65. Eric Sundquist, *William Faulkner: The House Divided* (Baltimore: Johns Hopkins University Press, 1983), 31, 40.

66. Ibid., 34.

67. Ibid., 36.

68. My formulation here is indebted to Houston Baker's distinction between the "mastery of form" and the "de-formation of mastery." See Baker, *Modernism and the Harlem Renaissance* (Chicago: University of Chicago Press, 1987), 49–50.

69. Thomas Keenan, *Fables of Responsibility: Aberrations and Predicaments in Ethics and Politics* (Stanford: Stanford University Press, 1997), 1.

Chapter 5

1. Caroline Ware, introduction to *The Cultural Approach to History*, ed. Caroline Ware (New York: Columbia University Press, 1940), 5–6, 4.

2. Ibid., 10.

3. Ibid., 13.

4. Ellen Fitzpatrick, "Caroline F. Ware and the Cultural Approach to History," *American Quarterly* 43, no. 2 (June 1991): 175.

5. Caroline Ware, "Cultural Groups in the United States," in Ware, *Cultural Approach to History*, 64.

6. Ibid., 73.

7. Warren Susman, "The Culture of the Thirties," in *Culture as History: The Transformation of American Society in the Twentieth Century* (New York: Pantheon, 1984).

8. Ware, "Cultural Groups in the United States," 72.

9. Ibid., 73.

10. On the emergence of ethnic writers, see Michael Klein, *Foreigners: The Making of American Literature, 1900–1940* (Chicago: University of Chicago Press, 1981); and Michael Denning, *The Cultural Front* (New York: Verso, 1996).

11. Fitzpatrick, "Caroline F. Ware," 192.

12. Werner Sollors, *Beyond Ethnicity: Consent and Descent in American Culture* (Oxford: Oxford University Press, 1986), 245.

13. Sollors and Tom Ferraro consider Roth's novel the apotheosis of a form they call "ethnic modernism." Sollors, *Beyond Ethnicity*, 248, 256; and Thomas Ferraro, "Avant-garde Ethnics," in *The Future of American Modernism*, ed. William Boelhower (Amsterdam: VU University Press, 1990), 1–32. In discussing *Call It Sleep*, I have added "proletarian" to the concept of ethnic modernism for the following reasons: first, to reflect Roth's political radicalism at the time he was writing the text; second, to signify the novel's influence on other radical writers; and third, because, if the incredibly and vociferous debate carried on in the pages of the *New Masses* and the *Daily Worker* are an indication, reviewers in the radical press seemed to recognize the novel as "one of their own."

14. Henry Roth, *Call It Sleep* (New York: Noonday Press, 1962), 17.

15. Ibid., 419.

16. Ibid.

17. See Werner Sollors, "'A World Elsewhere, Somewhere Else': Language, Nostalgic Mournfulness, and Urban Immigrant Family Romance in *Call It Sleep*," in *New Essays on "Call It Sleep*," ed. Hana Wirth-Nesher (Cambridge: Cambridge University Press, 1996), 127–88.

18. In "Theses on the Philosophy of History," Walter Benjamin states, "To articulate the past historically does not mean to recognize 'the way it really was.' . . . It means to seize hold of a memory as it flashes up at a moment of danger." Benjamin, *Illuminations*, trans. Harry Zohn (New York: Schocken Books, 1968), 255.

19. Roth, *Call It Sleep*, 419.

20. Ibid., 420.

21. Ibid., 419. Mark Schoening has argued that "Roth's novel invites us here to understand David's drive to the rail in the context of a critique of America that calls for revolution on the grounds that the nation has arrived at the point of systematically betraying the promises made to its citizens"—a critique very similar to the one offered by *Christ in Concrete*, as I argue below. Schoening asserts that "Roth's novel imagines the modernist celebration of the irreducibly alienated subject—the subject alienated, in this case, expressly beyond the available therapeutics of cultural or class identification—as constituting precisely the kind of politics widely associated in this period with the embrace of classed, raced, or cultured subjects." Mark Schoening, "T. S. Eliot Meets Mike Gold: Modernism and Radicalism in Depression-Era American Literature," *Modernism/Modernity* 3, no. 3 (1996): 63, 64.

22. See Klein, *Foreigners*, 8. Klein's text is an important—and often over-

looked—corrective to studies of modern American literature that neglect the works produced by ethnic and African American writers. However, his text is underwritten by a reductive opposition between "modernism" and "barbarism" that separates these two traditions too cleanly and completely. Modernism, in Klein's view, is an inherently "elite" (37), conservative formulation, "a sensibility and a value system to which fascism was amenable when it came along" (9). While I do not disagree with Klein's assessment of the generally conservative nature of high modernism, Klein seems to conflate a social formation (a generation of high modernists) and an aesthetic style (modernism) that are not completely coextensive. While the writing of Eliot and Pound may have been ideologically conservative, the aesthetics of modernism were not inherently "amenable to fascism." Indeed, modernist techniques and methods were articulated to varied ideological ends.

23. Thomas Strychacz argues for the similarities between modernist writing and professional specialization. "If a body of formal knowledge underpins the professional's power within mass society, than the idiom of modernist writing—arcane illusion, juxtaposition, opaque writing, indeterminacy, and so on—performs precisely the same function within mass culture." In short, modernists created a language that prohibited its reception by a mass or popular audience—including the very American "ethnics" who were Henry Roth's neighbors on the Lower East Side. Thomas Strychacz, *Modernism, Mass Culture, and Professionalism* (Cambridge: Cambridge University Press, 1993), 27.

24. For more on Roth's debt to T. S. Eliot, Eugene O'Neill, and especially James Joyce, see Ferraro, "Avant-Garde Ethnics."

25. Pietro di Donato, *Christ in Concrete* (New York: Penguin Books, 1993), 208. Further citations are given parenthetically by page number in the text.

26. For biographical information, I have relied on Michael D. Esposito, "The Evolution of Pietro di Donato's Perceptions of Italian-Americans," in *Italian Americans through the Generations*, ed. Rocco Caporale (Staten Island, N.Y.: The Association, 1982).

27. Louis Adamic, "Muscular Novel of Immigrant Life," *Saturday Review of Literature*, August 26, 1939, 5.

28. Ibid.

29. Ibid.

30. Louis Salomon, "Men at Work," *Nation*, August 26, 1939, 223.

31. "A Fine and Unusual First Novel," *New York Times Book Review*, August 20, 1939, 6.

32. Ibid.

33. Review of *Christ in Concrete* in *Time*, April 10, 1939, 75–76.

34. Franco Mulas, "The Ethnic Language of Pietro di Donato's *Christ in Concrete*," in *From the Margin: Writings in Italian Americana*, ed. Anthony Julian Tamburri, Paolo A. Giordano, and Fred L. Gardaphé (West Lafayette, Ind.: Purdue University Press, 1991), 311.

35. Ibid., 309, 310.

36. June Howard, *Form and History in American Literary Naturalism* (Chapel Hill: University of North Carolina Press, 1985), 81.

37. Paula Rabinowitz, "Voyeurism and Class Consciousness: James Agee and Walker Evans' *Let Us Now Praise Famous Men*," *Cultural Critique* 21 (Spring 1992): 145.

38. For more on the dynamics of exposure and shame in British working-class writing, see Pamela Fox, "De/Re-fusing the Reproduction-Resistance Circuit of Cultural Studies: A Methodology for Reading Working-Class Narrative," *Cultural Critique* 28 (Fall 1994): 53–73.

39. Quoted in Esposito, "Evolution of Pietro di Donato's Perceptions," 179.

40. Quoted in Michael D. Esposito, "The Travail of Pietro di Donato," *MELUS* 7, no. 2 (Summer 1980): 51.

41. Ibid., 50.

42. Quoted in Arthur Casciato, "The Bricklayer as Bricoleur: Pietro di Donato and the Cultural Politics of the Popular Front," *Voices in Italian Americana* 2 (1991): 70.

43. Ibid.

44. On the novel's linguistic hybridity, see Robert Viscusi, "De Vulgari Eloquentia: An Approach to the Language of Italian Fiction," *Yale Italian Studies* 1, no. 3 (Winter 1981): 21–38; and Fred Gardaphé, *Italian Signs, American Streets* (Durham, N.C.: Duke University Press, 1996), 68–69.

45. I have taken the example of "per piacere" from Jerre Mangione's review of *Christ in Concrete*, "Little Italy," *New Republic*, August 30, 1939, 111.

46. Fred L. Gardaphé, introduction to di Donato, *Christ in Concrete*, xii.

47. The novel allegorizes the dominant forces of social existence: labor, which the novel refers to as "Job," is not merely an occupation, it is a living being, an animate force; "Tenement" is not only a location, a building, but also an organic entity; the characters are not only workers, but also mythic figures—Christ in concrete. In *Christ in Concrete*, allegory is explicitly tied to social critique. For example, warning that the city government is not likely to provide Geremio's family compensation in the wake of his death on the job, one of the family's neighbors comments that "'the full gut sees not the hungry face'" (107). Here, class discrepancy is rendered in stark, corporeal terms as the complexities of social and political power are reduced to the clarity of allegorical comprehension.

48. William Boelhower, *Through a Glass Darkly: Ethnic Semiosis in American Literature* (Oxford: Oxford University Press, 1987).

49. For this definition of modernism, see Astradur Eysteinsson, *The Concept of Modernism* (Ithaca, N.Y.: Cornell University Press, 1990).

50. On modernism as a form of "secular transcendence," see Quentin Anderson, "The Emergence of Modernism," in *Columbia Literary History of the United States*, ed. Emory Elliot (New York: Columbia University Press, 1988), 704. Fredric Jameson, "Reflections in Conclusion," in *Aesthetics and Politics*, by Ernst Bloch, Georg Lukacs, Bertolt Brecht, Walter Benjamin, and Theodor Adorno (New York: Verso, 1977), 206.

51. Peter Bürger, *Theory of the Avant-Garde* (Minneapolis: University of Minnesota Press, 1984), 54. Although he discusses early twentieth-century movements such as Dadaism and Cubism, Bürger notes that the "new approach" that characterizes avant-garde works "is not restricted to such works" (82).

52. Michael Kowalewski, *Deadly Musings: Violence and Verbal Form in American Literature* (Princeton, N.J.: Princeton University Press, 1993), 25.

53. Janet Zandy, *Hands: Physical Labor, Class, and Cultural Work* (New Brunswick, N.J.: Rutgers University Press, 2004), 152.

54. See, for example, Jane Gallop, *Thinking through the Body* (New York: Columbia University Press, 1985); and Suren Lalvani, *Photography, Vision, and the Production of Modern Bodies* (Albany: State University of New York Press, 1996). In "History of the Body," Roy Porter outlines seven branches of the history of the body that deserve study, ranging from "The Body as Human Condition" to "Sex and Gender" to "The Body and the Body Politic." He fails to mention, however, the body as an agent of labor. See Porter, "History of the Body," in *New Perspectives on Historical Writing*, ed. Peter Burke (State College: Pennsylvania State University Press, 1991), 206–33.

55. See, for example, John Jervis, *Exploring the Modern* (London: Blackwell, 1998).

56. Anthony Giddens, *Modernity and Self-Identity: Self and Society in the Late-Modern Age* (London: Polity Press, 1991).

57. In a brief review of recent scholarship on the body in literature, which has tended to emphasize questions of desire over questions of work, Terry Eagleton notes, "If the libidinal body is in, the labouring body is out." Eagleton, "Body Work," in *The Eagleton Reader*, ed. Stephen Regan (London: Blackwell, 1998), 158.

58. Karl Marx, *Capital* (New York: Penguin Books, 1976), 1:128.

59. Ibid.

60. Ibid., 134.

61. Elaine Scarry, *The Body in Pain: The Making and Unmaking of the World* (Oxford: Oxford University Press, 1985), 259.

62. Ibid., 252.

63. Ibid., 244.

64. Ibid., 261.

65. Ibid., 260–61.

66. Ibid., 264.

67. Ibid., 265.

68. Ibid., 267.

69. Ibid.

70. Marx, *Capital*, 1:617.

71. Ibid.

72. Ibid., 617–18.

73. David Harvey, *Spaces of Hope* (Berkeley: University of California Press, 2000), 103.

74. The novel's ethos of labor, in which work is conceived as a realm of self-expression and self-sufficiency as well as a medium of exploitation, reworks the Catholic ideologies of labor value that were prevalent in many ethnic American communities during the 1930s. Although not as radical as various forms of socialism advocated by progressive labor groups during the decade, the Church's doctrine explicitly condemned capitalist greed and exploitation and praised the social and moral value of labor. See Gary Gerstle, *Working-Class Americanism: The Politics of Labor in a Textile City, 1914–1960* (Cambridge: Cambridge University Press, 1989), 247–59.

75. Erika Doss, "Looking at Labor: Images of Work in 1930s American Art," *Journal of Decorative and Propaganda Arts* 24 (2002): 230–57.

76. Doss, "Looking at Labor," 255–56.

77. Walter Kalaidjian, *American Culture between the Wars: Revisionary Modernism and Postmodern Critique* (New York: Columbia University Press, 1993), 138.

78. On labor as the making and unmaking of the world, see Scarry, *Body in Pain*, esp. chap. 4.

79. Georges Bataille, "The Notion of Expenditure," in *Visions of Excess: Selected Writings, 1927–1939* (Minneapolis: University of Minnesota Press, 1985), 126–27.

80. See Mark Seltzer, *Bodies and Machines* (New York: Routledge, 1992), and my own discussion of his theories in chapter 1.

81. Peter Stallybrass and Allon White, *The Politics and Poetics of Transgression* (Ithaca, N.Y.: Cornell University Press, 1986), 20. On the fantasy body of

modern capitalism, see Tim Armstrong, *Modernism, Technology, and the Body* (Cambridge: Cambridge University Press, 1998).

82. On the concept of "willfully damaged signs," see Paul Gilroy, *The Black Atlantic: Modernity and Double Consciousness* (Cambridge, Mass.: Harvard University Press, 1993).

83. Lewis Hine, *Men at Work: Photographic Studies of Modern Men and Machines* (New York: Dover Publications, 1977), n.p.

84. Joshua Freeman, "Hardhats: Construction Workers, Manliness, and the 1970 Pro-War Demonstrations," *Journal of Social History* 26 (Summer 1993): 728.

85. Hine, *Men at Work*, 15, 22.

86. Alan Trachtenberg, *Reading American Photographs: Images as History, Matthew Brady to Walker Evans* (New York: Hill and Wang, 1989), 210.

87. Ibid., 224–25.

88. For the prevalence of a discourse of the "people" in thirties culture, see Warren Susman, *Culture as History: The Transformation of American Society in the Twentieth Century* (New York: Pantheon, 1984), chap. 9.

89. Robert Orsi, *Madonna of 115th Street: Faith and Community in Italian Harlem, 1880–1950* (New Haven, Conn.: Yale University Press, 1985), 200.

90. Ibid.

91. In his history of Italian American devotion to la Madonna del Carmine—which culminated in an annual procession of the statue of the Holy Mother through the streets of Italian Harlem—Orsi highlights the deeply material way in which the community represented its faith, the "sensuous, graphic" quality of the people's piety (Orsi, *Madonna of 115th Street*, xxii). Blessings and prayers were offered to the Virgin in material form such as money, candles, jewels, and, most relevant to *Christ in Concrete*, wax body parts. Orsi notes that booths were set up on the sidewalks the day of the procession, selling "wax replicas of internal human organs and . . . models of human limbs and heads" to be offered to the Virgin as signs of which part of the body a person needed to be healed (3). Until the late 1930s, the Madonna's altar would be piled high at each year's festival with wax body parts, melting in the heat of the abundant candles (10). The image of disintegrating body parts, offered as tokens of prayer and healing, resonates with di Donato's vivid, graphic description of the shattered bodies of Nazone and Geremio. The similarity is most certainly unintentional, but it suggests a link between di Donato's narrative and his Catholic heritage, between his grotesque modernism and his ethnic community, between concrete and Christ. Although di Donato, like Paul, ultimately rejected Catholicism, he seems to have retained a sense of the particular materialism of his community's faith.

92. Dorothee Von Huene-Greenberg, "A *MELUS* Interview: Pietro di Donato," *MELUS* 14, nos. 3–4 (Fall–Winter 1987): 36.

93. Orsi, *Madonna of 115th Street*, xvi.

94. Bataille, "Notion of Expenditure," 127.

95. My argument here bears some resemblance to Fred Gardaphé's. He suggests that the novel's final scene, in which Paul cradles his dying mother, is an inversion of the pieta, in which "the mother has become the new Christ, who in witnessing what America has done to her son, dies and through her death frees her son from the burden of his Catholic past." This allows him to "become not a new Christ but more of a John the Baptist figure," preparing workers for revolution. Gardaphé, *Italian Signs, American Streets*, 71–72.

Chapter 6

1. For an overview of visual metaphors in Wright's novel, see, to begin with, James Nagel, "Images of Vision in *Native Son*," *University Review* 36, no. 2 (Winter 1969): 109–15.

2. Richard Wright, *Native Son and "How 'Bigger' Was Born"* (New York: HarperCollins, 1993), 36. Further citations are given parenthetically by page number in the text.

3. Richard Wright, "How 'Bigger' Was Born," in Richard Wright, *Native Son and "How 'Bigger' Was Born,"* 537. Further citations are given parenthetically in the text, abbreviated as HBWB.

4. See Harold Hellenbrand, "Bigger Thomas Reconsidered: *Native Son*, Film, and King Kong," *Journal of American Culture* 22 (1983): 85.

5. Robert Walker, "*King Kong* (1933)," *Cinema Texts: Program Notes* 7, no. 7 (September 12, 1974): 2, quoted in James A. Snead, "Spectatorship and Capture in *King Kong*: The Guilty Look," in *White Screens/Black Images: Hollywood from the Dark Side* (New York: Routledge, 1994). On the film as a response to Depression-era political unrest, especially the 1932 Bonus Army march of the unemployed on Washington, D.C., see Robert Torry, "'You Can't Look Away': Spectacle and Transgression in *King Kong*," *Arizona Quarterly* 49, no. 4 (Winter 1993): 61–77.

6. For a detailed elaboration of connections between film and novel, I am indebted to Hellenbrand, "Bigger Thomas Reconsidered."

7. Snead, "Spectatorship and Capture in *King Kong*," 30.

8. Cynthia Erb notes that "when all is said and done, it is the hand of Denham that is more menacing than Kong's." Erb, *Tracking King Kong: A Hollywood Icon in World Culture* (Detroit: Wayne State University Press, 1998), 114. Larry Hanley also makes this point. See Hanley, "Popular Culture and Crisis: *King*

Kong Meets Edmund Wilson," in *Radical Revisions: Rereading Thirties Culture*, ed. Sherry Linkon and Bill Mullen (Urbana: University of Illinois Press, 1996), 242–63.

9. Erb, *Tracking King Kong*, 116.

10. James Baldwin, "Many Thousands Gone," in *Notes of a Native Son* (Boston: Beacon Press, 1955), 40. Further citations are given parenthetically by page number in the text.

11. The first two quotations in this sentence are from Baldwin, "Everybody's Protest Novel," in *Notes of a Native Son*, 23, 15. For the notion of a world without majorities, see "In Search of a Majority," in Baldwin, *Nobody Knows My Name* (New York: Dell, 1961), 105–14.

12. On the fundamental ambiguity of stereotypes, see Homi Bhabha, "The Other Question," *Screen* 24, no. 6 (1983), reprinted in *The Location of Culture* (London: Routledge, 1994). See also Richard Dyer, "The Role of Stereotypes," in *Matter of Images: Essays on Representation* (London: Routledge, 1993), and Sander Gilman, who contends that stereotypes are inherently protean rather than rigid. See Gilman, *Difference and Pathology: Stereotypes of Sexuality, Race, and Madness* (Ithaca, N.Y.: Cornell University Press, 1985).

13. Richard Wright, *Black Boy: A Record of Childhood and Youth* (New York: Harper and Row, 1966), 171. Further citations are given parenthetically in the text, abbreviated as BB.

14. Richard Wright, *12 Million Black Voices* (New York: Thunder's Mouth Press, 1995), 35. Further citations are given parenthetically by page number in the text.

15. Nicholas Natanson, *The Black Image in the New Deal: The Politics of FSA Photography* (Knoxville: University of Tennessee Press, 1992), 247.

16. Ibid., 245.

17. Richard Wright Papers, box 63, folder 734, n.p, Yale Collection of American Literature, Beinecke Rare Book and Manuscript Library, New Haven, Conn.

18. Wright quoted in David Bradley, preface to Wright, *12 Million Black Voices*, xv.

19. See Maren Stange, "'Not What We Seem': Image and Text in *12 Million Black Voices*," in *Iconographies of Power*, ed. Ulla Haselstein, Berndt Ostendorf, and Peter Schneck (Heidelberg: C. Winter Press, 2003), 173–86.

20. Katherine Henninger contends that the photographs in *12 Million* "are meant to serve, unproblematically, as evidence." Henninger, "Zora Neale Hurston, Richard Wright, and the Postcolonial Gaze," *Mississippi Quarterly* 56, no. 4 (Fall 2003): 588. For the suggestion that *12 Million* is a work of "montage,"

I am indebted to Jack Moore, "The Voice in *12 Million Black Voices*," *Mississippi Quarterly* 42, no. 4 (Fall 1989): 418–19.

21. My grasp of Rosskam's layout techniques is indebted to Stange, "'Not What We Seem.'"

22. Stuart Culver, "How Photographs Mean: Literature and the Camera in American Studies," *American Literary History* 1, no. 1 (Spring 1989): 203. On the notion of visual-verbal resistance in photo-texts, see W. J. T. Mitchell, *Picture Theory: Essays on Verbal and Visual Representation* (Chicago: University of Chicago Press, 1994).

23. Paul Gilroy, *The Black Atlantic: Modernity and Double Consciousness* (Cambridge, Mass.: Harvard University Press, 1993), 172.

24. Robert Bone, for example, dismisses *Lawd Today!* as an "apprentice novel" that "adds nothing to Wright's reputation." Quoted in William Burrison, "*Lawd Today!*: Wright's Tricky Apprenticeship," in *Richard Wright: Critical Perspectives Past and Present*, ed. Henry Louis Gates and K. A. Appiah (New York: Amistad Press, 1993), 98.

25. Richard Wright, introduction to *Black Metropolis: A Study of Negro Life in a Northern City*, by Horace Cayton and St. Clair Drake (New York: Harcourt, Brace, 1945), xxxi.

26. Richard Wright, "Blueprint for Negro Writing," in *Richard Wright Reader*, ed. Ellen Wright and Michel Fabre (New York: Harper and Row, 1978), 45.

27. In "Blueprint for Negro Writing," Wright argues that fiction requires a balance of social theory and personal style. Although Marxism is essential to understanding the "social, political, and economic forces under which the life of [the Negro writer's] people is manifest," he also insists that "Negro life may be approached from a thousand angles, with no limit to technical and stylistic freedom" (47). In other words, although black authors should adopt a Marxist perspective to understand the conditions under which African Americans live in capitalist America, fiction should not be a conduit for political exhortation: "If the sensory vehicle of imaginative writing is required to carry too great a load of didactic material, the artistic sense is submerged" (48). "Image and emotion," Wright contends, "have a logic of their own" (48).

28. Arnold Rampersad, foreword to *Lawd Today!* (Boston: Northeastern University Press, 1993), vi.

29. Granville Hicks, review of *Lawd Today!*, *Saturday Review*, March 30, 1963, reprinted in Gates and Appiah, *Richard Wright*, 66.

30. June Howard argues that naturalism is structured by a divide between a privileged, autonomous narrator, with whom the reader is ideologically aligned, and a "brute," a degraded inhabitant of a deterministic world. Rather than an

autonomous subject, the "brute" is the central subject in a spectacle of determinism that confirms the power of the narrator's gaze and the moral authority and freedom of the readers. "The menacing and vulnerable Other"—the "brute"— "is incapable of acting as a self-conscious, purposeful agent[;] he can only be observed and analyzed by such an agent." However, although the spectator describes and explains the brute, he (rarely she) retains his autonomy from the deterministic environment the brute inhabits. While "we explore determinism, we are never submerged in it and ourselves become the brute." Ultimately, Howard argues, the narrator/brute split anticipates the Progressive movement, which placed reform in the hands of a small cadre of ostensibly enlightened, nonpartisan experts. "It is a very short step from naturalism's gesture of control to progressivism's," Howard contends, "from the sympathy and good intentions of the naturalist spectator to the altruistic and ultimately authoritarian benevolence of the progressive reformer." June Howard, *Form and History in American Literary Naturalism* (Chapel Hill: University of North Carolina Press, 1985), 104, 131.

31. Sterling Brown, review of *Native Son*, *Opportunity* 18 (June 1940): 185.

32. Ibid.

33. Michel Fabre, *The World of Richard Wright* (Jackson: University Press of Mississippi, 1985), 27; Michel Fabre, *The Unfinished Quest of Richard Wright* (Urbana: University of Illinois Press, 1993), 66.

34. Hazel Rowley, *Richard Wright: The Life and Times* (New York: Henry Holt, 2001), 157, 158.

35. One important exception is Paula Rabinowitz, whose *Black and White and Noir: America's Pulp Modernism* (New York: Columbia University Press, 2002) argues that Wright's novel *The Outsider* (1953) recasts classic noir tropes to construct a narrative critique of America's racial regime.

36. Letter to Wright from Nelson Algren, dated March 12, 1940, Wright Papers, box 93, folder 1167.

37. Ibid.

38. Margaret Wallace, "A Powerful Novel about a Boy from Chicago's Black Belt," *New York Sun*, March 5, 1940, reprinted in *Richard Wright: The Critical Reception*, ed. John M. Reilly (New York: B. Franklin, 1978), 61.

39. In *Richard Wright*, ed. Reilly, 52.

40. Fabre, *Unfinished Quest*, 93–94.

41. Fabre, *World of Richard Wright*, 109.

42. Ibid., 108.

43. Paula Rabinowitz, *Black and White and Noir*, chap. 3.

44. Michel Fabre notes, "One constantly finds traces in him of the poor black child who owes his spiritual survival in racist Mississippi and, in part, his voca-

tion as a writer to detective stories, popular fiction, and dime novels." Fabre, *World of Richard Wright*, 93.

45. Wright, untitled talk on literature [1940?], Wright Papers, box 6, folder 128, pp. 3–4.

46. Richard Wright letter to Mike Gold, Wright Papers, box 98, folder 1354, n.d., n.p.

47. Theophilus Lewis, review of *Native Son*, *Interracial Review* 13 (April 1940), reprinted in Reilly, *Richard Wright*, 88.

48. Ibid., 86.

49. Charles Leavelle, "Brick Slayer Is Likened to Jungle Beast," *Chicago Sunday Tribune*, June 5, 1938, sec. 1, p. 6.

50. Sandra Phillips, "Identifying the Criminal," in *Police Pictures: The Photograph as Evidence*, ed. Sandra Phillips, Mark Haworth-Booth, and Carol Squires (San Francisco: Museum of Modern Art, 1997), 44.

51. It is worth noting that this scene echoes the *Tribune* coverage of the Robert Nixon case. An article from the paper described Nixon being taken to the scene of the crime for a dramatic reenactment. "Last week when he was taken . . . to demonstrate how he had slain Mrs. Florence Johnson, mother of two small children, a crowd gathered and there were cries of: 'Lynch him! Kill him!' Nixon backed against a wall and bared his teeth. He showed no fear, just as he has shown no remorse." Cited in Keneth Kinnamon, "*Native Son*: The Personal, Social, and Political Background," *Phylon* 30, no. 1 (1969): 69. My discussion of *Native Son*'s attention to the visual dynamics of race and racism is indebted to Maurice Wallace's analysis of Wright's meditation on the "sociovisibility of black male subjects." Maurice Wallace, "'I'm Not Entirely What I look Like': Richard Wright, James Baldwin, and the Hegemony of Vision; or, Jimmy's FB-Eye Blues," in *James Baldwin Now*, ed. Dwight A. McBride (New York: New York University Press, 1999), 290.

52. Richard Wright, "Richard Wright Explains Ideas about Movie Making," *Ebony* 6, no. 3 (January 1951): 84.

53. Maurice Wallace, "'I'm Not Entirely What I look Like.'"

54. Richard Wright, introduction to Cayton and Drake, *Black Metropolis*, xxxii, xxxiii.

55. Michael Bérubé, "Max, Media, and Mimesis: Bigger's Representation in *Native Son*," in *Approaches to Teaching Wright's Native Son*, ed. James A. Miller (New York: Modern Languages Association, 1997), 117.

56. For some of these criticisms, see Trudier Harris, "Native Sons and Foreign Daughters," in *New Essays on Native Son*, ed. Keneth Kinnamon (Cambridge: Cambridge University Press, 1990); Alan France, "Misogyny and Appropriation

in Wright's *Native Son*," in *Bigger Thomas*, ed. Harold Bloom (New York: Chelsea House, 1990); and Maria K. Mootry, "Bitches, Whores, and Women Haters: Archetypes and Typologies in the Art of Richard Wright," in *Richard Wright*, ed. Richard Macksey and Frank Moorer (Englewood Cliffs, N.J.: Prentice-Hall, 1984).

57. France, "Misogyny and Appropriation in Wright's *Native Son*," 153.

58. For a detailed discussion of this plot, see Jacquelyn Dowd Hall, *Revolt against Chivalry: Jessie Daniel Ames and the Women's Campaign against Lynching* (New York: Columbia University Press, 1979), 145–57.

59. Robyn Wiegman, *American Anatomies: Theorizing Race and Gender* (Durham, N.C.: Duke University Press, 1995), 100–103.

60. Sondra Guttman, "What Bigger Killed For: Rereading Violence against Women in *Native Son*," *Texas Studies in Language and Literature* 43, no. 2 (Summer 2001): 185.

61. Eileen Boris, "'Arm and Arm': Racialized Bodies and Color Lines," *Journal of American Studies* 35, no. 1 (2001): 19.

62. Stuart Hall, "The Spectacle of the 'Other,'" in *Representation: Cultural Representations and Signifying Practices*, ed. Stuart Hall (London: Sage, 1997), 258.

63. Bhabha, *Location of Culture*, 80–82.

64. Howard, *Form and History in American Literary Naturalism*, esp. chap. 3.

65. My analysis here echoes Michael Davitt Bell's argument that *Native Son*'s narrative voice constitutes "an interesting literary experiment: a deliberate and self-conscious attempt to write in the mode of literary naturalism without succumbing to that mode's rigid and inherently racist division of knowing 'white' narrator from ignorant black 'brute.'" Michael Davitt Bell, "African American Writing, 'Protest,' and the Burden of Naturalism: The Case of *Native Son*," in *Culture, Genre and Literary Vocation: Selected Essays* (Chicago: Chicago University Press, 2001), 199.

66. Richard Wright letter to Mike Gold, Wright Papers, box 98, folder 1354, n.d., n.p.

67. On Wright's affinity with the Chicago School, see Carla Cappetti, *Writing Chicago: Modernism, Ethnography, and the Novel* (New York: Columbia University Press, 1993). On *Native Son*'s modernism, see Craig Werner, "Bigger's Blues: *Native Son* and the Articulation of Afro-American Modernism," in Kinnamon, *New Essays on Native Son*.

68. See Houston Baker, *Modernism and the Harlem Renaissance* (Chicago: University of Chicago Press, 1987).

69. For more on Wright's modernism—and *Native Son* as a modernist text—see Werner, "Bigger's Blues."

70. For more on this line of argument, see Ross Pudaloff, "Celebrity as Identity: Richard Wright, *Native Son*, and Mass Culture," *Studies in American Fiction* 11, no. 1 (1983): 3–18.

71. Kimberly Benston, "The Veil of Black: (Un)Masking the Subject of American Modernism's 'Native Son,'" *Human Studies* 16, nos. 1–2 (1993): 87.

72. Werner, "Bigger's Blues," 134.

73. On proletarian literature's images of solidarity, see, to begin with, Barbara Foley, *Radical Representations: Politics and Form in the U.S. Proletarian Fiction, 1929–1941* (Durham, N.C.: Duke University Press, 1993); Walter Kalaidjian, *American Culture between the Wars: Revisionary Modernism and Postmodern Critique* (New York: Columbia University Press, 1993); and Robert Shulman, *The Power of Political Art: The 1930s Literary Left Reconsidered* (Chapel Hill: University of North Carolina Press, 2000).

74. Homi Bhabha, "Culture's In-Between," in *Questions of Cultural Identity*, ed. Stuart Hall and Paul du Gay (London: Sage, 1996), 53–60.

75. John M. Reilly, "Giving Bigger a Voice: The Politics of Narrative in *Native Son*," in Kinnamon, *New Essays on Native Son*, 43.

76. Ibid., 50.

77. Baldwin, "Everybody's Protest Novel," 15.

Conclusion

1. The "classic" statement of this immensely influential position is Guy Debord, *The Society of the Spectacle* (New York: Zone Books, 1994).

2. For a theory of modernism as an exercise in cognitive and aesthetic unknowing, see Philip Weinstein, *Unknowing: The Work of Modernist Fiction* (Ithaca, N.Y.: Cornell University Press, 2005).

3. Caroline Bird, *The Invisible Scar* (New York: David McKay, 1966).

4. Richard Wright, *Native Son and "How 'Bigger' Was Born"* (New York: HarperCollins, 1993), 517.

5. On the iconography of the Madonna in the FSA files, see Wendy Kozol, "Madonnas of the Fields: Photography, Gender, and 1930s Farm Relief," *Genders* 2 (Summer 1988): 1–23.

6. Weegee, *Naked City* (New York: Da Capo Press, 1973), 190 (ellipsis in original).

7. Ibid.

8. Ibid.

9. Kaja Silverman, *The Threshold of the Visible World* (New York: Routledge, 1996), 71.

10. Weinstein, *Unknowing*, 3.

11. Allan Sekula, "The Body and the Archive," *October* 39 (Winter 1986): 3–64. For similar arguments, often Foucauldian in nature, see Suren Lalvani, *Photography, Vision, and the Production of Modern Bodies* (Albany: State University of New York Press, 1996); John Tagg, *The Burden of Representation: Essays on Photographies and Histories* (Minneapolis: University of Minnesota Press, 1988); and Terry Smith, *Making the Modern: Industry, Art, and Design in America* (Chicago: University of Chicago Press, 1993).

12. For an especially provocative articulation of such arguments, see Mark Seltzer, *Bodies and Machines* (New York: Routledge, 1992).

13. Gavin Jones, "Poverty and the Limits of Literary Criticism," *American Literary History* 15, no. 4 (2003): 780.

14. Ibid., 776.

15. Astradur Eysteinsson, *The Concept of Modernism* (Ithaca, N.Y.: Cornell University Press, 1990), 229.

Page numbers in italics refer to illustrations.

Barnard, Rita, 10, 33–34, 61, 276
 (n. 103), 281 (n. 56)
"Barn Burning" (Faulkner), 171
Barnes, Elizabeth, 43, 51
Barr, Alfred, 11
Barthes, Roland, 27–29
Bataille, Georges, 206–7, 213
Beauvoir, Simone de, 231
Bell, Michael Davitt, 40, 277 (n. 4),
 308 (n. 65)
Benjamin, Walter: on aesthetic aston-
 ishment, 18–19; on "tiny spark of
 accident," 29; on discontinuous
 tradition, 33; on modernity as
 "state of emergency," 73; on pho-
 tography, 108; on angel of history,
 164; on history, 185, 297 (n. 18);
 on metropolis, 271–72 (n. 45)
Benston, Kimberly, 251
Benton, Thomas Hart, 11
Berger, John, 28
Berger, Maurice, 109
Bérubé, Michael, 244
Bhabha, Homi, 123, 254, 291
 (nn. 34–35), 304 (n. 12)
Bird, Caroline, 258, 269 (n. 22)
Black Boy (Wright), 238
Blackface minstrelsy, 135–38
Black Metropolis (Cayton and Drake),
 232–33, 243
Blacks. *See* African Americans
Black Spring (Miller), 184
Blair, Sara, 74
Blast, 81, 93
Bloom, Peter, 12
Body: in Olsen's *Yonnondio*, 10, 34,
 143, 158–60, 167; in advertise-
 ments, 13, 271 (n. 44); and aesthet-
 ics of astonishment, 17–26; and
 aesthetics of disfigurement, 17–26,
 72–75; in Williams's doctor stories,
20, 30–31, 34, 73, 78–81, 96–106;
 as metaphor for society, 21; sym-
 bolism of, muscular male, 21, 22,
 203–4; in West's *Miss Lonelyhearts*,
 30, 60–65, 72, 73; in Le Sueur's "I
 Was Marching," 30, 66–68, 72, 73;
 in Trumbo's *Johnny Got His Gun*,
 30, 68–72, 73; Agee on torn, 31,
 65, 142–43, 160; scrutiny of, gen-
 erally, 35–36; in Fitzgerald's *The
 Great Gatsby*, 36–42, 46, 279–80
 (n. 30); in Steinbeck's *The Grapes
 of Wrath*, 43–46, 50; reduction of
 the poor to their, 45–46; in Wee-
 gee's photographs, 57–60, *58, 59,*
 72, 73, 258; capitalism's fantasy
 of perfect, 72; as symbol of social
 unity, 72–73; in Siskind's Harlem
 photographs, 107–8, 131–38; in
 Let Us Now Praise Famous Men,
 145–47; in Olsen's "The Strike,"
 158; in di Donato's *Christ in Con-
 crete*, 183–84, 194–208, 246; use
 of psychoanalytic and Foucauldian
 theories of, 196; in Roth's *Call It
 Sleep*, 184–86; Giddens on, 196–
 97; Marxist view of, 197–99; and
 classificatory body of culture, 207;
 of Hine's construction workers,
 207–8, *209, 210*; black male, 234–
 35; in Wright's *Native Son*, 244–
 46; in Lange's photography, 280
 (n. 43); Eagleton on, libidinal, 300
 (n. 57)
Boelhower, William, 193
Boris, Eileen, 245
Bourke-White, Margaret, 23–26, *25*
Bourne, Randolph, 182
Brecht, Bertolt, 18–19, 159, 258
Breton, André, 19, 56
Brewer, Clinton, 237

Communist Party, 63, 81, 113, 148, 191

Contact, 62, 89

Contact (as concept), 27, 31, 80, 81, 88–93, 106, 275 (n. 91)

Cook, Sylvia Jenkins, 171, 177

Cooney, Terry, 5, 6

Cowley, Malcolm, 147, 168

Crane, Stephen, 39

Crime, 16, 17, 41, 54, 55, 237–38, 241–42, 307 (n. 51). *See also* Violence

The Cultural Approach to History (Ware), 181–83

Culver, Stuart, 231

Curry, John Steuart, 11, 21

Curtis, James, 47

Czitrom, Daniel, 15, 17

Dahlberg, Edward, 7

Daily Worker, 113, 297 (n. 13)

Damon, Cross, 238

Davis, Rebecca Harding, 148

Dawahare, Anthony, 10

Dead End: The Bowery, 114

De Certeau, Michel, 168

Delano, Jack, *224*, *228*, *230*

Denning, Michael, 10, 12, 61

Depression. *See* Great Depression

Dereification, 67, 152

Dickstein, Morris, 7

Di Donato, Pietro: on class and class consciousness, 1, 10, 191–92; as sensational modernist generally, 2, 4, 74; compared with Roth, 32, 184–87, 201; writing career of, 33; compared with Agee, 143–44, 147; in working class, 143–44, 188–89; compared with Olsen, 163, 187, 192, 195; and ethnic proletarian modernism, 184–87; biographi-

cal information on, 188, 191; and Communist Party, 191; and Catholicism, 213; compared with Wright, 246, 254. *See also Christ in Concrete* (di Donato)

Discontinuity, tradition of, 33–34

Discourse of scrutiny. *See* Scrutiny/discourse of scrutiny

Disembodiment, aesthetics of, 74

Disfiguration: in di Donato's *Christ in Concrete*, 1, 32, 143, 183–84, 187, 190, 194–97, 205–8, 246; in Olsen's *Yonnondio*, 10, 34, 143, 158–60, 167, 258; and sensational modernism generally, 17–26, 72–75, 258; in Trumbo's *Johnny Got His Gun*, 30, 68–72, 73; in Weegee's photographs, 73, 258; in Wright's *Native Son*, 240, 241, 244–46; Wright on, 258. *See also* Body

Dr. Sax (Kerouac), 184

Documentary: Rabinowitz on impropriety of, 26–27; social, 27; Siskind on, 110–12

Documentary modernism: in literature and photography, 26–29; and Faulkner's *As I Lay Dying*, 177

Documentary photography: by Evans in *Let Us Now Praise Famous Men*, 1, 23, 30, 31, 47, *49*, 50–51, 109, 281 (n. 44); and portrayal of the poor generally, 1–2, 3; and phototext, 10; of Farm Security Administration (FSA), 21, 23, 46–51, 53, 108–9, 113, 114, 126, 127, 219, 225, 259, 262–63; by Bourke-White in *You Have Seen Their Faces*, 23–26, *25*; Rabinowitz on impropriety of, 26–27; and sensational modernism generally, 26–29; by Lange, 30,

nativist sentiment against, 83–84;
prejudice against and stereotypes
of, 83–84; in New Jersey, 83–86;
and labor unrest/strikes, 84–86;
"vital contact" with middle-class
bohemians and lower-class city
dwellers, 275 (n. 91); dialects of,
283 (n. 2). *See also* Poverty and the
poor; Working class

Independent, 17

Industry: and accidents and injuries
in workplace, 13, 158–60, 183,
187, 190, 191, 194–97, 205–7; and
productive integration, 51; Marxist
view of, 197–99; in di Donato's
Christ in Concrete, 199–203, 208

Injuries. *See* Industry

International Longshoremen's Asso-
ciation (ILA), 149–50

In the American Grain (Williams), 31,
89–91

"I Was Marching" (Le Sueur), 30,
66–68, 72, 73

James, Henry, 237, 243, 249

James, William, 186

Jameson, Fredric, 67, 152, 159–60,
194

Jehlen, Myra, 171

Johnny Got His Gun (Trumbo), 30,
68–72, 73

Johnson, Bob, 82

Jones, Gavin, 263

Joyce, James, 33, 94, 184, 186, 187,
232, 233, 249

Kalaidjian, Walter, 10, 21, 204, 270
(n. 33)

Kaplan, Carla, 143

Kasson, John, 13

Kazin, Alfred, 7, 147–48, 271 (n. 37)

Keenan, Thomas, 180

Kerouac, Jack, 184

King Kong, 12, 216–18

Klein, Marcus, 186

The Knife of the Times (Williams), 82

Kowalewski, Michael, 195

Kozol, Wendy, 27, 50

Labor. *See* Immigrants; Working class

Labor unions, 8

Labor unrest/strikes: Minneapolis
municipal strike, 8; statistics on, 8;
by textile workers in New Jersey,
8, 9–10, 84–86; by San Francisco
longshoremen, 8, 149–55; in Le
Sueur's "I Was Marching," 66–68,
72; in Olsen's "The Strike," 149,
150–55, 156, 158, 166, 179. *See also*
Unemployment

La Guardia, Mayor, 118

Lange, Dorothea, 30, 47, *48,* 50, 113,
222, 223, 280 (n. 43)

Language: relationship between pho-
tography and, 27–29; Agee on
incapacity of, 141–42, 144–45

Lauter, Paul, 10

Lawd Today! (Wright), 10, 32–33,
219, 232–36

Lee, Russell, 108–9, 225, 227

Lenz, Günter, 10

Lerner, Samuel and Ida, 148

Le Sueur, Meridel, 2, 30, 66–68, 72,
73

Let Us Now Praise Famous Men (Agee
and Evans): photography by Evans
in, 1, 23, 30, 47, *49,* 50–51, 109,
281 (n. 44); prose by Agee in,
1, 31, 65, 109, 141–47, 177; on
poverty viewed at a distance, 1,
73; on torn body, 31, 65, 142–43,
160; compared with Williams's
doctor stories, 106; bourgeois gaze
and middle-class privilege in, 109;

middle-class narrative of, 109; critics on, 141, 144–45; on incapacity of language, 141–42, 144–45; transcendence and desire in, 144–47; sexual objectification of sharecroppers in, 145–47, 292 (n. 8); final images of, 179; compared with *12 Million Black Voices*, 225; and love of tenant farmers, 292–93 (n. 10)

Levine, Lawrence, 5

Lewis, John, 8

Libretti, Timothy, 12

Life, 26, 47, 113, 225

Life along the Passaic River (Williams), 78–81, 82, 93–106

"Life along the Passaic River" (Williams), 94–96

Life in the Iron Mills (Davis), 148

Literature: relationship between photography and, 27–29. *See also specific authors and titles of their works*

Living newspapers, 10

Locke, John, 12

Look, 26, 113, 116, 125, 139

Lott, Eric, 135, 138

Lynchings, 9

Lynd, Robert and Helen, 16

MacArthur, Douglas, 8

Macfadden, Bernarr, 15

Madonna (Virgin Mary), 50, 259–61, *260*, 302 (n. 91)

Magione, Jerre, 183

Malraux, André, 237

"The Man Who Killed a Shadow" (Wright), 237

"The Man Who Lived Underground" (Wright), 237

"Many Thousands Gone" (Baldwin), 218

Marsh, Reginald, 21

Martin, Jay, 61, 64, 65

Marx, Karl, 197–99

Mass culture. *See* Popular culture

Matthews, John, 170–71, 267 (n. 11), 295 (n. 48)

McAlmon, Bob, 89

McCausland, Elizabeth, 113

McCleery, William, 53

McElvaine, Robert, 7

Medical profession, 86–88, 284 (n. 4), 286–87 (n. 32)

Melville, Herman, 263

Men at Work (Hine), 207–8, *209*, *210*

Mencken, H. L., 237

Middletown in Transition (Lynd and Lynd), 16

"Migrant Mother" (Lange), 47, *48*, 50

Mill, James, 12

Miller, Fred, 93

Miller, Henry, 184

Miss Lonelyhearts (West), 30, 60–65, 72, 73

Mitchell, W. J. T., 28, 231

Modernism: elements and devices of, 3; definition of, 3, 268 (n. 12); types of, 3–4; aesthetic, 73–74; Siskind on, 110–12; romantic, 114; and modernist documentary form, 114–15, 139–40; ethnic proletarian, 184–87; and higher education of modernists, 186; and shock of the new, 263–64; compared with professional specialization, 298 (n. 23); Klein on, 298 (n. 22). *See also* Documentary modernism; High modernism; Sensational modernism

Mori, Toshiro, 183

Morse, Samuel Taylor, 17

Moses, Robert, 118

Movies. *See* Films

Munson, Gorham, 81
Murphy, Richard, 19

Naked City (Weegee), 30, 52–60, 55, 58, 59, 72, 73, 259–62, 260, 267 (n. 10)
Natanson, Nicholas, 221
Native Son (Wright): compared with Wright's other works, 32–33; and "No Man's Land," 33, 34, 102, 220, 253–55; as "failure," 34; and naturalism, 75, 241, 248, 249; *Look* photo-essay written in response to, 125; sight and blindness in, 215, 242–43, 249; visual dynamics of race and racism in, 215, 243–44, 307 (n. 51); Wright's essay "How 'Bigger' Was Born" on, 215–16, 240–41, 247–51, 253, 255; trial of Bigger in, 216–17, 244, 251; compared with *King Kong*, 216–18; reviews of, 218, 236, 237, 241; stereotypes in, 218–20, 232, 246–54; female characters in, 220–21, 244–46; and pulp narratives, 236–41, 248; murders by Bigger in, 240, 241, 245–46; rape in, 240, 244–45; and newspaper crime reporting, 241–46; compared with di Donato, 246, 254; narrative indeterminacy in, 246–53, 308 (n. 65); blend of literary modes in, 248–49; and deformation of mastery, 249; Bigger's isolation in, 249–51, 253–55; Bigger's lack of integrated personality in, 250–52; Bigger's vision in, 252–53; scrutiny of Bigger in, 253–54; ending of, 254–55
Nativism, 83–84, 287–88 (n. 41)
Naturalism: and portrayal of the

poor generally, 1, 3, 265 (n. 5); in Wright's works, 33, 75, 232, 241, 248, 249; Seltzer on, 39–40, 207, 277 (n. 5); narrator/brute split in, 40, 190, 246–47, 265 (n. 5), 305–6 (n. 30); and antifeminine gender politics, 40–41; of di Donato's *Christ in Concrete*, 192–93; critics on, 271 (n. 37), 277 (nn. 4–5)
Nelson, Cary, 10
New Deal, 20, 113, 171, 182
Newhall, Beaumont, 113
New Masses, 85, 113, 297 (n. 13)
New York, Photo League in, 23, 31, 109, 113–16, 138–40
New York City: and Harlem riot, 9; tabloids in, 13, 14, 15, 16, 272 (n. 49); World's Fair in, 116; poverty in, 116, 117–18; and Harlem Renaissance, 117; parks in, 118. See also *Harlem Document* (Siskind); *Naked City* (Weegee)
Nicholls, Peter, 2, 41, 265 (n. 7)
Nixon, Robert, 241–42, 307 (n. 51)
North, Joseph, 150–51
Nuland, Sherwin, 96

Olsen, Tillie: as sensational modernist generally, 2, 4, 74; on class conflict, 10, 31–32; fragmentation and stream of consciousness in works by, 31–32, 149, 155–56, 162, 164–65; experimental literary techniques of, 31–32, 151, 158–68; writing career of, 33, 148–49; in working class, 74, 143–44; compared with Agee, 143–44, 147, 153, 154, 179; compared with Faulkner, 144, 169–79; family background of, 148; employment of, 148–49; on San Francisco long-

shoremen's strike, 150–55; collage technique of, 152–53; on writing as material act, 154; on Core Self, 165; compared with di Donato, 187, 192, 195. *See also* "The Strike" (Olsen); *Yonnondio* (Olsen)

Orsi, Robert, 211, 302 (n. 91)

The Outsider (Wright), 238, 306 (n. 35)

Painting. *See* Visual arts

Park, Robert, 221

Park Avenue North and South, 114

Parks, Gordon, 126, 127

Partisan Review, 150

Paterson (Williams), 83

Patterson, James, 13

Perloff, Marjorie, 101

Phillips, Sandra, 242

Photography: in tabloids, 15, 242, 273 (n. 58); history of, 26; in magazines, 26, 113, 116, 125, 139; and relationship between language, 27–29; Benjamin on, 108; abstract, by Siskind, 110–11; Rabinowitz on, 118, 120. *See also* Documentary photography; *and specific photographers*

Photo League, 23, 31, 109, 113–16, 138–40

Phototext, 10. See also *Let Us Now Praise Famous Men* (Agee and Evans); *12 Million Black Voices* (Wright); *You Have Seen Their Faces* (Caldwell and Bourke-White)

Pollock, Jackson, 113

Popular culture, 2, 12–17, 60–65, 268 (n. 13), 272 (n. 51)

Portrait of a Tenement, 114

Pound, Ezra, 81, 186

Poverty and the poor: high mod-ernism's portrayal of, 1, 2; senti-mental portrayal of, 1, 3, 35–36; and sharecroppers, 1, 23–26, 25, 31, *49*, 50–51, 141–47; realism's portrayal of, 1, 263; naturalism's portrayal of, 1, 265 (n. 5); docu-mentary photography's portrayal of, generally, 1–2; consciousness about, during Great Depression, 7; in Bourke-White's photographs, 23–26, 25; and depiction of sensa-tional bodies, 23–26, 25; scrutiny of, 35–36; in Steinbeck's *The Grapes of Wrath*, 43–46; reduction of the poor to their bodies, 45–46; in West's *Miss Lonelyhearts*, 64; in Harlem, 116, 117–18; as "shadow archive," 262–63. *See also* Immi-grants; Sensational modernism; Working class; *and specific authors and titles*

Progressive movement, 40, 277–78 (n. 8), 306 (n. 30)

Proletarian reportage, 150–51

Proust, Marcel, 233

Pulitzer, Joseph, 15

Pulp magazines and pulp fiction: and sensational modernism generally, 12, 13, 20; Rabinowitz on, 26–27; in Fitzgerald's *The Great Gatsby*, 41–42; and West's *Miss Lonely-hearts*, 62–63; and Wright's fiction, 219–20, 236–41, 248, 306 (n. 35)

Quin, Mike, 150

Rabinowitz, Paula: on pulp fiction, 26–27; on documentary, 26–27, 109; on looking at photographs, 118, 120; on Olsen's *Yonnondio*, 156; on class power, 190–91; on

aggressive icons of male vigor, 204; on Wright's *The Outsider*, 238, 306 (n. 35); on Agee's prose in *Let Us Now Praise Famous Men*, 292 (n. 8)

Race: Wright on, 222, 225, 243–44. *See also* Ethnicity; Stereotypes

Rampersad, Arnold, 233

Randolph, A. Philip, 9

Rasles, Père Sebastian, 90–91

Ratcliffe, S. K., 7

Realism: and portrayal of the poor, 1, 263; and surrealism, 11; Crane on, 39; Seltzer on, 39–40, 277 (n. 5); and Progressive movement, 40, 277–78 (n. 8), 306 (n. 30); and antifeminine gender politics, 40–41; of Williams's short stories, 96; and modernist documentary form, 140; of di Donato's *Christ in Concrete*, 192; critics on, 277 (nn. 4–5)

Reed, John, 84

Reed, T. V., 145

Reilly, John, 254

Reiser, Stanley Joel, 87

Riis, Jacob, 39, 53, 57

Roosevelt, Franklin D., 9, 47, 171

Rosler, Martha, 52, 142

Rosskam, Edwin, 219, 225, 226, 231

Roth, Henry, 12, 32, 33, 94, 184–87, 201, 297 (nn. 13, 21)

Rothman, N. L., 94

Rowley, Hazel, 237

Salomon, Louis, 188

Samuels, Shirley, 42

Sartre, Jean-Paul, 231

Savage Holiday (Wright), 237

Scarry, Elaine, 197–98

Scrutiny/discourse of scrutiny: definition and description of, 35–36; in Fitzgerald's *The Great Gatsby*, 36–

42; and documentary photography, 46–52; in Williams's short stories, 95–97, 254; in Wright's *Native Son*, 253–54

Sekula, Allan, 53, 263

Seltzer, Mark, 39–40, 207, 277 (n. 5)

Sensationalism, 2–3, 12–17, 36, 51, 239, 240–41, 257, 266 (n. 9). *See also* Sensational modernism

Sensational modernism: and popular culture generally, 2; and aesthetics of astonishment and bodily disfigurement, 2, 17–26; characteristics of, 2–5, 257, 263–64; and Depression modernity, 4, 5–23; and grotesque, 12; and modern culture of sensation, 12–17; and documentary modernism, 26–29; in literature and photography generally, 26–29; and tradition of discontinuity, 29–34; and scrutiny and sentiment, 36; and spectacle, 257–58; and disfiguration generally, 258–59; as poverty modernism, 263; compared with high modernism, 268 (n. 13). *See also* Sensationalism; *and specific authors and photographers*

Sentimental/sentimentalism: and portrayal of the poor, 1, 3, 35–36; compared with scrutiny, 35–36; definition and description of, 35–36; and democratic feeling, 42–43; and social control, 42–43, 279 (n. 26); in Steinbeck's *The Grapes of Wrath*, 43–46, 279 (n. 28); and documentary photography, 46–52, 259; in Lange's "Migrant Mother," 47, *48*, 50; and women's writing, 278 (n. 19)

Shahn, Ben, 226, *229*

workers, 9–10; doctor stories by, 10, 30–31, 65, 74, 78–81, 95–107, 176–77, 254; ill and exposed bodies of immigrant women in fiction by, 20, 30–31, 34, 73; and contact, 27, 31, 80, 81, 88–93, 106; short fiction of, generally, 33, 34, 91–93, 284–85 (n. 6); as editor of *Contact*, 62; and West, 62, 63, 65; in middle class, 74; poetry by, 76–78, 83, 85, 284 (nn. 3–4); as doctor, 78, 82, 86–88, 284 (n. 4); and *Blast*, 81; and cultural politics of 1930s, 81–82; on poetry, 81–82; and immigrant labor in New Jersey, 83–86; family background of, 84; autobiography by, 87–88; experimental aspects of fiction by, 94; narrator's voice and gaze in fiction by, 95–97, 101–2, 284–85 (n. 6); on Evans's photographs, 285 (n. 17); on Eliot, 287 (n. 37); violence in writing of, 288 (n. 42). *See also specific works*

Wilson, Christopher, 160

Wilson, Edmund, 63, 64, 147

Working class: accidents and injuries of, 1, 13, 32, 143, 158–60, 183, 183–84, 187, 190, 191, 194–97, 205–8; in di Donato's *Christ in Concrete*, 1, 32, 183–214; and Democratic Party, 8; and bodies of workers, 10, 20–26, 34, 143, 158–60, 167, 194–208, 258; in Fitzgerald's *The Great Gatsby*, 36–42, 44, 46, 63; Roosevelt on revolt of, 47; in Olsen's *Yonnondio*, 155–69; and class consciousness, 191–92; and contact between middle-class bohemians, 275 (n. 91). *See also* Immigrants; Labor unrest/strikes; Poverty and the poor

"World's End" (Williams), 104–5

World War I veterans, 8, 68–72

Wright, Herbert C., 237

Wright, Richard: as sensational modernist generally, 2, 74; racial stereotypes in works by, 20, 32–33, 73, 218–19, 232–36, 246–54; on consolation of tears, 23; on "No Man's Land," 33, 34, 102, 220, 253–55; on film, 215–16; and pulp narratives, 219–20, 236–41; on race, 222, 225, 243–44; and high modernism, 232–33, 248–50; on autonomy of craft, 233; on authorship, 239; on disfiguration, 258; on fiction, 305 (n. 27). *See also specific works*

Yezierska, Anzia, 183

Yonnondio (Olsen): wounded, disfigured proletarian bodies in, 10, 34, 143, 158–60, 167, 258; experimental literary techniques in, 31–32, 149, 155–56, 158–68, 179–80; as "failure," 34; and aesthetics of objectification, 75; compared with Faulkner, 144, 169–79; Olsen's notes for, 148–49, 157–58; as unfinished work, 155, 156, 157, 164, 179–80; publication after rediscovery of, 155, 157, 164, 177, 179; narrators of, 155–56, 168–69; radical modernism of, 155–69; working class in, 155–69; as socialist feminist text, 156, 294 (n. 39); title of, 156–57; cameo scene in, 160–62; "woman's blabbin'" in, 161; doctor's visit in, 161–62; hegemonic relations between poor and privileged in, 161–62; anticapitalist surrealism in, 163; compared with di Donato,

163, 192, 195; violence in, 163–64; Maizie's consciousness in, 164–65; identity in, 165–66; redemptive or resistant bodies in, 167; alternative culture of working class in, 167–69; conflicting, contradictory impulses and themes in, 178–79; and activist readers, 180; ethnicity in, 211

You Have Seen Their Faces (Caldwell and Bourke-White), 23–26, 25, 221, 225

Zandy, Janet, 196